WORLD ART

WORLD ART

WORLD ART

An Introduction to the Art in Artefacts

Ben Burt

B L O O M S B U R Y

LONDON • NEW DELHI • NEW YORK • SYDNEY

Bloomsbury Academic

An imprint of Bloomsbury Publishing Plc

50 Bedford Square
London
WC1B 3DP
UK

175 Fifth Avenue
New York
NY 10010
USA

www.bloomsbury.com

First published 2013

British Library Cataloguing-in-Publication Data

A catalogue record for this book is available from the British Library.

ISBN: HB: 978-1-8478-8944-7
 PB: 978-1-8478-8943-0

Library of Congress Cataloging-in-Publication Data

Burt, Ben.
World art: an introduction to the art in artefacts / Ben Burt.
pages cm
Includes bibliographical references and index.
ISBN 978-1-84788-943-0 (alk. paper) — ISBN 978-1-84788-944-7 (alk. paper) —
ISBN 978-1-84788-945-4 (alk. paper) — ISBN 978-0-85785-812-2 (alk. paper)
1. Art and anthropology. 2. Art and society. I. Title.
N72.A56B87 2013
701'.18—dc23 2012033114

Typeset by Apex CoVantage, LLC, Madison, WI, USA.

CONTENTS

PART III: ARTISTIC GLOBALIZATION

LIST OF ILLUSTRATIONS

ACKNOWLEDGMENTS

This book owes a special debt to Fiona Candlin, who devised a course on World Art and Artefacts as a collaboration between the University of London's Birkbeck College and the British Museum and invited me to teach it with her from 2003 to 2010. She then allowed me to combine her art-historical contributions with my anthropological ones in a book that we might have written together, if only we could agree on what we meant by "art." As this implies, her generous support for the book does not make her responsible for its contents.

The book also owes a great deal to the British Museum, to my experience gained in working there, to its collections and resources, and to colleagues who have contributed advice on their various areas of expertise. These include Marjorie Caygill, on British Museum history; Jill Cook, on Ice-Age European archaeology; Robert Storrie, on Northwest Coast Native Americans; Colin McEwen, on the archaeology of Peru and Ecuador; Julie Hudson, on the British Museum Africa program; and Lissant Bolton, on the Vanuatu Cultural Centre. Many of the illustrations also derive from the British Museum.

Valuable advice as well as illustrations was also provided by Nancy Munn, for Walbiri Aboriginals, with agreement from the families of Murray Wood Japangardi and Long Paddy White Jakamarra and senior men of Yuendumu; Monica Udvardy, for Mijikenda sculptures; Sokari Douglas Camp, for Kalabari masquerade and her own sculpture; Pamela Rosi and Larry Santana, for Papua New Guinea painting; and Agnes Henson Darby, for the Kiribati-Tunguru Association. Others who generously provided illustrations without charge include Barry Craig, Charles Wells Ltd, Rita Willaert, Nina Chang, and Matthew Isaac Cohen.

Advice and encouragement was offered by John Reeve, Katharine Hoare, Nick Stanley, Jane Huxley-Khng, several anonymous reviewers, and the editors at Bloomsbury: Anna Wright and Louise Butler.

The book is dedicated to Annette Ward, in the hope that she may one day read it.

INTRODUCTION

What do we mean by "art," and does it matter?

As a special category of objects and activities, the idea of art belongs to a particular cultural tradition, originally European, then Western and now increasingly global; but how useful is it for understanding other cultural traditions? The theme of this book is that if we want to understand art in its most general sense as a universal human value, we need to look at how Western concepts of art were constructed, in order to deconstruct and then reconstruct them through an understanding of the wider world. The Western concept of art developed within a system of roles, relationships, and institutions, which has now become the "art world," whose values and theories interpret the things regarded as art to everyone else. Art in this sense has made a major contribution to Western civilization, as its historians and philosophers can show, but what does the art world have to do with "world art"?

Looking out from the Western art tradition to understand other art in other terms is not a simple matter. Europeans have colonized so much of the world and dominated it for so long that their ideas about art have had a pervasive influence upon non-Western cultures as well as upon Western attitudes toward them. So if we want to investigate world art—whatever that proves to be—it helps to begin with a critical look at the Western ideas of art that were formulated as Western knowledge of the world expanded through exploration and trade, conquest and colonization, and through research into other cultures, present and past. This is the theme of Part 1 of this book, on **Western perspectives on art**.

Chapter 1 traces the **origins of art** in these terms, as the European intellectual elite formulated the concept of art and founded museums, galleries, and academies to collect, classify and research new information about the world and its products. Chapter 2 explains how, in the process, Europeans based their claims to cultural superiority on a Mediterranean heritage of so-called **Classical art**, which set standards for comparison with other cultural traditions—recent and ancient—supported by the discipline of art history. The study of these others dignified their products as art only of special and generally inferior kinds. Chapter 3 examines how the category of **Oriental art** contributed to the construction of an enduring opposition between Asian and Western civilizations. Chapter 4 shows how ideas of **primitive art** helped explain small societies as the inferior

antecedents of those of their colonizers, as studied by anthropology to advance various theories of culture history. Chapter 5 considers how changing understandings of human origins involved artefacts treated as **prehistoric art** in issues around the character of human culture in general and the identity of non-Western cultures in particular.

With the benefit of historical hindsight, the study of these subjects as art was a kind of conceptual colonization, imposing Eurocentric categories upon other cultures, with an enduring legacy that is the reason for focusing on it here. However, during the twentieth century the adequacy of Western art values to explain other artistic traditions was increasingly challenged by more relativistic approaches from both anthropology and art history. In Part 2, on **cross-cultural perspectives,** we look at theoretical insights that have contributed to more universalistic comparative views of art and to a clearer understanding of the usefulness of the concept of art itself.

In Chapter 6 we see how the analysis of **form** by art connoisseurs was paralleled by anthropological studies identifying formal style and structure in the artefacts of small societies. Chapter 7 looks at how anthropological studies of the **meaning** of artefacts to those who made and used them employed theories of symbolism shared with art history to interpret non-Western systems of iconography. Chapter 8 points out that the artistic values of artefacts are often realized only in the active **performance** of the social roles and events for which they were devised. Chapter 9 provides examples of how **archaeology** has used all these insights from art history and anthropology to interpret ancient cultures from their artefacts and iconography. In Chapter 10, such perspectives on non-Western artistic traditions contribute to an explanation for **the work of art** in society. A consideration of what the form, meaning, and performance of artefacts achieves in non-Western societies allows us to go beyond the narrow categories of Western art to support a definition for world art, which can be summarized as the patterning of form and meaning—visual and conceptual—as an aspect of all cultural production, in contrast to the Western concept of art as a category of artefact and activity.

Having considered Western histories and theories of art, we are in a better position to examine world art and the role of Western culture in making it what it has become. Part 3, on **artistic globalization**, considers questions and issues arising from the historical relationships that have brought the world's artistic traditions together under the influence of Western art values. How has art been used by colonizing and colonized societies in the causes of collecting and commerce, cultural hegemony and autonomous identities? How have non-Western peoples reacted to Western art values, as they attempted variously to emulate, adapt, or avoid them?

In Chapter 11, we subject the **art world** and its values to the kind of scrutiny applied to non-Western cultures. Looking beyond its self-proclaimed aesthetic values to the hierarchies of worth applied to artefacts collected through markets and mediated by institutional interests helps explain the global impact of Western art values. Chapter 12 focuses on ideas of **the exotic primitive,** which have influenced both Western art and the collection of exotic artefacts, raising issues of the Western appropriation and

representation of other artistic traditions. Chapter 13 examines non-Western responses to such collecting as **marketing exotic art**, with local artefact traditions developing to satisfy international consumers in ways that challenge art-world values of authenticity. Chapter 14 looks at the **artistic colonialism** that has represented colonized peoples to their colonizers and taught them the Western art values that have drawn some of them into the global art world. It remains to review the prospects for a continuation of the diversity that has characterized world art up to now. Chapter 15 compares **the global and the local** through examples of cultural communities that have developed alternatives to Western art institutions and reconstituted local traditions in response to global commodification and homogenization.

The arguments developed in the book are intended to challenge conventional Western assumptions about the West's own artistic tradition as well as other peoples', by taking an anthropological perspective which uses categories that allow comparison between cultures. Art historians might question whether we can speak of non-Western artefacts as art without imposing Western categories upon other cultures, but anthropologists would reply that any attempt to understand other cultures in their own terms requires us to devise cross-cultural categories—that is, anthropological ones. As a Western discipline, anthropology begins with such familiar concepts as politics, economics, and religion and then seeks to modify and qualify them to produce categories of universal application. Hence economics must transcend the ideology of capitalism and religion the theology of monotheism, to explain also the material and spiritual values of societies that recognize neither impersonal market transactions nor the worship of gods. Anthropology has not actually been very successful in doing this with art, too often falling back on Western art-historical perspectives on the non-Western small societies it usually studies, and this is why an anthropological definition of art is another focus of this book.

The book deals mainly with artefacts: the material objects that people make. These things have various artistic properties that may also be identified in speech, music, dance, and other activities, but we are focusing on what Western culture defines as "visual arts." We cannot escape such Western categories, which include the comparative and relativistic concepts of anthropology. For the purposes of this book, art is a property or aspect of all artefacts, so we are looking at the art in artefacts, rather than at artefacts of a particular kind. Artefacts have various uses and purposes to which their artistic qualities contribute, but they are not in themselves "art," any more than they are "economics," "politics," or "religion," all of which may also be represented in them. Calling them "art objects" denies other purposes that actually contribute to their artistic value. That said, it is not easy to write about art without sometimes objectifying it in this way, particularly when describing Western ideas and practices that do so. In this book, rather than put every instance of Western usage in quotation marks, the context should explain the distinction, while recognizing the inevitable ambiguity involved in a Western critique of Western culture.

To illustrate its arguments, the book has a special focus on the history and collections of the British Museum. One reason for this is that, as a product of European Enlightenment and empire, the British Museum has long represented the dominant ideologies and art values of the West. Now responding to the political shifts of globalization, it continues to raise issues relevant to this book as it repositions itself as a "world museum" in terms still contested by opponents of Western cultural hegemony. The other reason is that the author has worked for the British Museum for almost forty years, as an educator and curator in the Department of Ethnography, latterly Africa, Oceania and the Americas. This book is by no means a British Museum project, but it is a critical tribute to one of the great institutions of the art world and of world art.

As a brief introduction to a vast subject, the book draws upon a wide sample of historical, theoretical, and descriptive sources. The further readings suggested at the end of each chapter are mostly chosen for brevity and availability, but many other works cited may also repay study, and all are given in the References at the end of the book.

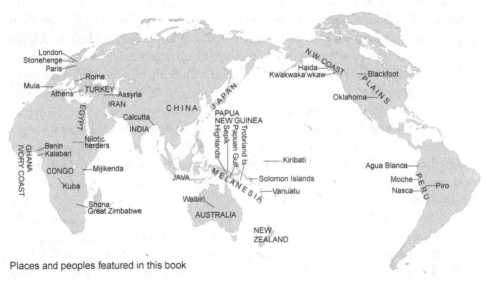

Places and peoples featured in this book

Figure I Map of the world, showing places mentioned as case studies in the book

PART I
WESTERN PERSPECTIVES

How ideas of art that developed in Europe were applied to other cultures, both present and past, with the expansion of Western knowledge of the world through exploration, commerce, and colonization.

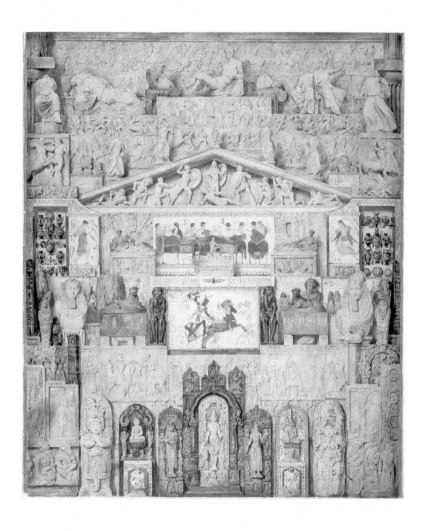

I THE ORIGINS OF ART

We begin by looking at how the Western idea of art was constructed during the past five hundred years, while Europeans were exploring the world and developing their claim to be at the apex of human civilization. While distinguishing their own most valued products as art, they also collected and classified the artefacts of the world, founding museums, galleries, and academies to serve concepts of art that were inherently ambiguous and contested.

Outline of the Chapter

- New Worlds and Histories
 A historical review of European expansion, the Renaissance of ancient Mediterranean culture, and the idea of art.

- Industrial and Intellectual Revolutions
 The roots of the eighteenth-century Enlightenment and the development of art connoisseurship

- British Museums
 The collection and classification of artefacts since the eighteenth century, with a focus on the British Museum.

- Politics and Commerce, Art and Craft
 A preliminary look at the Western culture of collecting.

Art originated in Europe, but not, as Europeans tend to assume, with the cave paintings of the Paleolithic. Rather, it began only a few hundred years ago as a cultural tradition of distinguishing the creation of particular artefacts and activities that communicate significant ideas and emotions. This was not a simple matter even when Europeans applied it to their own culture, and it produced all sorts of contradictions when applied to other peoples' artefacts as they were drawn into ever closer relationships through globalization. If the concept of art is indeed to have the universal application that "world art" implies, it is important to understand how it came to mean what it does through the history of its construction in Europe and its application to the rest of humanity.

NEW WORLDS AND HISTORIES

It was five hundred years ago, at the beginning of the sixteenth century, that peoples around the world began to have the generally unpleasant experience of being "discovered" by Europe. In the process, Europeans began to come to terms with the widening horizons, as well as the wealth and power, that the onset of globalization brought them in the centuries that followed.

In the 1490s, the Spanish reached the Caribbean, and the Portuguese found a route around Africa to India. In the 1500s, the Spanish began conquering territory in and around the Caribbean, and the Portuguese founded a colony at Mozambique. In the 1510s, the Portuguese captured Malacca in Malaya and began trading with southern China, while the Spanish began the conquest of the Aztec empire of Mexico. In the 1520s, the Portuguese began to colonize Brazil, and the Spanish sailed around the world. In the 1530s, the Spanish conquered the Inca empire of Peru. By the mid-sixteenth century, Europeans were trading South American silver for Indian cotton cloth, Southeast Asian spices and Chinese silks, and were shipping Africans as slave labor to work sugar plantations in the Americas. By the early seventeenth century, the British, French, and Dutch were establishing their own overseas empires, in competition with the Spanish and Portuguese.

The riches brought home to Europe helped shift the balance of power in society, challenging the political and intellectual certainties of the state and church. As prominent men increasingly bought their power with commercial wealth, rather than extracting wealth by political power under feudal relationships, they became increasingly unwilling to accept theological justifications for the old order. It was no longer enough to insist on a single absolute divine truth, from which knowledge had to be deduced rather than added to by new experience and research. In their search for new explanations for their changing experience, Europeans discovered an ancient past for themselves at the same time that they were discovering the wider world. The "age of discovery" also saw a revival of ancient Mediterranean culture and the emergence of new ways of thinking, which led in time to new cultural traditions of science, and of art.

The revival of ancient knowledge and skills produced new theories of history. Following the fourteenth-century Italian philosopher Francesco Petrarch, it came to be generally agreed that civilization had gone through a cycle of "ages." Growing from "archaic" beginnings, it had achieved its highest point in "classical" Greece and Rome (when, among other things, painting and sculpture were perfected), had declined with the Roman empire under Christianity and the barbarian invasions, been forgotten in the ensuing "dark ages," recovered somewhat in the transitional Christian "middle ages," and eventually revived with the rediscovery and rebirth, or "renaissance," of antiquity from the mid-fourteenth century. Later, in the eighteenth century, Europeans decided they had seen through the ignorant illusions of their predecessors, in the "enlightenment," which paved the way for "modernity."

This way of viewing European history, in which civilizations rose, fell, and rose again to reach the heights of contemporary achievement, laid the ground for later theories of world history, including why most of the newly discovered peoples had never risen in the first place. It was no coincidence that among the ancient Mediterranean practices revived in the Renaissance was commercial slavery, under which it was acceptable to force supposedly less civilized peoples, such as Muslims, Amerindians, and Africans, to work for the benefit of Christians.

ART AND ARTISTS

The cycle of history was realized, among other things, in a revival of the ancient conventions for painting and sculpture, which required that the appearance of things be idealized to represent the beauty of nature. For the Florentine sculptor Lorenzo Ghiberti in the mid-fifteenth century, this revival was signaled by the paintings of Giotto in the early fourteenth century. While the skills of making things could be loosely described as "arts," practiced by artisans, Renaissance painters and sculptors were increasingly treated as "artists," who, analogous with poets, pursued an intellectual discipline under divine inspiration. By the mid-sixteenth century, the standards for assessing their work were being set down in influential writings that focused on prominent artists and their influence upon one another, allowing a history of styles, schools, and periods to be constructed. The Italian architect and painter Georgio Vasari in *The Lives of the Painters, Sculptors and Architects* described how, in the cycle of decline and revival from ancient times, the individual creativity of contemporary artists had attained a divine "grace." Vasari and like-minded artists founded academies of art under royal patronage throughout Europe from this time, setting standards derived from Plato's concept of perfect forms, which the mind could conceive as underlying the imperfect world of experience.

Classical works provided models and inspiration for an emerging hierarchy of artistic value, formalized by the national academies and explained in the 1660s by André Félibien, art historian of the French royal court:

> the pleasure and instruction we receive from the works of painters and sculptors derive not only from their knowledge of drawing, the beauty of the colours they use or the value of the materials, but also from the grandeur of their ideas and from their perfect knowledge of whatever they represent . . .
>
> Thus, the artist who does perfect landscapes is superior to another who paints only fruit, flowers or shells. The artist who paints living animals deserves more respect than those who represent only still, lifeless subjects. And as the human figure is God's most perfect work on earth, it is certainly the case that the artist who imitates God by painting human figures, is more outstanding by far than all the others. However, although it is a real achievement to make a human figure appear alive, and to give the appearance of movement to something which cannot move; it is still the case that an artist who paints only portraits has not yet achieved the greatest

perfection of art and cannot aspire to the honour bestowed on the most learned of his colleagues. To achieve this, it is necessary to move on from the representation of a single figure to that of a group; to deal with historical and legendary subjects and to represent the great actions recounted by historians or the pleasing subjects treated by poets. And, in order to scale even greater heights, an artist must know how to conceal the virtues of great men and the most elevated mysteries beneath the veil of legendary tales and allegorical compositions. (Félibien 1669)

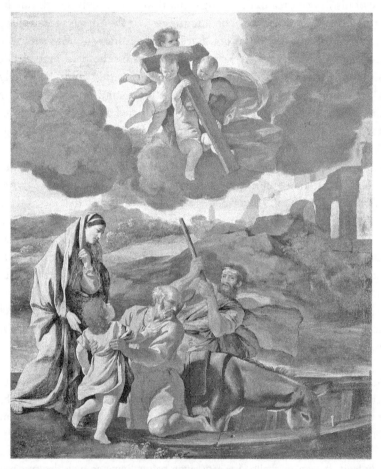

Figure 2 Nicolas Poussin, a seventeenth-century French artist working in Rome, produced what his friend André Félibien described as the highest class of painting. Poussin drew upon Classical as well as biblical themes to represent moral, philosophical, and emotional values in paintings carefully composed in appropriate stylistic modes. *The Return from Egypt*, painted about 1630, showed the child Jesus having a vision foretelling his crucifixion; the ferryman presumably alluded to Charon, who in Greek mythology carried souls across the river Styx, separating the living from the dead. (Dulwich Picture Gallery)

During the seventeenth century, such values became increasingly important to the wealthy elite who commissioned, purchased, and collected such works for private enjoyment and public display. Experts refined the skills to assess the artistic and hence the commercial value of paintings. In 1719, the English painter Jonathan Richardson published criteria "Shewing how to judge I. Of the Goodness of a Picture; II. Of the Hand of the Master; and III. Whether 'tis an Original, or a Copy." He set out principles of content, composition, and style, and wrote on "the science of a connoisseur," concerning the quality, authenticity, and value of artefacts treated as art.

By the eighteenth century, the European elite had identified the knowledge and skill to create beautiful, thought-provoking images as an art superior to the production of other artefacts and had established as disciplines the history of art (or at least of artists) and the connoisseurship of artistic value. The vague and flexible concept of art, from being a general description of creative skill, was now helping to distinguish the culture of the elite from its lower classes. In this sense, it proved both useful and resilient as Europeans gained more experience of other cultural traditions.

INDUSTRIAL AND INTELLECTUAL REVOLUTIONS

As Europeans prospered from the fruits of discovery—from the labor of Native and African slaves on Native American lands, and military and political control of the maritime trade around Africa to India, China, southeast Asia, and across the Pacific to the far side of America—so their own culture changed with the experience of increasing globalization. By the late eighteenth century, when they began to invest the wealth of the world in the development of their own manufacturing industries, Europeans were becoming convinced that they had surpassed the achievements of antiquity and were now in the forefront of human development, ready to take charge of the world, intellectually as well as politically. This was still subject to divine providence, of course, but there was a shift from acceptance of the divine received wisdom of the theologians to a "natural philosophy" investigating God's work in a world of ever-widening horizons. There were debates over the seventeenth-century philosophies of the French René Descartes, who used reasoning by deduction from divinely instituted general facts and first principles, and of the English Francis Bacon, who preferred reasoning inductively from facts established by empirical investigation, as adopted by the British philosophers John Locke and Isaac Newton. Philosophy contributed to the scientific developments that produced new industrial technologies. The industrial revolution of the second half of the eighteenth century was also the product of an intellectual revolution, still described as the "Enlightenment," which opened Europeans' eyes to the world as we now imagine it to be. Kim Sloan has characterized it as "a desire to re-examine and question received ideas and values and explore new ideas in new ways. Through an empirical methodology, guided by the light of reason, one could arrive at knowledge and universal truths, providing liberation from ignorance and superstition that in turn would lead to the progress, freedom and happiness of mankind" (2003:12).

Among these new intellectual developments were new attitudes to art. By the mid-eighteenth century, connoisseurship had become a serious historical methodology. Then, in 1764, the German Joachim Winckelmann published a history of art that rejected Vasari's focus on individual artists in favor of more general considerations of cultural history. Winckelmann identified certain stylistic qualities with phases in the rise and decline of civilizations, from Egyptian through Etruscan and Greek to Roman. This supposedly reflected the history of the human spirit as identified by Plato, with the greatest artistic achievements made under the conditions of liberty attributed to ancient Greece, which reflected the political aspirations of Enlightenment intellectuals.

At the same time, the definition of "the arts" was changing, producing what has become the idea of "art for art's sake," as Shelly Errington has explained:

> The eighteenth century took the idea of framing [images] further than the literal frame by distinguishing art from craft and separating the fine arts into five types: painting, sculpture, architecture, music, and dance. . . . By the end of that century, then, all five "fine arts" became useless contemplatable objects and required the frame—whether a picture frame, a pedestal, or a stage—to function as a boundary between the piece of art and the world, setting off art from everyday life, from social context, and from mundane utility. The frame pronounces what it encloses to be not "real" life but something different from it, a representation of reality. Thus at the end of the eighteenth century and the first part of the nineteenth century, music and dance, which are activities, were turned into aesthetic objects by framing them (with stage or platform) and separating them from the audience, which then contemplated them as spectacles, as the art connoisseur contemplated the painting on the wall. (1998:83–84)

A refined concept of the arts did not diminish interest in other artefacts, many of which became recognized as art of one kind or another in later times. Among those who prospered from the economic opportunities of the eighteenth century, some spent money as well as time and energy on collecting and classifying evidence of God's creation and the world's marvels in the form of "curiosities," both natural and artificial. In the early eighteenth century, the Swedish botanist and explorer Carl Linnaeus devised the system that Westerners—from biologists to gardeners—use to this day for classifying the natural forms of the living world, in a hierarchy of subspecies, species, genus and family, order, and so on. The "artificial curiosities" proved more difficult to classify, and the category of fine arts was not particularly helpful. Collectors tended to treat such artefacts as paintings, coins, and medals as illustrations of historical texts rather than as sources of historical evidence in their own right. They preferred to classify others typologically in order to make broad comparisons across humanity, rather than to distinguish cultural traditions geographically or historically. Their intellectual contributions were superseded, but the collections themselves survived and continued to grow over the years. Their legacy is the public museums that still house the collections, and notions of art that owe so much to the practices of collecting.

BRITISH MUSEUMS

The first of these museums in Britain was the Ashmolean Museum in Oxford, founded in 1683, but the greatest museums developed in London as national collections, beginning with the British Museum in 1753. As collections grew, they were divided according to the increasing specialization of scholarly interests, and this illustrates changing ways of classifying the products of the world, including artefacts and art.

The British Museum, greatest of the world's public museums, was founded from the collections of Sir Hans Sloane, a wealthy Irish physician who joined the intellectual elite of London in the late seventeenth century. Sloane collected mainly natural history, but also artificial curiosities, partly to illustrate human progress through the art of different ages and nations. They were classified in one of his many catalogs according to the developing scientific interests of the day as "Miscellanies, Antiqities, Seals etc., Pictures etc, Mathematicall instruments, Agate handles etc., Agate cups botles, spoons etc."

Examples from Sloane's Catalogs

Miscellanies

325 One of the poyson'd arrows w.ch being try'd had no effect on a wounded pigeon [from a set of darts from Borneo]

446 A small arrow head of black flint from Virginia

1070 A Japanese box for physick for powders & pills with gold & silver labells & two gold & silver bodkins

1935 A piece of flowered weaved stuffe made of grasse leaves from Angola worth there one shilling. [raffia cloth]

Antiqities

216 A basso relievo in which are 2 dogges upon a wild boar

518 An Egyptian head of the sun in basalt [actually from Mexico]

598 A small square sepulchral Roman lamp without any figures or inscription

726 An earthen bottle of grey earth coloured black in the form of a porpesse with a handle from Peru by Dr Houston said to be one of their Gods

Impressions of seals etc

96 An anchor & two arrows thro a heart in brasse a seal

98 King Charles the first great seal [wax impression]

Pictures and Drawings

278 St. Thomas Moore in Crayons June 1535 by Hans Holbein

Cameos

187 Leda in Sardonyche found in a grave in Shropshire.

By the early eighteenth century, Sloane's collection was famous in scholarly circles, and he left it to be purchased for the nation at a fraction of its value "to the manifestation of the glory of God, the confutation of atheism and its consequences, the use and improvement of physic, and other arts and sciences, and benifit of mankind." The government responded reluctantly, founding the British Museum in 1753. Marjorie Caygill, historian of the museum, has described its early years as:

> the "cabinet of curiosities" in which "a section of an old palace near Moscow" was displayed next to earthenware from Southern America, figures of German miners, Chinese and "other shoes"; where, before modern principles of classification imposed an element of uniformity, the model of a Chinese junk, bows and arrows and snow shoes were thought to be fit companions for King William and Queen Mary cut in walnut shells and a landscape painted on a spider's web, not to mention the jaw and other parts of an unknown animal from Maastricht, stones from the bladders of horses and hairballs from the stomachs of cows. (1981:3)

COLLECTING AND CLASSIFYING

The growth of these collections illustrates the accumulation of European knowledge of ancient and contemporary cultures of the world, and the British Museum's institutional history reveals the emerging categories into which this knowledge was classified. Books as stores of knowledge were originally the core of the collection, and three great collections were added in the first few years: the Cotton library, Harley manuscripts, and the Old Royal Library, dating back to the fifteenth century. The director of the museum was for long also the Principal Librarian, and the museum's Printed Books (including prints) and Manuscripts (which included coins and drawings) were distinguished from its "natural and artificial productions." Collections acquired in the 1760s and 1770s included ancient Greek vases from Sir William Hamilton (establishing the Classical collections); Pacific Islands and Native American artefacts from Captain Cook's voyages; plays from the actor David Garrick; artificial curiosities from the Royal Society; and coins, medals, gems, minerals, and drawings from Rev. C. M. Cracherode.

In 1807, a Department of Antiquities was formed, including Prints and Drawings, creating a distinction from the Library and Natural History collections. Antiquities acquired in the 1800s included ancient Egyptian sculpture and inscriptions from the British victory over the French in Egypt, and a collection of Roman sculpture from Charles Townley. In the 1810s came a cabinet of minerals, sculptural friezes from the Temple of Apollo at Bassae, ancient Egyptian monumental sculpture, and the much-admired sculptures from the Parthenon in Athens, as well as artefacts from a diplomatic visit to the West African kingdom of Asante.

For the general public, the British Museum did not compare well with commercial exhibitions of the early nineteenth century. While the British Museum still begrudged

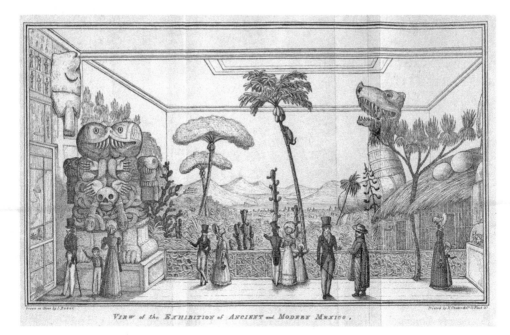

Figure 3 The frontispiece to Bullock's *Descriptive Catalogue of the Exhibition, Entitled Ancient and Modern Mexico* (Bullock 1824).

access to its poorly displayed collections, with bureaucratic ticketing and rushed tours, Londoners could pay at the door to visit waxworks, mechanical theatres, historical tableaux, and painted panoramas. In 1812, Bullock's Museum opened in the Egyptian Hall in Piccadilly, featuring stuffed birds and animals in natural habitats as well as arms and armor, Roman antiquities, exotic artefacts from the Pacific Islands, North America, Africa, and elsewhere, and a great ancient Egyptian exhibition in 1821. When William Bullock sold his collections, many items went to the British Museum and other public museums, and in 1825 Aztec antiquities from his Mexico exhibition became the core of the British Museum's Central American collections.

From 1823, the British Museum started rebuilding on a grand scale, beginning with the King's Library to house books from George the Third and continuing into the 1850s, to produce the magnificent neoclassical monument that stands today. In the meantime, it was acquiring artefacts from the Arctic, ancient Mexico, British Guiana and Tierra del Fuego, Australia, the Pacific Islands, and West Africa. By the 1840s and 1850s, the enlarged museum had room for ancient architectural sculpture from Assyrian sites in Mesopotamia and Greek-style Lycian monuments in Turkey. The expanding Library dominated the museum as a whole, with the Round Reading Room built at its center in the 1850s, but the Classical collections were the most valued of the antiquities, followed by those with biblical associations from Egypt and Mesopotamia.

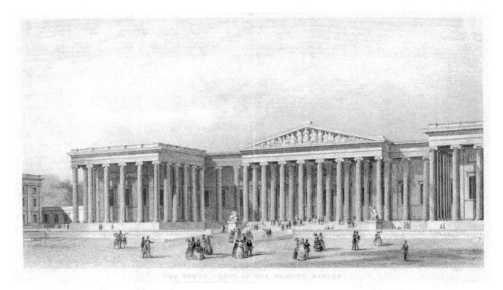

Figure 4 The neoclassical Ionian façade of the newly rebuilt British Museum, from the *Stationer's Almanack* of 1852. (The Trustees of the British Museum; 1880,1113.4427)

There had been public galleries of paintings in Europe from the late eighteenth century, and in 1824 the British government was persuaded to found a National Gallery, confirming the distinction of fine art from other museum collections. The British Museum's best paintings were transferred there, although Prints and Drawings remained. As the National Gallery grew, at first focusing on the Italian Renaissance, it moved to its new neoclassical building in the 1830s, and the collections of more recent British painting and sculpture went to the new Tate Gallery in 1897. The National Portrait Gallery was founded separately in 1856.

In the mid-nineteenth century, a shift in Western attitudes toward the collection of artefacts was signaled by the 1851 "Great Exhibition of the Works of Industry of All Nations," promoted by the Royal Society of Arts in the style of earlier commercial exhibitions. From this, the South Kensington Museum, later renamed the Victoria and Albert Museum, was formed in 1857. Both the Exhibition and the museum were imitated in Europe and its colonies in the second half of the nineteenth century, with the purpose of improving the standard of manufacturing design through public education in "practical art." The Victoria and Albert concentrated on Medieval and Renaissance Europe and on the technologically most sophisticated civilizations of Asia. It duplicated the British Museum in collecting recent European and Oriental luxury artefacts, but did not challenge its dominance in the fields of antiquities and the "ethnographical" products of less admired "savage and barbarous peoples." In 1909, the Victoria and Albert's technology collections went to the new Science Museum nearby, leaving it to develop as a museum of "decorative art," specializing in technical connoisseurship rather than on the historical and cultural interests of the British Museum.

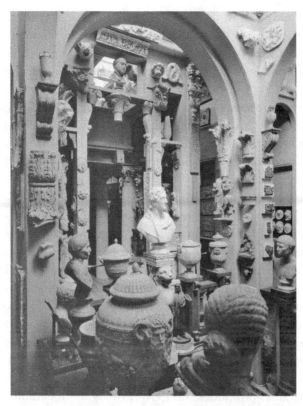

Figure 5 A glimpse of nineteenth-century Classical collection and display can be had at Sir John Soane's Museum near the British Museum, where his sculptures, books, pictures, architectural drawings, and models have been on display to the public since 1837. (By courtesy of the Trustees of Sir John Soane's Museum, Martin Charles photo)

During the second half of the nineteenth century, the British Museum's other collections grew to match its Classical and biblical antiquities, in quantity if not in esteem. This owed much to the curator Augustus W. Franks, who purchased many artefacts at his own expense and also arranged the donation of his friend Henry Christy's huge collection of prehistoric and ethnographic artefacts in the 1860s, too big to be housed on site. The all-embracing Department of Antiquities was reorganized in 1861, the new departments being: Greek and Roman Antiquities, large collections representing the antecedents of Western civilization; Coins and Medals, a specialist interest within this scholarly tradition; and Oriental Antiquities, covering everything else; that is British and Medieval Antiquities, Egyptian and Assyrian Antiquities, and Ethnography. Ethnography was a residual category, covering all those cultural traditions that had not produced antiquities then of scholarly interest. Even so, as the British Museum explained in the early twentieth century: "the great ancient civilizations . . . even that of Greece, arose gradually from primitive stages of culture; the instruments and utensils of savage and barbarous peoples are therefore not without interest to the study of antiquities." (British Museum 1910:1).

Then, in the early 1880s, the natural history collections were moved to a magnificent new British Museum (Natural History) next to the Victoria and Albert, allowing space for the Christy collection at the British Museum. In the 1890s and 1900s, important new ethnographical collections arrived from Benin in Nigeria and from the Congo (see pages 174–76). In the 1920s and 1930s, major archaeological collections came from the royal cemetery of Ur in Mesopotamia and the Anglo-Saxon burial at Sutton Hoo in Suffolk. A large private collection of Chinese antiquities was shared with the Victoria and Albert, which also handed over to the British Museum an important collection of ancient Maya architectural sculpture and casts, which it had not exhibited for thirty years.

Throughout the twentieth century, the opportunistic and equivocal classification of artefact traditions was illustrated above all by the "ethnographical collections," which were identified less by what they were than by what they were not. They covered Africa (except ancient Egypt, the ancient Greek and Roman and urban Islamic societies of north Africa, and later European and Asian immigrants); the Americas (all native peoples and ancient civilizations but not European or African immigrants), the Pacific Islands and Australia (again, indigenous peoples only); and contemporary peoples of Asia and eastern Europe (as distinct from the Oriental antiquities of the major civilizations to which most of these peoples belonged). In 1921, all these collections came under Ceramics and Ethnography (including China, which produced a lot of ceramics). In 1933, Ethnography (now excluding China) became a sub-department of Oriental Art and Antiquities. In 1946, Ethnography became a separate department, still in effect devoted to "the instruments and utensils of savage and barbarous peoples."

In the 1950s and 1960s, separate departments were also formed for Egyptian Antiquities, Assyrian Antiquities, Prehistoric and Roman Britain, and Medieval and Later Antiquities. The Coins and Medals, Prints and Drawings, and Greek and Roman departments continued from earlier times. As all these collections continued to outgrow the building, Ethnography was the department chosen to make space. From galleries occupying the whole upper floor of the east wing, Ethnography was moved to a separate building in 1970, named, in imitation of Museums of Man in Paris and Ottawa, the Museum of Mankind. After thirty years, at the turn of the century, when the British Library had moved out of the British Museum as a separate institution, Ethnography was reincorporated, with no more gallery space than it had in the 1960s. Some collections were reclassified under Oriental Antiquities, renamed Asia, and the rest became the Department of Africa, Oceania and the Americas.

The British Museum long ago ceased to be the universal museum of the Enlightenment ideal, with the loss of natural history, fine art, and books to other institutions. It is now said to be a museum of "world cultures," and as such it maintains Britain's claim to represent the world once dominated by its empire through the artefacts it acquired in those times. The invidious distinction between antiquities and ethnography may

be fading, but even so the British Museum still classifies and presents its collections according to European values of connoisseurship inherited from its foundation. In the early twenty-first century, the Classical collections continue to dominate the gallery space, followed by Egyptian and Western Asiatic antiquities. Ancient Greek and Roman antiquities occupy well over twice the space of that given to Africa, Oceania, and the Americas.

POLITICS AND COMMERCE, ART AND CRAFT

The British Museum has long been a monument to British national identity and pride, and other countries have sought to establish similar institutions for themselves. Among its peers is the Louvre in Paris, which in 1793 was transformed by the French Revolution from a palace housing the royal art collections into a national Central Museum of the Arts, open to the public. It was stocked with artefacts confiscated from the church and aristocracy and from countries defeated in France's European wars—from Dutch paintings to Italian antiquities—claimed for the nation under the new Republic. With the defeat of the French under Napoleon in 1815, the victorious allies repatriated much of these collections, and the recipient countries then used them to found their own national museums. As the Enlightenment project of removing artefacts from their original contexts to display for national prestige continued during the nineteenth century, the Louvre rebuilt its collections and expanded their scope, often in competition with the British Museum.

During the nineteenth century, collecting, with or without intellectual pretensions, became specialized into the kind of objects still collected today, from postage stamps to porcelain figurines, from bottles of wine to children's toys, including various things defined as art. From the mid-nineteenth century, collecting by wealthy American industrialists boosted the market by importing many antique luxury goods from Europe, from furniture and decorative artefacts to fine-art paintings and sculpture, some of which became the founding collections of great art museums. During the twentieth century, the range of artefacts collected as art expanded to include "Oriental art," "primitive art," and other non-Western artefacts defined ambiguously as art, including non-Western contributions to the Western genre of fine art. For the wealthy elite—Western and increasingly global—these became speculative investments. More and more artefacts were produced specifically to be collected, from "contemporary art" and limited-edition prints to special-issue postage stamps, pictorial plates, and so on.

The development of museums, connoisseurship, and Western concepts of art can be seen as a manifestation of a Western culture of collecting, which Russell Belk has described as a product of "the materialistic consumption ethos of a consumer society" (1995:64), in which value depends upon scarcity. Collecting, fueled by growing

prosperity, extended to all kinds of objects, even living plants, as in the Dutch tulip craze of the early seventeenth century. Markets developed to supply whatever was in fashionable demand, establishing commercial values for various collectibles, with an emphasis on the exotic, the novel, and the extraordinary. Although museums collected on behalf of the public, they were built upon private collections and participated in collectors' markets from the first. The founding collection of the British Museum was valued by Sloane at £100,000, although it was purchased for £20,000. Lord Elgin sold the Parthenon marbles for £35,000 and claimed to have spent twice as much to acquire them, and the sum of £10,000 was spent on a collection of Greek and Roman coins in 1872.

The market in such artefacts developed in parallel with the museums, which have always depended on gifts from collectors wealthy enough to purchase them as well as on purchases from commercial importers, exhibitors, and dealers like William Bullock. The London auctioneers Sotheby's and Christie's, now international companies, grew out of businesses founded about the same time as the British Museum, while Phillips' and Bonham's were founded in the 1790s. Their experts, in fields equivalent to museum departments, have long exchanged connoisseurial knowledge with the curators of public museums, who validate the artefacts on sale even if they cannot afford to purchase them.

Which of these things are "art" rather than "craft," and of what kind, may be disputed, but the criteria for evaluation are still those of the connoisseur as the arbiter of quality, taste, and authenticity, in an artistic hierarchy established centuries ago. In many situations, art and craft can be more or less the same thing. One word derives from Latin, the other from German, and English dictionaries define both in terms of the application of specialized skill. The terms can be used interchangeably of activities from warfare to writing, and of artefacts from sculpture to pottery. Even so, the individual creativity attributed to artists makes an important difference—works of fine art are unique, decorative art is scarce, craft is common and, at the bottom of the scale, most industrial products are ubiquitous. Art in the Western tradition is not simply a matter of artistic qualities, however these are judged, but also a matter of rarity and collectability.

QUESTIONS FOR DISCUSSION

- What did developing theories of world history contribute to Western concepts of art?
- How far has the classification of artefacts by museums reflected emerging categories of art?
- What implications might the classification of world cultures by museums have for the idea of world art?

FURTHER READING

- Caygill's book *The Story of the British Museum* (1981) is an informal authoritative history.
- Syson's chapter "The Ordering of the Artificial World" in Sloan's book *Enlightenment* (2003) describes the intellectual developments of the period as represented by the British Museum.
- Baker and Richardson's book *A Grand Design* (1999) is a history of decorative arts as represented by the Victoria and Albert Museum.
- Belk's book *Collecting in a Consumer Society* (1995) raises issues to be explored in more depth in Chapter 11.

2 CLASSICAL ART

European claims to cultural superiority emphasized an intellectual and artistic heritage from the civilizations of ancient Greece and Rome. Antiquities with biblical associations were compared unfavorably with "Classical" art values, which became the measure for Eurocentric histories of art.

Outline of the Chapter

- The Obsession with Ancient Greece
 The role of the Parthenon marbles in the idea of a Classical founding inspiration for Western art.

- Biblical Antiquity
 The discovery of remains from Egypt and Assyria and comparisons with Europe's Classical heritage.

- Classical Art History
 The European history of its own tradition, as summarized in Ernst Gombrich's *The Story of Art.*

- Classicism and Eurocentrism
 Some critiques of the Western appropriation of ancient Greece.

Since Europeans began expanding around the world and reviewing ancient Mediterranean culture in the process of adjusting to the experience, they have held the artefacts of ancient Greece and Rome in special reverence. Wealthy Northern Europeans going on grand tours to Italy from the early eighteenth century extended their researches to Greece, with Winckelmann establishing the stylistic history of Greek sculpture in the 1860s. The idea that Greece and Rome represented the "Classical" expression of European culture has influenced Western concepts of art ever since. It has also supported a cultural identity that claims superiority over all other traditions and whatever it defines as their art. Classical art deserves special consideration in the study of world art, for its role in Western art history.

THE OBSESSION WITH ANCIENT GREECE

The influence of Classical art can be illustrated by the recent history of some fragments of an ancient Greek temple that became some of the most famous possessions of the British Museum.

At the beginning of the nineteenth century, when Greece was still part of the Turkish Ottoman empire, the British ambassador to Constantinople, Lord Elgin, was documenting ancient Greek monuments and admiring the dilapidated Parthenon on the Acropolis of Athens. The Parthenon had been built in the fifth century B.C.E. as the city's treasury and a temple to Athena, in celebration of victory over the Persians. Since that time, it had been converted into a Byzantine church in the seventh century C.E., a Catholic church in the thirteenth century, a mosque in the fifteenth century, and, in the seventeenth century, an arms dump, which exploded during an attack by Venice, demolishing the center of the building.

Elgin was there during the Napoleonic Wars, and Turkish gratitude for the British expulsion of the French from the Ottoman province of Egypt enabled him to take hundreds of chunks of sculpture from the Parthenon in 1802 and eventually ship them to London, where he offered them to be purchased for the nation in 1816. In entrusting the sculptures to the British Museum, Parliament endorsed what was claimed to be the salvage of some of the greatest works of art of European antiquity from neglect by the barbarous Turks, in competition with the acquisitive French. Its report also explained why Britain was such an appropriate home for the sculptures:

> But if it be true, as we learn from history and experience, that free governments afford a soil most suitable to the production of native talent, to the maturing of the powers of the human mind, and to the growth of every species of excellence, by opening to merit the prospect of reward and distinction, no country can be better adapted than our own to afford an honourable asylum to these monuments of the school of Phideas, and of the administration of Pericles; where, secure from further injury and degradation, they may receive that admiration and homage to which they are entitled, and serve, in return, as models and examples to those, who by knowing how to revere and appreciate them, may learn first to imitate, and ultimately to rival them. (House of Commons 1816)

The marbles have retained their exalted status ever since, but their significance changed. For the British Museum in 1929, "The Parthenon Marbles, being the greatest body of original sculpture in existence, and unique monuments of the first maturity, are primarily works of art" (Beazley, Robertson, and Ashmole 1929). As the British Museum's expert on the sculptures, Ian Jenkins, has explained, such evaluations were self-fulfilling: "Removed from their original setting and exhibited at eye level . . . the sculptures were transformed from architectural ornament into objects of art" (2007a:17). This also increased the importance of the sculptures to the Greeks, as symbols of the national identity they

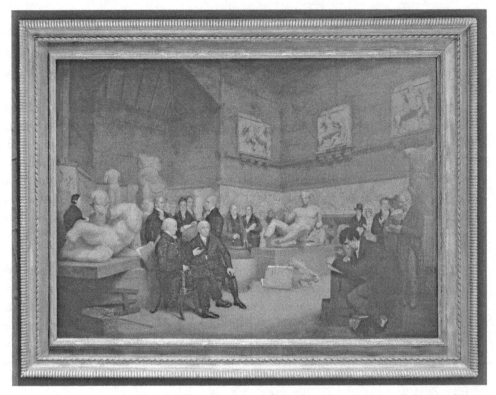

Figure 6 An imaginary scene painted in 1819 by Archibald Archer, showing the recently acquired Parthenon marbles in the Temporary Elgin Room, with the president of the Royal Academy, museum staff, and visitors. (The Trustees of the British Museum; Painting 30)

established after gaining independence from the Ottomans in 1833. In demanding their repatriation in the 1980s, Greek Minister of Culture Merlina Mercouri described them as "the essence of Greekness" (Mercouri 1986). Continuing arguments over the rightful possession of the Parthenon marbles are the more passionate because they have become symbolic of the cultural heritage not merely of Greece but of Western civilization.

BIBLICAL ANTIQUITY

At the same time that Europeans were claiming a Classical heritage from the Greeks, they were also seeking out relics of other ancient civilizations to the east, identified from their biblical and Classical educations as opponents of the Hebrews and the Greeks, and as distant predecessors of the Ottoman empire. From the seventeenth century, European envoys and travelers brought home descriptions of the ruins of Persepolis, capital of the Persian Achaemenian empire, which had fought the Greeks in the fifth century B.C., including the incomprehensible Mesopotamian cuneiform script. In the eighteenth

century, images of Egyptian monuments were published and some artefacts were exhibited, but interest in ancient Egypt really took off in Europe in the nineteenth century.

ANCIENT EGYPT

The British reception of ancient Egyptian artefacts has been described by Alex Werner (2003). At the turn of the nineteenth century, the French invaded Egypt, taking a team of antiquarians who assembled a collection of antiquities, which was confiscated by the British after Nelson defeated Napoleon at the Battle of the Nile. The Egyptian trophies—including the Rosetta Stone, which enabled Egyptian scripts to be deciphered—were exhibited at the British Museum in 1802, later occupying part of a suite of new galleries mainly devoted to Greek and Roman antiquities.

While art historians were interested in Egyptian artefacts mainly for their formative influence on ancient Greek art, ancient Egypt itself captured the public imagination. Collectors purchased Egyptian artefacts, while architects and designers of household fittings imitated Egyptian styles. In 1821, Bullock's Museum housed a massive exhibition of antiquities brought from Egypt by the collector Giovanni Belzoni. This included a reconstructed tomb, monumental sculpture and, of course, mummies. As the French rebuilt the collections of the Louvre after their dispersal with the fall of Napoleon, they too acquired many Egyptian artefacts, led in the 1820s by the curator Jean-François Champollion, decipherer of the Rosetta Stone,.

Painters used Egyptian architecture to depict grandiose scenes from biblical history (not necessarily from Egypt), and huge painted dioramas gave audiences the impression

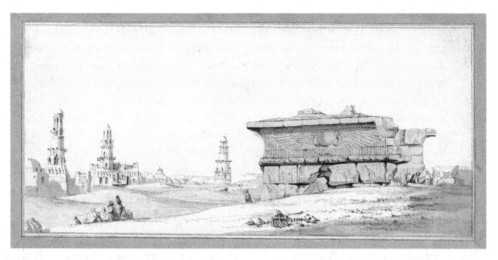

Figure 7 A scene of antique Egyptian ruins, with Islamic mosques, drawn for publication in 1802 by Dominique Denon—French minister of arts and director of the Louvre—who had accompanied the French invasion of Egypt. (The Trustees of the British Museum; 1836,0109.127)

of visiting the ancient sites. In the 1840s, the British Museum opened new Egyptian galleries, including the ever-popular mummies in their painted coffins. In the 1850s, the Crystal Palace, successor to the Great Exhibition (see page 16), featured an Egyptian Hall with truly monumental (if not full-size) reconstructions of Egyptian temples, which survived until the palace burned down in 1936. But despite its huge popularity, ancient Egyptian art was not well regarded by art commentators, including a writer in the *Illustrated London News* in 1854:

> All Egyptian sculpture and architecture were noticeable alike for massiveness and grotesqueness. But the massive and the grotesque are not enough to constitute "the grand." There must be some high, if not imperishable, idea and sentiment conveyed by the vast blocks; such as the grief, or the courage, or the self-devotion, or the sense of majesty, or the instinct of love, which are, in their turns, shed over the glyphic productions of Greece and of other lands. (1854:70)

ANCIENT MESOPOTAMIA

Competition between the French and the British continued as both also began investigating Mesopotamian sites to corroborate biblical accounts of the Tower of Babel and the cities of Babylon and Nineveh. By the 1840s, they were discovering spectacular architecture and sculpture buried in great mounds associated with Babylonia and Assyria. The British archaeologist Austen Henry Layard described the first discoveries of his French colleague Paul-Emile Botta in 1844 at Assyrian Nineveh, which preceded his own explorations:

> He soon found that he had entered a chamber, connected with others, and surrounded by slabs of gypsum covered with sculptured representations of battles, sieges, and similar events. His wonder may easily be imagined. A new history had been suddenly opened to him—the records of an unknown people were before him. He was equally at a loss to account for the age and nature of the monument. The art shown in the sculptures, the dresses of the figures, the mythic forms on the walls, were all new to him, and afforded no clue to the epoch of the erection of the edifice, and to the people who were its founders. Numerous inscriptions covering the bas-reliefs, evidently contained the explanation of the events thus recorded in sculpture. . . . M. Botta had discovered an Assyrian edifice, the first, probably, which had been exposed to the view of man since the fall of the Assyrian Empire. (Layard 1849:9–10)

From the very first, the Assyrian sculptures were compared unfavorably with those of ancient Greece, in terms that illustrate the European obsession with Classical art. Henry Rawlinson, British consul-general at Baghdad, wrote in 1846 of Assyrian sculpture and of:

a supposed comparison of the slabs with the Elgin or Halicarnassus Marbles. I still think the design in general crude and stiff, the execution careless, the grouping confused and fantastic. I am sure, in fact, that modern art cannot desire instruction from the marbles of Ninevah, and that the mere connoisseur in statuary will be offended at the inelegant (sometimes even grotesque) forms. But far be it from me to declare the marbles valueless on this account. I am rather afraid of erring on the other side—afraid that my antiquarian predilections may cause me to overestimate their importance (from Jenkins 1992:156).

British and French reactions to their discovery of ancient Assyrian remains has been described by Frederick Bohrer (1994, 1998). In the early nineteenth century, European knowledge of ancient Mesopotamia was based on hostile biblical and Classical Mediterranean sources, contributing to contemporary impressions of a desert land where the great civilizations of Assyria and Babylonia had fallen and been obliterated as a result of their own corruption. In the 1820s, this history was captured in such images as John Martin's paintings *Belshazzar's Feast* and *The Fall of Niniveh*, showing Oriental grandeur and luxury (with ancient Egyptian architecture) succumbing to inevitable destruction.

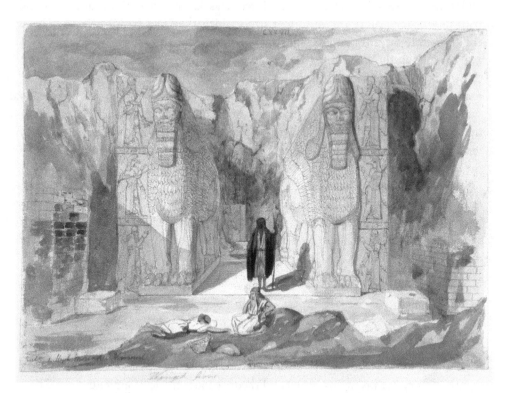

Figure 8 A sketch from Layard's excavations, later reproduced as an engraving in his book as *Entrance to small Temple (Nimroud)*. (The Trustees of the British Museum; 2007,6024.155)

classical art **27**

These were visual metaphors for European colonial aspirations in the region, particularly their relations with the Ottoman empire.

The first archaeological investigations of these civilizations were led by British and French diplomats posted to the Ottomans. Still competing, as in the Napoleonic Wars, for access to territories linking the Mediterranean to India, these two countries acquired archaeological relics for their national museums as antiquarian trophies. In the 1840s, Botta for the French at Nineveh and Layard for the British at Nimrud, excavated Assyrian remains, in competition between the Louvre and the British Museum. With export permits from the Ottomans, these museums gained great quantities of monumental sculpture, which provided new images of ancient Mesopotamia.

With the lower and middle classes gaining political influence and demanding greater access to public collections, both national museums put their Assyrian acquisitions on display as soon as possible, in 1847. The trustees and curators of the British Museum disdained the artistic quality of the sculpture and resented competition for space with their Classical collections, but were obliged by popular interest to provide galleries for them in 1853, as part of the rebuilding of the museum.

Rather than being treated as works of art in any way comparable with the Greek sculpture, the Assyrian reliefs excited interest as illustrations of antiquity, identified with the contemporary exotic Orient from which they had been retrieved. This was emphasized in Layard's popular illustrated book *Discoveries at Nineveh* (1854), as well as by articles in the *Illustrated London News*, in commercial panorama displays, and in theatrical productions. Henceforth, British (although not French) painters began to incorporate Assyrian motifs into imaginary ancient Mesopotamian scenes, rather than drawing on Egyptian and Mediterranean sources as before. During the second half of the nineteenth century, the British at least considered that they had gained authentic insights into the art and culture of ancient Mesopotamia when they used it to portray the exotic Orient.

The mid-nineteenth-century rebuilding of the British Museum as a Classical-style monument was an opportunity to put its antiquities in some kind of order. Henceforth, by walking through Egyptian and then past Assyrian sculpture galleries, you reached the relatively modest Lycian Greek temple sculpture before arriving at the Parthenon marbles at the end.

CLASSICAL ART HISTORY

In the nineteenth century, "Hellenomania," as the fetishism of ancient Greek art has been called, was reflected in the development of the history of art. From the mid-nineteenth century, art historians traced and theorized artistic developments from Classical antiquity through the Middle Ages and Renaissance to the modern world, under the assumption that art was self-evidently a property of a progressively evolving European

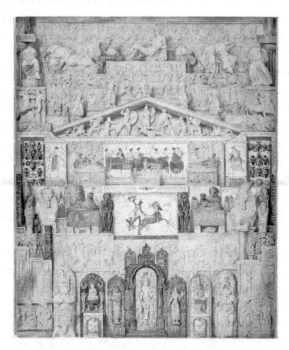

Figure 9 *An Assemblage of Works of Art in Sculpture and Painting from the earliest Period to the time of Phydias* (i.e., the Parthenon), painted by James Stephanoff in 1845 from the British Museum collections. His painting illustrates a conceptual hierarchy shared by the Museum, disregarding chronology. It was captioned (with dates added):

> At the base of the picture are specimens of Hindu [c. tenth century C.E.] and Javanese sculpture, and on either side are the colossal figures and bas-reliefs from Copan and Palenque [seventh-eighth centuries C.E.], those above them are from Perse-polis [522–338 B.C.E.] and Babylon, followed by the Egyptian [fourteenth century B.C.E.], Etruscan [c. fifth century B.C.E.], and early Greek remains, and surmounted by the pediment from Aegina; bas-reliefs and fragments from Xanthus [380s B.C.E.] and Phygalia [c. 400 B.C.E.]; the Theseus, Ceres and Latona, the Fates, and other figures from the Parthenon; and terminating in a portion of the equestrian bas-reliefs of the Panathenaic procession in the Temple of Minerva [430s B.C.E.]. (Trustees of the British Museum 1994,1210.6)

civilization. Since the early nineteenth century, European ideas of art had drawn increasingly on broader theories of history, notably those of the German philosopher Georg W. F. Hegel. According to Hegel, history was determined by the "spirit of the age" (*zeitgeist*), which progressed according to a dialectic in which a situation gave rise to internal contradictions, which were resolved in a new situation (often summarized as thesis, antithesis, and synthesis). This provided a new philosophical explanation for the old cycles of civilization theory based on the working out of the "World Spirit" (and adapted by Karl Marx as "dialectical materialism," driven by economics instead). For Hegel, the contradiction between the random "nature" of a thing and the "idea" of it created by the mind to reflect its spiritual essence was resolved in the work of art, which represented its "ideal" form. The point was that art should idealize nature rather than portray it, being created by the mind free of the constraints imposed by society. Hegel projected this fantasy scenario back upon ancient Greece and Rome, legitimating the ideal of Classical art.

Hegel's theory of artistic progress as a succession of contrasting movements had a lasting influence on art history. Jacob Burckhardt introduced art and literature as a cultural dimension of history, characteristic of its age but without the mystical elements of Hegel's historical theory. Aby Warburg (founder of the Warburg Institute in London) attempted to realize this project by collecting images representing all times and places and applying psychological theory to culture. At the end of the nineteenth century, Alois Riegl applied Hegel's theory that historical periods had their own spiritual laws to artefacts in general, rather than just fine arts. In seeking to understand artistic periods in their own terms, rather than making judgments on the rise and fall of civilizations, he attributed the styles of artefacts to artistic impulses that reflected the culture and worldview of particular societies. Paul Frankl took Hegel's ideas into the twentieth century, treating the development of style as reflecting philosophy, religion, and politics as the spirit of society, operating beyond human intention.

THE STORY OF ART

Even art historians who were skeptical of Hegelian ideas of "spirit" shared the underlying assumption that European civilization was at the forefront of artistic progress. Their art histories illustrate the development of Western art values and help explain how the West has understood and influenced other artistic traditions. *The Story of Art* by Ernst Gombrich was published in 1950, and despite subsequent developments in art history it remains popular and influential, having been reprinted ever since and translated into more than thirty languages.

Gombrich was a professor at the University of London, Director of the Warburg Institute, a Trustee of the British Museum, and an admirer of Classical art. *The Story of Art* was about the beauty and expression created and appreciated through the effort of individuals, and it concerned "the history of building, of picture-making and of

statue-making" (p. 18). Gombrich introduced successive periods or styles through their architecture before going on to deal with painting and sculpture and tracing relationships between them. His approach was to imagine the intentions of the artist and the problems he was trying to solve as he worked toward the realization of what the West has come to regard as the highest achievements of art. Gombrich acknowledged that his own Western idea of art as "some kind of beautiful luxury" was very recent, while many buildings, paintings, and sculptures had been created by people with no such concept of art. For these traditions, Gombrich assumed that their primary interest was in the utility or function of their artefacts, as if this was less significant in the Western tradition:

> The further we go back in history, the more definite but also the more strange are the aims which art was supposed to serve. The same applies if we leave towns and cities and go to the peasants or, better still, if we leave our civilized countries and travel to the peoples whose ways of life still resemble the conditions in which our remote ancestors lived. . . . Among these priorities, there is no difference between building and image-making as far as usefulness is concerned. Their huts are there to shelter them from rain, wind and sunshine and the spirits which produce them; images are made to protect them against other powers which are, to them, as real as the forces of nature. Pictures and statues, in other words, are used to work magic. (1950:20)

These imagined primitives, living in a world of childish fantasy uncorrected by critical rationality, provided the backdrop to *The Story of Art* as a cultural history of Western civilization. This began with ancient Egypt, whose painters and sculptors achieved a well-defined style or set of rules that "give every individual work the effect of poise and austere harmony" (p. 38). Gombrich characterized Mesopotamian art in similar terms, as governed by the religious and political demands of ruling elites, and the implications of this became clear when he introduced Greek art as "The Great Awakening" (Ch. 5). "It was in the great oasis lands, where the sun burns mercilessly, and where only the land watered by rivers provides food, that the earliest styles of art had been created under Oriental despots, and these styles remained unchanged for thousands of years. Conditions were very different in the milder climes."

Gombrich then described Greece as a region of small, independent city-states whose political culture of fractious bickering was a source of the artistic values so admired by later Western artists. When viewing the simple architectural harmony of modest Doric-style temples, "One feels that they were built by human beings, and for human beings. In fact, there was no divine ruler over the Greeks who could or would have forced a whole people to slave for him" (p. 45). He associated "The great revolution of Greek art, the discovery of natural forms and of foreshortening" (p. 52) with the democracy of the Greek states, particularly Athens. This democracy allowed artists, participating in government even as humble manual workers, to break free of the stylistic conformity

characteristic of the despotic Oriental traditions of Egypt and Assyria (although the slave base of Greek society and the military oligarchy of Sparta, home of Doric architecture, passed unremarked). Hence, great sculptors were able to go beyond ancient notions of idolatry to "a new conception of the divine" when, at the height of Athenian democracy in the fifth century B.C.E., the Parthenon was built, with sculptures that "reflect this new freedom perhaps in the most wonderful way" (p. 59).

As Gombrich put it, "The great awakening of art to freedom had taken place in the hundred years between, roughly 520 and 420 B.C." Henceforth, into the Hellenic period of the empire established by Alexander over Greece, southwest Asia, and north Africa, Greek sculptors developed not only idealized human images but also more expressive and individual portraiture. Paintings began to include everyday scenes, still life, and landscapes, as artists worked for a growing market of wealthy art connoisseurs. "Art had largely lost its old connection with magic and religion," which in Gombrich's terms brought it closer to the Western idea of art for the sake of beauty (p. 77).

Gombrich treated the Romans as merely building on Greek artistic traditions; developing new architectural styles, more naturalistic portraiture, and commemorative monuments. He saw early Christian art as a retreat from the Greek achievements of free expression of beauty to a concern for religious messages and sacred images governed by tradition, although still benefiting from elements of Greek formal style. When Christianity became the official religion of the Byzantine Roman empire in the fourth century, sculptural images declined in a reaction against idolatry, but painting was promoted as a means of religious instruction. But rather than maintain the ideal of realism, Byzantine art stylized Greek and Roman images in such a way that, as Gombrich put it, "Christian art of the Middle Ages became a curious mixture of primitive and sophisticated methods. The power of observation of nature, which we saw awakening in Greece about 500 B.C. was put to sleep again about A.D. 500" (p. 97). In the ninth century, after a period in which it discouraged religious images, the Byzantine church accepted the contrary doctrine that religious images were manifestations of divinity and hence subject to doctrinal conventions, limiting the initiative of the artist. So a cycle was completed in the rise and fall of civilization and art, leading to the Dark Ages of 500–1000 C.E.

Gombrich then took the opportunity to "cast a glance at what happened in other parts of the world during these centuries of turmoil by looking eastwards" (p. 102) and commenting on Islamic, Moghul, Chinese, and Buddhist art. The significance of these traditions for his story of art can be inferred by the inclusion of images ranging from the second to nineteenth centuries, from Spain to Japan, as an interlude between Byzantine and medieval art, and Gombrich's comment on the Orient that "styles lasted for thousands of years and there seemed no reason why they should ever change" (p. 137).

With the European Dark Ages, we are back to the realm of the primitive, with the art of the "armed raiders from the north . . . as a means of working magic and exorcising evil

spirits" (pp. 114–15). Gombrich admired the complexity of the intertwining patterns, adapted to Christian manuscripts, but was surprised by its effects on human figures derived from the Classical tradition, which "look almost as still and quaint as primitive idols" (p. 118). But despite such stylistic constraints, he interpreted this medieval style as representing the artists' feelings in a way that neither Classical nor Oriental art had done: "the Egyptians had largely drawn what they *knew* to exist, the Greeks what they saw; in the Middle Ages the artist also learned to express in his picture what he felt." He interpreted these feelings according to his own self-evident Christian faith, but made little effort to extend the method to other artistic traditions by attempting to understand their religious motivations.

In line with his assumption that naturalism was the highest achievement of artistic style, Gombrich treated the medieval period as one of regression. Of the Bayeux Tapestry he wrote, "When the medieval artist of this period has no model to copy, he drew rather like a child" (p. 124). On the other hand, the abandonment of naturalism allowed art to communicate religious narratives: "Painting was indeed on the way to becoming a form of writing in pictures" (p. 136). Then the Gothic style of church architecture superseded the Romanesque, as an engineering accomplishment that "seemed to proclaim the glories of heaven" (p. 141). When thirteenth-century Gothic artists began to experiment with naturalism once again, the better to represent "the sacred story," Gombrich implied that this was a lesser aim than the Greek pursuit of the beauty of the body for its own sake. He regularly compared these ancient artists with those of his own time who worked in the Classical tradition: "We think of an artist as a person with a sketchbook who sits down and makes a drawing from life whenever he feels inclined" (p. 147), in contrast to the training of a medieval artist as a craft apprenticeship, learning to repeat conventional images and designs.

The revival of Classical naturalism Gombrich attributed less to Gothic art than to its preservation in the Byzantine tradition, which influenced the Italian painter Giotto in the early fourteenth century and led the history of art to become "the history of the great artists." Both Byzantine and Gothic traditions contributed to the fourteenth-century development of religious paintings and sculptures, commissioned for the private use of an increasingly prosperous European elite who appreciated studies from nature, of flowers, animals, and people, in what became an "international" style.

This development throughout the increasingly integrated western region of Europe laid the ground for a revival of the still-revered achievements of ancient Rome in the early fifteenth century. So began the Renaissance, which Gombrich endorsed as the rediscovery of Classical artistic values. The rise of the merchant class and their gilds as sponsors and trainers of artists led schools of art in various European cities to develop distinctive styles as they explored the possibilities of naturalism and perspective through the Gothic and the revived Roman styles. Historical circumstances made it possible for the artist to be elevated from lowly craftsman to esteemed master: "At last, the artist was free" (p. 219).

Gombrich paid great attention to this Italian "High Renaissance" and its leading artists, with appraisals of their innovations in perspective, anatomy, and Classical style and an account of their influence on some of the Gothic-style artists of northern Europe. He went on to trace later stylistic and technical developments in Catholic southern Europe through the eccentric innovations of the sixteenth century and the Baroque elaboration of Classical style in the seventeenth century, contrasted with the suppression of religious painting under the Protestant Reformation of northern countries, which led to developments in portraiture and paintings of contemporary life. Gombrich traced this history through the artistic values developed by individual artists and debated with the wealthy connoisseurs who commissioned and collected their work. As to the questions of whether beauty depended on the imitation of nature or its idealization: "Even the 'idealists' agreed that the artist must study nature and learn to draw from the nude, even the 'naturalists' agreed that the works of Classical antiquity were unsurpassed in beauty" (p. 376).

The Enlightenment or "Age of Reason" of the late eighteenth century, Gombrich described as breaking with this tradition through a new self-consciousness of artistic styles, stimulated by the French Revolution, the development of antiquarian and historical studies, and the academic training of artists which promoted a distinction between art and craft. During the nineteenth century, as craft skills were undermined by industrial production, art diversified in both style and content, and popular conventional art was challenged by idealistic nonconformists, motivated by their "artistic conscience." Gombrich saw this as a triumph of individualism: "the history of a handful of lonely men who had the courage and persistence to think for themselves, to examine conventions fearlessly and critically and thus to create new possibilities for their art" (p. 399). Through the efforts of these artists, he traced a series of experimental movements rebelling against the perceived artificiality of conventional popular styles, constantly solving problems in pursuit of new artistic values. These developed from the mid-nineteenth-century French Realism, which sought truth rather than affectation, and the British Pre-Raphaelite ideals of medieval simplicity, into the later French Impressionist attempts to capture immediate visual experience, the British Arts and Crafts reaction against industrial technology, and the Art Nouveau adaptation to this technology at the end of the century. Gombrich also noted the way late-nineteenth-century improvements in photography undermined portrait and documentary painting, and the interest in Japanese prints, which provided new alternatives to European conventions of pictorial composition.

The story of art presented by Gombrich was one of individual artists solving problems in realizing the current aspirations of a Western cultural tradition through the creation of a very limited category of prestigious artefacts. In his own time, this tradition was deliberately and effectively challenged from within, through the development of so-called "modern art" from the early twentieth century. Gombrich described this as a period of "experimental art," ranging from architectural experiments with the functional

forms created by new engineering techniques to the "modern art" movements of Expressionism, Cubism and Primitivism early in the twentieth century, Surrealism in the inter-war period, and Dadaism, Abstract Expressionism, Pop Art, and so on and so forth after the Second World War. Although these movements challenged Gombrich's art values as well as previous conventions, he saw them as the culmination of a series of discoveries in artistic representation inherited from the Egyptians through the Greeks to the early Christians and the people of the Renaissance (p. 408).

CLASSICISM AND EUROCENTRISM

One thing about this kind of art history that contrasts with a comparative discipline like anthropology is that it makes little attempt to stand outside the cultural tradition it describes. For all his insights, Gombrich felt free to make his own personal and cultural judgments as an art connoisseur and advocate of Classical values with no interest in cultural relativism.

In tracing continuities between the Classical tradition and modern art, Gombrich's art history had some difficult contradictions to overcome, particularly as the Modernist artists made it their business to challenge the values of earlier artistic achievements. These artists rejected conventional standards of naturalism and beauty; contradicted the predictable, slow cycles of early, middle, and late phases of artistic development; and claimed individual inspiration, which appeared to refute theories of art as a reflection of society. Their success in capturing the imagination of the art-world subculture obliged art historians to adapt their theory and methodology accordingly, and the Modernist interest in certain non-Western traditions, particularly African and Pacific Islands sculpture, encouraged art history to expand its scope.

Even so, the Classical preoccupations of art history have been challenged less by artists than by historians of the late twentieth century, who criticized the construction of a Eurocentric Western identity based on false oppositions with the Orient. One such critic was the economic historian Samir Amin:

> The myth of Greek ancestry performs an essential function in the Eurocentric construct. It is an emotion claim, artificially constructed in order to evade the real question—why did capitalism appear in Europe before it did elsewhere?—by replacing it . . . with the idea that the Greek heritage predisposed Europe to rationality.

Amin went on to summarize the book *Black Athena* (Bernal 1987):

> Martin Bernal has demonstrated this by retracing the history of what he calls the "fabrication of Ancient Greece." He recalls that the Ancient Greeks were quite conscious that they belonged to the cultural area of the ancient Orient. Not only did they recognise what they had learned from the Egyptians and the Phoenicians, but they

also did not see themselves as the "anti-Orient" which Eurocentrism portrays them as being. . . . Bernal shows that the nineteenth century "Hellenomania" was inspired by the Romantic movement, whose architects were moreover often the same people whom [Edward] Said cites as the creators of Orientalism. (Amin 1988:90–92)

Such critiques have yet to change the dominant Western view of art history so firmly established in the Western art institutions of museums, galleries, and academies. In the British Museum, the Parthenon marbles now occupy a grand hall built in the 1930s that was paid for by the wealthy art collector Joseph Duveen and designed to reflect the Doric-style grandeur of the original temple. Since its opening in the 1960s (delayed by the Second World War), the marbles have stood around the walls as works of art, long bleached of their original paint, the center of the hall uncluttered by any related artefacts from the museum's massive ancient Greek collections. Fragments from this one Greek temple occupy more of the museum's scarce gallery space than the whole of sub-Saharan Africa.

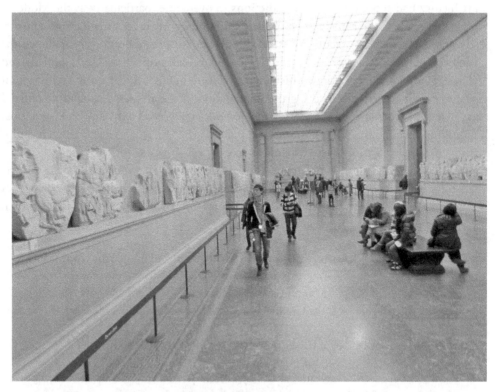

Figure 10 The British Museum's Duveen Gallery in 2011, with the frieze from the top of the Parthenon ranged along the wall, as if the temple was inside-out. (Ben Burt photo)

QUESTIONS FOR DISCUSSION

- Has admiration for the artistic achievements of ancient Greece contributed to or obstructed our understanding of world art?
- Is a theory of the progressive cycle of civilizations relevant to an appreciation of the development of artistic traditions?
- If judgments of artistic value are to assist the understanding of art history, what criteria should they be based on?

FURTHER READING

- Beard's book *The Parthenon* (2002) is a history of attitudes toward the temple and its sculptures.
- Werner's chapter "Egypt in London" (2003) covers the British exploration of ancient Egypt.
- Bohrer's chapter "The Times and Spaces of History" (1994) covers the history of Assyria at the British Museum.
- Pooke and Newall in Chapter 1 of their *Art History: The Basics* (2008) review the history of art history from an art-historical perspective.
- Bernal's *Black Athena* (1987) provides a detailed analysis of the historical "fabrication of Ancient Greece" and its implications for a Eurocentric view of the world.

3 ORIENTAL ART

As Europeans became acquainted with Asia, the "Orient" provided civilizations against which they could define their own culture. Asian artefacts became recognized as art of a kind, but according to colonial stereotypes of Islam, India, and China that ignored the artistic values of those societies.

Outline of the Chapter

- Orientalism
 The Orient as the defining opposite of Europe and the West, reflected in attitudes toward its art and its representation in museums.

- Islamic Art: An Orientalist Stereotype?
 How useful is the category of Islamic art for understanding the artistic traditions of western Asia and North Africa?

- Indian Art: Decorative and Denigrated
 British colonial perspectives on Indian artefacts and interpretations of Indian evaluations.

- Chinese Art: Unrecognized Connoisseurship
 A tradition of art appreciation which was ignored by Europeans in their concern for Chinese export art.

As the intellectual elite of Europe, traveling on commercial and diplomatic business, became more familiar with other continents, it was in Asia that they first found cultural traditions they could identify in their own terms as art. The great civilizations of western Asia, India, and China were far more sophisticated than Europe in several fields of technology and in the artistry of many of the artefacts they produced for trade. Europeans may not have understood very well what the artefacts meant to those who made, used, and exported them, but they recognized in them enough of their own values to start appreciating them as "Oriental art."

ORIENTALISM

The idea of the Orient always carried some ambivalent connotations. As imagined by the British and French in particular in their dealings with the Ottoman empire, the word "Oriental" conjured up images of despotism, exotic luxury, and cultural conservatism, as well as alien religions. This Orient had been the enemy of Europe and its cultural ancestors since the Egyptians and Babylonians oppressed the Israelites, the Greeks fought off the Persians, and the Crusaders attacked the Muslims, continuing in conflicts with the Ottomans in the nineteenth and early twentieth centuries. The Orient took different forms in lands further east, as European interests developed in India and China, and it has been revived in the late twentieth century as the "clash of civilizations" that identifies Islamic resistance to Western hegemony as an existential threat. This Orient has helped define Europe and the West as it wished to imagine itself: as the home of Christian values, liberalism and progress, freedom, and democracy.

According to Edward Said:

The Orient was almost a European invention, and had been since antiquity a place of romance, exotic beings, haunting memories and landscapes, remarkable experiences. . . . Unlike the Americans, the French and the British . . . have a long tradition of what I shall be calling *Orientalism*, a way of coming to terms with the Orient that is based on the Orient's special place in European Western experience. The Orient is not only adjacent to Europe; it is also the place of Europe's greatest and richest and oldest colonies, the source of its civilizations and languages, its cultural contestant, and one of its deepest and most recurring images of the Other. In addition, the Orient had helped define Europe (or the West) as its controlling image, idea, personality, experience. (1978:1)

In the eighteenth century, when scholars seeking to identify the origins of human culture were debating the roles of biblical Hebrews and archaeological Egyptians, they also considered the contribution made by Asian civilizations to the history that culminated in the founding of European civilization by the Classical Greeks. A contrast between Asian and European culture was theorized in the early nineteenth century by Hegel, in terms of historical manifestations of the "world spirit." The "Oriental realm" represented the spirit in a less developed stage, lacking the self-awareness realized in full by contemporary Europe. Art reflected the spirit of the culture, so Chinese and Indian art compared unfavorably with that of Europe, as well as contrasting with each other: "over against the thoroughly prosaic mind of the Chinese, we find set the dreaming unregulated fancy of the Hindus; the unimaginative realism of the former is confronted by the fantastic idealism of the latter" (from Mitter 1977:210).

Despite insisting on the inferiority of Asian culture, Europeans did extend their category of art to include certain kinds of Asian artefacts and to debate why others should be excluded. Even this exclusion represented an extension of the category, as is clear from the distinctions made by the art historians between fine art, of which Asians produced rather little, and decorative art, produced by artisans rather than artists, which they were judged to be rather better at. This did not necessarily earn European esteem. According to the influential nineteenth-century art critic John Ruskin:

> All ornamentation of that lower kind is pre-eminently the gift of cruel persons, of Indians, Saracens, Byzantians, and is the delight of the worst and cruellest nations, Moorish, Indian, Chinese, South Sea Islanders, and so on . . . the fancy and delicacy of the eye in interweaving lines and arranging colours—mere line and colour, without any natural form—seems to be somehow an inheritance of ignorance and cruelty (Ruskin 1873:307).

Such opinions pervaded European attitudes toward Asia, even as they researched its history and collected its artefacts for their museums, often as "ethnography" rather than as art. Ancient Greece remained a basic standard of artistic value, and art history was strongly colored by moral judgments that compared all other traditions more or less unfavorably with the realization of Classical ideals. But the characterization of Oriental art traditions also reflected the history of European relationships with particular regions of Asia.

ISLAMIC ART: AN ORIENTALIST STEREOTYPE?

European interest in the Islamic Orient developed from the war between the French and the British for control of the Mediterranean at the turn of the nineteenth century, when Napoleon's scholars initiated the study of Egyptian antiquity. Most of this Orient was actually in north Africa, but the dominant power was the Turkish Ottoman empire. As France and Britain increased their commercial and political interests in these lands in the course of the nineteenth century, so they constructed from them the Orient of their romantic imaginations. Traveling writers and painters brought home accounts and images suggestive of a timeless way of life, reminiscent for some of biblical antiquity, of the luxury and decadence of Oriental despots and harems, and abandoned monumental ruins. Islam, despite prejudices about a history of pagan barbarism, gained respect for its solemn piety and the beauty of its religious architecture and art. From European perspectives on the exotic Orient, the religion against which their forebears had fought their holy wars in medieval times was an obvious art-historical theme, but it was not until the end of the nineteenth century that they identified "Islamic art," in an attempt to complete an art history linking antiquity with medieval Europe.

A critical review of Islamic art has been provided by Sheila Blair and Jonathan Bloom (2003). When Westerners use the term they usually mean the artefacts of those lands

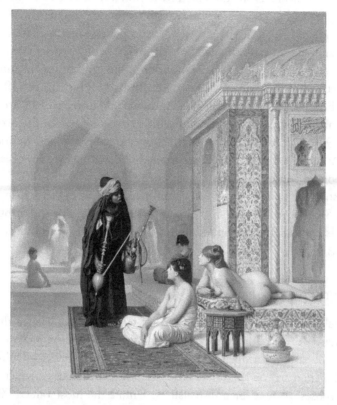

Figure 11 During the nineteenth century, European artists who had visited southwest Asia and north Africa gave visual form to popular fantasies about the Orient. Documentary painting of the people, their surroundings, and artefacts was often combined with imaginary scenes of opulence and eroticism. *Pool in a Harem* was painted about 1873 by Jean-Léon Gérôme, a French academician who liked to include naked women in detailed studies of Oriental art, drawing on his travels to Turkey and Egypt in the 1850s. (Hermitage Museum, St. Petersburg)

that the Arabs, inspired by their new religion, conquered in the seventh and eighth centuries. These extended from Arabia through North Africa to Spain in the west, and through Asia to Bengal in the east, with a core area between Egypt and central Asia. The Muslim rulers introduced artistic calligraphy in a single script to publicize their religious texts and promoted new artistic styles under the patronage of ruling classes enriched by trade within and beyond this vast empire.

The idea of Islamic art originated in the late nineteenth and early twentieth centuries, at a time when European colonial expansion was making inroads into the Muslim empires of the Moghuls in northern India and the Ottomans in southwest Asia and the

eastern Mediterranean. From the end of the nineteenth century, Europeans studying the archaeology and languages of southwest Asia began to identify Muslim history of the eighth and ninth centuries with an artistic period intermediate between antique and medieval, between Eastern and Western. In the early twentieth century, Islamic art became the theme of publications, exhibitions, and collections, including the exceptional collections of the British Museum and British Library. In the 1920s and 1930s, emigrating European scholars established museum and university departments in North America, which led the study of the subject in the second half of the twentieth century. From the 1970s, North American and European economic and political interests in southwest Asian oil led to increasing sponsorship, including extensive Islamic galleries at the Metropolitan Museum of Art, which opened in New York in 1975, and the World of Islam festival in London in 1976, accompanied by an expansion in the market for Islamic art. Since then, despite shifts in emphasis provoked by the turbulent history of the region, Islamic art has continued to flourish in museums and universities in Europe and North America.

PROBLEMS WITH ISLAMIC ART

Unfortunately, the category of Islamic art has failed to acknowledge the religious and cultural diversity of Muslim peoples, past and present. It seldom includes the later Muslim converts of eastern Europe, tropical Africa, and southeast Asia. Unlike the religious focus of "Christian art" or "Buddhist art," "Islamic art" includes artefacts made for non-Muslim purposes, by and for non-Muslims. Unlike the most valued Western art, it is mostly "decorative" as distinct from "fine art." Islamic art is not a category recognized by Muslims, even by the connoisseurs who treat calligraphy and book illustration much as Westerners treat fine art. Nor is there much interest in Islamic art in Muslim countries, despite the support that the oil states have given it through sponsorship in the West. There are Muslim writers who take a rather mystical Sufic approach in tracing artistic styles to the universal revelation of Islam itself, in effect finding an Islamic legitimation for a colonial concept. But more often the focus in Muslim countries is on particular local traditions, acknowledging the Islamic contribution but tracing continuities from earlier civilizations, such as ancient Persia or the nomadic Turks. When such traditions are confounded with contemporary national identities, as in Iran or Turkey, equally important historical relationships may be neglected for the sake of legitimating political categories that also derive from Western colonialism.

Western attempts to find more manageable and less political alternatives to the unwieldy category of Islamic art have resulted in publications, often associated with exhibitions, on such themes as particular Muslim dynasties or rulers, great buildings, catalogs of important collections, and technical categories such as architecture, book illustration, ceramics, metalwork, and textiles. Blair and Bloom considered the concept of Islamic art to be most useful for the early period when Muslim conquests promoted and

disseminated a shared cultural tradition throughout the empire from Spain to central Asia. After the Mongol invasions of the thirteenth century, local traditions diverged, and relationships with non-Muslim cultures of areas like the Mediterranean became more influential. As Muslim countries have become increasingly involved in Western colonial and global culture, attributing them with Islamic art risks accusations of Orientalist prejudices about the unchanging East.

The continuing Western tendency to stereotype Islamic history and culture as a single tradition in opposition to the West makes reform of the category of Islamic art difficult in practical terms, particularly as Muslims become convinced of the opposition. The heirs of scholars who once developed the Orientalist category of Islamic art find themselves trapped in it now that it is proving intellectually limiting. Art historians are confounded by Islamic art because, as Blair and Bloom pointed out, "It is neither a period nor a style, it is not restricted to one country or region, and it studies things not normally considered art" (2003:55). The category does draw attention to cultural relationships overlooked by other perspectives, but as long as Islam is politicized in the dispute between Muslims and the West, alternative perspectives on the art traditions of Muslim regions will be difficult to promote.

The British Museum has an Islamic World gallery which illustrates this critique. It includes artistic artefacts from a region stretching from Spain in the west to India in the east, but none from Muslim sub-Saharan Africa or Indonesia which were held until recently not in the Department of Oriental Antiquities but in the Ethnography Department.

INDIAN ART: DECORATIVE AND DENIGRATED

The history of European attitudes toward Indian artefacts as art has been described critically by the art historian Partha Mitter (1977). He has explained how, from the mid-nineteenth century, Indian ornamental design, long familiar in Europe from imported textiles and luxury goods, was seized upon by Europeans disillusioned with the way their own design tradition had suffered from a decline in craftsmanship caused by industrial manufacturing. Indian design seemed to have a coherence of style, which Europe had lost to "illusionist" decoration, which concentrated on naturalistic images rather than aesthetic form. Alternative theories of design were being promoted through new art schools, and Indian design became increasingly popular after its display in the Great Exhibition of 1851. For its admirers, the virtues of Indian design reflected a romantic view of pre-industrial society, which seemed to have survived in Indian village life and its craft traditions. It was intended to provide inspiration for British art and design, from the very artisan traditions that British industrial exports and colonial policy were undermining.

European commentators were at pains to distinguish such products from anything that could be described as fine art, as defined in their own Classical art tradition. George

Birdwood, a colonial official and adviser on Indian art for the South Kensington Museum (precursor of the Victoria and Albert), was quite explicit:

> The monstrous shapes of the Puranic deities are unsuitable for the higher forms of artistic representation; and this is possibly why sculptures and painting are unknown, as fine arts, in India. . . . It is not of course meant to rank the decorative art of India, which is a crystalised tradition, although perfect in form, with the fine arts of Europe, wherein the inventive genius of the artist, acting on his own spontaneous inspiration, asserts itself in true creation. The spirit of fine art is indeed everywhere latent in India, but it has yet to be quickened again. (Birdwood 1880:125, 131).

Even so, collections of Indian art—archaeological and recent—were accumulating in the British and South Kensington Museums. In 1874, Henry Cole published a *Catalogue of the Objects of Indian Art Exhibited in the South Kensington Museum*, which classified art styles into three main periods, as already identified by archaeologists since the eighteenth century:

> —the *Brahmanical* which includes the spread of the Aryans over the northern portions of India from their first arrival in the Panjab to the rise of Buddhism, and which would comprise the earliest section of the history of the Aryan race, during which time the religion of the Vedas was the prevailing belief in the country:—the *Buddhist* period which includes the history of the rise and decline of the Buddhist religion and art, from the era of Buddha to the conquest of Mahmud of Ghazni, during which time Buddhism was the principal religion:—the *Muhammadan* period which embraces the rise of Muhammadan power, from Mahmud of Ghazni to the battle of Plassy or about 750 years, during which time the Mussalmans were the paramount sovereigns. (Cole 1874:6)

Cole drew upon the Hegelian theory that art reflected the innate spirit or essence of cultures, identified as "nations" or "races" of varying character and merit, as did James Fergusson, who published a history of Indian architecture in 1876. Fergusson proposed a similar succession of races, identified from a detailed survey of architectural styles, with the presumption that the mixture of originally pure races had over time debased the character of the more superior ones, leading in particular to the degeneration of the Aryan culture which had produced the religion and art of the Hindus. Cole and Fergusson both regarded Buddhist art as superior to the decadent ornamentation of its Hindu successor and claimed the Buddhist sculptures of Ghandara, admired since the 1830s for their simple lines and drapery, as the highest achievements of Indian art. This style was attributed to inspiration from the Classical Mediterranean as a result of Alexander the Great's conquests of the fourth century B.C.E. As in later "diffusionist" theories in anthropology (in which culture seems to migrate; see pages 58–61), the cultural achievements of non-Western peoples were acknowledged only as poor imitations of Western antecedents,

which had influenced them by tenuous or unspecified means; in this case a short-lived invasion that left no artisans or monuments in India. The underlying assumption was that Indian culture had degenerated since the time of the Aryans and the Greeks, with art declining into craft. According to the expert on Indian history, Vincent Smith:

> The Gándhára or Pesháwar sculptures . . . would be admitted by most persons competent to form an opinion, to be the best specimens of the plastic art ever known to exist in India. Yet even these are only echoes of the second rate Roman art of the third and fourth centuries. . . . In the India of to-day painting and sculpture are both lost arts. The little feeling for beauty that survives is almost confined to small bodies of skilled artizans, and is with them rather the inherited aptitude of the members of a guild for the work of their trade, than a genuine artistic taste. (Smith 1889:173)

DEFENDING INDIAN ART

Such derogatory attitudes were not unchallenged. Rajendralala Mitra, a Sanskrit scholar who led the Orissa section of the Indian Archaeological Survey, was arguing for the Indian origins of its own architecture in the 1870s:

> But whatever the origin or the age of ancient Indian architecture, looking to it as a whole it appears perfectly self-evolved, self-contained, and independent of all extraneous admixture. It has its peculiar rules, its proportions, its particular features,—all bearing impress of a style that has grown from within,—a style which expresses in itself what the people, for whom, and by whom, it was designed, thought, and felt, and meant, and not what was supplied to them by aliens in creed, colour and race. (Mitra 1875:22)

Mitra was directly contradicted by Fergusson, with sarcastic allusions to his native origins. Eventually, in 1910, the outspoken prejudice of George Birdwood provoked a public British reaction led by Ernest Havell, first director of the Calcutta Art College. Havell and others advocated the assessment of Indian art in its own terms, as the representation of the spirit or divinity deriving from an ancient Vedic philosophy that few Europeans had gone to the trouble of understanding. The Indian artist was responding to an inner spiritual world that contrasted with Western materialism, including the earthly natural beauty imitated by Classical artists. From this perspective, the Classical distinction between fine and decorative art was irrelevant, and the applied arts demanded equal respect. From the 1900s, Ananda Coomeraswamy, an art historian of Indian background and British education, idealized Indian crafts in a critique of capitalism shared with British socialists such as William Morris, whose Arts and Crafts movement sought to revive the artisan traditions of Europe. They drew parallels with European medieval society, in which art and religion were one, represented by the "pious artisan" rather than the artist seeking personal expression of aesthetic or philosophic

ideas. Coomeraswamy even proposed that the ancient Indian translation of divinity into artistic form had been mediated by yogic contemplation, promoting a unity of consciousness with the beings represented.

Havell also offered a critique of European academic art by pointing out that the British Museum's Parthenon marbles were originally brightly painted, in an "Oriental" manner that would have outraged the taste of Classical scholars: "The Greeks themselves, I have no doubt, would have scoffed at academic distinctions between 'fine' art and 'decorative': they would have given unstinted praise to the sculpture at Kalugumalai, and recognised in the Sun-temple at Mudhera, in Gujerat, an art not less perfect than their own" (Havell 1911:178).

As art critics, Havell and Coomeraswamy effectively challenged the Eurocentric prejudices of antiquarians like Cole and Fergusson. Even so, their approach to Indian artistic values was still based in European theories and stereotypes of Indian culture. Looking back to the superior culture of a former age, they too drew upon the Hegelian legacy of

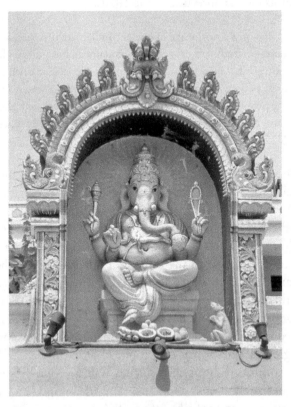

Figure 12 The Hindu god Ganesh in south Indian style, in Sri Mariamman temple, Singapore, in 2008. (Ben Burt photo)

idealism by imputing a spiritual reality of the mind that underlay the creation of arte-facts as its material reflections, thus attributing a European mysticism to ancient India.

Having provided a detailed critique of his predecessors in the field of Indian art his-tory (1977), Partha Mitter summarized an alternative approach:

> The unique qualities of Indian art can be appreciated less by a stylistic analysis based on western categories or by metaphysical generalizations than by a cultural history that places Indian art in its social and religious setting. . . . Basically, the traditional Indian approach is very different from our own modern outlook on architectural decoration. The concept of ornament played a central role not only in art but in other areas, in both sacred and secular spheres. Ancient Indians regarded ornament as a sine qua non of beauty; things lacking in ornament were considered imperfect or incomplete. . . . If we turn to Sanskrit high literature, we find that it revels in the wealth of rhetorical ornaments—metaphors, similes, alliterations, and other literary effects. In short, the function of ornament is to add richness, to heighten mood and emotion. . . .—an aesthetic outlook that was in most cases incompatible with the western Classical canon. (1999:112–13)

CHINESE ART: UNRECOGNIZED CONNOISSEURSHIP

Although Europeans constructed their theories of Oriental art with little consideration of Asian artistic values, they sometimes had more in common with the Asians than they realized. Europeans were not the only people with an ancient tradition of wealthy connoisseurs collecting fine artefacts according to a sophisticated philosophy of artistic value; the Chinese had been doing this for hundreds of years longer.

Until the mid-twentieth century, the Chinese maintained a carefully structured ad-ministration governed by Confucianist philosophy, as a hierarchical system of rights and duties in support of the imperial state. In this bureaucratic tradition, the produc-tion of fine artefacts served the official hierarchy. Goods were manufactured on a large scale in state factories to produce ranges of quality and style appropriate to complex distinctions in the rank and occupation of their owners. Luxury artefacts were allocated according to official regulations governing quality and quantity. Objects of precious materials varied in size, weight, and elaboration, with members of the royal court possessing the biggest and best in many times the quantity of the poorer versions belonging to junior aristocrats. Buildings, too, were ranked by the scale and elabora-tion of their floor plan, and tombs and grave goods imposed the same hierarchy upon the afterlife. There was a corresponding hierarchy of materials, the most precious of which were imitated in porcelain. The forms and uses of ancient jade and bronze ritual utensils were reproduced in green-glazed porcelain for household altars and scholars' furnishings, and white porcelain in a different style was modeled on gold and silver eating utensils.

But above all these symbols of rank, wealth, and status, the scholarly elite who administered the state valued writing and painting, in much the same way that the European elite valued painting and sculpture as fine art. Texts for display and contemplation were commissioned and collected, exhibited and discussed, as part of the refined social life that validated high social status. Scholarly connoisseurs appended their comments to the paintings as a record of gatherings to admire each other's collections, enhancing their value within this elite artistic subculture.

Chinese painters were praised for capturing the essential qualities of their subjects, not through the imitation of visual appearances as in the Western Classical tradition, but through the mastery of techniques, which also represented the essential character of the painter. This derived from a tradition of calligraphy in which the painter was embodied in his brushstrokes, and there was an expectation that master painters were also

Figure 13 A seventeenth-century scroll of a poem painted by Zhang Ruitu, one of the most esteemed calligraphers of the Ming dynasty, bearing a collector's seal.
(The Trustees of the British Museum; 1963,0520,0.5)

the calligraphers who painted the accompanying texts. Texts were as important in style and content as the images they accompanied, and calligraphic style was judged for the way the brushstrokes evoked visual metaphors for the cosmic moral values expressed in the work as a whole. These values were founded on the principle that human fortunes depended upon behavior being in harmony with the cosmos; so painters, poets, and calligraphers should both express and mediate favorable cosmic forces. Unsurprisingly, the scholarly administrative elite regarded cosmic harmony as the maintenance of the values that ensured their own authority within the Chinese state.

THE EUROPE TRADE

This tradition of Chinese connoisseurship was a complete mystery to European admirers of their artefacts until well into the twentieth century. It was in the sixteenth century that Spanish and Portuguese ships began a trade in South American silver for Chinese luxury goods, including porcelain to be sold in Europe. In the seventeenth century, the Dutch took control of the trade, and in the eighteenth century, the British. By this time, Chinese manufactures such as porcelain and silk textiles had become secondary in value to tea. At first, Europeans collected Chinese artefacts as exotic curios with little idea of their actual provenance, contributing to earlier romantic fantasies about the idealized civilization of Cathay. The ceramics trade thrived due to superior Chinese technology and because Europeans had no suitable clay. In the early seventeenth century, as trade expanded with the development of the British and Dutch East India companies, the Chinese responded by making export ceramics to European tastes, including stereotyped romantic images of themselves, like the "willow pattern" design. By the mid-eighteenth century, they were taking commissions to reproduce complex European motifs and designs, while Chinese porcelain was being imitated in Europe in Delft earthenware, which was itself imitated and exported by the Chinese. Other luxury imports that influenced European impressions of Chinese culture included paintings on glass, ivory carvings, and furniture. None of the goods exported from China were of high value to the Chinese elite, so the European elite who imported them formed their impressions of Chinese culture in ignorance of Chinese values. As luxuries, the goods were purchased particularly by the new rich and by women, whom male intellectuals regarded as lacking in good taste. Europeans who thought their own painting the peak of artistic achievement despised imported Chinese painting for its lack of naturalism, yet seldom saw the artefacts made for the Chinese elite and knew nothing of their connoisseurial values.

European attitudes toward these artefacts changed with their political and economic relationships with China. Unlike India, the Chinese empire was at first strong enough to control the trade with Europe, forbidding European merchants to travel beyond their coastal bases in Canton, demanding payment in silver, and refusing to buy European manufactures. Europeans could only form opinions from the objects the Chinese were prepared to export. In the late eighteenth century, the British began selling opium in

defiance of the Chinese authorities, and then forced the Chinese to open their ports and to cede Hong Kong to the British in the Opium War of 1842. This encouraged British popular interest in China, portrayed as a backward country now benefiting from free trade and a source of fascinating exotic artefacts, which were featured in a huge "Chinese Collection" exhibited in London after the war. However, by the time of the Great Exhibition of 1851, the general impression was that Chinese products were intricate but trivial, uninspired and conservative. Moreover, China was held to have reached the peak of its artistic achievement a century earlier, before a decadent decline from the beginning of the nineteenth century. It was then that European imperial inroads into China began to supply more prestigious artefacts as trophies representing the imperial glories of China as well as of Europe.

Although Chinese (and Japanese) pictures were dignified as art by inclusion in the British Museum's Department of Prints and Drawings in the nineteenth century, Chinese collections there and in the Victoria and Albert were dominated by decorative art, particularly ceramics, and even this was not highly regarded. Owen Jones, an influential designer who contributed to the Great Exhibition and the South Kensington Museum, wrote in his world survey of *The Grammar of Ornament*; "Chinese ornament is a very faithful expression of this peculiar people . . . the Chinese are totally unimaginative, and all their works are accordingly lacking in the highest grace of art,—the ideal" (1856:87). Even when connoisseurs claimed to have discovered fine art in Chinese artefacts in the 1930s, this was still defined by their own understandings of the Chinese as a "race" with a certain "character" rather than by any Chinese criteria, which remained unknown and uninteresting to Westerners until late in the twentieth century.

European ignorance of Asian artistic values, at first inevitable but later willful and prejudiced, reflected a sense of cultural superiority appropriate to the building of commercial and political empires. Museums stand as monuments to this colonial history, collecting and classifying Asian artefacts as Western property to be interpreted according to Western perspectives. Avoiding a Eurocentric understanding of the traditions presented as Islamic art, Indian art, and Chinese art demands an acknowledgment of this history.

QUESTIONS FOR DISCUSSION

- What do Western attitudes toward Asian artefacts reveal about Western art values, as distinct from Asian ones?
- How useful are European art categories for understanding Asian artefacts?
- How far do nineteenth-century colonial attitudes toward the Orient continue to influence Western views of Asian art traditions?

FURTHER READING

- Blair and Bloom's article "The Mirage of Islamic Art" (2003) deals with the issues around this category.
- Chapter 24 of Sloan's book *Enlightenment* (2003) summarizes early European attitudes toward the artefacts of India, Indonesia, China, and Japan.
- Mitter's book *Much Maligned Monsters* (1977) provides a detailed history of European attitudes toward Indian artefacts.
- Mitter and Clunas's chapter "The Empire of Things" (1997) summarizes colonial attitudes toward Chinese and Indian artefacts in the context of the Victoria and Albert Museum.
- Pagini's chapter "Chinese Material Culture" (1988) explains British attitudes of the nineteenth century.

4 PRIMITIVE ART

European colonizers of small societies imagined them as the primitive antecedents of their own society and used their artefacts to theorize the evolution and diffusion of culture around the world. Although discredited and superseded by studies of culture areas and art styles, such theories continue to be influential and sometimes useful.

Outline of the Chapter

- Savages and Anthropologists
 The idea of "primitive man" as a colonial designation for small societies, compared with the insights provided by anthropology and the idea of "primitive art."

- Evolution, Diffusion, and Speculation
 Using comparisons between artefacts from small societies to propose ahistorical theories of cultural evolution and diffusion from more advanced cultures.

- Identifying Cultures, Areas, and Styles
 How cultural traits including artefact styles have been used to define ahistorical culture areas for Native North America, and the connoisseurial identification of tribal art styles in Africa.

- The Survival of Evolution and Diffusion
 The examination of artistic form in recent, more rigorous analyses of the archaeology of Melanesia.

As Europeans continued to consolidate and expand their colonial control of the world, so the notions of art they had developed by the end of the eighteenth century increasingly colonized the artefacts of other cultures, which they brought home to their private collections and public museums. Some things were more readily incorporated into this conceptual empire than others. Asian artefacts whose makers had developed specialized skills and technologies to serve the demand of wealthy ruling elites for sophisticated and beautiful things were easy to recognize as "decorative arts" comparable with those of Europe, if not as "fine art." It took a bit more imagination to treat artefacts as aesthetic objects of contemplation when they had been made by simpler technologies according

to incomprehensible formal principles by exotic peoples who were generally regarded as beneath consideration in any case.

SAVAGES AND ANTHROPOLOGISTS

By the mid-nineteenth century, theories of evolution were claiming that all humanity shared common biological origins as a single species and that, in the same way that natural species had evolved, so had human societies (or "races"), some developing more than others. That Western civilization was the culmination of human development was agreed by historians, philosophers, and everyone else who belonged to it. Since larger societies had evidently developed from smaller ones, as recorded history showed, contemporary small societies, which seemed to have no history, were presumed to suffer various kinds of racial or cultural deficiencies. The native peoples of Africa, the Americas, the Pacific Islands, and other regions far from the great civilizations of Europe and Asia might be called "savages" if they lacked the political organization to put up strong concerted opposition to their colonizers, or "barbarians" if they had only petty chiefdoms rather than kingdoms or empires.

Among the various terms for these peoples, as the "others" who highlighted the character of Europe most of all, the one that served longest and best was "primitive." From meaning "original," "pure," and "simple," the word was used from the end of the eighteenth century to describe early or aboriginal peoples. During the nineteenth century, these came to represent the primal stages of modern human evolution, which Darwin projected even further back to pre-human "primates." Believing they had left this primitive state far behind, civilized peoples felt free to describe it in condescending terms, on the basis of no experience or evidence.

These attitudes to exotic cultures have a long history in Europe. The ancient Greek identification of neighboring peoples as incomprehensible barbarians was adopted by the Romans who, as Christians, later applied it to "heathens." As revived in the Renaissance, these notions were combined with Medieval tales of monsters in distant lands and attributed to the Native Americans they met in the sixteenth century. Contradictory stereotypes such as Shakespeare's bestial Caliban and spiritual Ariel in *The Tempest* became in later centuries the brutal savage of Hobbes and the noble savage of Rousseau, each serving to make a particular contrast with civilization. Both contributed to the treatment of colonized peoples as instinctual and childlike, incapable of self-development and self-government, and in need of control and guidance so that they could take their place in the civilized world—an ideology that legitimated some terrible deeds during the nineteenth and twentieth centuries. The familiar assumptions of the nineteenth century were still being repeated by the British Museum up to 1925: "The mind of primitive man is wayward and seldom capable of continuous attention. His thoughts are not quickly collected, so that he is bewildered in an emergency; and he is so much the creature of habit

that unfamiliar influences such as those which white men introduce into his country disturb his mental balance" (British Museum 1910:31, reprinted 1925).

There was little consideration that people in small societies might have reasons to reject the influences and resist the authority of those seeking to develop or civilize them for their own ends. The possibility that they might regard their own ways of life as more humane and agreeable than colonial rule was seldom contemplated. Nor was the fact that many small societies belonged to bigger ones, with the federation of clans into small states, their subjection to kingdom and empires, the ebb and flow of trade networks, or the rise and fall of popular political movements. For Europeans, willful ignorance of the history of colonized peoples made it easier to justify their mission to civilize the primitive natives of other lands while exploiting their economic resources.

PERSPECTIVES FROM ANTHROPOLOGY

If we are really interested in understanding the differences between such peoples and large civilizations, it is not hard to explain them in sociological terms that do not denigrate their humanity but point instead to the structural limitations of life in a small society. Peoples without powerful rulers or elites to unite them sought security in their own local communities, which were self-governing and often divided from each other by feuding over local disputes. This allowed the creation of varied—even eccentric—local cultural traditions that further separated them, perhaps willfully; producing, among other things, diverse artistic styles. Such communities did indeed lack the economic organization to contribute to large-scale trade or the incentive to develop specialized technologies for creating luxury goods, complex weapons, or grand monuments for the benefit of a privileged few. In fact, they tended to resent those who took advantage of others to raise their own standing, and they had the power to cut such antisocial ambitions down to size. At the same time, more people learned a greater range of the social, cultural, and technical skills required to participate creatively in the artistic traditions of their society. While supporting the local communities they depended on, such egalitarian peoples saw no reason to admit the superiority of outsiders and often resisted colonial conquest as fiercely as they could.

The invention of "primitive man" ignored these small-society values and conveniently avoided the difficult contradictions between ideas of universal humanity, cultural difference, and colonial self-interest. When Europeans did try to understand such peoples within an inclusive view of humanity, they had to develop theories of society and culture that could account for contrasting ways of life. Politics had to explain the workings of power in communities without rulers or governments, religion had to deal with belief in spiritual forces other than gods, and art had to account for visual forms created by people who knew nothing of European painting and sculpture. From such comparisons developed the discipline known variously as ethnology, ethnography, social anthropology, or cultural anthropology. This produced theories of art intended to be cross-cultural and potentially universal, although no less colonial, as Rana Kabbani has pointed out:

nineteenth century anthropology was predominantly a system for the hierarchical classification of race. As such, it was inextricably linked to the functioning of empire. Indeed, there can be no dispute that it emerged as a distinctive discipline at the beginning of the colonial era, that it became a flourishing academic profession towards its close, and that throughout its history its efforts were chiefly devoted to a description and analysis—carried out by Europeans, for a European audience—of non-European societies dominated by the West. It was the colonial cataloguing of goods; the anchoring of imperial possessions into discourse. (1986)

An underlying assumption of early anthropologists was that small societies represented earlier, more or less primitive, stages of human development. Some explained their exotic character in terms of primitive mentality or racial inferiority; others preferred fantasies of primal instincts unfettered by cultural control; but all agreed that primitive peoples represented less developed culture, were inherently conservative and resistant to change, and needed to be civilized in the European tradition. Even after primitive peoples ceased to be called barbarians or savages, by the mid-twentieth century, they were seen as relics who could give Europeans glimpses into their own distant past. For some, this was the crude and impoverished past before the development of the cultural benefits of civilization. For others, it was the idealized natural past before humanity developed the cultural or personal problems that they ascribed to Western civilization. Either view says as much about the civilized West as about the other cultures.

By the end of the nineteenth century, ethnography curators and other scholars of anthropology were using collections of artefacts to speculate about the development of primitive culture, including primitive art. This was a concept resisted by some art historians, including George Birdwood, the scholar of Indian art:

"primitive art", by which its specialised students and expositors mean the so-called "art" of contemporary savages . . . by no charity of aesthetic sensibility can be regarded as embellishing . . . and decorative . . . and by no elasticity of technical definition can be classed as artistic objects; while they can be characterised as ornamental . . . only in the primary and strictly etymological sense, and, in the nomenclature of the arts, a strained sense, of that word. (1903:881)

While most art historians and connoisseurs preferred to reserve the concept of art, particularly fine art, for expressive creativity in the Western Classical tradition, anthropologists seeking to explain the whole of humanity within a single evolutionary scheme persisted in applying it cross-culturally. Like the historians of Oriental art, they attributed artistic differences to characteristics that were more or less innate in particular nations or races, proposing that higher cultures had influenced lower ones while degenerating through racial and cultural mixing. Pure races, presumed to be isolated and truly primitive, such as the Aborigines of Australia and the Inuit of Canada, could be distinguished from those with a long history of foreign contact, like New Guinea, which was credited with debased

versions of cultural traits borrowed from the superior civilizations of east and southeast Asia. Such ideas survive in fantasies of lost civilizations discovered by European explorers among degenerate primitives—a long-standing popular theme of novels and films.

EVOLUTION, DIFFUSION, AND SPECULATION

Anthropological theories of the late nineteenth century attempted to explain the development of human culture by detailed comparison of particular cultural practices that could be identified and traced across often vast reaches of time and space. As James Frazer's *The Golden Bough* (1890) did for tales and ritual practices, so others traced themes in the forms and meanings of artefacts and motifs. Opposed but complementary theories focused on the local invention and evolution of cultural traits and on their adoption by "diffusion" from other sources of cultural creativity. It was assumed that such traits could be analyzed on their own, without much regard for cultural context. There was a presumption that the "high cultures" of major civilizations were centers of origin for both processes, particularly those claimed as antecedents of the Western tradition. The resulting culture histories, based on the accounts and collections of colonial travelers rather than first-hand research, relied more on speculative deduction than on historical evidence, which was scarce in any case. Artefacts from the historically shallow colonial period were expected to illustrate evolutionary stages hundreds or thousands of years old.

EVOLUTIONISM

Augustus Lane Fox Pitt-Rivers, the nineteenth-century collector who founded Oxford's university museum in 1884, sought to demonstrate the evolution of human culture from primitive simplicity to civilized complexity by arranging artefacts from around the world in sequence according to what he named "typology." In an essay on *Principles of Classification*, first published in 1874, Pitt-Rivers held that contemporary savages could be taken to represent earlier stages of human evolution in that their culture had been passed down by "that modified instinct which assumes the form of a persistent conservatism." Unless "savage races" have been degraded from a higher condition of culture, "We shall find, firstly, that the forms of their implements . . . will, in proportion to the low state of their civilization, show evidence of being derived from natural forms . . . and secondly, we shall find the persistency of the forms is proportioned to the low state of their culture" (1906:10–11). On this basis, Pitt-Rivers constructed typological series showing development from simple to complex forms, each stage being represented by "survivals," which cultural conservatism had allowed to continue from ancient times to the present. "Amongst other advantages of the arrangement by form, is the facility it offers for tracing the distribution of like forms and arts, by which means we can determine the connexion that has existed in former times between distant countries, either by the spread of race, or culture, or by means of commerce" (1906:15). His diagram of the

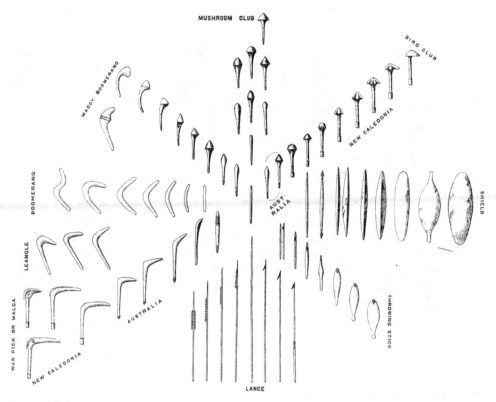

MUSHROOM CLUB

WADDY BOOMERANG

BIRD CLUB

NEW CALEDONIA

BOOMERANG

AUST-RALIA

SHIELD

LEANGLE

AUSTRALIA

THROWING STICK

WAR PICK OR MALGA

NEW CALEDONIA

LANCE

Figure 14 An example of Pitt-Rivers's typology, showing the supposed evolution of Australian and Pacific Islands weapons from a stick. (1906: pl. 3)

evolution of clubs and shields follows the pattern of typologies of European archaeological artefacts such as stone and bronze axes. His museum, constitutionally obliged to illustrate his theory, continues to exhibit artefacts grouped by functional type rather than by cultural or historical categories.

Working from the same basic assumptions about the nature of primitive man, others spent much time and energy in tracing the local evolution of forms and motifs and coming to contradictory conclusions. Gottfried Semper, a German art historian, held the theory that geometric designs developed first, from technical processes such as plaiting and weaving. British curators such as Charles Read of the British Museum, Alfred Haddon of Cambridge University Museum and Henry Balfour of the Pitt Rivers Museum, tried to demonstrate that abstract designs had resulted from the degeneration of earlier attempts to represent natural phenomena, due to distortion by repeated copying, and that, by the same token, graphic designs developed from three-dimensional ones. For these theoretical purposes, primitive artefacts were imagined to be at once ancient and unchanging and to provide evidence for various stages of evolutionary change in the products of a few recent generations. By the early twentieth century, alternative theories

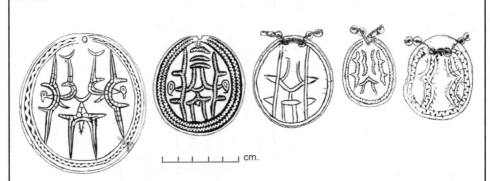

cm.

Figure 15 These pendants from Malaita in Solomon Islands illustrate the kind of design variations used by early evolutionary theorists. The standard design of three frigate birds is incised on disks of clamshell, worn singly or several on a necklace as valuable ornaments (see page 113). The relationship between the images on the left and the apparently abstract designs is evident, but since all were made and worn in the second half of the twentieth century they tell us nothing about long-term cultural evolution. (Burt 2009:101, 104–5)

to nineteenth-century evolutionism included the "parallel" or "independent" invention of similar forms and practices in different times and places and their "survival" long after they had ceased to have a function.

DIFFUSIONISM

The most speculative and least plausible of these alternatives to evolutionist theories appear obsessed with explaining the culture of exotic peoples as borrowings by "diffusion" from more advanced cultures, in terms that denied their ability to develop on their own. A prominent exponent was Grafton Elliot-Smith of University College London, who traced the traits of non-Western civilizations back to ancient Egypt, regardless of distance in time and space. From the 1930s, Germanic scholars were attempting to trace cultural diffusion in the Pacific as a way of defining regional art styles. Felix Speiser, a Swiss art historian who did field research in Melanesia, tried to identify Pacific Islands art styles on the basis of a diffusionist theory that he published in 1941.

Speiser regarded true art as the emotional experience of both creator and observer of a work, which for primitive peoples involved particularly the fear and relief evoked by images of the spirits that dominated their lives. The ideal forms recognized by a community as expressions of such emotions formed an art style, which developed from their shared essence and represented their cultural character. By claiming empathy with such emotional expression, Speiser also believed he could perceive the deterioration of art as its forms were reproduced by mere artisans, losing their symbolic meanings and changing their form to become merely decorative. In this way, the art styles of influential

"high cultures" were spread with the migration of peoples whose culture deteriorated even as it enriched that of the "lower cultures" they encountered. This was the theory that informed his account of Pacific Islands art styles.

In addition to a half-formed and scattered "primary style" representing the original inhabitants of the region, Speiser described a "Curvilinear style" associated with Papuan peoples of coastal New Guinea, Trobriand Islands (see figures 48 and 49, pages 150–51), and New Britain, with traces in Solomon Islands and a strong presence in New Zealand (see figure 16, page 60); a "Tami style" of straight andss angular lines predominant in east New Guinea and island Melanesia (origins unexplained); a "Beak style" of long-nosed figures of northwest New Guinea, with traces in Solomon Islands, Vanuatu, and New Caledonia, presumed to have originated from the Hindu elephant god via Indonesia (see figure 12 on page 46); a "Korwar style" of squatting figures from northwest New Guinea, with traces in the Admiralty Islands, New Ireland, western Solomon Islands, the Marquesas Islands, and Easter Island, presumed to originate from Cambodia via Indonesia; and a "Malanggan style" of New Ireland, neither Papuan nor Melanesian but reminiscent of the "overabundant fusion of diversified figures" of Indian Hindu temples.

In the 1960s, one of the last senior academic diffusionists, Douglas Fraser of Columbia University, republished Speiser's paper with one of his own in a similar vein (1966a). Fraser started from the assumption that if a motif was too complex and arbitrary to have derived from universal human interests, its widespread distribution must result from diffusion from one place to another. He took the example of what he called the "heraldic woman:" a frontal image of a woman sitting with legs spread, particularly when flanked symmetrically by other images. He traced this image back to what archaeologists had interpreted as the "mother-goddess" of southwest Asia as represented in Iran in the early first millennium B.C.E.; then to the Etruscans in Italy in the sixth century B.C.E. via shared regional cosmologies and religious iconography; to medieval Europe as a revival of southwest Asian forms; to Afghanistan as a religious survival in the early first millennium C.E.; and to India as a new introduction at that time. He mentioned early twentieth-century Cameroon as a connection yet to be explained, before moving to the Sepik region of Papua New Guinea, where, by interpretation of local cosmology, he found the heraldic woman also symbolizing fertility. He linked these images to the Etruscans of about 2,700 years earlier through the shared motif of the extended tongue, associated with the gorgon as an aspect of the ancient Mediterranean mother-goddess and with various images from China of the third to fourth centuries B.C.E., Indonesia of the second century C.E., and other recent peoples of the Pacific. Various theories of ancient Mediterranean influence on China accounted for supposed gorgon motifs there (the heraldic woman being "rather indecorous" for Chinese taste), and others again suggesting Chinese influence on the Pacific accounted for the presence there of the frontal female figure at the center of symmetrical designs. Fraser also found similar motifs in North and South America from various periods, although their derivation was unexplained. He concluded with a defense against the general critique of diffusionism of the time,

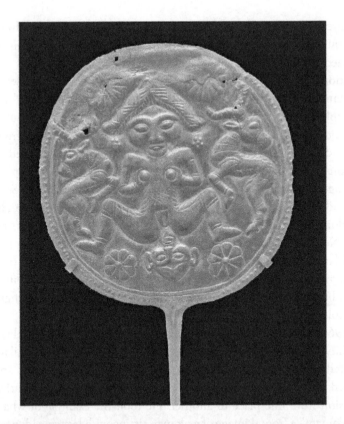

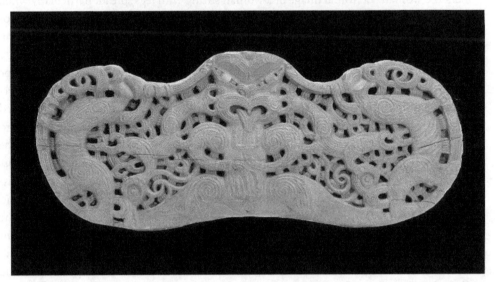

Figure 16 Two of Fraser's "heraldic women"; a bronze garment-pin from Luristan in Iran, dated 1500 to 700 B.C.E. (in the Louvre, Dynamosquito photo); and a nineteenth-century Maori house-board from New Zealand (The Trustees of the British Museum; Oc,NZ.87) (not to scale)

claiming that the independent invention of the motif in each case "would require a fantastic degree of convergence, tantamount to a repeal of the laws of chance" (1966a:79).

This kind of stylistic analysis, using formal traits to demonstrate diffusionist speculations, had fallen into academic disrepute long before Douglas Fraser published *The Many Faces of Primitive Art* in its defense. Although his diffusionism revealed a deep prejudice against the inventiveness of the societies he dealt with, it was actually based on the manipulation of cultural data to create the heraldic woman with her associations of fertility and protection, warfare, headhunting, or whatever he chose from the ethnographic record. He was suggesting that this complex of images and ideas was transmitted, for reasons unexplained through histories unknown, to survive for hundreds or thousands of years in certain small societies that remained primitive and unchanged until recent times. Without the presumption of diffusion, most of Fraser's comparisons would seem spurious, leaving only some rather basic observations that frontal human figures have commonly been made the central focus of symmetrical designs including other significant images, and that women's sexuality and fertility, with its obvious symbolic potential, can effectively be proclaimed in this way.

CHARACTERIZING PRIMITIVE ART

Despite the accumulating historical information on particular societies, those who accepted the basic assumptions about primitive man (including most Western intellectuals) still held that "his arts" had enough in common for them to be treated together as "primitive art" in books and museums that covered every continent of the world, well into the late twentieth century. Fraser also wrote a book, *Primitive Art*, illustrating some basic premises of the concept, which continued in popular culture long after they had lost academic credibility.

Primitive Art is unchanging

> Primitive man has always been extraordinarily conservative. Every facet of his religious and social life encourages stability and permanence. Consequently, the art forms produced today probably resemble very closely those made by his forefathers centuries ago. The more isolated a style is from the mainstreams of world art, the greater will be its tendency to remain unchanged. The most primitive of peoples always have the most ancient of art styles—unless historical accident has introduced new visual ideas. . . . Without European contact or other upheaval, the Aztecs would have gone on reproducing their traditional style indefinitely. (1966b:32–3)

This ignored the most basic contrary evidence; as Fraser would have known, the Aztecs actually ruled a large and complex empire as the last of many great indigenous traditions in Mexico that had repeatedly developed distinctive new art styles over the centuries.

Such theories of far-flung artistic links, in the absence of any historical evidence, now seem so fantastical that most academic researchers dismiss them out of hand, but they continued to be popular throughout the twentieth century. Thor Heyerdahl's voyages on

replica ancient craft from Peru to Polynesia and from Egypt to Central America are the most famous explorations of theories supposing that difficult and unlikely ocean voyages could enable a few stray mariners to transform the cultures of distant lands. Heyerdahl's attempts to show that styles of artefacts such as monumental architecture had diffused rather than evolved locally captured the popular imagination but were refuted by more methodical research.

In due course, the recognition that societies and cultures operate as systems of relationships and ideas rather than as collections of customs and practices that can develop, travel, and survive more or less independently, made a nonsense of the grand theories that traced "traits" in primitive cultures to civilizations on the other side of the world. Yet such ideas have persisted in wishful popular theories of derivations from ancient Egypt, lost continents, or outer space. It is tempting to regard these as "survivals" of earlier stages of thought resembling those the theorists spoke of, but they are actually features of a persisting ideology that prefers mystical fantasy to mundane recognition of the cultural potential of peoples still regarded as primitive. Considering the underlying racist assumptions that certain peoples were incapable of development without the influence of "higher cultures," it is ironic to find similar theories adopted by people attempting to counter such racism by writing their own histories. Some among the African diaspora in Europe and America have attributed cultural traits in contemporary sub-Saharan Africa to the Egypt of several thousand years ago, according to the same kind of diffusionist theory. In reclaiming Egypt as an African civilization, they risk denying the achievements of their own ancestors.

IDENTIFYING CULTURES, AREAS, AND STYLES

By the turn of the twentieth century, anthropologists were collecting empirical facts through detailed field research among now-colonized peoples such as Native North Americans, Africans, and Pacific Islanders, whose apparently disappearing cultures were more accessible than ever before. In reaction against futile speculation over the unverifiable histories of cultural traits, the American anthropologist Franz Boas advocated the study of whole cultures as the products of particular historical circumstances. From 1885, Boas researched with the Kwakwaka'wakw, or Kwakiutl, one of the Native American peoples of the North west Coast renowned for their sculpture, painting, and theatrical performance. This and his background as a German Jewish immigrant who protested against both German anti-Semitism and American racism, informed his book *Primitive Art*, published in 1927.

Boas prefaced the book with an attack on academic theories of European superiority. He refuted primitive mentality by citing personal experience of the common humanity of primitive and civilized peoples. He attributed differences solely to culture, hence refuting racial factors, while citing examples of supposedly primitive mentality as universal and shared by civilized peoples, whose culture and personal behavior could also be irrational in Western terms. He rejected naïve evolutionism, the theories of unilineal

cultural evolution that inevitably treated European civilization as most evolved, on the basis that all cultural traditions have their own histories and that their historical development had not and could not be documented in terms that allowed the comparisons necessary to demonstrate the theory. Demonstrable similarities between diverse cultures were as likely to be the products of similar environmental, physiological, psychological, and social conditions. He denied naïve diffusionism by asserting that cultural traits survived or died within culture as an organic whole, not as autonomous phenomena whose distribution could in itself provide evidence for their antiquity or otherwise. Cultures were in a state of constant flux, and the study of cultural history through geographic distribution had to take this into account.

CULTURE AREAS

In the 1910s, one of Boas's successors, Clark Wissler, combined Boas's "particularist" approach with the analysis of cultural traits as units or features of social practice to develop a comparative method across cultures. By mapping a set of traits of Native culture throughout North America, he identified "culture complexes" of traits that coincided with each other in certain regional environments to form a series of "culture areas." Culture complexes were supposed to help explain if and how traits might evolve or diffuse, but they proved more useful as ways of classifying cultures and their artefacts. They grouped the Native cultures of North America into regions such as Plains, Southwest, and Northwest Coast, with similar areas in South America, Africa, and elsewhere. The criteria for defining traits, complexes, and areas were very much those of the Western researchers' commonsense observations, aided by environmental geography, and served to group populations that could not easily be identified by nations or states.

Native North American culture areas are still used more than a century after most of the cultural traits have disappeared with the colonial suppression of local ways of life. The scheme always had a certain unreality, including in the same maps, books, and exhibitions certain Native American peoples who had disappeared or relocated centuries before certain others had been identified. Hence the "Five Civilized Tribes" are usually identified with their earlier homelands in the southeast United States, before they were forcibly moved to Oklahoma in 1838, which was before the peoples of the Plains had even been mapped in the territories they became identified with, having arrived in their culture area only a generation or so previously. Culture complexes also largely ignored the presence and cultural influence of the colonizers, which was evident in the technologies and styles of Native artefacts. They did help differentiate the cultures of Native Americans in the popular imagination after they had all been colonized in the early twentieth century, but they also perpetuated stereotypes of primitive peoples even as they were being more or less absorbed into American society.

When the British Museum's Native North America Gallery opened in 1999, it employed the culture area approach, and although many of the artefacts displayed dated

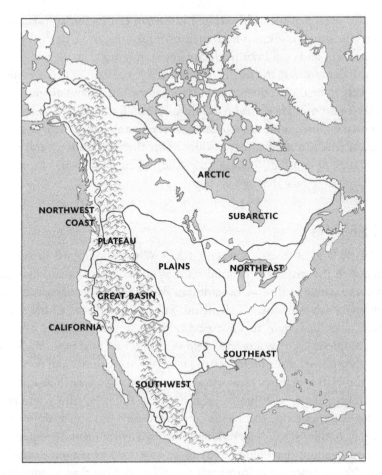

Figure 17 A conventional culture area map of Native North America, from a British Museum educational publication. (Burt, Mindel, and Woff 2002)

from the colonial period, there was little mention of life during the twentieth century. There were a number of new artefacts made for sale to the non–Native market, whether as reproductions of old styles, exotic novelties, or "contemporary art." Otherwise, the colonial or reservation period (which had now lasted as long as the horse and buffalo period of the Plains Indians) was identified only in photographs of people continuing precolonial activities. The colonial culture itself, which had exerted its hegemony over Native Americans for five hundred years, was not explicitly represented at all, unless you count an eighteenth-century West African drum from Virginia, which seems to have been included because it was made by a "native," if not a Native American.

The culture area approach worked rather well with the kind of connoisseurship developed by nineteenth-century art historians, but applied to "tribal" styles rather than individual ones. Particular features of artefacts were compared in order to identify formal

conventions presumed to be stable due to primitive conservatism and conformity. Artefacts that did not fit the stereotype might be treated as the result of styles influencing each other through processes that could not actually be described, for lack of evidence or understanding. In 1965, William Fagg, a renowned expert on African art who was a curator and later Keeper of the British Museum's Department of Ethnography, wrote that "Art . . . provides one of the principal criteria for the identification and delimitation of tribes," which could be clearly outlined on the map of Africa if it were not for "processes of social and material decay and of commerce" that had occurred since the early twentieth century (Fagg 1965:13). Fagg's identification of styles with precolonial "tribes" is still followed by primitive art dealers and some museum curators. As Sidney Kasfir has put it: "The idea that before colonialism most African societies were relatively isolated, internally coherent, and highly integrated has been such a powerful paradigm and so fundamental to the West's understanding of Africa that we are obliged to retain it even when we now know that much of it is an oversimplification" (Kasfir 1992).

THE SURVIVAL OF EVOLUTION AND DIFFUSION

However, neither primitivist theories nor culture area studies have completely discredited analysis of the evolution and diffusion of artefact design. This was revised and refined in the late twentieth century to distinguish cultural influences through close examination of artefacts. Barry Craig has called for more studies of local material cultures and the relationships between them based on a methodology for comparison that would reveal patterns of distribution of artefact types and styles, and perhaps the history of their development.

Craig's study of shield designs from the Sepik area of Papua New Guinea (2005) confirmed other research to show that people may adopt new designs and motifs while retaining the underlying techniques and especially the structures of their local style, such as particular principles of symmetry. His study of Mountain Ok and upper Sepik designs on arrow foreshafts showed that certain kinds of formal symmetry were preferred in certain language groups. He suggested that if such preferences were to be found in other types of artefact, this could be treated as diagnostic of a local culture. Having discovered some remarkable resemblances between the inland arrow designs, and designs on 3,000-year-old pottery of the maritime immigrant Austronesian Lapita culture, he concluded that this supported other theories that the Lapita adopted a style already practiced by the local Papuans. He regarded this as more likely than the possibility of Lapita designs being adopted from coastal immigrants throughout a large region of interior New Guinea, because the underlying structural principles of the Papuan style would have prevailed over foreign innovations over the period of three thousand years. That is, the Lapita Austronesians could have adopted Papuan designs as they settled the coastal areas on their migration from southeast Asia into the Pacific without adopting their underlying structural principles.

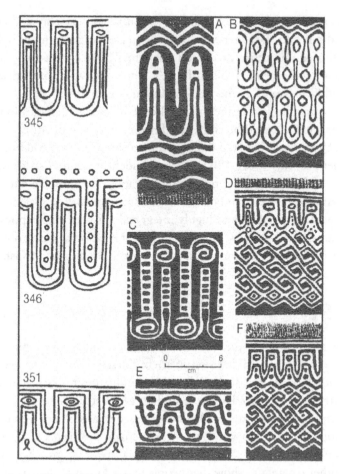

Figure 18 The Lapita "face" design (left column) and corresponding New Guinea arrow-shaft designs. (Craig 2005:506; left column, Anson 1983; middle column, north coast New Guinea, Australian Museum and Leiden Museum; right column, Craig fieldwork data)

In Craig's opinion, the clarification of such historical issues required detailed studies of large quantities of artefacts to measure, count, and compare their formal properties in order to define styles that could be identified with cultural categories such as Papuan or Austronesian. His theory depended on the identification of such styles with populations characterized by other cultural traits, particularly language, on the basis that they were essential to the culture for structural reasons. Contrary to the old diffusionists, he could not accept that an introduced art style could spread from a few migrants to a large population, and his theory of underlying artistic structures was an attempt to bring rigor to the question of whether and how cultural traits had moved (or in old-fashioned terms, diffused) between cultural groups. The question of how such groups should be identified and defined, however, remained problematic.

"Primitive art" has gone through several transformations in recent generations. A gradual recognition that "primitive" is an insulting description of people who are increasingly asserting their rights as equals within the societies of their erstwhile colonizers has led to various euphemisms. "Primal art," favored by the French, gives a positive sense of the primitive as original. "Ethnographic," the residual museum category for cultures that could not be classed as "civilized," sounds more neutral and scientific than the "savages" and "barbarians." "Tribal art" suggests a social definition that is suitably exotic and ill-defined, and "ethnic art" is so vague that it resists definition and hence criticism. But there is no disguising the category, sometimes still referred to as "so-called primitive art."

QUESTIONS FOR DISCUSSION

- Do the artistic traditions of societies once called primitive have anything in common which is worth studying as a category of art?
- What kind of evidence is required to make evolution and diffusion plausible explanations for similarities between artefacts from different times and places?
- How might the concepts of culture areas and tribal styles be adapted to take into account historical change, and would this make them more useful for understanding artistic traditions?

FURTHER READING

- Langness's book *The Study of Culture* (2005) reviews the development of anthropological theories such as evolutionism and diffusionism.
- Morphy and Perkins's Introduction to *The Anthropology of Art* (2006) begins by reviewing the development of relevant anthropological theory, and the book also reprints the Introduction to Fagg's *Tribes and Forms* (1965) on classifying African art styles.
- Craig's chapter "What Can Material Culture Tell Us about the Past in New Guinea?" (2005) sets his own research in the context of earlier primitive art studies.

5 PREHISTORIC ART

While exploring the wider world, Europeans were also extending their own history into "prehistory," defining early stages of human development and speculating about artefacts from undocumented antiquity. Interpretations of archaeological remains have been used to debate cultural origins according to the social and political issues of the times.

Outline of the Chapter

- Discovering Antiquity
 The development of European awareness of a pre-Classical and prehistoric past through antiquarianism and archaeology, leading to definitions of Stone, Bronze, and Iron Ages.

- The Dawn of Art
 The interpretation of archaeological remains by analogy with contemporary small societies, and fanciful explanations for Paleolithic cave painting.

- Prehistoric Myths
 How changing theories of social and cultural origins such as the prehistory of gender relations have influenced the interpretation of ancient remains such as Paleolithic figurines and Stonehenge.

- The Politics of Prehistory
 Some interpretations of archaeology according to political agendas, as contested in Zimbabwe and the United States.

While Europeans were broadening their knowledge of other regions of the world and evaluating cultural development in relation to their own standards of civilization, they were also extending their understanding of human history further back into the past. The investigation of ancient artefacts was carried out within the cycles of civilization model, which informed understandings of human progress toward the achievements of modernity. As previously unknown ancient artefact traditions came to light, so the idea

of art was extended back from cultures that had left written records into the "prehistoric" past. This raised issues about the origins and development of humanity, which were reflected in the interpretation of ancient artefacts.

DISCOVERING ANTIQUITY

Until the eighteenth century, European understandings of the distant past had depended entirely on documentary records, which reached back via the histories of ancient Rome and Greece to the first books of the Bible and the creation of the world. In the mid-seventeenth century, on the basis of Old Testament genealogies, Archbishop James Ussher calculated that the world had been created in 4004 B.C.E. (as published in the King James Bible and corroborated by Isaac Newton and others).

Scholars with antiquarian interests had been investigating ancient sites since the sixteenth century, and in the late seventeenth and eighteenth centuries they often combined this with other branches of "natural philosophy." As part of this study of God's work, antiquarians researched the historical truths recorded in the Bible and other texts inherited from Greece and Rome. These sources, with dates inscribed on monuments and recovered artefacts including coins, were the only means of establishing a chronology for ancient remains. In Britain, artefacts unfamiliar from Roman and later remains, including stone circles and bronze ornaments, were evidently earlier and so assigned to peoples mentioned by the Romans in historical sources. These were the ancient Britons or Celts and their mysterious Druid priesthood, who captured the popular imagination in the eighteenth and nineteenth centuries.

By the end of the seventeenth century, it was recognized that things found deep in the ground had been buried under layers of deposits over long periods of time. Information about savage peoples in the Americas and then, in the eighteenth century, the Pacific Islands, provided models for ancient European society and eventual confirmation that the stone "thunderbolts" and "fairy arrowheads" found in the ground were actually human implements from a time before the use of metals. Antiquarians, finding such artefacts and human bones associated with the bones of animals no longer present in Europe, generally assumed that this difference indicated a transformation of the world by the biblical flood (dated by Ussher to 2349 B.C.E.).

From this, they began to emphasize narratives, interpreting archaeological remains to trace the development of humanity in terms of "culture history" and identifying artefact styles by time and place. By the beginning of the nineteenth century, Scandinavian scholars were confirming the sequence of Stone, Bronze, and Iron Ages already inferred from Genesis, on the basis of systematic excavation of ancient sites. During the first half of the nineteenth century, antiquarians also became interested in the human bones and flint tools associated with the bones of extinct animals that were emerging in gravel pits in France, England, and elsewhere, deep under layers of alluvial deposits. Developments in geology

demonstrated that these sediments must have been deposited gradually over a far longer period than that allowed for by the theory that they resulted from the Flood. In the 1830s, an ancient Ice Age was proposed from comparisons of rock distribution in Britain with glacial moraines in the Alps. From the 1860s, Darwin's theory of evolution confirmed doubts over the biblical version of antiquity and the early development of humanity.

In his book *Prehistoric Times*, first published in 1865, John Lubbock pronounced:

> From the careful study of the remains which have come down to us, it would appear that Prehistoric Archæology may be divided into four great epochs.
>
> I. That of the Drift; [drift-beds of river-gravel] when man shared the possession of Europe with the Mammoth, the Cave bear, the Wooly-haired rhinoceros, and other extinct animals. This I have proposed to call the "Paleolithic" Period.
>
> II. The later or polished Stone Age ; a period characterized by beautiful weapons and instruments made of flint and other kinds of stone ; in which, however, we find no trace of the knowledge of any metal, excepting gold, which seems to have been sometimes used for ornaments. For this period I have suggested the term "Neolithic."
>
> III. The Bronze Age, in which bronze was used for arms and cutting instruments of all kinds.
>
> IV. The Iron Age, in which that metal had superseded bronze for arms, axes, knives, etc. ; bronze, however, still being in common use for ornaments (1913:2).

From the 1880s, the Bronze and Iron Ages of northern Europe were being dated by typological studies based on artefacts imported from dated cultures of the Mediterranean. Old Stone Age (Paleolithic) people lived by hunting, later renamed "hunting and gathering" in recognition that important wild staples like shellfish and nuts are not hunted, and better described as "foraging." New Stone Age (Neolithic) technology was found to coincide in Europe with the development of farming and herding.

THE DAWN OF ART

When archaeologists deal with artefacts that have survived their makers and users too long for a cultural legacy to be identified, let alone for them to be questioned about it, and especially in the absence of legible texts, interpretation depends upon drawing analogies with more familiar and better documented cultural traditions, including the archaeologists' own. At a simple level, this is little more than guessing that a blackened ceramic hemisphere was a cooking pot, that a shaped and sharpened piece of hard stone was an axe, or that a flattened lump of gold stamped with distinctive designs was used as a standard of value for exchange as a coin. But when artefacts have less obvious technical purposes and more apparently symbolic and aesthetic ones, the analogies drawn to understand them become more speculative, reflecting the cultural prejudices and fashions

of the time. Such analogies often live on in popular Western culture long after they have been overtaken and discredited by new archaeological theories, perhaps more methodical and tentative, if less in tune with popular stereotypes.

An example is the persisting image of the "dawn of art" in Ice Age Europe with the peoples of the Old Stone Age, who were the first modern humans in this region of the world. The discovery of human and animal remains and artefacts, evidently originating thousands of years ago in a very different environment and climate, led to analogies with the culture of contemporary peoples such as Native Americans, which made it reasonable to suppose that those people had been hunters. From the 1860s, it became accepted that they had produced the small carvings in bone, antler, and stone being found in rock shelters in France and Spain, and in the 1900s it was established that they had also made the wall paintings found deep inside caves since 1880. In Lubbock's book, titled in full *Prehistoric Times as Illustrated by Ancient Remains and the Manners and Customs of Modern Savages*, he explained that, on the basis that fossil animals can be identified by comparison with certain living species:

> if we wish clearly to understand the antiquities of Europe, we must compare them with the rude implements and weapons still, or until lately, used by the savage races in other parts of the world. In fact, the Van Diemaner [Australian] and South American are to the antiquary what the opossum and the sloth are to the geologist. (1913:430)

PALEOLITHIC CAVES

The main problem with such comparisons has been the use of fallacious assumptions about so-called savage races to support theories that have persisted since the nineteenth century. Conventional interpretations of Paleolithic remains from southwest Europe, based on ill-informed observations of Australian Aborigines and southern African San (Bushmen) as makers of "rock art," were largely discredited by the mid-twentieth century but still repeated in the twenty-first. This summary comes from a *World History Atlas*:

> The art of the last Ice Age and its aftermath, ranging from painted caves to engraved and finely carved objects and clay sculptures, is found in many parts of the world. Since much of the art is probably associated with religious rituals concerned with hunting, fertility, and the initiation of the young, it is a testament to the increasing complexity and sophistication of human society. (Black 2008:17)

Other theories drew parallels with the shamanistic dreams and visions of San and arctic foraging peoples but, as research among Australian Aboriginals has shown (see pages 153–55), foraging societies can have cosmological, ritual, and artistic traditions far more sophisticated than the imaginations of prehistorians.

In the mid-twentieth century, *Teach Yourself Archaeology* described a famous Paleolithic site in France:

> Tuc d'Audoubert was discovered in 1912. They found marks of the naked feet of the original artists who had penetrated to this carefully concealed sanctuary in which were skilfully modelled clay figures of a male bison following a female.
>
> Near by, in front of a small clay hillock, are interlacing heel-marks which are thought to have been made during a sacred dance, doubtless for the purpose of making the species increase and multiply, as the scene clearly portrays propagation. It would seem, then, that, just as at Niaux [cave] the cultus was directed to the magical destruction of the animals required for food, so at Tuc d'Audoubert it was a fertility ritual that was enacted to maintain the supply, very much as the native tribes in Australia hold elaborate ceremonies at rocks adorned with drawings of sacred animals (totems) to promote their multiplication. (Brade-Birks 1954:91–2)

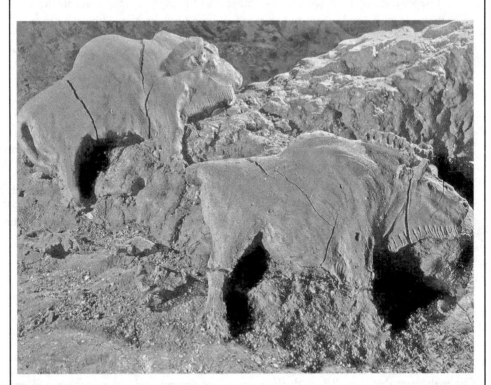

Figure 19 The bison of Tuc d'Audoubert.
(Rod Jones photo http://www.rodjonesphoto graphy.co.uk).

Some art historians have made even more fanciful assumptions, like Kenneth Clark, prominent in the Eurocentric tradition of his discipline:

> We must suppose, and Bushmen within living memory confirm it, that in prehistoric times the relationship between men and animals was closer than we can imagine. Man had barely learnt the use of tools, and his speech was rudimentary. Animals were in the ascendant, and distinguished from man less by their intellectual limitations than by their greater strength and speed. Personally I believe that the animals in the cave paintings are records of admiration. (1977:14)

Clark's ignorance of San culture exceeded that of the prehistorians' of Aboriginals, insofar as he identified them with pre-human beings. But by his time, such speculation was being superseded by more methodical "ethnographic parallels": comparisons drawn with the research of anthropologists among such small societies, which produced much more tentative theories. From the 1960s, the culture history approach was overtaken by "processual archaeology" focusing on evidence for cultural change. Archaeological remains were examined for the way they reflected technical processes by analogy with detailed anthropological studies of contemporary peoples of similar material culture. These showed that some peoples still living by foraging actually gathered more food than they hunted and that, even in marginal environments like the deserts of the Kalahari and central Australia, this could provide a good living by meeting modest material needs with equally modest amounts of work. In contrast to earlier stereotypes of Stone Age life being hard, miserable, and reliant on hunting magic, it even came to be called "the original affluent society." "Post-processionalists" eventually cautioned that archaeology, as a cultural practice itself, had its own biases, and its conclusions were inevitably conjectural and no more than probabilities.

The general conclusion of archaeologists is now that, during the Upper Paleolithic between 35,000 and 10,000 BP, people who were biologically similar to us began making artefacts now recognized as art, including cave paintings, bone and ivory implements, and sculptures. These appear in the archaeological record very suddenly, as if resulting from a neurological development stimulated perhaps by the environmental and social changes resulting from migration from Africa into glacial Europe. Archaeologists of the Ice Age are now less interested in speculative interpretations of artefacts such as paintings than in forensic examination using such techniques as digital imaging and laser recording to analyze tool-marks, paint, and so on. They have identified local painting traditions over time and distinguished individual painters, to construct life-stories for paintings and sites as art historians do, albeit using different methods.

PREHISTORIC MYTHS

Primordial humanity has always been the place where grand theories about society, culture, and human nature are explored, in order to suggest what humans are by trying to

establish what happened "In the beginning" (as the Bible puts it). Interpreting the mea-
ger archaeological remains of prehistory depends so heavily on analogies with peoples
whose culture has been stereotyped according to Western prejudices that the ideological
agenda behind these grand theories is often quite transparent. The symbolic properties
of artefacts are invoked as particularly potent evidence for theories that come and go,
and then come back again in new forms.

Few issues of human nature have such perennial appeal as gender relations. Many
societies have theories about an original social order in which women held powers
that were appropriated by men to produce the current status quo of male supremacy.
These are often termed myths, as fictions that legitimate a particular vested inter-
est, but this to deny their acceptance as (pre-) historical truths. One such theory,
developed in the late nineteenth century, revived ancient Greek ideas to propose that
society was originally "matriarchal;" that is, governed by women, whose mysteri-
ous powers of reproduction were honored in the worship of a mother-goddess. The
theory received support from the research of anthropologists Lewis H. Morgan and
Edward Tylor, on the basis that matriarchy had survived among supposedly primitive
peoples such as the Iroquois of northeast North America. The assumption behind
this theory was that "patriarchal society," controlled by men, was an evolutionary
advance toward male-dominated modern European society. So it seemed appropriate
to identify the earliest images of women with fertility and mother-goddesses, even
when they were shown to be thousands of years older than the first records of such
ideas, as published for the ancient Mediterranean region by folklorist James Frazer in
The Golden Bough (1890).

PALEOLITHIC FIGURINES

Jill Cook of the British Museum has shown (in unpublished lectures) how such inter-
pretations suffer from European cultural prejudices, particularly of gender. Sculptures
of women were part of the very long European Paleolithic tradition of artefacts repre-
senting animals and humans. They have been found in habitation sites, as distinct from
caves, which seldom contain images of women. Earlier sculptures showed women with
prominent breasts, belly, and buttocks, while later ones, engraved or made as pendants of
special materials, were very stylized, with an emphasis on the profile of the lower body.

Analysis of these images has been hampered by assumptions on the part of male pre-
historians that sculptures of obese women had been made by men and were intended to
be erotic symbols of fertility. The "Willendorf Venus" figurine, discovered in 1909, was
the first Paleolithic female figure to attract popular attention and one of those proposed
as mother-goddess images. The name Venus derived from a prurient interest in its sexual
characteristics, evoking a similar reaction to the "Hottentot Venus," a woman from South
Africa who was exhibited in Europe and died in Paris in 1816. Both were used to repre-
sent ideas of primitive sexuality, associated with Africans and lower forms of humanity

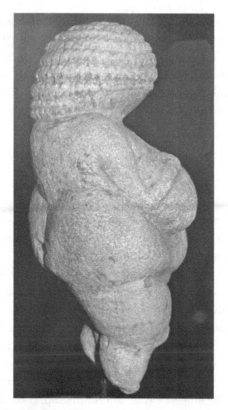

Figure 20 The Willendorf Venus, now in the Museum of Natural History, Vienna. (Don Hitchcock photo)

in contrast with the current puritanical sexual morality of Europe. Prehistorians imputed their own cultural values to the peoples they studied. As Cook testified, the attitude she encountered as a student in the 1970s still persists in some archaeological circles: "We all know what Paleolithic Man was thinking when he made this (nod, wink)."

Cook's research, reacting against these European male preconceptions, has shown that most of the female figurines represented pregnant or middle-aged senior women past childbearing age, rather than erotic images. She has suggested that they are as likely to have been made by and for women as by men, and could represent women's self-perceptions of their bodies, as seen looking down at themselves. Although such theories cannot be proved, they are at least as plausible as those they challenge.

During the twentieth century, research by anthropologists demonstrated that societies in which people inherit through women are governed not by the women but by their brothers and uncles, much as husbands and fathers do elsewhere. But if primordial matriarchy was discredited among academics, it remained a popular theory that was revived and turned on its head in the 1970s by Western feminists seeking a

historical theory to justify their opposition to male domination. In this new formulation, patriarchal society was the regressive reversal of a morally superior situation, and might itself be reversed. The proposition was taken up by anthropologists, supported by Marx's endorsement of the nineteenth-century theory and new research among recent foraging peoples. This has provided more sophisticated analogies for interpreting European prehistory, in particular the shift from a foraging to a herding and farming economy.

STONEHENGE

The architecture of Stonehenge provides an example of this theory of gender role transformation. From being associated since at least the eighteenth century with the Druidic religion of the pre-Roman ancient Britons, the monument was surveyed in the twentieth century to reveal an alignment with the solar calendar, and its origins have been dated by archaeologists to about five thousand years ago. Late-twentieth-century research into the form and significance of ancient stone monuments and earthworks in Britain of this period has revealed astronomical correlations that contradict popular expectations and apparently corroborate anthropological theories of crucial cultural developments in the shift from foraging to herding and farming economies around the time Stonehenge was built. Close examination of the geometry of Stonehenge and other monuments demonstrated that they were designed to focus on the eve of the longest night of the year, rather than the dawn of the longest day as commonly supposed, and in correlation with significant phases of the moon in a nineteen-year calendar cycle. Theorists proposed that this represented an emerging contradiction between an old moon-focused cosmology and a new sun-focused one, involving a transformation in male-female cultural roles. The reasoning, based on research into recent foraging peoples such as the San of southern Africa and the Inuit of North America, is that the lunar calendar governed men's hunting routines and women's menstrual cycles under an ancient form of community organization dominated by groups of related women. Herding and farming favored men as the focus of community relations under a seasonal regime based on a solar cosmology (Sims 2006).

The theory, argued on the basis of detailed research based on scientific methodology, comes to the same conclusion as late-nineteenth-century assertions that an earlier matriarchal stage of human social development was superseded by the familiar patriarchal one of recent times, but for contrary reasons. Whereas patriarchy was formerly regarded as a mark of development toward civilization, female solidarity and strength can now be proposed as a more benign state, usurped by the male dominance that seems to account for so many of the world's ills. The artistic properties of architectural monuments like Stonehenge, as visual models of the ancient cosmos, now appear to bear witness to this revised history of gender relations. In the continuing pursuit of theories of world culture history, a rigorous methodology now meets the more exacting criteria of

twenty-first-century academic credibility, while satisfying the ideological values of its time, just as naïve evolutionary and diffusionist theories did a century ago.

It is interesting to compare such theories with those of peoples of Papua New Guinea, such as the Abelam (see pages 107–110), who say that the spiritual powers and secrets through which men dominate their ceremonial and artistic life were originally appropriated from the women who first discovered them. Whether or not such histories could have survived for thousands of years from some primeval event, they reveal a concern for the tensions in gender relations shared by Western and other societies, present and past. An analogy with the Abelam also suggests an alternative interpretation of Paleolithic cave painting. If men made these paintings, in remote and difficult places quite separate from the domestic sites where the female figurines and other artefacts were found, might the caves have been male religious sanctuaries, like the sanctum houses of the Abelam, built and used by men but forbidden to women? Paleolithic cosmology, like that of the Abelam and other Papua New Guineans, Amazonian Indians, and who knows who else, might have supposed that men had their own creative domain, complementing the fundamental reproductive powers of women. Maybe the men were introduced to the spiritual forces governing their lives as hunters through ritual procedures conducted deep in their painted, womb-like caves, as Abelam men thousands of years later on the other side of the world were initiated in their painted, womb-like sanctum houses.

It seems likely that relationships between men and women have always been a matter for concern, and it is hardly surprising if gendered theories of culture are legitimated by projecting them back to the origins of humanity. Maybe the people of the Paleolithic were doing the same, and insofar as feminism requires ancient precedents, the antiquity of gender issues could be one.

THE POLITICS OF PREHISTORY

As the history of prehistory shows, interpretations of archaeological artefacts are as much cultural and historical products as the artefacts themselves. Even if archaeologists are not dealing with human origins, they still raise contentious issues of cultural politics. Artefacts from the past are always used, whether or not consciously and conscientiously, to legitimate or contest the ideologies of the present.

GREAT ZIMBABWE

Peter Garlake (2002:23–5) illustrated the role of ideology by summarizing interpretations of monumental ruins in present-day Zimbabwe:

1. For the first European colonists, and especially for their sponsor, financier, and propagandist Cecil John Rhodes, Great Zimbabwe epitomized the promise of the golden riches of an ancient land and the success awaiting its new exploiters. Rhodes himself drew the parallels between Phoenicia, from which

he believed its first colonizers had come, and Britain: both were tiny countries on the edge of continents and hence both nurtured the most intrepid seafarers and determined traders the world had seen. He paid for and found support from the first archaeologist to investigate the site. Pictures of Great Zimbabwe soon embellished the share certificates of mining companies.

2. The archaeologist who in 1929 proved conclusively that Great Zimbabwe was an entirely indigenous African creation was also content to dismiss its architecture as the product of an infantile mind and of a divided society where the builders were the slaves of the occupiers.

3. Her successors in the 1950s periodized Great Zimbabwe's history but were not able to accept that the developments that defined their periods could have been generated internally. All change could only be the result of external forces, usually invasions by different tribes, each generally accompanied by violence and destruction. This was only a reflection of the then common view of African history, notoriously described as "the unrewarding gyrations of barbarous tribes."

4. The racist rebellion in Rhodesia in 1965 stimulated a considerable literature—none of it by archaeologists—based on racist assumptions about irredeemable black incompetence on a scale that ensured Rhodesia would always have to be subject to rule by some master race. The rebels not only denied that Great Zimbabwe was African, they promoted the ruins as concrete proof of the ancient presence of previous exotic overlords and threatened and censored professional archaeologists who opposed this.

5. As limited African competence was grudgingly accepted by Rhodesians, it was held that African states could only survive with foreign capital and trade, as neo-colonial states. At the same time Great Zimbabwe was presented as the product of long-distance international trade.

6. A contrary view emphasized the control and management of cattle as the primary means of generating wealth and controlling people. It implied a critical view of the benefits of globalization.

7. When the South African government created Bantustans to further its policy of apartheid, propagandists for the policy presented the traditional African ways of life as admirable and worth protecting but so exotic and irrational that they were incomprehensible to and unassimilable by outsiders. A flavour of this can be sensed in a concurrent interpretation of Great Zimbabwe. Against all common sense, the vast labour and skills used in the construction of the main building were said to have served solely to provide a rarely used initiation centre. Design, layout, and decoration were seen as coded messages about such things as fertility, procreation, and respect for the elderly. It has been rejected with considerable force by all knowledgeable anthropologists, archaeologists, and indigenous Zimbabweans familiar with their traditions and history.

8. Zimbabwe's independence in 1980 ushered in a short period of general euphoria. The first black Director of Museums rapidly published a book

denouncing all archaeological studies as imperialist. He presented Great Zimbabwe as the epitome of "Merrie Africa," the entire populace in a continuous state of revelry and the prosperity of the state determined by the size of the ruler's genitals.

9. The new government paid lip-service to "Marxism-Leninism" for a brief period and there were a few tentative attempts to portray Great Zimbabwe as the product of the cooperative enterprise of an "African socialism."

10. Finally, now that the country is characterized by the accumulation of great wealth in the hands of a small elite, the country's senior archaeologist proposes that the period to which Great Zimbabwe belongs can only be understood as the consequence of "a decisive, ideological change . . . a shift in the system . . . in which the material accumulation of goods by individuals is encouraged."

11. In this book, I suggest that the architecture of Great Zimbabwe has a symbolic content expressing and validating the nature of the ruler's relationship to the land he rules. This can be seen as a reflection of current concerns in Zimbabwe over the ownership of land.

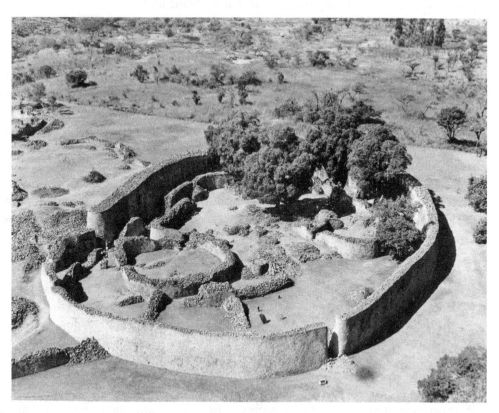

Figure 21 Great Zimbabwe in about 1970. (Rhodesia Ministry of Information; photo, The Trustees of the British Museum)

NATIVE AMERICAN PREHISTORY

A further challenge comes with non-Western interpretations of archaeological remains, particularly when ancestral heritage and ethnic identity is at stake. This is the kind of issue facing the archaeology of Native North America, as reviewed by David Hurst Thomas in *The Skull Wars* (2000).

While Euro-Americans trace cultural antecedents to ancient Greece, Native Americans seek to reclaim American history from those who colonized their land and seem intent on appropriating their identity and culture too. In the United States, Native American objections to the excavation of ancient ancestral sites led in 1990 to the Native American Graves Protection and Repatriation Act (NAGPRA). This gave Native Americans rights in ancient sites and prevented archaeologists from treating human remains simply as "prehistory," belonging to the discoverers, their nation, or humanity in general. With the support of NAGPRA, some Native Americans have managed to persuade archaeologists to take their inherited traditions seriously, as oral history to aid interpretation of their finds. Information passed on for hundreds of years has been corroborated in the excavation of sites that could not otherwise have been identified with particular societies, enriching Native as well as academic history.

However, some Native histories will always remain at odds with Western ideas of prehistory. Just as American Christian creationists continue to insist that the truth about human origins lies in the Bible, some Native Americans maintain that their original ancestors descended from the sky or emerged from the ground. But there is more than religious cosmology at stake for Native American creationists. Some Native Americans, like the Lakota scholar Vine Deloria, regard the now widely accepted theory that the first people to arrive in America came from Asia via the Bering Strait during the Ice Age as having the colonial implication that Native Americans are no more truly indigenous to the Americas than the colonists themselves. It reminds them of earlier colonial theories that they were descended from the Lost Tribes of Israel, or from the medieval Welsh prince Madoc, according to the kind of diffusionism that denies the cultural integrity of the colonized. David Hurst Thomas quotes a Choctaw, Gary White Deer:

> "To archaeologists, the idea of consulting with potential specimens must seem annoying. For Native Americans, it's yet another version of the country's oldest and deadliest game: Cowboys and Indians." . . .
>
> Rebecca Tsosie, a Native American and executive director of the Indian legal program at Arizona State University, [commented that] "Western science gives us a way of knowing the world, a noble goal, but it's not the only way to establishing something as the truth." (2000:213, 255).

Whether such alternative truths can easily coexist depends as much on the politics as on the cosmology of what the West calls "prehistory."

QUESTIONS FOR DISCUSSION

- Is prehistory a useful category for understanding ancient art?
- Can ancient art provide evidence for grand theories of human development, or should this work the other way around?
- Does it matter whose realities or truths are represented in the interpretation of ancient artefacts?

FURTHER READING

- Greene's book *Archaeology* (2002) reviews the development of Western ideas of the past and its interpretation in Chapters 1 and 6.
- Cook's chapter reviews "The Discovery of British Antiquity" (2003).
- Sims's article "Stonehenge and the Neolithic Counter-revolution" (2008) argues for a Neolithic shift from a female to a male-focused society.
- Deloria's book *Red Earth, White Lies* (1995) is a Native American challenge to scientific interpretations of prehistory.

PART 2
CROSS-CULTURAL PERSPECTIVES

Some theories and methods through which Westerners have tried to understand what art contributes to other cultures and to humanity in general.

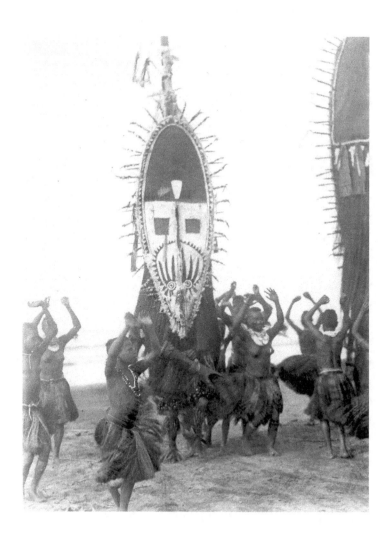

6 FORM

While art historians and connoisseurs of the early twentieth century treated the form of artefacts as the basis of a subjective aesthetics, anthropologists analyzed it to understand small-society art traditions. Studies drawing on Native American culture of the Northwest Coast contributed to structuralist theories, which identified binary and then more complex patterns in artefacts and culture.

Outline of the Chapter

- Connoisseurs of Form
 Assessing artistic value subjectively to interpret other peoples' art.

- Form in Northwest Coast Art
 The search for cross-cultural understandings of artistic form and an analysis of Northwest Coast formal style.

- Structure in Northwest Coast Art
 Theories identifying and interpreting binary forms.

- Structure in Northwest Coast Culture
 Looking at the structures of conceptual systems governing culture and cosmology as a whole.

One assumption of connoisseurs of Western art was that the forms of artefacts could be assessed according to universal human values. The problem was that they presumed these values to be their own Western ones, or at least ones they could read from a Western perspective. Anthropologists sought such universals by looking at traditions as different as imaginable from their own, in "primitive art." The rich artistic traditions of the Native Americans of the Northwest Coast were a particularly valuable field of research.

CONNOISSEURS OF FORM

At the end of the nineteenth century, there was a reaction among Western painters and art critics against the art-historical interest in iconography and symbolic content. They concentrated instead on visual design as the source of aesthetic values that were the essence of art. This "formalist" approach tried to identify principles of composition, such as organic unity among diverse elements, balance reflecting a sense of symmetry, recurring shapes, and so on, that should apply regardless of whatever might be represented. At its most extreme, formalism became the rationale for the Western abstract painting of the early twentieth century, which refused to represent anything other than art itself.

An early-twentieth-century British exponent of formalism was Clive Bell, who maintained that " 'significant form' is the one quality common to all works of visual art." What he regarded as significant was the form itself, not its representational content, if any: "certain forms and relations of forms, stir our aesthetic emotions" and "All systems of aesthetics must be based on personal experience—that is to say, they are subjective." This experience was not the same as viewing natural beauty, nor illustrations that arouse interest and emotion by their content, as photographs can do, for what was represented was irrelevant to the significant form. "Art transports us from the world of man's activity to a world of aesthetic exaltation" (Bell 1913).

In dealing with Western art, formalism assumed the connoisseur to be the best judge of what was significant, in terms of universal aesthetic values. A similar approach was taken to exotic art, after it had been brought to the attention of connoisseurs by the Primitivist art movement of the early twentieth century. William Fagg of the British Museum was a notable advocate of formalism whose search for "meaning in African art" was an exercise in connoisseurship, "having regard both to universal values in art and to specific tribal values." His method was explicitly subjective: "what is required is instantaneous intuitive recognition (to be followed up as necessary by analytical methods) of the qualities, including the authenticity, of the work." The objective was to identify "the finest works" of a style, these being best at "communicating the ineffable, that is the truths, values, feelings, etc." of a particular ethnic group or "tribe." This property of art he regarded as far more important than the "subject matter" or symbolic content of the sculpture (Fagg 1973:153, 155).

But even if Fagg did indeed manage to identify artistic values shared by the sculptor and his community, he had no explanation for their visual appeal. Long before he wrote this, others had attempted more methodical and rigorous interpretations of artistic form in non-Western traditions.

FORM IN NORTHWEST COAST ART

While connoisseurs like Bell were trying to train and refine European sensibility to the formal properties of painting and sculpture which would elevate the mind,

anthropologists were seeking to understand what these properties meant to humanity in general. In contrast to Bell's extreme "aesthetic hypothesis," which disregarded representational content, anthropologist Franz Boas tried to explain how form and content worked together. In *Primitive Art* (1927; see page 62), he looked for universal principles by making comparisons across societies and cultures, rather than applying Western aesthetic values to non-Western artefacts, and he drew heavily on his own research among the Native peoples of the Northwest Coast of North America (see map, page 64).

Boas arrived at a theory of art as the appreciation of humanly created form by demonstrating the importance of basic formal qualities that were influenced by technical processes and enhanced by virtuosity and symbolic associations. Although writing about "primitive art," he made a point of attributing these qualities to all humanity. He wrote in the Conclusion to *Primitive Art*:

> Artistic enjoyment is . . . based essentially on the reaction of our minds to form. . . . forms that are not the handiwork of man . . . may not be considered as art, although the esthetic reaction is not different . . .
>
> The esthetic effect of artistic work developing from the control of technique alone is based on the joy engendered by the mastery of technique and also by the pleasure produced by the perfection of form. The enjoyment of form may have an elevating effect upon the mind, but this is not its primary effect. Its source is in part the pleasure of the virtuoso who overcomes technical difficulties that baffle his cleverness. As long as no deeper meaning is felt, its effect for most individuals pleasurable, not elevating.
>
> . . . art that is apparently purely formal, is given a meaning endowing it with an emotional value that does not belong to the beauty of form alone. It is an expressionistic element that is common to many forms of primitive art. It is effective because in the mind of the tribes certain forms are symbols of a limited range of ideas. (Boas 1927:349–50)

Boas treated art as the introduction of aesthetic values; that is, the creation of formal qualities with sensuous appeal, into all kinds of human activity, including music, poetry, and dance as well as visual arts. The measure of aesthetic value was a certain level of technical excellence, judged against certain accepted formal standards of beauty. Artists strove for ideal forms created by technical processes, which produced styles—that is, stability of form dependent on high technique—which would be attempted by artists with varying success.

For Boas, the human creation of form might be enhanced by its association with significant ideas, but he stressed the primacy of the formal qualities of art over the expressive or communicative. He identified certain universal formal principles, which in visual arts included symmetry, rhythmic repetition, and the enhancement of form by decoration. When the forms expressed deeper meanings, from the appreciation of technical virtuosity to symbolic associations, enjoyment of art became elevating. This could be true of formal (decorative) art, but it applied particularly to symbolic (iconographic) art. Boas explored these distinctions in relation to arguments about the derivation of

conventionalized and geometric styles from representational ones, which was a subject of debate in his time (see page 57).

In using the Northwest Coast art as a case study, Boas distinguished men's "symbolic" from women's "formal" art. He characterized the symbolic style by conventions for representing creatures (as described on page 105). Usually the whole creature was represented, adapted to fill the available space on an artefact or to encompass it by splitting the image head to tail into two profiles. He recognized "rigorous formal principles" in the graphic elements (or "symbolic decoration"), such as ovals and U shapes, and suggested that the elaboration of this art style was related to the way its products were used to mark "rank and social position" in a hierarchical society.

For some time after Boas, anthropologists left the field of art to art historians and connoisseurs, who continued to pursue the kind of primitivist theories he had dismissed. However, by the 1960s, researchers were coming forward with new theories of form and meaning that drew heavily on Boas's Northwest Coast research. Those who turned their attention to formal style were able to give the lie to the primitivist stereotypes of artisans slavishly imitating the established styles of their predecessors. Some demonstrated the scope for innovation and individual initiative within the conventions of even consciously conservative cultural traditions.

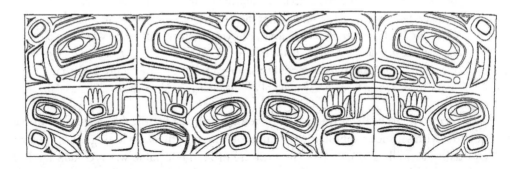

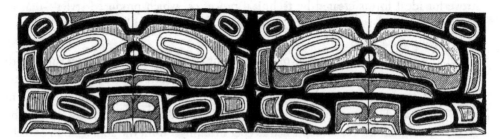

Figure 22 Examples of Northwest Coast design from Boas (1927:268), showing four-sided boxes opened out, which illustrate principles of repetition and symmetry as well as certain stylistic conventions in representing creatures to fit a defined space.

FORMLINES

The formal principles governing carving and painting from the northern peoples of the Northwest Coast were reconstructed by Bill Holm. From the 1940s, unable to find anyone still living who had received training in the local style (for reasons explained on pages 190–91), Holm worked from museum collections. His conclusions, published in

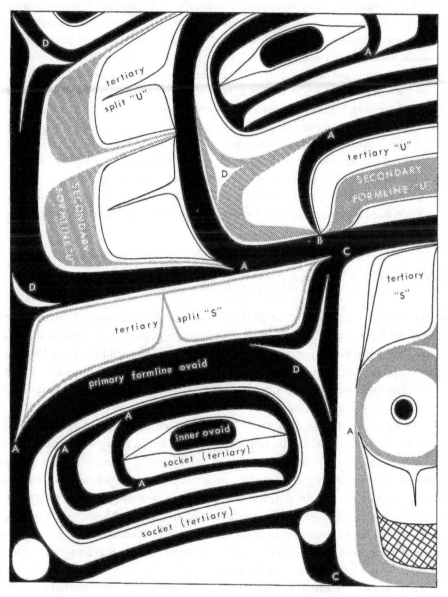

Figure 23 A painted box design, annotated by Holm to explain the formline principle (Holm 1965:59, reprinted by permission of the University of Washington Press).

1965, helped make the style intelligible to later generations of Native American artists as well to art historians.

> It is apparent that there was, on the Northwest Coast, a highly developed system for the organization of form and space in two-dimensional design as an adjunct to the well-known symbolism. Design ranging from nearly realistic representation to abstraction resulted from the application of the principles of this system. Chief among these principles was the concept of a continuous primary formline pattern delineating the main shapes and elaborated with secondary complexes and isolated tertiary elements. Also important to it was a formalized color usage that prescribed the placement of the three principal colors: black, red and blue-green. There was a set series of design units which could be arranged and varied in proportion to fit the requirements of space and representation. Important among these were the formline, the formline ovoid, and the U form. To design forms and to maintain the fluidity of design, a group of transitional devices was used. Monotony was minimized by nonconcentricity and avoidance of parallels, as well as by firm semiangularity of curves. A limit to the degree of elaboration was imposed which was independent of the scale of the design.
>
> The total effect of the system was to produce a strong, yet sensitive, division of the given shape by means of an interlocking formline pattern of shapes related in form, color and scale. (Holm 1965:92)

STRUCTURE IN NORTHWEST COAST ART

Insights gained from the analysis of the formal principles governing formal styles like those of the Northwest Coast did little to explain the other significances of the artefacts, either to their makers and users or to the connoisseurs who studied them. But a shift in focus to the relationships between forms led to a "structuralist" approach, which captured the imagination of academics in various disciplines, with promises to reveal deeper significances in culture, including art.

In the 1960s, the formal qualities of Northwest Coast designs identified by Boas were among the examples used by the influential French anthropologist Claude Lévi-Strauss (1963) to demonstrate structural principles for which he claimed underlying cultural meanings. Lévi-Strauss began by criticizing the deficiencies of prevailing diffusionist approaches to primitive art for drawing conclusions from analogies between separate cultural traditions on the basis of poor methodology and weak evidence. As he pointed out, even if similarities had resulted from diffusion, their continuation over great periods of time presumed other factors to be at work inhibiting subsequent change. Even so, Lévi-Strauss recognized some of the analogies on which diffusionist theories were based, and accepted that other research had demonstrated some shared "fundamental principles" in diverse artistic traditions, particularly in varieties of symmetry. He challenged diffusionism by taking similar evidence from several traditions widely separated in time and space,

for which diffusionist explanations would be quite implausible, and sought instead psychological explanations through "the structural analysis of forms." He did not completely discount diffusionary influences, but accepted only "a diffusion of organic wholes wherein style, esthetic conventions, social organisation, and religion are structurally related."

SPLIT REPRESENTATION

Lévi-Strauss focused on the "split representation" of creatures in Northwest Coast artefacts, which Boas had analyzed as two profiles joined at the head. He noted that Leonhard Adams had commented independently, in terms very similar to Boas's, on the designs on ancient Chinese bronze vessels. He made a comparison with women's face painting from his own research with the Caduveo people of southern Brazil, in which symmetry was complicated by inverting designs from one side of the face to the other, so that diagonal opposites corresponded. He also commented on Maori men's facial tattoos, which show similar complexity, though not the inverted symmetry, and on their carvings, which also use split representation.

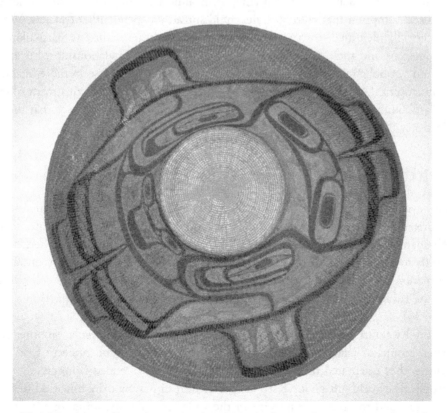

Figure 24 A Northwest Coast hat painted with a split design of a creature with teeth and fins. (The Trustees of the British Museum; Am,+6220)

In all cases, the split designs seemed not merely to ornament the object so much as to integrate the creature depicted into the object by encompassing it. Lévi-Strauss treated this as a dualistic relationship between object and design, equivalent to that between the face and its painted or tattooed decoration. These were among a series of dualisms in those societies, including "carving and drawing" and "person and impersonation."

This is where Lévi-Strauss made his characteristic leap from interesting observation of cultural structure to the imposition of his own analytic constructions upon the culture. He described all these examples as "masking cultures" (including graphic face decoration), where persons have their faces artificially transformed, with "the splitting technique, [as] not only the graphic representation of the mask, but the functional expression of a specific type of civilization." This "specific type" was one where masking represented the identity between persons and their roles in a social hierarchy. His general conclusion was that the formal structures of art were symbolic reflections of identifiable types of social structure.

Lévi-Strauss's proposition that modes of social and cultural organization could not only diffuse and survive, but also retain or otherwise share specific symbolic systems identified from such a superficial analysis, is almost as simplistic as the earlier diffusionist assumption that cultural traits could spread independently of society. While he successfully identified structures present in diverse cultural traditions, particularly pairs or dualisms and their transformations into more complex relationships, his attempts to find symbolic relationships between such relationships often seem more imaginative than empirical. As with his analysis of oral literature as "myth," his treatment of images as "art" illuminates common structures but ultimately fails to convince that they have deeper symbolic meanings.

STRUCTURE IN NORTHWEST COAST CULTURE

However, the structural analysis that Lévi-Strauss inspired did produce interesting interpretations, particularly when applied in more holistic studies of particular societies. Abraham Rosman and Paula Rubel (1990) used research by Boas and others from the 1890s to show how Northwest Coast culture displayed the kind of structural transformations in culture and cosmology that Lévi-Strauss had identified. They focused on the Kwakiutl people of Vancouver (the Kwakwaka'wakw, also featured in on pages 229–30).

The Kwakiutl calendar was divided into two seasons. In the secular summer season, when groups of related families worked together to obtain and preserve food for the winter, they celebrated their shared heritage as a clan descended from certain animal-people. They held gift-giving festivals (potlatches) to bestow titles inherited from these ancestors and to raise their prestige in the wider community, impersonating them in masks and ceremonial regalia.

For the winter season, when they moved into their clan big-houses in large coastal villages, they lived on stored food while performing theatrical ceremonies. The winter procedures and regalia were given to clan ancestors by certain spirit-beings, but instead of inheriting them through the clan, men were chosen, often from other clans, to be initiated into their secrets and powers. At the beginning of the season, they were snatched away and apparently devoured by the spirits, which were ferocious monsters and cannibals. After a period of seclusion in the forest, the initiates returned at the climax of the winter ceremony in the community hall, impersonating and possessed by their spirit mentors and accompanied by other such spirits in their masks and costumes.

When humans appeared in masked costumes as other creatures, they impersonated clan ancestors and spirits who were both. In the clan histories, people encountered such creatures living as if they were humans, as in the earliest times before humans and other creatures became distinct, and as still experienced in dreams and visions. Rosman and Rubel explained the summer and winter seasons and their ceremonials in terms of paired oppositions between the ordinary secular world and the secret spiritual one of dangerous powers. Masquerades enabled the Kwakiutl to cross over from the secular human world, which dominated the summer season, into the extra-human world, which was dominant in the winter.

The winter spirits were transformations—monstrous or comic—of the animals that were portrayed, with normal human characteristics, in the summer masks. Theirs was the world from which shamans gained their powers to cure and kill; the world in which humans were hunted and devoured by other creatures, instead of hunting them for food as they did in the summer. In the winter season, it was the rank of their spirit mentors that determined men's precedence in the public ceremonies, rather than the rank inherited from clan ancestors, which they proclaimed in the summer festivals through demonstrations of wealth and generosity. As Rosman and Rubel concluded, "Together with the forms of social organisation and ceremonial life enacted in each season, the art objects of the Kwakiutl only make sense . . . when seen as part of a complex transformational set."

BEYOND BINARY OPPOSITIONS

All cultures employ such basic dualisms and transformations to make sense of the world, but it is also possible to find more complex structures. In the 1970s, Joan Vastokas used a structural "cognitive approach" to look at Northwest Coast culture (1978). She came to some very different conclusions to Lévi-Strauss about its underlying structures of meaning by examining it in the context of the culture as a whole.

According to Vastokas, a cognitive approach to visual art depended upon understanding a cultural tradition in its own terms, and art as a vital component of the systems

that comprised the culture, rather than simply as a product or expression of the culture. In this respect, the art itself could be seen as a cognitive subsystem with its own set of interacting principles. This also had to be explained in its own terms, as one of several conceptual subsystems, rather than by analogy with systems like language, since visual systems had their own special cognitive properties independent of language. To avoid presumptions about Northwest Coast concepts, Vastokas dealt with "visual imagery" in the broadest sense: its governing principles and how it communicated meaning. She drew her illustrations mainly from the Kwakiutl.

Looking beyond the bilateral symmetry identified by Lévi-Strauss to the broader context of artistic motifs in architecture and performance in the Northwest Coast big-house, dualistic structures could be seen operating in terms of down and up as well as left and right, vertical as well as horizontal. However, the horizontal symmetry was often of three parts rather than two, as with the snake-monster motif with a head at each end and a human face in the middle. In such cases of Lévi-Strauss's "split representation," the central image could be read both as a front view and as two profiles. Furthermore, designs often had four sides, which were rendered as curves within a continuous flowing formline. The contradictions between the central axes—horizontal and vertical—and the open-ended margins; between the two and three parts of the symmetrical image; and between the four-sided shapes and their flowing outlines, all contribute tension and ambiguity to Northwest Coast graphic designs.

This dualistic tension and ambiguity could be seen in Northwest Coast cosmology in the relationship between humans and animals, who were regarded as transformations of each other. This transformation was enacted as the focal point of ritual performances through animal masks that split in two to reveal another character in the story. But it was the point of transition that was most significant, confirming other evidence that North-west Coast people thought more in terms of three-part structures than dualisms. The three-part snake-monster played a major part in cosmology, shifting in the stories between sky-world and sea-world but representing land by its human face, hence mediating the three parts of the cosmos, which were also represented in the structure of the longhouse.

In ritual performances, the interior of the house was referred to as the middle world, the roof as the upper world, the ground below as the underworld, and the walls as the edges of the world. A pole mounted on the central axis of the house, toward the back, linked the three worlds in the cannibal-spirit ritual performances, representing the sha-manistic travel between them. At the same time, the central axis from front to back of the house linked the sea out in front of the house, the inhabited shore area, and the forest behind the house, in a horizontal three-part structure complementing the vertical one. The central point of these axes, where the horizontal and vertical lines crossed, was the point of power and prestige, the residence of the highest-ranking person of the village or in the house, and the focus of ritual sanctity in performance, as with the cannibal pole. The shape of the world was a square, like the house and other artefacts of a people who worked with planks of wood.

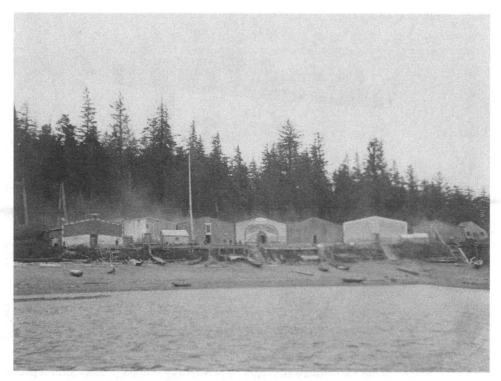

Figure 25 A Kwakiutl village of communal big-houses, on a beach between the forest and the sea, on Vancouver island in about 1900. (The Trustees of the British Museum; Am,B59.20)

It thus appeared that formal patterns observed in the art of the Northwest Coast corresponded with social and cosmological structures, in which three-part structures were more salient than simple dualisms or four-part structures. But in all cases, Northwest Coast art seemed to represent "latent cultural-cognitive tensions"; forms constrained but flexible; stable at the center but mobile at the margins; vertical and horizontal axes fixed at the central point. Vastokas considered that such tensions and ambiguities also corresponded to contradictions between economic subsistence and surplus, social egalitarianism and rigid social hierarchy, and individual shamanistic and ritualized priestly religion, which were social as well as cognitive or intellectual.

All cultural traditions are full of contradictions, tensions, and ambiguities, revealed in many other art studies, and pairs mediated by a third are not hard to find. But as Vastokas's conclusions for the Northwest Coast suggest, cultural and artistic structures may be much more complex, and more revealing, than Boas's formalism and Lévi-Strauss's binary oppositions proposed.

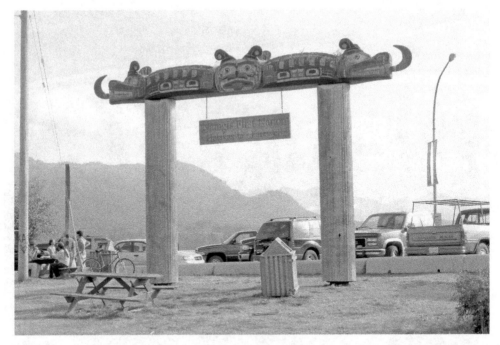

Figure 26 A double-headed serpent, displayed at the entrance to the Namgis First Nation reservation (one of the Kwakwaka'wakw nations), at Alert Bay in 2006. (Robert Storrie photo)

QUESTIONS FOR DISCUSSION

- What does formalist connoisseurship have in common with the structural analysis of art traditions?
- Does structural analysis help us understand how people appreciate their own art traditions?
- How far might we expect the formal principles identified in Northwest Coast artefact traditions to apply to other cultures too?

FURTHER READING

- Pooke and Newall in Chapter 2 of their *Art History* (2008) summarize formalism as a Western art fashion.
- Fagg's chapter "In Search of Meaning in African Art" (1973) explains his connoisseurial approach.
- Boas's formalism is summarized in the Conclusion to his book *Primitive Art* (1927).
- Lévi-Strauss's paper on "Split Representation in the Art of Asia and America" (1963) is an example of his structuralist theory.
- Vastokas's chapter on "Cognitive Aspects of Northwest Coast Art" (1978) reviews previous studies of structure in Northwest Coast culture.

7 MEANING

The explicit meanings and implicit connotations of images can be read and explained by those versed in particular art traditions, such as official and religious iconography. However, visual symbols also seem to communicate more than people can explain in words, raising questions about the level at which we can understand the iconography of unfamiliar cultures.

Outline of the Chapter

- Reading Symbols
 The connotations of familiar iconography, as illustrated by heraldry and advertising.

- Explicit Meanings
 The kind of explanations given for symbolic systems, as researched in the royal court of Benin in Nigeria.

- Limits to Iconographic Analysis
 When the identity of images is less important than that of their users, as with Native Americans of the Northwest Coast.

- Hidden Meanings
 Reading images in ways their makers cannot explain, as proposed for the Abelam of Papua New Guinea.

Out of the study of form and structure, informed by anthropological field research into the iconography of small societies but still influenced by the mystical traditions of connoisseurship and primitivism, came an interest in how artefacts convey messages within the cultural tradition that produced them. Attempts were made to read art traditions as systems of communication by deciphering their code of visual signs to gain insights into the culture and its worldview. But although these approaches accepted that such signs had to be understood within the context of their culture, questions still remained about communicating them across cultures.

READING SYMBOLS

The things we experience are held in the mind as concepts, but to make sense of them and share them by communication with others, they have to be distinguished from each other, put in order and represented through an equivalent system of sound and sight as "signs." Following the early-twentieth-century linguist Ferdinand de Saussure, signs are taken to comprise "signifying" forms representing "signified" concepts. The forms need bear no natural or inevitable relation to the concepts they signify, any more than words resemble the things they describe. Rather, they serve to identify concepts within the system of signs that people construct to communicate with each other in society as the "language," spoken and unspoken, of their shared culture. In this "semiotic" approach to culture, visual signs can be interpreted, like speech, from an understanding of the underlying language or code. As human creations, cultures and the signs they employ vary over time and space, and individual minds vary with personal histories, so communication is always inexact and subject to interpretation.

In the 1960s, Roland Barthes introduced a further distinction between the concepts a sign "denotes" at the obvious level of description, and its "connotation" of other symbolic meanings within the wider cultural system. Barthes used the example of commercial advertising, in which images of commodities are contrived to represent appealing social values. This kind of analysis, dealing with less precise and more complex levels of meaning, was more interpretive and less supposedly scientific than Saussure's linguistic model. When artefacts are made to denote other objects by resembling them as images or "iconic" signs, it is these symbolic connotations that communicate the less obvious meanings. They can be read as metaphors by those versed in the culture, to communicate what Barthes called "the rhetoric of the image." The code governing relationships between motifs, as a system of iconography, can be compared to the grammar that allows an intelligible reading of a language (Barthes 1977).

People can decode at least some of the symbolic images they encounter within their own cultural tradition and explain them in ways that make sense to those less knowledgeable. Not everyone knows everything, and some symbols are deliberately esoteric, but at a certain level many meanings are fairly obvious. Sometimes a system of visual symbols depends for its purpose on an explicit code that makes it quite clear what the artefacts mean.

BRITAIN

So it is with heraldry, the tradition of graphic emblems that represent the histories and prerogatives of high-status individuals, families, and corporate bodies in Europe. Of the people who see these emblems all around them, the vast majority recognize "coats of arms" and "crests," and a few can identify particular motifs, but those who want to know more can consult books about heraldry, many written by the official heralds who govern this artistic tradition.

In British heraldry, the graphic assemblage of a coat of arms focuses on a shield ("escutcheon") with distinctive motifs, surmounted by a helmet ("helm") bearing a "crest," usually with a "motto" below. Aristocratic rank is distinguished by the type of helm and, for peers of the realm or lords, by additional motifs including a particular style of "coronet" beneath the helm, and creatures holding the shield at each side as "supporters," standing on a base or "compartment." Variations include bishops' miters instead of helms for high-ranking church officials, special coronets for corporate and military institutions, and lozenge-shaped escutcheons for female title-holders. The arms of several families can be combined in certain ways to signify marriage and shared inheritance, allowing the shield to become a graphic genealogy, and seniority of inheritance from the first to the ninth son can be distinguished by superimposed motifs. Other emblems may be added to "augment" the arms as signs of distinctions earned, or displayed separately as "badges."

The codification of heraldic design ("blazonry") is so precise that the description of a coat of arms in specialized heraldic language (mostly Anglicized French) is sufficient to generate an accurate image of it. The geometric motifs on the shield ("ordinaries" and "sub-ordinaries"), the representational ones ("charges") including creatures and objects with archaic associations, and their relationships to one another, all have standard names and descriptions. The basic colors ("tinctures") are prescribed, with the rule that a "colour" and a "metal" ("or," yellow or gold, and "argent," white or silver) should not be superimposed on another colour and metal respectively, and there is an allowance for images to be shown in their "proper" natural colors.

This iconographic code, described in many books on heraldry, is both explained and legitimated by its long history. Coats of arms, badges, and other insignia derive their motifs from obsolete military equipment of the medieval aristocratic armored cavalry. By the late fifteenth century, as the armor used in tournaments became ineffective in warfare with the advent of firearms, its distinctive forms were increasingly used as graphic designs, not just by the aristocracy but by the rising merchant class. A College of Arms was founded to grant coats of arms as symbols of achievement and status to aspiring individuals as well as companies, trade gilds, and city corporations. The heralds of the College standardized the motifs, designs, and markers of rank, and codified the rules governing style and iconography.

The popularity of heraldry in Britain fluctuated over the centuries, with an enormous increase in grants of arms during the sixteenth century, a decline in the late seventeenth century, and a revival in the late eighteenth century. Design fashions changed, from the earliest bold motifs to naturalistic images and scenes in the eighteenth-century revival, back to conventional motifs in new arrangements in the late nineteenth century, and with an elaboration of geometric motifs and new images in the twentieth century. The purposes of heraldic display changed too, from identifying competitors in tournaments to proclaiming aristocratic ancestry in funeral ceremonies and monuments and marking the status of a family or institution on buildings, household utensils, and documents.

ACHIEVEMENT

of

Sir William-Peirce-Ashe a'Court *Bart:*

impaling

Wyndham

Figure 27 The frontispiece from a book of genealogy showing the arms or "achievement" of the a'Court family, in a graphic style characteristic of the eighteenth century. On the "dexter" or right side (left as viewed) are the arms of Sir William Peirce-Ashe a'Court; the a'Court arms quartered with those of his great-grandmother Ashe and his grandmother Peirce, both heiresses who brought their estates into the family. "Impaled" on the "sinister" side are the family arms of Letitia Wyndham, whom William married in 1777.

To give a sample of the heraldic description, the a'Court arms in the first and third quarters would read: "per fess, or, and paly of six, erminois and azure; in chief an eagle, displayed, sable, beaked and membered, gules; charged on the body with two chevronels, argent."

In the center the red hand of Ulster on a white shield has been added to show the rank of baronet or hereditary knight, which is also indicated by the helm, open and front-on. This bears the a'Court crest of the same eagle holding in its beak their badge, a "lily slipped proper." (From a book belonging to the Holmes a'Court family)

Figure 28 Following Barthes, we can illustrate the connotations of heraldry with an example of graphic advertising. This 2010 poster produced by the Wells brewery, advertising a brand of beer, features the emblem used to identify it when on sale in an English pub. The badge on the beer pump, reproduced on the glass, is a shield bearing what customers can easily recognize as the cross of St. George, displayed on flags by sports fans and others as English nationalists. The cross also shows on a smaller shield, imitating a coat of arms with implicitly English lions as supporters. The name of the beer, Bombardier, has masculine connotations of an archaic military rank and is written on a scroll reminiscent of old inscriptions such as heraldic mottos.

The purpose is to promote Bombardier bitter as a "real ale"—that is, a beer produced to high traditional standards, served by a manual pump in a pint glass (albeit a short pint by dint of the froth). Its proclaimed Englishness is affirmed by the connotations of history and tradition that the iconography and formal style of heraldry help convey. (Charles Wells Ltd. poster)

Heraldry can be read at several different levels. Beyond the "language" of the iconographic code, with its signs denoting rank and genealogy and its rules of graphic composition, comprehending what is actually being "said" requires acquaintance with the motifs belonging to particular families or institutions and the histories of honors awarded to them by the state. But the motifs also have less explicit connotations, recognized by those familiar with the culture but not necessarily obvious to others, even from the heraldry books. The lion and the unicorn supporting the royal arms of the United Kingdom are emblems of the kingdoms of England and Scotland and denote their union, but they also have connotations of nobility—one as the brave "king of beasts," the other as the defender of purity, tamed only by a virgin. Such archaic symbols pervade heraldic imagery, recognized in various degrees according to people's historical and literary education.

A popular sense of this symbolism explains the continued use of heraldry in England to honor high achievers within the governing establishment with coats of arms appropriate to their titles, as well as displaying the honors and prerogatives inherited from previous generations. The royal arms are displayed by courts of law and other institutions to proclaim state authority and by commercial companies as signs of royal patronage. The arms of other aristocratic families appear on buildings on their estates, on their domestic utensils, and on local pub signs.

But at yet another level, we might consider the role of heraldic display in legitimating the hierarchy of social class, headed by the monarch, with all the ambivalent and contested values this entails. Like any iconographic system, heraldry can be read at various levels, which require an understanding of the cultural contexts from which they take their meanings. When the British use shield motifs to display inscriptions, formalized mythical animals as trademarks, imitation coats of arms to ornament domestic goods, and even badges for their clubs and letterheads, they are drawing, more or less, on the artistic tradition of heraldry and its connotations of tradition and quality associated with cultural conservatism and inherited status.

EXPLICIT MEANINGS

Such interpretations of Western iconography may seem too mundane and obvious to comment on, but they might still be misinterpreted by someone unfamiliar with Western culture. Interpreting the iconography of an unfamiliar culture requires similar consideration of its social context. From the outsider's perspective of the anthropologist, understanding the symbolic language both requires knowledge of the worldview of the people under study, and reveals more about it.

BENIN, NIGERIA

The iconography of the kingdom of Benin in Nigeria was researched by Paula Ben-Amos in the 1960s (1971). Benin artefacts became known in Europe after the royal palace was

looted during the British conquest in 1897 (see pages 174–75). The cast brass sculptures, including plaques from the pillars of an earlier palace and altar-pieces, with carved ivory tusks, as well as regalia, woodcarvings, and ironwork, were subsequently purchased by the British Museum and other museums.

Among the many and varied images of kings, chiefs, palace officials, soldiers, and Portuguese merchants from the sixteenth century onward are various animals. Their significance only became apparent to the Europeans who possessed the palace artefacts when researchers began to ask the Benin people themselves. Ben-Amos found that the meanings of these animal images helped define the Benin view of the world and the nature of human society.

The people of Benin, having a well-ordered hierarchical society in which every-one, from kings and nobles to commoners in various occupations, knew their place, saw the world as a whole in terms of different realms with their own rulers and laws. As elsewhere in West Africa, animals in history, storytelling, and proverbs acted as meta-phors for human characteristics, acting out human situations.

According to one such tale, the King of the Forest and its wild animals is the leop-ard, but he was defeated in war by an early King of Benin as King of the Home, the realm of human habitation, with the support of God, who gave him dominion over the Forest. Some of the creatures who joined the king of the Home became domesticated, such as the cow, the sheep, and the chicken. Others, who were docile and easy to kill, such as the antelope, mudfish, and pangolin, were given to be used by humans for food and sacrifice. More fearsome animals of the forest, who were not so easily subdued by ordinary humans, represented the powers of human authorities. The leopard, beautiful and good-natured but predatory and ferocious, was king of the animals and likened to the King of Benin, who was benevolent but alone had the authority to sentence people to death. The elephant, often in rivalry with the leopard in folktales, was like a great chief, who might be a challenge to the king. The river-dwelling python, king of snakes, was the messenger of the god Olokun, King of the Waters, who was also once defeated in battle by the king of Benin as King of the Land. The crocodile was Olokun's police-man, attacking wrongdoers, and the fish-eagle, also vicious and predatory, was king of the day birds. As leaders of their own domains, with the power to take human life, these dangerous animals were identified with the King of Benin and could be killed or sacrificed only under his authority. This rule represented his dominion as King of the Home over the realms of the Forest, the Waters, and the nonhuman world in general, sanctioned by God.

Hence images of these creatures in the artefacts of Benin can be seen as symbols of the hierarchy of powers within the Benin kingdom and of dominion over other realms of the world. The leopard from the Forest is there as a king, the crocodile from the Waters as a policeman, the cow from the Home as a sacrificial victim. All these creatures, and others besides, can be seen on artefacts from the royal palace, in situations that imply a vast range of subtle messages about political relationships. Beyond the palace, they

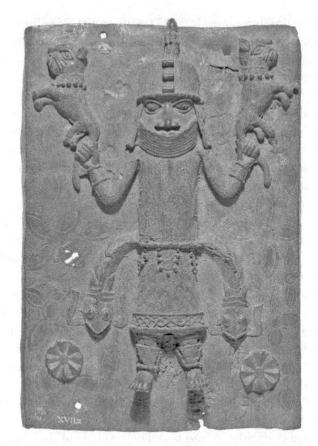

Figure 29 On this brass plaque from the palace of Benin, the figure is identified by his crown, collar, and tunic of coral beads as the King of Benin. The leopards he holds are an annual sacrifice to his own head, focus of his power. The mudfish at his belt identify him with Olokun, god of the Waters and source of wealth. (The Trustees of the British Museum; Af1898,0115.31)

pervaded the lives of the common people in folktales, proverbs, and artefacts representing their own perspectives on Benin society and cosmology.

LIMITS TO ICONOGRAPHIC ANALYSIS

Insofar as an iconographic system can be explained in so many words, it operates at a fairly simple and obvious level, but the symbolic connotations that people find easiest to explain may not reveal all the significant meanings of the images.

NORTHWEST COAST NATIVE AMERICA

Images of creatures were even more pervasive on the artefacts of the Native Americans of the Northwest Coast, but the iconography was more ambiguous. In this tradition, ornamental designs of all kinds could be identified as images, even by outsiders who had trouble seeing through the formal style. Franz Boas attempted to decode them, describing how the creatures represented on various Northwest Coast artefacts were "characterized by their symbols." His examples included:

1. Of the beaver: large incisors; large, round nose; scaly tail; and a stick held in the fore paws.
2. Of the sculpin: two spines rising over the mouth, and a continuous dorsal fin.
3. Of the hawk: large, curved beak, the point of which is turned backwards so that it touches the face.
4. Of the eagle: large, curved beak, the point of which is turned downward.
5. Of the killer-whale: large, long head; elongated large nostrils; round eye, large mouth set with teeth, blow-hole; and large dorsal fin. (1927:202)

And so on, for the shark, bear, sea-monster, dragonfly, frog, snag (an animated underwater obstruction), and snail. Boas admitted that "An examination of carved and painted specimens shows clearly that this description of symbols is theoretical rather than rigidly normative, for in many cases considerable freedom in their use may be observed" (1927:207). He found that even the most accomplished carver and painter was not always able to identify many of the creatures represented by others. Even so, Boas considered that such distinguishing features could be discerned even in designs in which creatures were distorted or fragmented to fit artefacts of quite different shape, including the "splitting" from head to tail later seized upon by Lévi-Strauss and the stylistic conventions analyzed by Holm (see Chapter 6).

But according to Marjorie Haplin (1994), Boas (and later Holm) were mistaken in assuming that the creatures shown could be unambiguously identified by these symbols. Boas recognized that creatures were "totemic" emblems of social groups, displayed to proclaim rank, titles, and privilege—like European heraldry—but subsequent research showed he was wrong to assume that knowledge of their symbolic meaning was public or widely shared. Particular "crest" emblems actually represented histories of encounters with nonhuman beings that legitimated the claims to the land, titles, and social status of individuals and their close families. They could only be displayed at ceremonial events entailing gifts of property, where they featured as objects including totem poles, house decorations, and dance regalia. In exhibiting these individual or family histories, such objects portrayed composite beings of spiritual power rather than the limited number of unambiguously identified creatures that are the emblems of a limited number of clans.

Because of their many and varied origins and distinctive combinations of forms, the most valued emblems of Northwest Coast art cannot be reduced to a standard set of

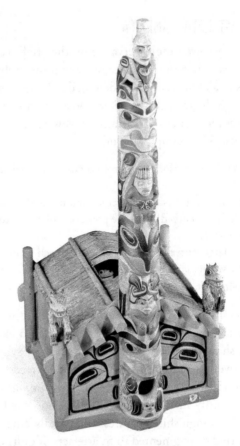

Figure 30 An 1890s Haida model of a big-house, with a pole including two sea-monsters—hybrids of killer whales and grizzly bears—at the bottom and second from the top. The pole from the original house, built about 1850, is displayed in the British Museum. (The Trustees of the British Museum; Am,1898,1020.1)

iconographic conventions. They were actually ambiguous and continually developing to represent the history of significant new encounters with non-human beings.

HIDDEN MEANINGS

Beyond the social connotations of iconography, there is also the question of how far people can actually explain the meanings of their artistic images. How well can ideas be translated from a visual medium of communication to a verbal one? If a message could be conveyed by words, why should people seek to communicate it through artefacts, and if it cannot, how can either they or those who study them put it into words? If visual symbols are required to communicate deep and subtle meanings, this reflects the limitations of speech to do the same. Since speech is the surest way for people to explain such

meanings to persons of another culture, this implies that researchers such as anthropologists cannot be certain of the significance such symbols have to those who create and experience them.

One way to resolve this question is the suggestion that artefacts have deep meanings that their makers and users apprehend at some level of understanding that they cannot put into words, beyond dropping useful hints through the more superficial meanings they are able to talk about. This approach has produced some very illuminating and plausible studies of local art traditions, if we can believe the analyst rather than the people concerned.

THE SEPIK, PAPUA NEW GUINEA

In the 1960s, Anthony Forge made a study of the Abelam people of the Sepik River of Papua New Guinea (1973). This was an area where independent communities of several interrelated cultural traditions had become renowned for their elaborate artefacts and, in particular, their decorated men's sanctum houses or *haus tambaran*. Forge tried to explain the meaning of what were apparently images, although he found that in separate communities similar motifs could have quite different meanings, despite showing evidence of common origins. He concluded that what such motifs represented, or were named for, was less important to their creators than the way they communicated ritual, secrecy, and power, partly through their aesthetic qualities.

Forge analyzed a series of paintings made on sago-palm spathe panels to decorate the façade and initiation room of the sanctum house. The designs were dominated by a few motifs, especially a pointed oval called "belly," often combined with M and W shapes to form the body, arms, and legs of a squatting human figure. There were also triangles and circles, which might form hairstyles and eyes or stars. But whether these formed a human image or a similar design not recognized as an image was not significant for the purposes of the painting.

What Forge found interesting was that, although these paintings were used for the men's sanctum and its rituals, from which women were strictly excluded, the motifs all had feminine associations rather than male ones. The essentially feminine association of the pointed oval was emphasized in a row of squatting women painted across the façade of the house, which were made up of these shapes to show body, breasts, and vulva. Below these, the faces of the dangerous male spirits whose power underlay the men's rituals and the fertility of yams and pigs, included no pointed ovals at all, but their headdresses and an unnamed similar shape below framed each face within a pointed oval, as if to emphasize the female source of their power.

These associations were confirmed in the history and ritual forms of the sanctum. Women were said to have discovered yams, the crop that men gave so much attention to growing and exhibiting, and the sanctum house that was the site of their religious rituals, before these were taken over by men. In the sanctum house, men initiated boys into

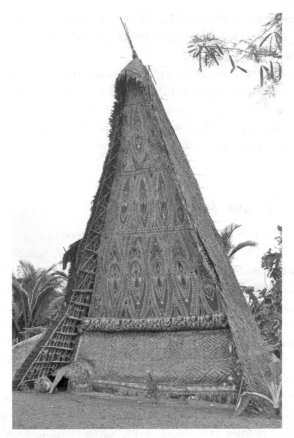

Figure 31 The façade of an Abelam sanctum or *haus tambaran* in 2009. (Rita Willaert photo, www.flickr.com/photos/rietje/4182317709/)

manhood through a dramatized form of rebirth, and the painted panels lining the initiation room were called by the local name for the *bilum* string bag. The *bilum* was symbolic of womanhood and maternity, made and used by women to carry everything from food to babies, while "baby-*bilum*" meant "womb." The spirits behind the sanctum rituals were originally the women's lovers, until men discovered them and took them for their own ritual purposes, transformed into logs of wood which represented them in the rituals.

Forge's interpretation was that these designs expressed the primacy of the female natural creativity of childbearing over the male cultural creativity of ritual. Hence the meaning of the designs lay not in what they represented (and they might be nonrepresentational) so much as in the relationships between things the motifs were associated with. In this case, the significant meaning was the relationships between men and women in their access to spiritual power, which were basic cosmological and theological questions. As Forge wrote, "Woman as prime creator and man as nourisher come clearly out of much of the Abelam art" (1973:189).

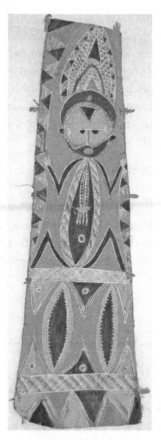

Figure 32 A painting of the kind analyzed by Forge, from the interior of an Abelam sanctum house, the whole of which was purchased for the British Museum in the 1980s. (The Trustees of the British Museum; Oc1987,05.4)

The difficulty with Forge's interpretation of these paintings is that, as he admitted, the Abelam did not confirm it and might even deny it. But he explained that this was because the men learned the meanings only at an unconscious level, as part of their practical education in preparing for and taking part in the rituals. Forge claimed to have discovered in the paintings a "grammar" that people could operate as they did the grammar of language, without necessarily being aware of it. Regularities in the combination of motifs and colors were "meaningful in terms of Abelam cosmology and values," and the ambiguity of metaphor enhanced their impact. In describing Abelam painting as like language, he could explain variations between the styles of local communities as "dialects," and the contradictions between their interpretations of motifs as words borrowed by people who did not fully understand what they meant in the original language (1973:190).

Style in cultures such as those of the Sepik is essentially a communication system. A system that, unlike those to which we are used, exists and operates because it is not verbalized and probably not verbalizable, it communicates only to those socialized to receive it. The constantly invoked ancestral sanction or magical correctness which is all the explanation the Abelam give, are true precisely in so far as the paintings do transmit across the generations concepts and values and their inter-relationships that are fundamental to Abelam society and do fit with the society as it is when they are received. (Forge 1973:191)

The obvious question raised by this kind of analysis is how we can tell what is in other people's minds when they cannot tell us themselves. Psychoanalysis attempts this all the time by close examination of individuals, but can Western cultural analysis do something similar for another culture? The symbolic meanings discerned by Forge are corroborated by much circumstantial evidence from other societies in Papua New Guinea, but ultimately we can only imagine what it is to experience Abelam paintings as an Abelam person.

QUESTIONS FOR DISCUSSION

- What are the limitations to the analogy between visual images and languages as systems of communication?
- Why are symbolic images so effective for political and commercial propaganda?
- Is it plausible to suggest that images have symbolic meanings that people may apprehend without being able to explain in words?

FURTHER READING

- Pooke and Newall in Chapter 4 of their *Art History* (2008) explain the theories of semiotics.
- Gynne-Jones's book *The Art of Heraldry* (1998) is an illustrated introduction to the iconographic and stylistic history of British heraldry.
- Boas's book *Primitive Art* (1927) includes much information from his Northwest Coast research.
- Ben-Amos's book *The Art of Benin* (1995) is a standard introduction to this subject.
- Forge's edited book *Primitive Art and Society* (1973) includes his chapter on "Style and Meaning in Sepik Art" as well as Fagg's "In Search of Meaning in African Art."

8 PERFORMANCE

The forms and meanings of many kinds of artefact have their intended full effect only by enhancing the person, from costume used to affirm and perform social roles, to the impersonation of other beings. Transformations of the body, combined with music and dance, maximize the symbolic power of artistic artefacts.

Outline of the Chapter

- Showing Off
 Artistic costume as a means of communicating social status, from Amazonia and Solomon Islands to China.

- Parades
 The messages conveyed by formal group displays in the Papua New Guinea Highlands and in Britain.

- The Art of Impersonation
 Invoking spiritual and political power through the transformation of masquerade in Papua New Guinea and Nigeria.

- Performance by Proxy
 Artefacts which take the roles of persons, in Javanese shadow-theatre.

Studies of art as communication have to take into account the roles that artefacts play in society, but very often these entail dynamic social activities that depend for artistic effect also on other media, such as music, dance, drama, or ceremony. Costume artefacts, which have a visual impact even when not being worn, have long been collected, exhibited, and analyzed as art, especially sculptural masks but also clothing and body ornaments. It is hard to appreciate the significance of such things for their source communities by treating them as static objects displayed for contemplation in museums or photographs, as art historical approaches tend to do, but from the 1960s anthropologists began to study the artistic properties of masks as part of masquerades, ornaments

as costume, and bodies as artistic creations. Looking at the performative roles of the artefacts as part of the artistic roles of persons also enables us to consider types of artefacts well outside Western understandings of visual arts.

SHOWING OFF

At a basic level, people attire themselves and each other to help them perform their roles in society, enhancing their bodies artistically to communicate who and what they are. Costume is a virtually universal way of distinguishing men from women, and in taking the dominant public roles, men have used the most elaborate ways of differentiating their rank and status. Often the most obvious distinction among women is whether they are sexually mature or married, which is something men seldom have to show. The way costume can be used to proclaim social roles and status can be illustrated by a few contrasting examples.

AMAZONIA

The way the Piro of the Amazonian forests of eastern Peru painted designs on the body was researched in the 1980s by Peter Gow (1999). Piro women painted linear designs on various artefacts such as certain kinds of pots, men's robes and bags, and women's skirts. The skill was in spacing the motifs well and joining them up, as when they met from opposite sides of the object, by making the paint and the lines "flow." This required envisaging in advance how the whole design would fit, since the paints were indelible and mistakes would spoil the whole object, and sketching or copying a design was something only untrained girls would do. Each design was based on the repetition of one of a dozen or so basic line-forms, which were joined up by appropriate improvised lines to form a coherent design pattern, making the painted object beautiful.

The big events of Piro society were girls' coming of age ceremonies, when neighboring communities were invited to celebrate a girl's emergence from a year of seclusion. On this occasion, grandmothers painted flowing designs on the bodies of girls whose reproductive lives were beginning with the flow of menstrual blood, for celebrations made enjoyable by the flowing of manioc beer produced by their mothers. The ceremonies thus demonstrated what it meant to be a "real Piro woman," whose life culminated in the mastery of painted designs. When this skill, so central to a woman's identity, was applied to beautify the newly initiated girls, it also represented some basic truths about womanhood through the concepts of flow, which for the Piro explain human physiology, society, and design.

SOLOMON ISLANDS

The body ornaments of Malaita island in Solomon Islands have been documented by this author (Burt 2009:7):

Formerly . . . Malaitans dressed in very little, but on special occasions they ornamented their bodies with fine and valuable objects. They put on bands and combs patterned with bright red and yellow fibres, rings, pins and pendants of glistening white shell and pearlshell, intricately carved plaques and rings of turtleshell, strings and straps of valuable red, white and black money beads and dolphin teeth, and coloured and scented leaves. By such means they presented themselves as youths and maidens, husbands and wives, men of possessions, priests, warriors, and worthy heirs to the ancestral ghosts whose festivals they dressed to celebrate.

For Malaitans, the visual effect of such ornaments was enhanced by their value in the money beads and dolphin teeth, which were also strung into standard lengths and denomination to exchange for goods, services, and contracts. Shell rings and

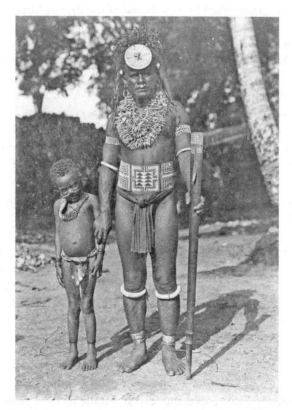

Figure 33 Irobaoa of Suaba in north Malaita, an important man of the early twentieth century, with his daughter. His valuable ornaments, including quantities of dolphin-teeth money, show his status as a leader; her waistband and leaf are women's costume, with a dolphin-teeth-strap showing her father's wealth. (Edge-Partington collection)

pendants (like those shown on page 58) could be purchased for large money denominations, and patterned fiber ornaments for small amounts. Some shell ornaments, inherited from ancestors, also represented the spiritual power of their ghosts. So when a man was dressed in a full set of ornaments, he might be displaying enough wealth to pay brideprice for a wife or restitution to save someone from being killed for a serious offense, while representing his ancestral ghosts as their priest. No wonder Malaitan elders of the late twentieth century recalled being awestruck by the sight of men in full dress, in the days before these ornaments went out of fashion with the new forms of wealth, spiritual power, and dress introduced by British colonization (Burt 2009).

CHINA

The rules prescribing the clothing worn by Chinese state officials on public occasions were documented in the mid-eighteenth century as part of the ceremonial protocol of the imperial court, summarized by Jane Portal of the British Museum:

> Hats were worn at all times and the details were strictly regulated, for example in respect of the types of lining fur that could be employed by different ranks. The status of a person was also shown by stone or glass insignia mounted on top of the hat, a practice dating back to the sumptuary laws of 1636. . . . The stones used by officials were also strictly regulated according to rank, as was the size of the setting. In 1736 it was decreed that rubies were to be used by officials of the first to third ranks, sapphires by fourth-rank officials, crystals by fifth- to sixth-rank officials, and gold by those of the seventh and eighth ranks. Officials of the ninth rank had no jewel.
>
> In 1652 it was decided that the hat insignia were not sufficient to distinguish officials within the complex bureaucracy . . . Therefore, from this time all civilian and military officials had to wear rank badges, displayed on three-quarter-length dark overcoats. . . . The imperial nobility wore round badges decorated with dragons, while civil officials wore square ones displaying a different kind of bird according to their rank. Military officials wore square badges displaying animals symbolising courage. . . . Court necklaces . . . based on Buddhist rosaries, were used only by officials of the fifth rank and above. . . . Court belts . . . varied in colour according to rank. (1992:198–200)

PARADES

If costumes can distinguish people, they can also unite them in displays of solidarity, coordination, and strength that may impress even those who do not understand the body symbolism. Whatever the artistic effect of an individual, such costumes realize their full potential in group performances.

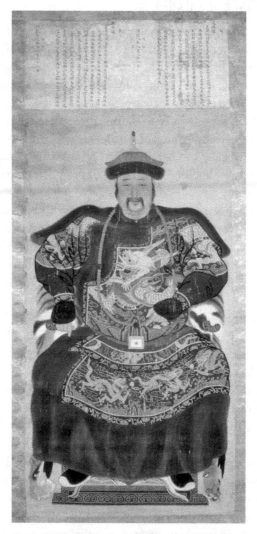

Figure 34 This portrait declares the rank achieved in the Chinese imperial hierarchy by court official Cai Shying as of 1668. His insignia could be read by anyone familiar with court protocol, and the inscription proclaims his promotion by the emperor, first to Grand Master for Assisting Towards Good Governance, then to Grand Master for Splendid Happiness. His dragon robe, worn without the overcoat, is less-formal court dress. It shows his rank in its color and in the number and type of dragons, four-clawed side-on being lower than the five-clawed front-on dragons of the imperial family. The materials of his hat, its jewel, his necklace, and so on were all prescribed in similar ways. (The Trustees of the British Museum 1910,0212,0.542)

PAPUA NEW GUINEA HIGHLANDS

A well-documented example is the spectacular parade costumes of the Papua New Guinea Highlands, with elaborate feather headdresses, painted faces, greased bodies, and shell ornaments. These were first studied in detail in the 1960s by anthropologists Andrew and Marilyn Strathern for the Melpa of the Mount Hagan area, as "statements about social values." When men of a clan were seeking glory by a lavish presentation of pigs and shell valuables to their guests at a festival, they made themselves look bright and glamorous, prosperous and triumphant. For a religious performance, they would show the health and vitality they sought to obtain. When going to fight, they would wear black, to become aggressive and frightening. There were also implicit messages in the "brightness" of friendship and fertility and the "darkness" of strength and aggression; qualities associated with men and women respectively, but worn by both according to the situation. Like other artefacts, decorated persons communicated in ways that words could not, and the messages were about themselves (Strathern and Strathern 1971:171–73).

Other researchers added different perspectives. Paul Sillitoe (1988) explained how the Wola of the Western Highlands saw men maintaining peace and cooperation between communities by exchanging the wealth produced by women in their festivals. The beauty and vitality that they displayed in their dances could be drained by sexual intercourse, and they likened themselves to the birds of paradise whose feathers they wore, who did not breed but performed for other unadorned birds (not recognized as females of the species).

A study by Michael O'Hanlon of the British Museum (1989) focused on how the Wahgi people of about 1980 themselves assessed the effect of their costumes. Like other Highlanders, their greatest occasions were periodic festivals at which a local clan killed hundreds of pigs to feast neighboring clans, in a generation-long ritual cycle coordinated with other clans so that they could attend each other's festivals at regular intervals. These were the most important of many exchanges of food between clan groups to demonstrate generosity and friendship, at which men displayed their strength to their neighbors, both to entertain them as friends and to impress them as rivals and potential enemies. Men of the host clan dressed in uniform costumes—in festive or martial style, according to the event—and danced in massed ranks and files to emphasize their strength and solidarity as a group.

According to O'Hanlon, Wahgi bodily adornment and display was understood to reveal the moral state of persons and groups more truly than what they said; hence it was used to bear out their claims to moral standing and was evaluated accordingly. O'Hanlon dealt with the problem of discovering meanings that people could not explain directly by considering what they said to each other in evaluating adornment. Hence, if the Wahgi discussed body decoration in terms of moral judgments on the wearers, then that would be the way to understand its meaning and significance to them.

Wahgi assessments were not made in front of the performers, to avoid offense, but mainly in preparatory meetings. Criteria for evaluation included the number of

performers, representing the strength of their group. The men should be robust and vigorous, tall, muscular, and light on their feet, for old men, boys, and men in poor physical condition reflected badly on the group. Their plumage should accentuate these qualities in the way it swayed with the dancing and should be robust enough to withstand the wear and tear. Singing should be well-paced, sounding rich, resonant, and full; drumming should be resonant and regular; and cries should be loud and strong.

Contrary to Western expectations, color was not important in assessing adornment and display. Red and black had various significances in different situations, but more significant were distinctions between glossy, glowing, or fiery, and dull, dry, flaky, or matte, which judged colored objects by their tone rather than their hue. The value of gloss and shine was associated with the cosmetic use of pig fat, valued as food and crucial to ceremonial exchange, which contrasted with the dull, dry effect of mud used as body paint for mourning.

Such aesthetic criteria for judging public displays served important social purposes. Clan groups sought to impress their audience with a display of strength, to deter others from attacking them, as a group or as individuals. They tried to create an intimidating impression that would be taken to reflect the moral caliber of the group in their relationships with each other and with outsiders. Bad feeling within a clan could affect the group's well-being in general and compromise their attempts to put on a good public show in various unpredictable ways, from problems in raising good, healthy men to preventing

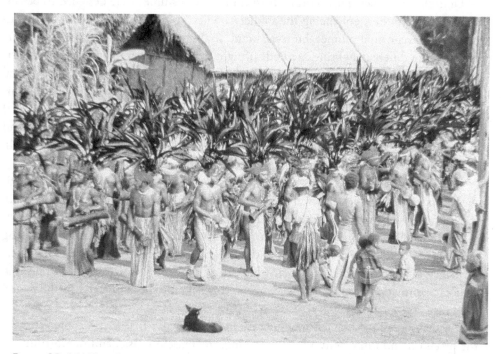

Figure 35 A Wahgi dance photographed by Michael O'Hanlon in about 1980. (The Trustees of the British Museum Oc,F.T.6013)

them from making good ornaments. Grievances might also lead men to damage their own group's appearance at a display, or enable rivals to do so, through sorcery. The men tried to avoid such problems by confessing offenses and resentments among themselves, particularly during their preparations for a public display. Otherwise they risked revealing to spectators of rival clans the kind of problems they would prefer to conceal, showing weakness as a group by their bodies' appearing dull and unfit, their ornaments coming loose during dancing, and so on. This would lead to public criticism and might invite aggression from others who perceived them as weak. On the other hand, as it was said, "a man whose skin glows has not transgressed" (O'Hanlon 1989:139).

In this respect, artistic judgments were also moral and political ones, debated among rival groups and sometimes contrived and proclaimed for political ends. As in the West, such motives could not be admitted openly without invalidating the artistic evaluations that supported them.

BRITAIN

Focusing on the social context of costume and performance allows comparisons with more familiar traditions often overlooked by Western studies of visual or performing arts. A common use of artistic costume in formation dancing can be seen in military parades.

Until the late nineteenth century, British military costumes were designed to be colorful and glamorous, enhancing the soldiers' bodies by tall headdresses and bright tunics, with ornamental plumes, buttons, braid, straps, and badges. The style of costume reflected the different fighting methods of light infantry, heavy infantry, light cavalry, and heavy cavalry and distinguished different regiments according to their own local and historical identities. The costumes are still celebrated in paintings and prints, miniature models and museum exhibitions, but as uniforms, intended to disguise individual identity, they were made to be viewed in massed assemblies. These would impress friend and foe alike, stirring patriotic fervor, courage, or fear. As such, they were displayed in martial performances—in effect, dances—which is their principal use today.

The British pride themselves on the quality of these performances, in which regiments accredited to the monarch as Guards (heavy infantry) and Household Cavalry (heavy cavalry or dragoons) parade for state occasions such as the Opening of Parliament, Remembrance Sunday, and royal weddings and funerals, as well as for paying audiences as in Beating the Retreat and the Edinburgh Tattoo. The most elaborate performance is Trooping the Colour, in which the Guards regiments march to music in elaborate formations around a parade ground, to honor the monarch's birthday and their own "colours" or flags.

On such occasions, the costumes contribute to a display that is also appreciated for the precision and uniformity of the marching, the martial music, and the fortitude of the performers, who will collapse in a faint rather than admit fatigue. The archaic costumes, not used in battle for more than a century, give a sense of tradition to a display

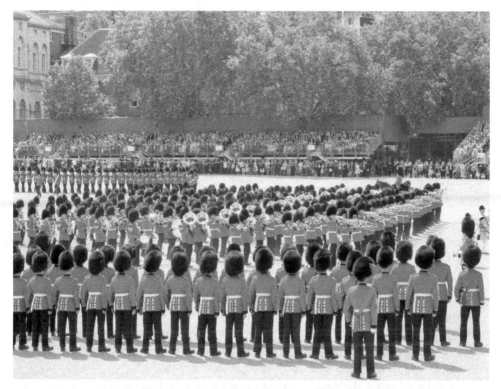

Figure 36 The Brigade of Guards Trooping the Colour in 2008. (Ibagli photo)

of solidarity and power. The intended effect is to evoke a sense of national pride that proclaims the historical legitimacy of the monarchy, the army, and other powerful state institutions. This gratifies monarchists and political conservatives and annoys republicans and socialists, all of whom recognize the symbolic power of such martial arts.

THE ART OF IMPERSONATION

While costumes make persons into artefacts, they may do more than represent social roles and collective identities, by transforming the wearers into other beings. Acting in theatrical costumes is familiar enough in the West, but in other traditions a costume can also enable the role to take over the actor to the extent of possessing him (and usually it is him) with another spiritual identity. Impersonating spiritual beings is a way of dealing with them in the human world, and the symbolic power of artefacts enables this to happen in performance, in imagination, and in emotional experience.

How far the impersonators of spiritual beings feel themselves becoming those beings can be a moot point. Their purpose may be to make the spirits real to an audience, whose interpretation of the reality may also be debatable or ambivalent. When do people suspend, or cease to suspend, their disbelief?

PAPUAN GULF, PAPUA NEW GUINEA

The masquerade mysteries of the Elema people of the Papuan Gulf on the southern coast of what is now Papua New Guinea were documented in the 1930s by the British colonial government anthropologist F. E. Williams (1940). Elema communities centered on enormous sanctum houses facing the beach, where all the men kept the relics of their clan's ancestors and initiated their sons as a group into spiritual mysteries, in secret from their womenfolk. The mysteries included the spirit-voice of the bullroarer, a pointed oval board whirled on the end of a long cord to make an unearthly hum. This was said to have been obtained originally from women (like so many Melanesian men's mysteries; see page 108) and to be the prototype for other spirit artefacts, including masks representing sea-spirits.

Invoking these sea-spirits, dangerous female beings who threatened sea-goers, was the main focus of the sanctum group's communal work. This was an expensive program that might take ten to twenty years. It began with building a new sanctum, followed by making masks to represent the spirits, and it climaxed with their public visitation. In the process, the youths of the community were initiated into its various stages, at the cost of pigs presented in exchange for shell ornaments to the brothers of their mothers, belonging to other communities. The masks, of painted barkcloth over a rattan frame, were constructed in secret in the sanctum by men for their sons, to inherited clan designs memorized by the elders. The mystery revealed to the novices was that of the spirits bringing the raw materials to dress their daughters, the masks.

In preparation for the final arrival of the sea-spirits, a door was built to close off the end of the sanctum. This was celebrated with a feast for neighboring communities, who brought mats for the door and danced from dawn to dusk in comic masks that represented themes from clans histories. Then sago-leaf skirts, made by women, were bound to the masks by the novices as a further stage of their initiation. Next the masks came down from the sanctum several times, screened from women, to "stretch themselves" as the novices learned to wear them, applied the final decorations, rehearsed their dances, and so on.

Public ceremonies began with exchanges of pigs for shell ornaments, by men on behalf of women in acknowledgment of women's contribution to the program, and climaxed in the revelation of the sea-spirits. Following a feast of pigs and dramatic drumming, the sanctum door was lowered at dawn and the sea-spirit masks emerged in procession to the beach to dance with their relatives, including women (who could evidently identify the masked novices). They danced intermittently for about a month, concluding with a major performance on the beach and a procession back into the sanctum, followed by a feast. Then, in the sanctum, the masks were ceremonially killed, taken out and burned, and the men enacted their return to the sea, in which they purified themselves. Finally, the whole community destroyed human effigies as substitutes for the sacrificial victims of former times.

These masquerades enabled the Elema to organize great public works and spectacular events for the enjoyment and glory of the whole community, staged and performed by

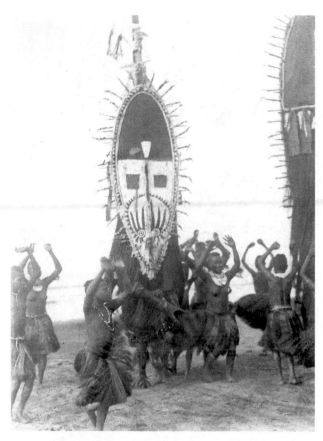

Figure 37 Elema women dancing with the sea-spirits, photographed by the missionary Harry Dauncey in the late nineteenth or early twentieth century. (The Trustees of the British Museum; Oc-A1-7)

the men but supported by the women, as producers of food and pigs and as audience. The prestige and power to be earned by participation created a strong vested interest in the reality of the sea-spirits, with the masks as a dramatic and colorful confirmation. Only when the colonial plantation economy introduced competing sources of wealth and prestige did the Elema open their mysteries to all, destroy their sanctums, and become Christians, the last of them not long after Williams's research.

THE NIGER DELTA, NIGERIA

The ritual transformation of masquerade can effect an emotional transformation for both the performer and the audience, enabling them to experience spiritual manifestations. So it was for performances of the Ekine men's society of the Kalabari of southeast Nigeria, described by Robin Horton in the 1960s (Horton 1963).

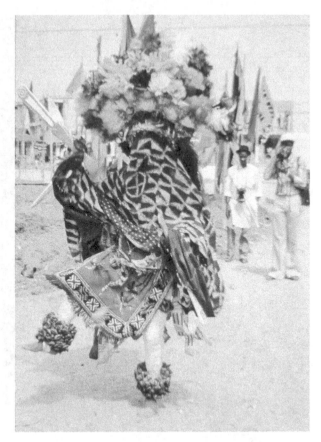

Figure 38 An Alagba spirit mask of the Kalabari Ekine society in a performance in Buguma in 1985. (Alan Camp photo)

The Ekine performed masquerade plays in which they impersonated and invoked the water-spirits of the creeks of the Niger delta. Like other men's institutions from which women were excluded except as the audience, it was said to have been given to a woman by the spirits and then taken over by men. Each play in a seasonal cycle, performed in the town square, invoked particular water-spirits from their homes in the creeks and then sent them home again afterwards. These spirits were not the ones that the community depended on for the general benefits of health, prosperity, and peace. They were otherwise distant beings, invoked mainly to empower and possess the dancers who impersonated them. In the plays, they acted out stereotyped social roles and activities, often unpleasant and amusing, directed by the music of the drums. A dancer had to learn these directions, including references to the shrines of local ancestors, which he had to point out in the dance. When the drum rhythms took him over, the spirit might possess him and give a spectacular performance.

The dancer's costume was an essential part of the performance, especially the distinctive carved headpiece, which might help promote possession by the spirit. But the headpiece was not necessarily prominent in the visual effect of the performance, as it might face upward or be obscured by decorations, communicating with the gods as much as with the human audience. It was the dancing that the spectators admired, to which the headpiece contributed spiritually as part of the total costume of tight-fitting cloth sewn around the dancer. His identity was completely concealed, unless he were to be unmasked in disgrace for an incompetent performance.

The Ekine society was devoted to dancing and enjoyment, but, although it was not supposed to be political, a man needed to belong in order to gain standing in the community. Horton considered that the role of the potentially dangerous water-spirits was to separate the performances and their enactment of problematic social issues from real life and relationships in the community. At the same time, since the performances were only plays learned from the water-spirits, they did not actually represent the reality of the water-spirits either.

PERFORMANCE BY PROXY

As persons become artefacts, so artefacts can be treated as persons. Artefacts can represent persons, from skulls preserved to represent the continuing spiritual presence of dead ancestors and images of gods to focus people's prayers, to commemorative portraits and photos that evoke memories of absent friends. But some artefacts actually perform as persons, including the characters in films, and their precursors, puppets. Like body ornaments, uniforms and masks, puppets (and film characters) only realize their potential when they are performed in the context they were designed for, and then they can be just as powerful in their effect.

JAVA

Shadow puppets are a popular form of theatre in Java. There are several kinds of performance based on local versions of Hindu epics, introduced centuries ago from India. Besides the shadow puppets, which appear as silhouettes on a cloth screen, the same characters can be represented by human actors in elaborate costumes and masks and by several other kinds of wooden puppets.

The shadow puppets are intricately cut from parchment and also delicately painted to be viewed in the light, as portrayals of gods, kings and heroes, giants and demons, and their comic retainers. They can be appreciated as pictures, but they are intended to have their full effect as part of religious ceremonies to bless as well as entertain public gatherings for births, circumcisions, and weddings, and to exorcise the spiritual causes of affliction. The performer gives appropriate prayers and offerings as a priest. During

the play, which begins in the evening and goes on for about nine hours, he holds the puppets against a cloth screen in front of a lamp casting the shadows. He speaks their parts, sometimes reciting, sometimes improvising, sings, and directs the accompanying percussion orchestra. Those sitting on his side can watch him and the orchestra and admire the painted puppets; those on the other side see the play as shadows on the screen.

The performer can draw upon a stock of hundreds of stories from the Ramayana and Mahabharata epics, as moral tales appropriate to the occasion and the audience. Being sponsored by community leaders in the countryside and by the royal courts in town, the morality of the plays was formerly that approved by the ruling elite, idealizing aristocratic virtue, refinement, and authority as the basis for social harmony. The violent conflicts between good and evil enacted by the plays were projected onto a mythical world in which the characters represented the virtues and vices of various types of human personality. While the heroes and villains were lords and ladies, the comic lower-class characters who supported them allowed ordinary people to have some fun at the expense of their betters, bringing them down to earth and satirizing real social situations familiar to the audience. The analogies could be subtle and complex. Performances to exorcise spiritual affliction were based on a story of gods acting the characters in a shadow play to appease an ogre-god and introducing into the play people from the audience and their ancestors to confront the ogre. The exorcism, involving the recitation of sacred texts, was thus enacted symbolically at several different levels of meaning.

The subversive possibilities of the plays were recognized by the Dutch colonists of Indonesia, who encouraged the royal courts to standardize performances as religious folklore, rather than as potentially anticolonial social critiques. The authoritarian government of independent Indonesia later used them as a means of political propaganda. But the enduring popularity of the shadow plays derived from the way they interpreted the ancient religious stories both to reaffirm and to criticize the social values of the time. Barbara Hatley summarized how these ideals were represented by the iconography of the puppets:

> the most admired characters have elongated, narrow eyes, long noses—indicating refinement—and bowed heads—showing patience and imperturbability. These qualities are consonant with the Javanese aristocratic ideal of emotional quiescence within—reflected in exquisitely *alus* ("refined") outward behaviour—and strict adherence to formal etiquette. Crude, violent characters with excitable dispositions have round, bulging eyes, bulbous noses, heavy builds, and upturned faces, though in some revered heroes . . . round eyes and upturned faces are not unfavourable characteristics but indicate bravery as well as directness. Thus, while each member of society has a place in the moral universe of the Wayang [theater], the equating of moral virtue with social and political prominence helps sanctify social differences. (1971:89)

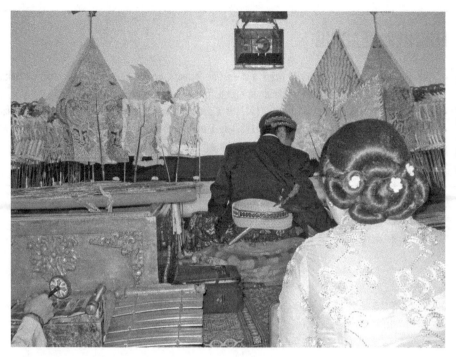

Figure 39 The puppeteer Ki Anom Rusdi of Langen Budaya performing in Losari, Brebes, Central Java, in 2009, seen from his side of the screen, with the gamelan percussion orchestra. (Matthew Isaac Cohen photo)

Of all artefacts, persons in costume or in effigy serve their purpose best in dynamic social situations. In other contexts, the artistic values of the costumes may have their own effects, as images of persons or as separate artefacts, but these can never reproduce the effects of the actual performance. The Western preference for visual art as objects of contemplation underestimates the artistic power of artefacts in action.

QUESTIONS FOR DISCUSSION

- What are the relationships between visual appeal and such values as wealth, status, and power?
- Is a distinction between visual and performing arts really useful?
- What can people achieve as artefacts that artefacts themselves cannot?

FURTHER READING

- The *Berg Encyclopaedia of World Dress and Fashion* includes studies of many local costume traditions, including several from the Pacific Islands in Volume 7 relevant to examples here.
- The Stratherns' book on *Self Decoration* (1971) is a detailed study from the Papua New Guinea Highlands.
- Mamiya and Sumnick's paper on *Hevehe* (1982) is a short account of Elema masquerade festivals.
- D'Azevedo's chapter on *Mask Makers* (1973) is a study of West African masquerade.
- Sears's article on *Aesthetic Displacement* (1989) describes the styles of Javanese shadow play.

9 ARCHAEOLOGY

Theories explaining the significance of exotic artefact traditions in their social contexts allow plausible interpretations to be made of archaeological findings. Methodologies for analyzing the iconography of ancient Peru illustrate the potential of artefacts for the reconstruction of otherwise unknown cultures.

Outline of the Chapter

- Archaeological Methodology in Peru
 Interpreting ceramics from the ancient Moche and Nasca cultures.

- Moche Iconography
 Interpreting images by historical and anthropological analogy.

- Moche Culture
 Reconstructing the cosmological context for the imagery.

- Nasca Iconography
 Methodological issues in the interpretation of a related but different artistic tradition.

Artefact traditions that have no one to explain them, even through documentary sources, can only be understood by analogy with others that do. On the basis that all human cultures have certain common characteristics, we can assume, for instance, that motifs and designs will allude to objects from the world of sensory experience which we can recognize in the environment, in humanity, and in artefacts, including objects of the imagination that reinterpret sensory experience. If such images occur repeatedly within consistent contexts, we can assume that they are the product of a shared culture. We can further assume that the objects are represented because they have symbolic connotations, if only at the level of aesthetic value but probably much more.

Such fundamental assumptions, which can be applied to our own culture, are usually unspoken by archaeologists but need to be acknowledged because of the temptation to draw more information from them than can be justified by logic. That is, unless we are careful to specify the social and cultural contexts of our analogies, we risk assuming that our own cultural experience is sufficient to interpret images from other cultures. The history of archaeological studies is full of theories that were later declared ethnocentric and hence mistaken. Even so, we can observe that societies everywhere organize relationships through birth, mating, and death; distinguish roles in terms of age and gender; share and transmit knowledge; make artefacts; set rules and break them; fight and kill, and so on. We also know that how they do these things varies in ways that can often be predicted by the scale and complexity of social groups and the regional distribution of shared cultural traditions. By making such observations, anthropology has supplied archaeology with examples, models and theories that allow more rigorous analogies to be drawn. This is the basis upon which archaeologists have interpreted the artistic traditions, especially the iconography, of societies whose most obvious legacy has been buried in the ground.

ARCHAEOLOGICAL METHODOLOGY IN PERU

The ancient civilizations of the Americas provide good examples. European conquest so devastated the empires of Mexico and the Andes and their cultural traditions, that until the 1960s it was assumed that archaeological discoveries could only be interpreted by art-historical analysis of images. Then, with the gradual deciphering of the glyphs from Maya monuments (drawing on British Museum collections), the names and dates of rulers and historical events began to emerge, revealing political and cosmological meanings that no one had suspected. Researchers began paying more attention to the cultural context of the iconography, drawing upon anthropological approaches, and these insights were applied to the ancient cultures of Peru.

In archaeology, cultures are identified by complexes of artefacts that share a certain formal style. Changes in style in successive layers of cultural remains in the ground allow such styles to be put in a chronological order, as "periods" or "phases." A period when artefact styles are shared over a range of localities becomes a "horizon," indicating a time of widespread social integration. In the Andes, with no ancient written records, these periods have had to be dated by technologies that measure changes in the composition of materials found in the archaeological layers, such as radio-carbon analysis. By these measures, the Moche culture lasted, through a series of phases, from about 1 C.E. to 800 C.E., and the Nasca to the south from about 180 B.C.E. to 500 C.E.

The majority of surviving Moche and Nasca images are molded or painted on pots that were buried with the dead. Those in museum collections often have no archaeological context, having been looted from graves for the collectors' market. So how should archaeologists go about interpreting the wealth of artistic images on these pots?

In the 1980s, current theories about Nasca pottery were summarized by the art historian Richard Townsend:

> The ancient arts of Peru . . . offer windows to . . . ancient ways of looking at the world that are deeply rooted in the cultural traditions of this hemisphere and that continue to affect the lives of millions in Andean nations today. . . .
>
> the ceramics form a code, a cohesive "text" of signs and symbols; when deciphered, the "text" of this pictorial language reveals that the Nasca, like other Indian peoples of the Americas, believed that there was an active, sacred relationship between man and nature. According to this mode of thought, the divine order of the universe was reflected in the organization of society and in all important activities of human life. . . . This connection of cosmological ideas and social processes is a central point of enquiry in approaching the Nasca world. (1985:118, 122)

For Townsend, the Nasca shared widespread underlying notions of a "sacred geography" that animated the landscape, in particular with mountain- and water-deities. Themes of agriculture and warfare combined in figures with catlike faces and elaborate costumes, interpreted as masked ritual performers rather than mythical beings. He imagined such figures performing dances in which "animals, agriculture and the rites of war are linked to life and death" with "long formations of barbaric figures" following their sacred geography along the so-called Nasca Lines drawn on the arid plateau above their settlements (1985:137).

Townsend's account was actually a hypothesis based on several kinds of circumstantial assumptions rather than a methodical analysis of the evidence, but it proved a useful starting point for subsequent research. Work proceeded most rapidly on Moche pots, with line drawings and molded figures that were easier to identify as persons and objects than most of the Nasca designs.

MOCHE ICONOGRAPHY

Archaeologists were studying Moche remains from the early twentieth century, but only began to work on the pot iconography in the 1960s and 1970s. Under the archaeologist Chris Donnan, the University of California–Los Angeles (UCLA) compiled a Moche Archive of images of over 2,300 pots and drew many of the designs in the flat in order to study them. This work identified certain human and other figures and objects as motifs that recurred in certain combinations, apparently as "scenes." These were interpreted further by comparing the different scenes in which a particular motif occurred. More elaborate recurring combinations of motifs, comprising several such scenes, were identified as "themes" that illustrated a set or sequence of activities.

Interpretations of these themes have drawn on analogies with general propositions about human culture, with historical accounts of the Andean peoples, and with other

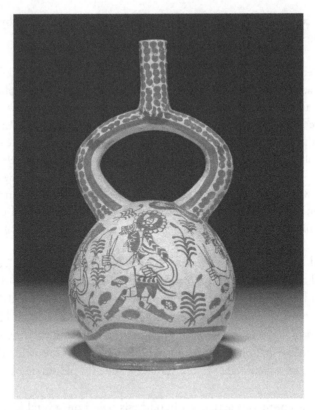

Figure 40 A Moche pot, painted with a "scene," interpreted as a warrior running through a desert landscape carrying what has been identified from other images as a bag of beans, also shown on the spout. (The Trustees of the British Museum; Am1909,1218.96)

archaeological findings. A theme eventually identified as the "Sacrifice Ceremony" illustrates the methodology. Initial identification of motifs was based on little more than commonsense recognition of human behavior. Elaborate costumes, unusual activities (such as capturing and killing, rather than working in the fields), and fantastic creatures were taken to imply a subject matter of great social and cosmological significance (assuming that ancient Americans would not decorate their grave goods with the equivalent of Disney cartoons). Hence, a naked man with a rope halter held by another man in elaborate costume and weapons was identified as a warrior's captive, and a man being tortured or killed was identified as a sacrifice.

Closer analysis of such scenes allowed more specific deductions. Hence, in scenes of fighting, the warriors all wore elaborate costumes with similarities and variations that did not correspond to victors and vanquished; they used maces and shields but not the lethal slingshots and spears shown in hunting scenes; warriors with naked captives carried bundles of weapons and fighting costume like trophies. All this could imply that the fighters were members of the same community, engaged in some kind of gladiatorial

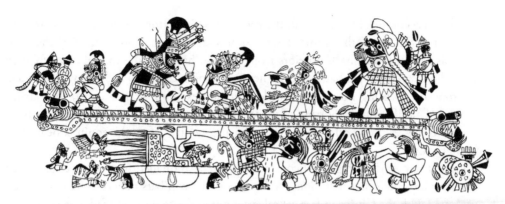

Figure 41 The Sacrifice Ceremony, drawn by Donna McLelland for the Moche Archive from a pot in the Staatliches Museum fur Volkerkunde, Munich.

hand-to-hand combat, rather than serious warfare between different groups. For the Sacrifice Ceremony theme, this kind of observation enabled Donnan to produce the following account:

> Once captured, some or all of the opponent's clothing was removed, a rope was placed around his neck, and his hands were sometimes tied behind his back. The victor then held the rope tied to the prisoner's neck and marched him off the field of battle. The prisoners were taken to a place where they were formally arraigned. One scene shows them being brought into a ceremonial precinct, defined by large pyramids with temple structures at their summits. Following arraignment, there was a ceremony in which the prisoners were sacrificed. Their throats were cut, and their blood was consumed in tall goblets. (1997:52–53)

HISTORICAL ANALOGIES

The problem with historical sources about Andean culture is that they postdate the Spanish conquest in the sixteenth century, and for the Nasca and Moche this followed about eight to eleven hundred years of life under other local cultural traditions, the latest being the Inca. Later accounts, including anthropological research from the twentieth century, add a further several hundred years of domination by the even more different Spanish culture. How much cultural continuity can we expect to find, especially considering the cultural repression of the Spanish regime and the way culture may be transformed in order to continue at all? It was one thing to show that Andeans now worshipped Christian deities at the same times and places as they did the pre-Spanish ones, but another to deduce the original ritual practices, let alone to project them back another thousand years. Yet this is what archaeologists have done.

Written accounts of the Inca and their former subjects from shortly after the Spanish conquest in the sixteenth century described how, at the new moon following the summer solstice (in December), warriors from the two halves of the capital city of Cuzco would hold a ceremonial battle. At the next full moon, there was a dance with a snake-like rope representing the arc of the sky. In the next month (February), the burned remains of sacrifices and a portion of the year's produce were thrown into the river to be carried to the sea, as an offering in return for prosperity, before the equinox beginning the wet season.

Present-day Andean highland communities are also divided into two sections, each marrying into the other half. Some hold ceremonial combats between the two halves, integrated with the Christian festival calendar but at the same time of year as Inca ritual combats in which the shed blood was offered to the earth and deities. In October, at the end of the dry season, Andean church festivals include observances that Christians elsewhere associate with Easter, with displays of the crucifixion and acts of penitence entreating deliverance from evils and calamities, in anticipation of the rains. This was the season when the Inca would torture to death moral transgressors in order to placate ancestors and deities for the same purpose.

Spanish accounts also imply that the Inca understood the cycles of human life and society as an integral part of a cosmos of celestial, seasonal, and ecological cycles. Lunar months were marked by sacrifices appropriate to the seasons of the solar year, meeting a vital obligation to maintain the circulation of life-force or power among living things, ancestral spirits, and personifications of the environment. These cosmic processes seem to be how the Inca understood their ecosystem, as "sacred geography." Andeans recognized that life in their arid region depended upon a circulation of water, from the rainfall in the mountains, which fed rivers irrigating the inhabited coastal valleys, to the sea. This was interrupted by an unpredictable El Niño season every five years or so, with warmer seas and heavy rain, which might seriously disrupt normal agricultural and fishing cycles. The deduction was that the Inca seasonal cycle of sacrifice and penitence sought to maintain a cosmic circulation of spiritual force to ensure the circulation of water, which was threatened, in particular, by the El Niño.

If Andeans have retained such cosmological ideas after hundreds of years of contradiction under Christian rulers, it seemed quite plausible that the Inca could have inherited them from their ancient predecessors.

MOCHE CULTURE

Since the 1940s, archaeologists had been excavating burials with costumes and other artefacts which are recognizable on the pots. This eventually led in the 1980s to the identification of individuals in the graves, presumably high-ranking from their association with elaborate artefacts and other less elaborately buried bodies, with particular characters from the pots. Masks covering the faces of these important persons might have

served to conceal their individuality, and as such burials recur in different places and times, the implication was that they represented roles in regularly enacted performances such as the Sacrifice Ceremony. Hence, the upper-right-hand figure version shown in Figure 41 seemed to be wearing a tunic covered with square metal plates, as found in a grave, and goblets and a club resembling those on the pots revealed traces of human blood in chemical tests. Four characters of the Sacrifice Ceremony were identified from such evidence by Joanne Pillsbury, as follows:

> The large figure on the left, holding a goblet, has been identified as the Warrior Priest, the figure to his right as the Bird Priest, and the figure behind them as the Priestess, shown wearing a headdress with plumes; the fourth figure wears a head-dress with what is probably a feline emblem on the front. In the lower register, two individuals appear to be drawing blood from the necks of two nude prisoners. They are flanked by a weapons display to the right and a litter to the left. (2001:15–16)

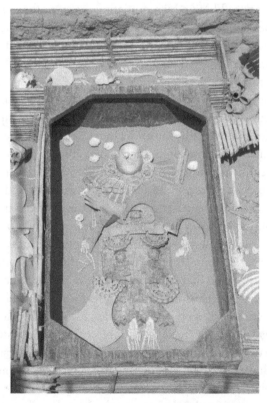

Figure 42 A Moche burial, reconstructed in the Royal Tombs Museum of Sipán from excavations in the 1980s. From his elaborate regalia, the central figure in this tomb seem to have performed a role in the Sacrifice Ceremony. (Oresaba photo)

As for the sacrificial victims, unburied skeletons have been excavated in the Temple of the Moon, a huge complex of mud-brick buildings of many layers. A set of about seventy skeletons of young men, showing signs of partly-healed injuries, throat-cutting, and mutilation, lay among deposits from flooding that could only have occurred during the rains of a severe El Niño season. Frequent images of creatures affected by this periodic climate disruption also imply a special concern for its effects. Many pots also showed images of people suffering atrocious tortures, implying that the Moche shared later expectations that suffering placated the deities.

So, using all these sources of information, the Sacrifice Ceremony has been interpreted as an ancient precedent for Inca and more recent Andean ceremonies, following the same calendar, with the two halves of the community holding a battle for captives, later dancing with a snake-headed rope, sacrificing the captives, and sending their remains off in boats over the sea. This would have anticipated the beginning of the mountain rains, which signaled the renewal of good relations with ancestors and deities, manifesting the ongoing circulation of water and life-force. The large number of sacrificed men in the Temple of the Moon suggests a desperate attempt to deal with an interruption to the seasonal cycle by a severe El Niño by propitiating the spirit forces responsible. The characters shown in the Sacrifice Ceremony could accordingly be identified with personified life-forces like those inherited by the Inca, perhaps impersonated during the ceremony by priests whose roles represented these deities. Considering that Native Americans, like people elsewhere in the world, often reenact legendary accounts of supernatural beings in order to invoke or reaffirm spiritual power for personal or community benefit, the pots could represent persons and events that were at once contemporary and legendary.

The Sacrifice Ceremony is only one of the themes that have been interpreted by these methods, from a mass of iconographic, archaeological, and ethnographic detail. There have also been attempts to synthesize these themes to reconstruct a single cosmological narrative. Scenes on some pots and a mural show weapons and military regalia with arms and legs attacking humans. These have been interpreted in terms of a Peruvian legend recorded by an early missionary in which artefacts and domestic animals turned upon their human owners during an apocalyptic period of darkness due to the death of the sun (Quilter 1990). Similar legends from the Maya and other Native Americans imply a cosmological theme that is both widespread and ancient. An interpretation of the scene, drawing on comparisons with the previous interpretations of other Moche scenes, suggests that an owl figure and a woman, associated with darkness, death, and the moon, were instigators of a "revolt of the objects," which was suppressed by a sunlike figure. The fact that motifs from this scene, such as animated weapons and certain costumed figures including the owl, also occur in the "sacrifice" scene suggests a narrative continuity between these (and other) scenes. This might entail a revolt of the objects as an inversion of the cosmic order that was resolved by the submission of the instigators and the sacrifice of captives in the sacrifice scene, possibly followed by the "burial" scene (which has also been analyzed in detail) and maybe others. Such scenes or themes could

portray focal episodes in a Moche cosmological narrative as enacted in ritual roles and performances, representing some deep concerns of Moche culture for the resolution of chaos and the maintenance of the social and cosmic order.

This interpretation of Moche iconography draws an analogy with the way scenes such as the Nativity, Last Supper, and Crucifixion, which dominate Christian iconography, are sometimes conflated with minor themes and characters to represent key concepts in Christian cosmology and ritual (as with the cross in the paintings on page 10 and pages 164–65). At this level, the conclusions depend upon some very general assumptions about ancient Andean, Native American, and human culture, but they do provide a plausible framework against which other interpretations of the archaeology can be tested. Hence the association of all these scenes with the late period of Moche culture, when the archaeology reveals shifts in settlement patterns among them and their neighbors, suggests that political and military stress may have increased their concern for cosmic stability.

NASCA ICONOGRAPHY

The images on Nasca pots have been examined anew since Townsend's paper, by a research program at the British Museum led by Colin McEwan and Edward de Bock, looking at hundreds of painted designs from pots in museums around the world. The nature of the iconography suggests rather different and less conclusive interpretations than the Moche studies.

The designs on Nasca pots are often quite difficult to discern, wrapped around circular or spherical vessels. The British Museum project followed the method of the UCLA Moche archive, photographing each pot from several angles, joining the photos together and tracing the design, to produce accurate roll-out images. With an archive of some seventeen hundred pots, the various motifs could be classified, correlated, and compared with the help of a computerized database.

Unlike the Moche images, the Nasca images did not appear to form scenes, but motifs were often combined to form very complex designs. The researchers identified separate motifs according to such categories as humans, living creatures, deities, severed heads, plants, objects, and geometric designs, each with subcategories, including different human roles and creatures such as land animals, birds, fish, and insects. Even at this stage, there were challenges in drawing analogies between motifs and the things they might represent. Identifying actual animals and plants from very stylized images required an understanding of the local environment that archaeologists might not share with local people, either ancient or modern. How could the archaeologists be sure which kind of bird was shown and whether this mattered? It took them some time to recognize the simple Pacific limpet, shown as an oval with lines across, so how could they tell whether the prominent and very elaborate catlike creatures were inspired by actual cats or pumas, let alone a particular significant species? The reasonable but unstated assumption was that such images either represented or derived from creatures still observable

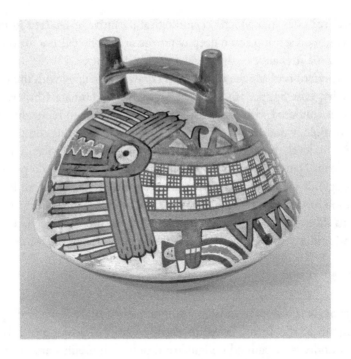

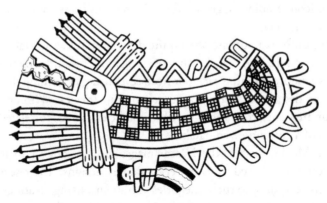

Figures 43 A Nasca pot and the design drawn from it; identified as a killer-whale deity, with bloodstained mouth, spears, and a trophy head in its hand. (The Trustees of the British Museum; Am1937,-.10, and the Nasca archive)

in the Peruvian Andes, for people everywhere draw inspiration from their natural surroundings. Archaeological remains helped explain some of the images; severed heads with the mouth and eyes pinned shut suggested the disembodied faces, catlike mouthmasks on buried bodies resembled the humans with animal heads, and so on.

But what if the Nasca imagination had strayed beyond observable animals and plants to dragons, or triffids, and how should creatures be interpreted when they combined

features of different animals, plants, and humans? Should we assume that human-animal hybrids were deities? Again, the assumption was that pre-industrial, and especially non-Western, societies had religious cosmologies which were represented in whatever images they created of their environment. In particular, creatures that appeared fantastic or imaginary were assumed to be symbolic of the special roles of spiritual beings. There was no room in such interpretations for political emblems like the ancient Roman imperial eagle or the British bulldog, let alone Mickey Mouse.

In terms of analogies with recent Andean cultures, the Nasca were assumed to have shared the notion of sacred geography animating the landscape. As with the Moche, it was proposed that the designs on burial pots represented human interventions in cosmological processes through ritual acts to imitate and promote them. Drawing on the kind of structural analysis used by anthropologists such as Lévi-Strauss (see page 91), the researchers supposed that Andean peoples, then as now, understood their world as sets of complementary opposites that needed to be balanced in order to maintain the ongoing cycles of life, of which humanity was but a part. In recent times these included communities divided into two intermarrying halves; high-low; male-female; first-second; mountain-earth; highlands-coast; flowing water–stagnant water; day-night; life-death; warriors-priests; warp-faced–weft-faced textiles.

The problem was to recognize such cosmological relationships in the Nasca motifs. The people of the Bolivian highlands share the Andean sacred cosmology, but their version of it reflects their experience as miners and farmers who have now worked for the descendants of their European conquerors for more than four hundred years. As Christians, they revere the ancient god of the earth as a devil who guards the mines and mineworkers, and celebrate such spiritual forces in an annual carnival. The carnival costumes feature animals associated with the earth—snakes, lizards, frogs—and with the sky—birds, especially the condor—but their designs derive from as many sources around the world as the carnivals of Rio or London. With so many cultural influences at work, how do we recognize the legacy of ancient Andean culture, when the creatures look like European horned demons and Chinese dragons?

The researchers decided that the meanings of the Nasca motifs could best be understood through relationships within a total iconographic system, and one focus was on which motifs commonly occurred together. By looking at how certain motifs combined or substituted for one another in different images, it should be possible to work out symbolic relationships between them. Hence, strong relationships emerged between severed heads and crop plants; males and the color red; females and the color yellow; oval eyes and live creatures; U-shaped eyes and the dead, and so on. In terms of structure, a central stripe between two opposed rows of identical motifs on a horizontal band is analogous to the present-day weaving of garments, where the central seam between two strips of cloth with mirror-image designs is called by the same name as the space in a village separating its two halves. Such correlations suggest that pot designs may reflect some deep and long-lasting cognitive structures in

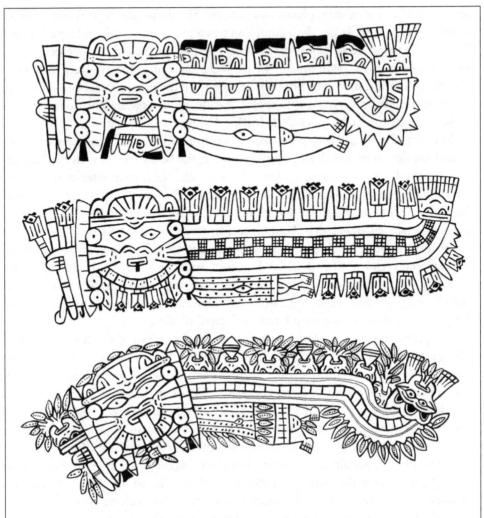

Figure 44 De Bock described a correlation between certain attributes of what he called the "puma deity." This creature was painted horizontally on open bowls, vertically on spouted vessels, and horizontally with a head at each end on both types of vessels. On this "composite" third variant, the creature's own head was like that of the vertical images; the right way up, red, with open eyes, a mouth-mask and ear-spools, and grasping weapons. The second head, at the far end of a band linking head and tail, was like that of the horizontal images; smaller and upside-down, yellow, with severed-head eyes and whiskers but no ear-spools or weapons. In the three composite images shown here, where the first has a row of severed heads, the second has maize plants with bloodstains and hair-plaits, and the third has severed heads sprouting with crop plants. (de Bock 2003, British Museum Nasca archive)

Andean cosmology and that the relationship between motifs is as significant as the motifs themselves.

Reading and comparing hundreds of images of objects, creatures, and prospective deities is a major research operation. The Nasca project suggests that cultures that share some basic underlying principles may develop and represent them in very different ways. The methodology also assumes, and seems to confirm, that humanity, for all its diversity, is actually fairly predictable in its artistic as in its other cultural traditions. Even so, no one has yet satisfactorily explained why the Moche, Nasca, and other ancient Andeans put these images on pots and buried them with the dead. Was there something special about pots still to be discovered?

QUESTIONS FOR DISCUSSION

- How can archaeologists be sure that their interpretations of ancient images do not derive from their own cultural preconceptions?
- Is it reasonable to suppose that ancient iconography necessarily represents significant cosmological ideas?
- Where would archaeology be without art history and anthropology?

FURTHER READING

- Quilter's article "The Narrative Approach to Moche Iconography" (1997) describes this methodology.
- Bourget's chapter "But Is It Art?" (2005) summarizes interpretations of Moche iconography.
- Donnan's book *Ceramics of Ancient Peru* (1992) illustrates the range of styles and techniques.
- d'Alva and Donnan's *National Geographic* articles (1988) summarize and illustrate the discovery of Moche royal tombs.

10 THE WORK OF ART

Having looked at ways of understanding the artefacts of diverse cultures, we can try to identify what it is about them that can usefully be described as art. Anthropological insights suggest that the combination of form and meaning in patterns that are both visual and conceptual contributes to all cultural production, mediating social relationships and constructing worldviews, as the work performed by art.

Outline of the Chapter

- Art in Anthropology
 Theorizing art as the patterning of human experience, illustrated by cattle husbandry in Nilotic East Africa.

- Art in Cosmology
 The power of artefacts to visualize world orders, from Christian images of heaven and hell to bone displays in the Papua New Guinea Highlands.

- Art at Work
 The theory of art as agency, reconsidered through the example of canoe decoration in the Trobriand Islands of Papua New Guinea.

- Art in Cosmic Agency
 The power of artistic forms to conceptualize and enact cultural worlds, as exemplified by the painting and performance of Aboriginal Australians.

Anthropologists took the study of art in new directions, to societies which art historians had never considered, but brought with them assumptions about art that, although they worked well enough in particular studies, they seldom attempted to define. Discussing definitions of art too often leads to long and tedious arguments that reflect the essential ambiguity of the concept in Western culture. This ambiguity may be useful to artists and art connoisseurs, who can adapt it to their own purposes while insisting that its

transcendental values are beyond intellectual explanation. But if we want to look beyond the Western tradition and seek to understand how humans in general understand and react to cultural creations that include what the West identifies as art, it helps to be a bit clearer about what exactly we are discussing.

In the Western tradition, art is a category of cultural products, and a very selective and hierarchical category too. In terms of visual art—that is, artefacts—it has been distinguished from aesthetics; the appreciation of formal beauty that appeals to the senses rather than stimulating the imagination or elevating the mind. In similar terms, expressive fine art is distinguished from more humble decorative art, although this distinction is constantly challenged and shifted as symbolic meanings are discovered in artefacts once deemed to have none. Similar ambiguities plague the persistent distinction of art from craft or artefact as the work of artists rather than craftsmen or artisans. The distinction reflects judgments of social status, as high-status French and low-status Anglo-Saxon terms for the same thing. In contrary terms, Franz Boas even distinguished art from iconography, which he regarded as lacking aesthetic values, as in his interpretation of nineteenth-century Plains Indian drawings of warlike adventures (as described on page 210; Boas 1927:67).

ART IN ANTHROPOLOGY

Anthropology is a Western discipline that makes its business the interpretation of all cultures in terms that allow comparisons between them, but it has never really come to terms with the category of art. It has taken Western concepts such as religion and economics and redefined them in terms that go beyond Christianity and capitalism, or even gods and markets, in order to gain insights not only into exotic societies but also, by comparison, into the Western tradition. As a result, it has become a truism in anthropology that such categories of human activity intersect each other in society: there is economics in politics and religion in both, once we know how to look for it. Maybe art is in there too, if we choose to approach it in this way.

In dealing with what they call art, anthropologists have usually focused on particular issues of formal development and structure, symbolism and communication, and so on, without proposing universal theories of art in society. Those who have attempted to do so have often been too bemused by Western art values to avoid falling back on them. For instance, Howard Morphy has proposed as a cross-cultural category: "art objects are ones with aesthetic and or semantic attributes (but in most cases both), that are used for representational or presentational purposes" (2007:xi). This illuminates his comparison between Australian Aboriginal artefacts and Western art, but as a definition it is more an extension of the concept of fine art than a way of transcending its limitations as a special Western category of artefacts. On the other hand, art historians who recognize the concept of art as a product of the Western cultural tradition tend to deny its relevance to other traditions that themselves have no category of art (or of politics,

economics, or religion either, if it comes to that). However, there are anthropological theories showing a way towards a general concept of art that can, as any useful definition should, broaden our understanding of phenomena which otherwise we cannot quite come to grips with. A book about world art needs to consider what its subject means.

ART AS THE PATTERNING OF EXPERIENCE

The idea propounded by the art historian Clive Bell (1913) that art is based on "significant form" makes good sense, once we free ourselves from his ethnocentric definition of what is significant. As he wrote, "The pure mathematician rapt in his studies knows a state of mind which I take to be similar, if not identical . . . [of] . . . the rightness and necessity of a certain combination of forms." Bell's problem was that, unlike mathematicians, he could not understand that the appreciation of form is as much an intellectual experience as an emotional one, to which the content makes a vital contribution. The relationship between the form of an artefact and the ideas it inevitably communicates, whether through images or symbolic connotations, seeks the same "rightness and necessity" as a mathematical equation. It is the capacity of artefacts to signify ideas through forms that produces the emotional effects described by art connoisseurs and experienced by everyone else who participates in the cultural tradition concerned.

Raymond Firth, an anthropologist who began a long lifetime of research in Boas's time, restated the theory of art as form more than sixty years later (1992). Firth recognized as art the creation of patterns that give meaning to all kinds of human experience, of the mind as well as of the senses. From this point of view, art was present in most, perhaps all, human activity. Just as anthropology recognized long ago that religion played a part in all institutions in society, so Firth made this point by calling religion an art, for the way it gives meaningful pattern at a transcendental level to human experiences and concerns. Firth stated his theory in a way that allowed it to include the meanings or symbolic associations of art, which Boas had left to one side.

> Art as I see it is part of the result of attributing meaningful pattern to experience or imagined experience. It is primarily a matter of perception of order in relations, accompanied by a feeling of rightness in that order, not necessarily pleasurable or beautiful, but satisfying some inner recognition of values.
>
> . . . religion itself is a human art. It constructs symbolically on what is termed an extra-human plane ideas which reflect in massive patterning the desires, hopes, and fears which people experience on the human plane. . . .
>
> Art . . . is essentially form; but only when the form is mobilized for human purposes, given meaning in human terms by comparative associations, . . . (1992:16–18)

Firth's comparison of art with religion is a reminder that people seek to impose pattern on all their cultural products and the relationships between them. Pattern is the

regularity that people perceive and create to enable them to predict and understand the world of experience. It is when artefacts participate in greater patterns of meaning, such as cosmology, that they gain the power which Western art critics recognize in their own category of fine art. Artefacts work in this way within particular cultural contexts, and we can but glimpse the possible significances to their makers and intended audience if we do not share their cultural background and worldview.

Treating art, in Firth's terms, as the patterning of culture rather than as a particular kind of cultural activity or product, frees us from the invidious and obstructive Western distinction between "art" and "not art." Beyond admiring works of art and analyzing their iconography or emotional impact, we can start to appreciate the meaning of art in societies that have little or no art in the Western sense, and to consider anew what art means in those that do. Some anthropologists have demonstrated the art in artefacts which are almost as far removed from conventional definitions as the famous pickled animals and unmade beds of Western "conceptual art," but with far more resonance in society.

NILOTIC SUDAN

Writing of the Nilotic herding peoples of southern Sudan, Jeremy Coote (1992) has drawn attention to their aesthetic appreciation of their cattle. For these people, such as the Dinka, Nuer, Atuot, and Mandari, cattle were their pride and joy, providing not only food but also the wealth that linked and reconciled people, to each other and to God, through marriage gifts, indemnity payments, and sacrifices. They studied and discussed cattle as objects of admiration, for the coloring, pattern, and sheen of their hides, the shape of their horns, the proportions and largeness of their bodies, their fatness, and the size of their humps. Men celebrated the appearance of their prize animals in poetry and song, with elaborate imagery likening them to other natural and cultural things. So central was this cattle imagery to their culture that they commonly described other visual experiences in terms of the appearance of cattle.

Coote used this tradition to argue that "All cultural activity has an aesthetic aspect" (1992:246)—"the marvels of everyday vision" as he called it—but he preferred to distinguish this from art as a matter of perception and experience. However, he demonstrated how the herders, rather than simply discovering aesthetic qualities in their cattle, actually created them, by shaping the animals' appearance, by developing complex criteria for judging it, and by attributing meanings to it that had much broader significances in their view of society and the world. Selecting well-marked bull calves, they castrated them to produce fat oxen, fed them up and groomed them, cut their horns to shape the way they curved, and added valuable decorative tassels. They associated aesthetic values with moral ones and, besides their cattle, they decorated their own bodies, utensils, and homesteads with designs that represented cattle, symbolized their qualities, or demonstrated the aesthetic principles of cattle design.

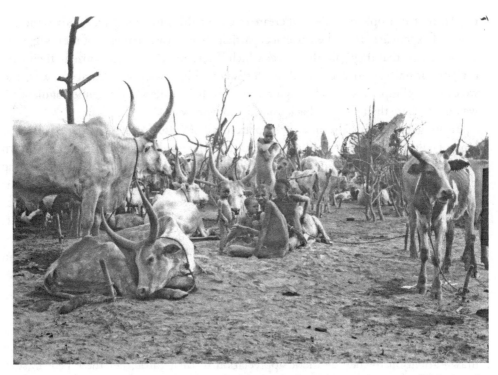

Figure 45 A Dinka camp in Sudan in the early twentieth century, with artistically designed cattle. (Seligman collection, The Trustees of the British Museum; Af,A37.73)

Insofar as Nilotic herders created and developed the aesthetic values of their cattle within a tradition that pervaded their culture, rather than merely appreciating their natural beauty, their cattle were art in the terms used by Boas and Firth. It may not be helpful to treat them as works of art rather than as works of husbandry, or their owners as artists rather than herders, but it could be informative to compare the art of Nilotic everyday life to that of societies who devote their artistic energies to painting, sculpture, or costume, rather than cattle. However, recognizing art as an aspect of culture rather than as a distinct field of cultural activity still leaves questions about how certain artefacts seem to be so much more artistic than others and how they make such powerful impressions on people. The challenge is to understand how form and meaning work together as the universal cultural phenomenon that the Western tradition has identified by its own crude and ambiguous, ethnocentric and elitist, contradictory and even ridiculous, but nonetheless useful, concept of "art."

If we follow Boas and Firth in treating art as the creation and perception of formal pattern, or the cultural patterning of human experience, we can go further to recognize these qualities in the patterning of relationships between form and meaning entailed in visual symbolism. We can recognize symbolism itself as artistic, on the level of the intellect rather than the senses (as suggested by Firth's comment on religion). Maybe

the Western definition of "the arts" to include literature, music, and dance as well as painting and sculpture, has a point. The use of metaphor and other kinds of symbolism, creates patterns of meaning that are in the mind rather than in the senses. This can be achieved by speech or text, which gains extra appeal if combined with rhyme or rhythm as poetry, plus melody as song or bodily movements as dance, or with visual patterns in calligraphy; but the meanings of symbols have their own aesthetic or formal appeal as patterns of ideas. It is when the conceptual values are combined with the sensuous ones in such ways that the effect is indeed what Western art critics describe as elevating, as their concept of fine art is intended to be.

ART IN COSMOLOGY

To develop Firth's theme, artefacts are particularly effective in helping to make basic cosmological principles visible, significant, and comprehensible to members of their societies of origin and, with interpretation, to others. Previous chapters include examples of structures and images that can be interpreted in this way, serving similar purposes to familiar Western religious iconography (as illustrated on the next page).

PAPUA NEW GUINEA HIGHLANDS

Displays of bones by the Mountain Ok of the central Highlands of Papua New Guinea in the 1960s were examined by Barry Craig (1998). According to their own history, the first sanctum house, where hundreds of relics of pigs and other animals were hung on the back wall, was originally the house of their founding woman ancestor. She decided to change places with her brother, or husband, who had been living in the family house, with the result that both were more contented and their gardens flourished. Since then, the sanctum of each settlement had always been the men's house, forbidden to women. Like so many Melanesian origin histories, this explained how the institutions of spiritual power into which only men were ceremonially initiated, were originally taken from women, who still retained the fundamental power to reproduce humanity.

In these houses, bags holding the relics of dead ancestors, whose blessing ensured prosperity and good fortune, hung from the top of the wall, above carefully arranged rows of pig jawbones and skulls, cassowary pelvises and other small animal jawbones, all from meals eaten by men in communion with their ancestors. The nature and arrangement of these relics varied among local communities, but seemed to reflect Ok cosmology in several ways. There was the division of the house as a whole into two sides, for farming and nurturing, hunting and killing, with separate hearths for cooking domestic and wild pigs. There was the arrangement of relics according to ecological zones, of upland wild animals, the middle settled area of domestic pigs, and the lowland forest of wild pigs and cassowaries. There was the use of relics to represent the relationships

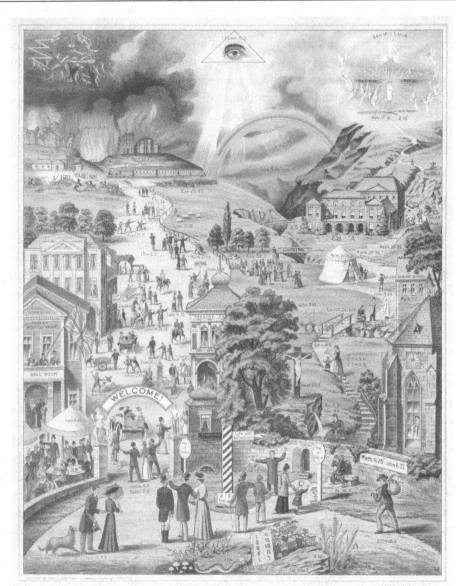

THE BROAD AND NARROW WAY.

Matthew VII. 13, 14.

Figure 46 *The Broad and Narrow Way*, a popular German print from the 1860s, contrasted worldly indulgence and sin with Christian piety and austerity, in scenes illustrating biblical verses. This English version was published in 1883. The picture gave visual form to some basic principles of Protestant Christianity and their consequences for humanity in damnation or salvation, easily read by anyone of this religious tradition. (Trustees of the British Museum 1999,0425.13)

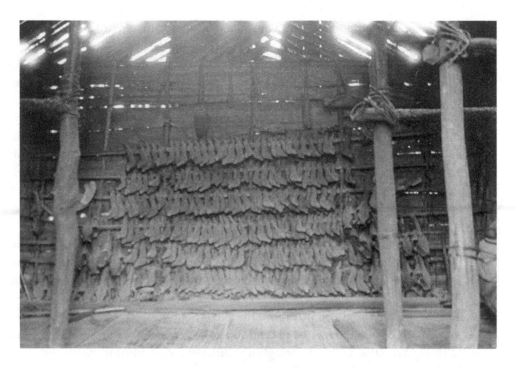

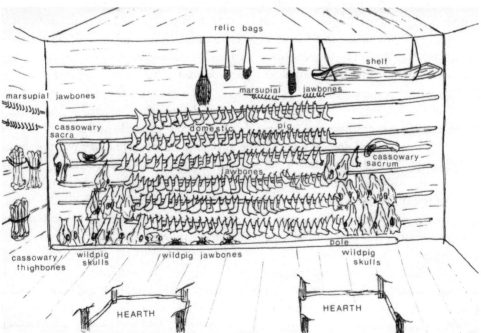

Figure 47 An array of relics and trophies in an Ok sanctum house in 1965, with an explanation of its contents. (Barry Craig photo and diagram)

between the men, their ancestors who governed their fortunes, and the land that pro-
vided their livelihood.

Craig judged these relic displays to be art works in terms of a particular definition
of art that emphasizes speculative innovation, in line with the Western distinction be-
tween art and craft. Regardless of this definition, his account demonstrates how even
rows of bones hanging on a wall can convey important cosmological meanings, vary-
ing subtly with cultural differences among local communities, through formal arrange-
ments that are as much conceptual and symbolic as they are visual, and artistic in this
general sense too.

ART AT WORK

The power of art to affect people's emotions, behavior, and worldview is not limited to
the elevation of Western art audiences, but studies of non-Western art traditions have
had trouble pinning it down theoretically. Then, in the 1990s, Alfred Gell developed a
flawed but influential theory of the "agency" of art: its power to act in society.

Gell (1992, 1998) proposed that the anthropology of art should eschew the values of
the believer—that is, aesthetics—as the anthropology of religion does relationships with
spirits, taking a position of "methodological philistinism" equivalent to "methodological
atheism." This methodological philistinism was not well served by sociological and sym-
bolic interpretations of objects, which failed to account for the role of the object itself.
Instead Gell attempted to treat art as a "component of technology" (being concerned
with made rather than found objects), which he called the "technology of enchant-
ment." This was the process by which art produced certain cultural consequences, as
propaganda for the status quo.

Gell's technology of enchantment was the enchantment of cultural significances by
the employment of forms and patterns that had certain psychological effects for geneti-
cally determined ethological reasons. The enchantment of technology was the impres-
sion created by an appreciation of the technical virtuosity entailed in creating an artefact
from something else, which was interpreted culturally as exhibiting unattainable, hence
valuable, skill. This enchantment could derive from intellectual and symbolic as well as
material virtuosity, as in the appreciation of conceptual art. It went beyond aesthetic
appreciation of the artefact itself to enhance and empower the social relationships that
the artefact mediated.

Patterns engage and trap the mind; hence they attract people to them and attach
people to artefacts as possessions that continue to engage attention and become part of
the owner's personal identity. But this quality of patterns can also be used to entrap hos-
tile attention as a means of protection, since comprehending the structure of complex
visual patterns tends to produce cognitive blocks, obstructing thought. Such patterns
may form intellectual puzzles, like geometrically designed mazes or labyrinths. In the
Trobriand Islands case used by Gell as an illustration, this technological enchantment

was part of the magic of artefacts, an idealization of technology that transcended the mundane reality of work.

Gell demonstrated in a variety of ways how artefacts could act as social agents, being treated as if they were engaged in relationships with persons, and could act upon their own account. He denied that this was a symbolic property, but this seems to reflect a peculiar definition of symbolism that fails to recognize its power. His whole argument was actually about the power of metaphor and was expressed in metaphorical terms. What he did not do was explain the agency of art, since he began by rejecting, and continued by ignoring, the only plausible defining characteristics of art; that is, the formal properties that he dismissed as "aesthetics." Without these properties, Gell produced a theory of the agency of material objects, particularly artefacts, which was willfully deprived of the explanatory power of a theory of form, that could include not only visual form but also the power of mimetic and metaphoric representation, compounded by the intellectual aesthetics of symbolic meanings. In formulating this theory of art as agency and rejecting aesthetic appreciation of artefacts in favor of their power to act in relationships between persons, Gell threw out the artistic baby with the aesthetic bathwater. The baby that he overlooked was the symbolic nature of this agency and its reliance on the aesthetic values that others before him had described as art. It might have been more useful to treat the Western aesthetics to which he objected as the theology of Western art, allowing that the aesthetics of non-Western cultures might prove as useful for understanding their art as their theologies do for their religions.

Even so, Gell demonstrated in new and interesting ways the power of aesthetic values, or patterning as others identify it, to affect human relationships. Once we have penetrated the very Western, art-world presentation of his argument, there are suggestions for a new direction in the study of art, focusing less on "works of art" in Western terms than on the work that art does in society.

THE TROBRIAND ISLANDS

An example used by Gell makes the point. Shirley Campbell (2001, 2002) described how the magical power of woodcarving designs in the Trobriand Islands of Papua New Guinea was generated by their aesthetic and symbolic properties. Throughout the Trobriands, there were small numbers of so-called specialists who carved important auspicious artefacts, such as boards to decorate yam-stores and voyaging canoes, working for commissions of valuables and food. They learned by apprenticeship, which gave them the magical knowledge to make their carvings "work," making their products more valuable than those made for sale by ordinary carvers, even the most talented. The purpose of the magic revealed the aesthetic values of the carving tradition, emphasizing the flow of water as a metaphor for the transmission of knowledge to the apprentice and thence into the flowing forms of his work.

Campbell described how the carved canoe boards were said to work not only because of their formal appearance but also because of the wisdom, knowledge, and precision that specialist carvers brought to the making of them. People responded emotionally by appreciating them as valid expressions of important social values entailed in the voyages for which the canoes were made: the *kula* exchange. Men visited neighboring islands to exchange shell-bead necklaces for coneshell arm-rings, in a circuit linking the islands together, the necklaces traveling in one direction and the arm-rings in the other.

A *kula* canoe, being made to sail in either direction, had a prow-board and splash-board on each end, carved to represent the characteristics of certain creatures, which were associated with certain parts of the body as the site of emotions auspicious for the aims of the *kula* voyagers. Hence, on the prow-board of the canoe, the "nose" was said to be an osprey, whose innate wisdom and skill in catching fish stood for success in the competitive exchanges of the *kula* and of man's life in general. The "head" of which the nose was a part was represented as the *doka*, a magical flying creature standing for human intelligence, creativity, and fallibility, as distinct from the osprey's innate magical wisdom. The "chest" of the board bore the image of a bat in black, again showing

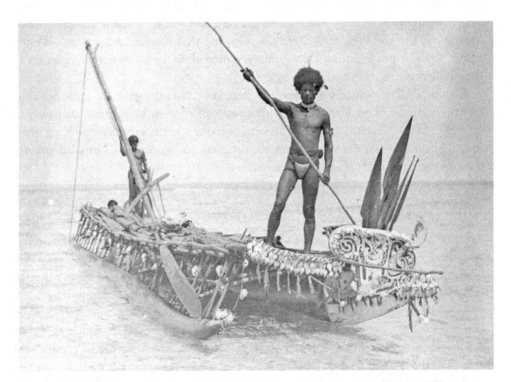

Figure 48 A *kula* canoe photographed by the anthropologist Bronislaw Malinowski in the 1910s, the newly painted prow/stern decorated with cowries. (London School of Economics archive Malinowski 3/4/8)

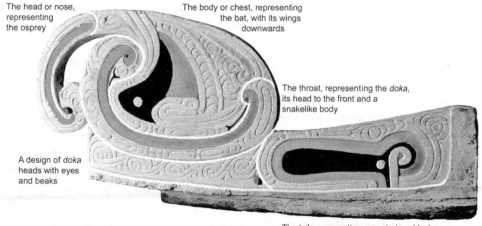

The head or nose, representing the osprey

The body or chest, representing the bat, with its wings downwards

The throat, representing the *doka*, its head to the front and a snakelike body

A design of *doka* heads with eyes and beaks

The tail, representing a mysterious black bird or fish with a beautiful voice

Figure 49 The prow-board from a *kula* canoe, showing the creatures represented by the main sections of the design. (Ben Burt photo)

innate wisdom in its ability to fly in the dark, as a *kula* canoe needed to sail, and also associated with the dark magic of sorcery and flying witches that threatened the success of *kula* voyages. The "tail" of the board represented a magical bird, known for its voice, which attracted as a man's voice attracts a woman, another quality required for success in the *kula* exchange. The splashboard behind the prow-board had a similar composition.

Space-filling motifs, intended to hold the lime paint as it eroded from the surface of the board, were also named for creatures with symbolic associations, such as the tracks of the hermit crab, which had the virtue of moving between sea and land and ate dead things, associating it with the flying witches. Such creatures were shown by motifs representing their significant characteristics rather than their visual appearance. The paints covering the carvings also had symbolic associations ensuring the success of the *kula*; white for newness and purity, red for sexuality and attraction, and black for age, death, and sorcery; each valued, like the qualities of youth, maturity, and age, according to the context.

In all, the prow-board and splashboard represented the inherent magical wisdom of certain creatures as an ideal that contrasted with the intelligence of humans, who must resort to magic for their success, and the tension between the two in human experience. Campbell showed how the symbolic associations of these artefacts played an essential part in the agency that Gell would attribute to visual captivation. The symbolic meanings and virtues conveyed by the particular combination of motifs and colors on the boards was understood in depth only by a minority, but their knowledge underpinned the superficial understanding of the majority that the designs conveyed the magical power to support their aims in the *kula*. These aims, including safe and speedy voyaging and enticing exchange partners to part with their *kula* valuables, were not only conveyed by the magical symbolism of the designs, but also promoted by their visual

qualities. These depended on the line quality being clean, strong, and balanced, the correct arrangement of the motifs within the design, and the effective distribution of the colors to enhance the design.

Magic for *kula* voyaging focused on the masculine values of lightness and mobility, which were associated with individuality, the sky, tree crops, and so on, contrasted with feminine values of heaviness and attachment to place, which were associated with the group, earth, root crops, and so on. The *kula* epitomized masculine values, but was threatened by feminine properties that somehow escaped from their proper place, such as flying witches and jumping stones as hazards of the ocean, against which the *kula* voyagers had to magically protect themselves. On arrival at the home of their *kula* partners, they represented the roving seductive male seeking to overcome the homebound female and obtain her gift, and the exchange of valuables that they negotiated was described as if it were marriage. Through the *kula*, men engaged in the reproduction of valuables and relationships, which mimicked the reproduction of persons and kinship by women, within a realm of masculine values that brought them fame and comradeship in the inter-island world beyond their home communities.

In Trobriand cosmology, women were associated with the land that men inherited through them, the fertility of gardens that men cultivated using magic with feminine sexual imagery, and the stability of the clan community that they fed and reproduced. Men were associated with the sky, which rained to inseminate the ground, which they penetrated with their digging sticks to plant their yams, which grew downward like metaphors for copulation and pregnancy. Men swooped on women as the osprey dived from the sky for fish, to seduce them and anchor and control their sexuality by marriage and producing children. Women not constrained in this way were suspected to be the flying witches who magically escaped their earthbound role to fly abroad as men did for *kula*, threatening the lives of the men on their adventurous voyages. This imagery pervaded the *kula* and its magic. Men were the top of the tree and women its roots. When a tree was made into a canoe, transformed from something fixed to the land into something that travels abroad by sea, the top was the outbound end, while the base looked homeward.

The *kula* canoe carvings worked within a cosmological system that, like other Melanesian traditions, recognized certain tensions between the complementary roles and realms of men and women, in which the men appeared to be compensating through artistic creativity for the more fundamental reproductive creativity of women. The *kula*, like other Trobriand activities, depended heavily on magical support based on cosmological metaphors, and it is this that explained the power or agency of the forms, motifs, and colors employed to decorate the canoes.

ART IN COSMIC AGENCY

Visual forms have their own special power to show patterns of meaning in relationships between different aspects of the world, levels of reality, or kinds of experience.

An example that is simple to describe but difficult to appreciate in its powerful impact on society is Australian Aboriginal iconography.

WALBIRI AUSTRALIAN ABORIGINALS

In the 1950s, the Walbiri people of the desert northwest of Alice Springs were living in government settlements but maintaining their own social and religious life. Nancy Munn (1962) described how their culture was still founded on the precedents set by their dreaming ancestors: personifications of creatures, plants, and natural forces who emerged from the ground at certain places and began traveling the land to forage for their living before returning to remain in the ground. These dreamings set out the routes followed by later generations, shaped the landscape, and dreamed the ceremonies that their descendants reenacted at the same places generation after generation, to recreate the dreamtime as the underlying meaning for their lives in the present. These ceremonies, inherited with the land in the male line, told the histories of the dreaming through songs, enactments, and graphic designs. Such designs were used by women to relate everyday events and stories by drawing in the sand, but their artistic power lay in the levels of meaning they could convey when used for ceremonial purposes. The designs used by men in their private enactments of dreaming histories had inner layers of meaning known only to the initiated descendants of the particular dreaming ancestors they represented.

Walbiri designs drew upon a set of simple line-shapes, each with a wide range of possible meanings, plus the tracks made by particular creatures. These were combined in certain ways that gave a more limited range of meanings, but the shapes could still represent other things at the same time. For instance, histories commonly related travel between campsites, shown by lines linking circles. But lines could stand not only for pathways but also for smoke, backbone, snake, penis, or tree trunk, and so on; circles could stand not only for a campsite but also for fire, stomach, snake hole, breast, or tree-roots, any of which might have a place in the story. Likewise, histories showed persons with objects by combining the U shape made by a person sitting on the ground, or a line where someone lay down, with circles or lines representing a fire, a waterhole, an artefact, or several such things at once. The meaning of the design depended on how much the viewer knew of its dreamtime history, the particular places and persons, and the inner levels of meaning of the dreaming it represented.

Walbiri men created these designs to illustrate dreamtime histories, on sacred boards as permanent embodiments of dreaming ancestors, and on the ground and their own bodies for rituals in which they transformed themselves into these ancestors through costumed performances. The designs acted as mnemonics for telling or enacting the history, but, more than this, they enabled multiple interrelated levels of meaning to be combined in a single form in a way that words and actions alone could not convey. Through such designs, the Walbiri were able to envisage their cosmos as involving multiple layers of meaning.

Figure 50 As an example, Munn explained a design representing four seated men (shown by U shapes) with their spears (the straight lines) at a campsite (the circles). The men were kangaroo dreamings who emerged from a particular waterhole (the inner circle), traveled around (the outer circles), went hunting, and returned along four paths (the straight lines, also tail- and foot-prints) before returning into the ground through the waterhole. The whole design represented a dreamtime event that explained the special relationship between the descendants of these ancestors and this sacred site.

Representing the history in this way gave visual form to certain equations that were essential to the history and to Walbiri culture in general. In the history, kangaroo tails became spears, and "tail" also means "penis," so the history reflected the equation of spear/kangaroo tail/penis that featured in boys' circumcision ceremonies. Waterholes were campsites, but they were also the places where dreaming ancestors emerged from and disappeared into the ground (drawn from Munn 1973: pl.2).

For Australian Aborigines like the Walbiri, whose artefacts made such little mark upon their environment, artificial designs stood out as particularly attractive and intriguing, but the formal patterns that gave the work its artistic power were more than simply visual images. The designs had meaning not just as signs, as writing represents sounds and concepts, but as symbols that showed how certain things were in a certain

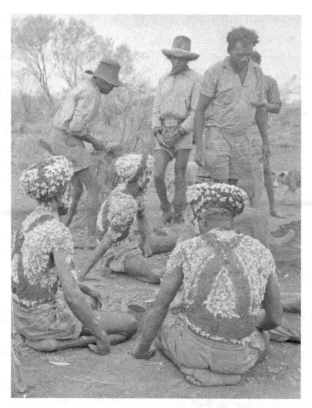

Figure 51 Walbiri men in the 1950s, dressed in designs of red and white fluff to impersonate rat-kangaroo dreamings, showing how such ancestral beings were envisaged. (Nancy Munn photo; first published as Munn 1973: pl.10)

way also different things, and other things again, in layers of meaning that revealed more and more inner realities as initiated men learned to understand them. The visual patterns evoked mental patterns through metaphors and equations that revealed layers of knowledge about the world in ways beyond the power of words.

Through these layers, the designs conveyed meanings that allowed people to understand the world in the terms developed by their ancestors through the cosmology of the dreamtime. In this worldview, the land and people formed by the first dreaming ancestors, as personifications of creatures and things, was reenacted by their human descendants to the present, as they traveled the land in the footsteps of their ancestors. Men's most important work, secret from women and the uninitiated, was to transform themselves into dreaming ancestors and recreate their formative acts in costumed ceremonial performances. The dreaming was a constant presence in their lives, at once past and present, in the landscape and in their dreams, as the spiritual dimension of the world.

The artistic values of such artefacts are as much intellectual as visual, which outsiders can appreciate only at a superficial level. We may enjoy the visual forms, read some

superficial meanings, and perhaps imagine deeper, mysterious hidden significances, but without a deep knowledge of the culture, this is like hearing the rhyme and rhythm of poetry in a foreign language without understanding the words, let alone the metaphors. In visual design, as in prose and poetry, theatre, song and dance, the power of art is in the way patterns of the senses evoke patterns of the mind to produce an effect greater than either. Artistic artefacts can shape the way people conceptualize their world, helping them impose meaningful patterns upon human experience. These patterns may work like the formalized symbolic images of Western fine art that elevate the mind of those culturally attuned to them, but other traditions can be even more powerful and pervasive. The work of all art is to contribute the kind of order that people seek to find, construct, and enjoy, to the world they experience.

QUESTIONS FOR DISCUSSION

- Can we still make art a separate subject of study if we treat it as an aspect of all cultural production, rather than as a thing in itself?
- Is it appropriate to compare the elevating effects claimed for Western fine art with the symbolic meanings of artefacts to members of small societies?
- How far can we hope to appreciate the significance of artistic creations to societies whose culture and worldview is so different from our own?

FURTHER READING

- Morphy's Introduction to his book *Becoming Art* (2007) discusses the complexities of cross-cultural categories.
- Firth's "Art and Anthropology," Coote's "Marvels of Everyday Vision," and Gell's "The Technology of Enchantment," are all chapters in Coote and Shelton's book *Anthropology, Art and Aesthetics* (1992).
- Morphy and Perkins's Introduction to *The Anthropology of Art* (2006) includes an art-historical discussion of anthropological theory. Their book also reprints the Firth and Coote papers mentioned here, with others by Gell and Munn, and a chapter by Morphy draws on his research into Australian Aboriginal design.
- Munn's work includes the article "Walbiri Graphic Designs" (1962) and a chapter in Forge's *Primitive Art and Society* (1976).
- Thomas's Introduction to Thomas and Pinney's book *Beyond Aesthetics* (2001) reviews developments in the anthropology of art leading to Gell's theory of agency, and in Chapter 6 of the book, Campbell introduces her work on Trobriand *kula* carvings.

PART 3
ARTISTIC GLOBALIZATION

How the world's diverse artistic traditions have been brought together under the influence of Western art values and how non-Westerners have responded.

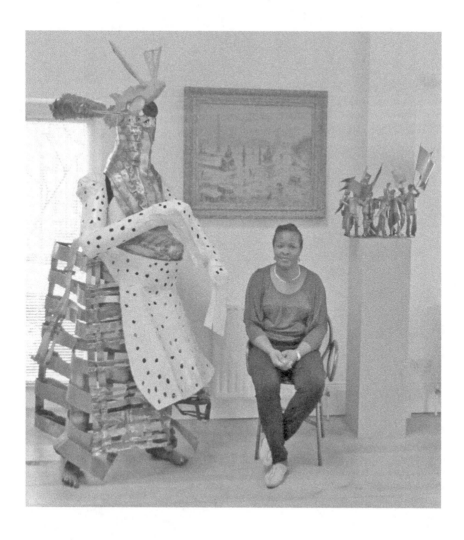

11 THE ART WORLD

Western art has had a profound influence on the world's other artefact traditions, so it is important to scrutinize them all in similar terms. Anthropology and art history demonstrate Western art to be artefacts for display that are valued according to hierarchies of class and gender and collected as commodities through markets promoted by public exhibition and brokered by the institutions of the "art world."

Outline of the Chapter

- Art History as Ideology
 The values that define the Western tradition of art.

- Reappraising Art History
 Some critiques of hierarchies of artistic value in terms of gender, class, and price.

- Art as Collectibles
 Some consumption and the conflation of artistic and commodity values.

- The Art Brokers
 The institutions that legitimate art values through the authentication, collection, promotion, and display of valuable collectibles.

Western ideas about art have had a pervasive and often profound effect upon other artistic traditions through the processes of colonial expansion and global hegemony. To understand the issues this raises for the artistic culture of the twenty-first century, it is useful to consider Western art in the way that anthropology attempts to do for non-Western culture: using what people say about themselves to inform more impartial observations of what they actually do.

The Western concept of art has always been ambiguous, and this is one of its strengths. Art marshals a diverse range of artefacts and activities to serve certain vested interests

while stimulating debate on the social and cultural issues of concern to an influential sector of Western society. Even the "art world," the network of professionals and patrons who mediate art with the public at large, has trouble defining what it means by art, which was one reason for reviewing the history of the concept in Part 1 of this book. We considered how ideas of art emerged from a series of intellectual theories and research methods within the cultural tradition of Europe and the West. These were developed through the cultural revolutions of the Renaissance and the Enlightenment to describe an artefact tradition claiming descent from the most esteemed cultures of the ancient Mediterranean. During the nineteenth and twentieth centuries, the concept of art was applied to other cultural traditions as these were encountered in colonization and explored through the disciplines of art history, anthropology, and archaeology. As theories and methodologies were developed and disputed, some consensus emerged that art, whatever it was and whatever else it meant, derived significance from its cultural and historical background. Even Western "fine art," said to be an autonomous activity creating objects for contemplation free from utilitarian social functions, was recognized by its own historians as deriving meaning from the historical and social circumstances of its creation and display.

ART HISTORY AS IDEOLOGY

Anthropology faces a problem in freeing the concept of art from the ideological control of this Western art world, which limits its potential for explaining human culture in general. Although the West has learned to accept that "religion" means more than Christian theology and to consider that "economics" should mean something other than the theology of capitalism, it has been less successful in subjecting its own concepts of art to the kind of scrutiny that has yielded insights into the role of art in other cultural traditions. By focusing on what Westerners involved in art actually do, rather than accepting at face value what they say they do, the utterances of makers, critics, brokers, dealers, collectors, curators, and historians of art, and the responses of their audiences and readers, become part of the social context of art rather than sufficient explanations of it.

We can begin with an art-world account of its own values. The art historian Ernst Gombrich took pains to explain an approach that continues to be popular and conventional: that art is what artists do. He began his popular *The Story of Art* (1950) with a statement of Western individualism: "There really is no such thing as Art. There are only artists." The artist should have freedom to express himself, guided by an intuitive feeling of rightness or harmony. The values expressed transcended rules and methodological analysis by communicating directly to the observer, whose taste might be informed by a connoisseurial understanding of art history, but was untroubled by any sense of cultural relativism or comparison with alternative cultural traditions.

As an anthropologist, Shelly Errington has provided a more detached explanation, pointing out that art has in practice been defined by the values of its consumption as much as the values of production and appreciation that Gombrich proclaimed:

> The vast majority of what becomes art, whether from medieval Europe or from other sources, is portable (paintings preferred to murals), durable (bronze preferred to basketry), useless for practical purposes in the secular West (ancestral effigies and Byzantine icons preferred to hoes and grain grinders), representational or at least iconic (human and animal figures preferred to, say, heavily decorated ritual bowls), and so forth. The selection process is also a hierarchizing process. (Errington 1998:116–17)

Despite the enduring popularity of the connoisseurial approach (and of Gombrich's book), art historians also came to question its claims to objectivity and acknowledge that art and its history was itself a historical product of its society and culture, rather than an autonomous activity and its disinterested study. Tom Gretton made an effective critique of art history as Western ideology in 1986, arguing that, since aesthetic values are culturally specific, art can only be a culturally specific relationship between people and artefacts. As a socially constructed category, it is founded on the non-utilitarian indulgence in timeless aesthetic values by talented individuals, whose work is set apart from mundane production, to be patronized and collected by a social elite who thus participate vicariously in these values. This promotes social hierarchy and cultural hegemony by demonstrating superior knowledge, even when its values are rejected from this elite position in favor of avant-garde artistic developments or philistinism. As a social and cultural construct, this art is institutionalized in Western society through education, publishing, museums, and galleries, and this makes its ideology inherently conservative. It depends on a mystification of the making of certain artefacts as transcending historical and cultural determinism through the special talent of the artist as an autonomous individual. Even attempts to demystify artistic production by focusing on the social history of the process fail by accepting this underlying concept of art, as Gretton explained:

> History of art is a specialized discourse about certain classes of objects, including paintings, sculptures, prints, drawings, and certain aspects of buildings. . . . Its subject matter is defined by reference to aesthetic criteria, and in particular to hierarchical judgements of worth. . . . First it makes absolute distinctions between those images which are "art" and those which are not, so that not all paintings, and very few printed images, for example, qualify. Secondly, within this arbitrarily defined group of objects, the process of application of aesthetic criteria is constantly at work (1986:63).

REAPPRAISING ART HISTORY

The self-consciousness of art historians in acknowledging the social and historical situation of their discipline and its subject matter developed in the 1970s, and by the

mid-1980s issues of methodology, social history, and gender bias had entered main-stream debate in Britain as the "New Art History". This did not lead to a fundamental reappraisal of the category of art, but it did produce critical analyses of its social and economic contexts, challenging established hierarchies of artistic value, particularly in terms of class and gender, from Marxist and feminist perspectives.

The most obvious of these hierarchies distinguishes artefacts credited with the expression of aesthetic and symbolic values as true art or "fine art" from lesser artefacts designated as applied or "decorative" art, "design," or "craft." The hierarchy is one of artistic and commercial value that affects the status and income of art collectors and curators, artists and designers, craftworkers, dealers, and shopkeepers, who all depend on the art and collection sectors of Western societies. It is supported by an institutional system of education and patronage, collection and exhibition, dealing and brokering, and publication of images and commentaries.

CLASS

The art hierarchy operates most obviously in terms of social class, with ruling elites claiming cultural superiority through the possession of the most valuable art objects and the educated discernment or taste to distinguish their true value. Such taste may be more difficult to acquire than the artefacts themselves, as established elites seek to prove by denigrating the new rich who show more money than taste when they collect the wrong artefacts. However, artefacts of differing social class complement each other within Western society. For example, Spanish Catholic churches are adorned with images in styles that vary in artistic prestige. Religious themes may be represented in Classical-style oil paintings, in painted wood and plaster carvings, and in painted ceramic tiles, among other media (see figure 52). A middle-class European has no trouble in identifying which of these religious icons is of most value, artistically and commercially. The oil paintings could be removed to an art gallery and expensively restored, but the sculptures are still being commissioned from craftsmen for churches and shrines, and the tiles are on sale in ceramic shops as house decorations. Those who know about the fine art of the oil paintings may regard the others as folk art or kitsch, insofar as they continue to be produced in quantity to appeal to the tastes and finances of the lower classes in imitation of art values appreciated by their betters. Although all these styles belong to the same cultural tradition, the popular lower-class artefacts receive little attention from art historians.

GENDER

Such hierarchies also have a gender bias, in which artefacts usually produced by men include the most prestigious arts while women's artefacts are treated as craft. Although

women have increasingly participated in the arts from the mid-twentieth century, the distinction between these technologies remains. From the 1970s, feminist contributions to the New Art History sought to reevaluate women's artefact traditions as art. *Old Mistresses* by Rozsika Parker and Griselda Pollock (1981: Ch.2) described the hierarchy of value in which the arts of painting and sculpture enjoyed an elevated status, while other arts that adorned people, homes, or utensils were attributed a lesser degree of intellectual effort and appeal and a greater concern with manual skill and utility. "The clear division of art forms into fine arts and decorative arts, or more simply the arts and the crafts, emerged in the Renaissance and is reflected in changes of art education from craft-based workshops to academies and in the theories of art produced by those academies" (1981:50).

This hierarchy was also one of gender. Hence flower painting, which developed from allegorical still-life paintings of the sixteenth and seventeenth centuries, mainly by men, became characterized as women's art by the late eighteenth century, symbolic of little more than feminine beauty and said to require manual dexterity rather than intellectual creativity, producing work that was decorative rather than elevating. Likewise, embroidery, a profession dominated by men under the gild system in Britain in the thirteenth and fourteenth centuries, became a domestic art for women from the sixteenth century, as the increased prosperity of merchant households released them from other work. With the participation of queens and aristocratic ladies, embroidery became an accomplishment reflecting leisured wealth, artistic taste, and domestic virtue, and by the eighteenth century it was women's work. As such, embroidery lost its status, ceased to be real work, and became a way of keeping women occupied and out of mischief, part of the formal preparation of girls for womanhood. Although producing much creative and expressive work, such as samplers with imaginative texts, embroidery and the geometric forms associated with it were stereotyped by art historians as intellectually limited, decorative, and trivial—characteristics explicitly attributed to women.

This distinction of men's and women's arts in the eighteenth and nineteenth centuries was part of a change in the definitions of masculinity and femininity, which corresponded with an emerging distinction between art and craft. This ultimately derived not from the artefacts or methods of producing them but from the distinction between public and domestic, corresponding to male and female realms. In the twentieth century, art connoisseurs have had to make honorable exceptions to this classification in order to treat as fine art artefacts such as Navaho Indian blankets, which have the prestige deriving from primitive art but would otherwise be dismissed as women's craft. These and other women's work, such as American patchwork quilts, have been exhibited and published as fine art, but only by denying the social context of their production. The individuality of the makers as women craftworkers is disguised under anonymous collective types, and their works have been treated in formal artistic terms as if they were paintings, taken out of the context of the rich social significances that gave meaning to

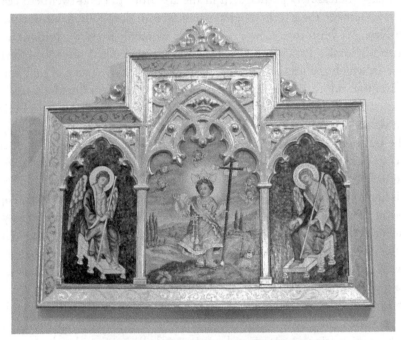

Figure 52 These images from a church at Mula in southern Spain all commemorate Fray Pedro Botia's vision of the Boy Christ in the mid-seventeenth century. The antique painting, the altar figure in its opulent setting, the tile painting, and the academic sculpture of the visionary himself each represent different categories within the value hierarchy of the art world, from folk art to fine art. (Ben Burt photos)

their production and use. Such gestures by the art galleries have done little to make tex-
tile work an acceptable medium for gallery art by Western women artists. As Parker and
Pollock concluded, the Western concept of art, from its inception in the Renaissance to
its florescence in the twentieth century, became an increasingly masculine category that
admitted women and their work only on its own terms.

Although art historians have exposed the inequities of class and gender discrimina-
tion within Western art and art history, they remain committed to the Western ideology
of art. From this position, they struggle to understand exotic artefact traditions because
of reluctance to attempt a universal theory with the power to make impartial cross-
cultural comparisons. Art historians tend to regard the anthropological treatment of art
as an aspect of all human culture as ethnocentric or colonial, but we do not have to allow
a Western definition to monopolize a useful cross-cultural concept if we can redefine it
in terms that have some comparative value, as argued in Chapter 10. Rather, we should
reconsider the artefacts which the West regards as art in order to demystify some of the
criteria used to distinguish them from artefacts that are not art. Art historians, philoso-
phers, and connoisseurs may focus on the fine art of non-utilitarian symbolic objects
made for contemplation, but we can also see them as commodities for sale, as status
symbols, as stores of wealth, or as a variety of other things revealed from a comparative,
anthropological perspective on Western culture.

ART AS COLLECTIBLES

We can better compare the Western ideology of art with other traditions by looking at
some of the interests it serves. The avowed purpose of art, particularly fine art intended
for contemplation, is display, and this is presumed to apply even to artefacts created long
ago, such as religious icons, conspicuous luxury goods, and public monuments. The dis-
play of artefacts as art became increasingly public from the eighteenth century, with in-
stitutions like the Paris Salon and the Royal Academy in London holding exhibitions of
new paintings for sale. Public exhibitions of art, from private collections and from the
growing public collections of museums and art galleries, became ever more popular in
the nineteenth century and continued to proliferate during the twentieth century. Vir-
tual exhibitions also developed in the course of the twentieth century, as improvements
in photography and printing allowed the publication of print reproductions, illustrated
books, and magazines, which brought images of art into the homes of its enthusiasts.

Whether art exhibitions feature the work of particular artists or art styles, permanent
collections or temporary assemblages, from public or private sources, for viewing only or
for sale, they all celebrate the artefacts as objects to be collected. This is central to the role
of art in Western society, and art objects have increasingly been co-opted from categories
of artefact that are collected but not made primarily for exhibition. Such artefacts are
often relegated to the less prestigious category of decorative or applied art, but as such

they can still be exhibited and hence bought, sold, and collected. Art can continually expand its boundaries in this way because of its inherently ambiguous definition, and it does so opportunistically because it is also a store of monetary value. The surplus capital of metropolitan elites can be invested in collectible artefacts, the exchange value of which is enhanced by their scarcity and acceptability to the art world that shapes the values of artefact exhibition. In the same way that collecting defines museums, so it defines art. As Nigel Barley of the British Museum noted of his African pottery exhibition in 1994, "It is probably more than a coincidence that this 'disappearing' pottery is the latest African artefact to enter the Western art market. The beauty, elegance and ingenuity of African pottery are beginning to gain wider appreciation just as the sales catalogues announce its imminent extinction" (Barley 1994:9) (as demonstrated in the British Museum's Africa galleries; see figure 59, page 187).

CONSUMER COLLECTING

In *Collecting in a Consumer Society*, Russell Belk (1995) has shown how the artefacts treated as art gain value from the practice of collecting, as a pervasive feature of the Western culture of material consumption. He defined collecting as "the process of actively, selectively, and passionately acquiring and possessing things removed from ordinary use and perceived as part of a set of non-identical objects or experiences" (1995:67). Belk explained how, in search of prestige and self-esteem within their community of shared interest and society at large, collectors may justify their accumulation of artefacts as having intellectual value; as contributing to historical knowledge, art, or science; and as preserving cultural capital for public benefit. They seek completeness in fulfilling their chosen categories and admire the expertise required to achieve it. They value above all the scarcity that makes their achievements rare and competitive, measured by value in the market that circulates the artefacts among collectors. Within this market, there is a hierarchy of prestige and price, from beer mats through postage stamps to art at the top, distinguished from craft and non-art and with its own hierarchy from decorative to fine. The art collector's expertise is elevated above the beer-mat collector's trivial knowledge and the stamp collector's erudition to become the connoisseur's aesthetic judgment. This hierarchy of collecting is also one of wealth and class, for although there are beer mats priced higher than some stamps, and stamps higher than some art, it is art that commands the highest prices of all. These prices also reflect a hierarchy of scarcity, the original art at the top being unique, with certified reproductions of limited quantity being of lower value, and mass-produced copies lower still. By insisting on originality, the upper classes maintain the value of their collectibles against the challenge of copies, from deceptive fakes to manufactured imitations.

The commercial value of fine art is maintained by an international network of wealthy collectors and dealers who negotiate the collectability of paintings and sculptures according to assessments of taste and fashion, personal means, and preferences, to buy and

sell them for sums measured in millions. Sales at auctions, art fairs, and dealers' galleries are social events where such issues are discussed among people conscious of the status conferred by connoisseurship as well as wealth. The socializing continues at receptions for exhibitions at museums, galleries, and festivals, where critics and curators become involved, legitimating the private art world by mediating with the public at large.

Belk also examined how museums provide public legitimation for collection values by acquiring, authenticating, and exhibiting artefacts that represent the collecting culture of the bourgeoisie who found, endow, and patronize them. Museums are particularly effective in making artefacts sacrosanct; set aside from normal use and commercial exchanges that always threaten to compromise their transcendent artistic values and the superior motivations and judgments of their collectors: "the grand and imposing temple architecture of museum buildings, their traditional glass-case hands-off distanced displays, and their solemn tomb-like demeanor, are intentionally off-putting for members of the lower social classes" (1995:108). World Fairs promoted more popular participation, exhibiting exotic products as decorative rather than as fine arts for commercial as much as connoisseurial purposes. They contributed to the foundation of museums in Europe and America, but of decorative art, ethnography, or technology rather than fine art.

During the twentieth century, the elitism of fine art collecting, based on artists who were antique or at least dead and whose work was thus in limited and predictable supply, was deliberately challenged by avant-garde painters and sculptors rebelling against the artistic establishment. Whatever their intentions, they too were adopted as producers of collectible art. The novelty of the Impressionists, followed by Cubists, Futurists, Dadaists, and so on in the early twentieth century, was in their popular everyday content as well as experimental styles and techniques. By the 1920s, such movements had revolutionized the values of art appreciation to the extent that they were exhibited and collected on similar terms to conventional art, while at the same time making novelty itself collectible and hence marketable. Subsequent movements flirted with ever more popularist or anti-elitist images, ostensibly revolutionary but actually following a pattern of rebellion that allowed each new generation to incorporate itself into the art establishment by gaining temporary ascendancy. In the latter twentieth century, the incorporation of commercial artefact fashions into fine art through movements such as Pop Art was matched by the promotion of such artefacts to art in their own right, through museum displays of advertising images like the Coca-Cola exhibition at the Royal Ontario Museum in 1991, and of fashion company products like the Royal Academy's Armani exhibition of 2003–4. This combined with the corporate sponsorship of exhibitions to involve museums in the promotion of commercial companies, lending them some of the prestige sought by private collectors as discerning supporters of high culture acting for the public good. Corporate collections of art serve a similar purpose when exhibited in company accommodation, while serving also as commercial investments. The effect is to obscure the crude, self-interested, and often controversial pursuit

of profit through commercial exploitation, by what Belk called "the sacralizing, elevating, and cleansing power of art" (1995:117).

THE ART BROKERS

For this system to work, it is essential that distinctions be maintained between art and other less worthy artefacts and exhibitions. Art galleries must be distinguished from even the most artistic of shop-window displays, and originals and "limited edition" reproductions from mass-produced artefacts purchased for domestic display. Other ideological proprieties also have to be observed to avoid undue conflict with the political establishment. Hence the products of artists who rebel against artistic convention can be co-opted as collectible novelties, but conventional artefacts sponsored by hostile regimes, such as statues of unpleasant dictators, are defended from destruction only if they survive long enough to become ancient monuments.

These are the kinds of judgments made by collectors and patrons, artists and dealers, art historians and curators, and other professionals who manage relationships between the art world and the broader public on whose support it ultimately depends. As art brokers, they need a good analytical understanding of the relationship between collecting, commerce, and public institutions. In a report from Arts Council England, Louisa Buck (2004) explained the role of private collectors and public collections in defining and giving market value to contemporary art, both "art by living artists" and the more speculative and prestigious "challenging contemporary art."

> the key difference between contemporary art and other luxury goods is that virtually all the elements operating within the market—the producers, suppliers and consumers—regard the public gallery or museum as the ultimate resting-place for the work they make, sell or buy. For the artist, achieving this aspiration still means that the work is in the optimum position to find its place in the history of art; for the dealer it is a sign that they have successfully managed an artist's career; and for the buyer donating an artwork to a major public collection, it is both a symbol of philanthropy and a sign of discernment. . . .
>
> In order to aspire to be considered "museum quality" an artwork has to be advocated, debated and endorsed by a network of experts within both public and private sectors. This comprises artists, curators, academics, art teachers, critics, collectors and dealers, all of whom make up a constantly shifting series of sub-groups with a number of key institutions at their core. To enable this process to function, it is crucial that these groups present a finely tuned interplay between both public and private sectors. If a sufficient number of these individuals hold the same views and combine to support the same artist then this consensus amounts to an endorsement. It is this dynamic which both characterises and drives the contemporary visual arts world, and within it, the market. The public sector is an indispensable part of this

equation but . . . it relies heavily on commercial elements to introduce artworks at key points, to support artists throughout their careers and to power them through the various permutations of the art market. (Buck 2004:12–14)

"Conceptual art," the most "challenging contemporary art" of Buck's analysis, is an extreme but telling example of the role of Western art as prestige commodity. Because its value depends so heavily on novelty, unlikely artefacts can be exhibited in art galleries to make symbolic points on the basis of "art is what artists do." Hence an artefact made for practical use can be incorporated into art, like a urinal turned upside down and signed by Marcel Duchamp, and an animal can be made into an artefact by pickling and adding a clever label. The broker's task is to negotiate acceptance by the art world, as Buck described, while maintaining the prestige of the genre in the eyes of an often skeptical public.

GLOBALIZING THE ART WORLD

The art world is firmly rooted in the upper and middle classes of Europe and North America, but the elites of other regions of the world have long been seeking membership. Since the latter twentieth century, "biennale" festivals exhibiting contemporary art have become increasingly popular, held in major cities around the world on alternate years. These were inspired by the Venice Biennale, running since 1895, which was copied by São Paulo in Brazil in 1951 and by an increasing number of venues ever since, reaching forty or more in the first decade of the twenty-first century. Most bienniales are in Europe and countries of European settlement, especially in South America but also in North America, Australia, and South Africa, but non-Western countries have also held them, beginning with Japan, then India and China, and, in the twenty-first century, Taiwan, Indonesia, and Angola. Biennales give the host city and country international recognition in the art world and beyond, which gains political support for the artistic ambitions of the organizers. Cities beyond the metropolitan art centers, including São Paulo when it started the trend, involve artists and art brokers from those centers, who participate to enhance their own international reputations. Exhibitors are often sponsored by their home states, inevitably serving state identities and interests, with over seventy national pavilions at Venice in the twenty-first century. So although the spread of biennales has been said to make the art world more open and diverse, it does so by incorporating more and more countries into an international system dominated by the art values and interests, institutional and commercial, of the Western art establishment.

The interests of the art world, in accordance with the values of Western art and economics, lie in continuous innovation and expansion to incorporate new kinds of artefacts and new markets for them. In the twenty-first century, new opportunities are offered by the increasingly wealthy elite of China, who are collecting contemporary art by Chinese artists, with a traditional Chinese preference for paintings. In 2011, an article,

published appropriately in *The Economist*, pointed to the need for "bona fide collectors" of connoisseurship and commitment, for "reliable dealers," sales galleries, and public museums, in order to develop the "Chinese art world." A spokesman for the exclusive Chinese Academy of Art spoke of "high-value goods" and the need to "develop a brand," like other products for the international markets that Chinese contemporary art aspires to join (*Economist* 2011). While the values of the art world are continually negotiated among artists and brokers, collectors and curators, and even by the generally disregarded skeptics who enjoy debunking them, they remain firmly grounded in the economics of collecting as consumerism and investment.

QUESTIONS FOR DISCUSSION

- What do the Western artefacts made and exhibited as art have in common with the products of other cultures that Westerners treat as art?
- How far do the hierarchies of value applied to Western art reflect the artistic values that the art world professes?
- Is there such a thing as art for art's sake, as the art world proclaims?

FURTHER READING

- Gretton's "New Lamps for Old" is a chapter in Rees and Borzello's *The New Art History* (1986), which also contains critical reviews of art historical developments in the Introduction and in a chapter by Overy.
- Pooke and Newall in Chapter 6 of their *Art History* (2008) review issues of gender.
- Belk's book *Collecting in a Consumer Society* (1995) has much to say about the social roles of art objects.
- Sotheby's, Christie's, and other art dealers illustrate art-world values in their published sale catalogs.

12 THE EXOTIC PRIMITIVE

The art world's fascination with colonial notions of primitive culture has motivated the Western collection of exotic artefacts and influenced its own painting and sculpture. Combined with the trade in such artefacts and their exhibition in museums, this raises issues of the appropriation and representation of the cultural heritage of certain exotic peoples.

Outline of the Chapter

- Primitivism and Primitive Art
 Colonial stereotypes of Africa and artefact collections from Benin and the Congo.

- Adopting Primitive Art
 The appropriation of small society artefacts to critique Western art and culture in the Primitivist art movement of the early twentieth century, and its legacy in art museums.

- The Primitive Art Market
 The price, the costs, and the rewards of collecting authentic primitive art.

- Exhibiting Exotic Artefacts
 Cultural contexts and connoisseurship in exhibitions at the British Museum and its Museum of Mankind.

The Western world's constant search for new art to collect and exhibit extended to the artefacts of those it colonized. People have always valued exotic artefacts and traded useful, curious, and prestigious imports from places they know little or nothing about. New Guineans exchanged shell artefacts from the coasts, community by community, up to the highlands, where people had never heard of the sea. Chinese factory workers made porcelain for Europeans long before either knew anything more about each other. But industrial capitalism created a new kind of market for exotic exports through the mass consumption of goods which conferred prestige as symbols

of the world that Europeans sought to dominate. While all societies define their own cultural identity by contrast to exotic others, the Western tradition does so in particular ways, with an underlying assumption of superiority deriving from a history of colonial mastery. Accordingly, exotic artefact traditions have been appropriated by the art world with condescension, ranging from patronizing to hostile, evoking stereotypes such as Orientals and primitives.

PRIMITIVISM AND PRIMITIVE ART

The idea that certain peoples were primitive, representing the ancient antecedents of the Western civilization that was destined to improve or supersede them, was at first an impediment to the appreciation of their artefacts, which were long collected as "curios" rather than as "art." The self-serving attitudes of this primitivism, developed during the Atlantic slave trade, were perpetuated in European colonialism of the late-nineteenth to mid-twentieth century and deserve examination to explain their social implications.

THE BELGIAN CONGO

The Congo Free State, a private colony of King Leopold of Belgium, was one place where these implications were most severe. Leopold defended his enterprise in 1898:

> The mission which the agents of the State have to accomplish is a noble one. They have to continue the development of civilisation in the centre of Equatorial Africa . . . Placed face to face with primitive barbarism, grappling with sanguinary customs that date back thousands of years, they are obliged to reduce these gradually. They must accustom the population to general laws, of which the most needful and the most salutary is assuredly that of work. (Burrows 1898:285)

A generation later, in 1925, the American Alexander Powell traveled to the Congo for a romantic primitivist experience: "to know the awful solitude of the tropic bush; to watch the naked blacks leaping and whirling to the thunder of the tom-toms in some fire-illumed forest clearing; to float for day after day, week after week, down dark mysterious rivers" (1925:9). He justified Leopold's colonial enterprise with the economic development theory of his time:

> The black man who grows cotton in the Sudan or raises rubber in the Congo is helping to support the family of a cotton-spinner in New England, to provide work for the employees of the tyre-factories in Ohio, while the latter are helping to pay the wages of an African labourer. . . . The black man who is absolutely self-contained, neither producing for export nor requiring any imports, has no place in the world's

work. That is why so many close students of African conditions have become con-
vinced that in some system of forced labour—ugly as is the name—lies the sole hope
of developing the vast resources of the continent and raising the status of the native
himself. (Powell 1925:229)

However, opponents of Leopold's Congo had long since exposed the ugliness of this
forced labor (the British Museum *Handbook*'s "unfamiliar influences" that could disturb
the "mental balance" of "primitive man"; see page 53) in that most unhappy of colonies.
As Edmund Morel wrote in 1904:

> the men pass nearly the whole of their lives in satisfying the ceaseless demands of
> the "Administration", or its affiliates the "Trusts"; whether it be in the collection of
> rubber, of gum-copal, of food-stuffs, or forced labour in government plantations, or
> in the construction of those "fine brick houses" on which the apologists of the State
> are forever harping. Women and children do not enjoy as much protection as a dog
> in this country. (Morel 1904:242)

Despite their contempt for the peoples they were incorporating into their global em-
pires, Europeans were often fascinated by their artefacts. Two important African collec-
tions that came to the British Museum in the 1890s and 1900s illustrate the developing
realization that African artefacts could be treated as art.

BENIN, NIGERIA

The British conquest of the kingdom of Benin in what is now southwest Nigeria has
been recounted by Annie Coombes in her book *Reinventing Africa* (1994: Ch.1). Having
provoked an attack on their diplomatic mission seeking trade concessions from the king
of Benin, in 1897 the British invaded and looted from the royal palace vast quantities of
artefacts of a quality and style quite new to Europeans of the time. Within the year, these
were being exhibited in the British Museum and other museums, where they attracted
the attention of the popular press as well as scholars. The general reaction was incre-
dulity that such sophisticated artefacts, particularly the lost-wax brass castings, should
be found in Black Africa, where local culture was regarded as crude and uncivilized.
The press illustrated the artefacts with predictable comments on the savagery of Benin,
emphasizing the civilizing mission of the British conquest rather than their trading
interests.

> Although little authentic knowledge of the Benin people is current, the main char-
> acteristics of the surrounding tribes are thought to be theirs also in an intensified
> degree, finding expression in habits of disgusting brutality and scenes of hideous
> cruelty and bloodshed, ordained by the superstitions of a degraded race of savages.
> (*Illustrated London News* 1897:123)

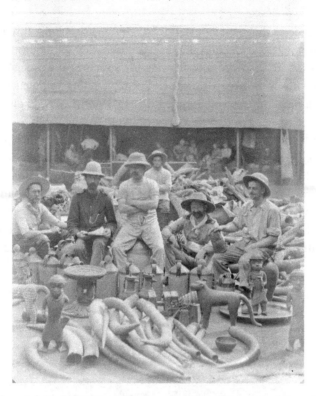

Figure 53 Members of the British invasion force with artefacts from the palace of Benin in 1897. (The Trustees of the British Museum; Af,A79.13)

The contradiction was explained under the familiar cycle of civilizations theory, supposing that contemporary Benin had degenerated from some earlier state of civilization deriving either from ancient Egypt or from trade with the Portuguese, which dated back to the end of the fifteenth century, or both. When the British Museum exhibited three hundred of the brass plaques that had decorated the pillars of the palace (like that shown in Figure 29, page 104), on loan from the Foreign Office, this provoked some scholarly reappraisal. Richard Quick of the Horniman Museum described Benin artefacts as "valuable works of art," as distinct from curios or relics, as they were first regarded. Henry Ling Roth of the Bankfield Museum made a technical and artistic appraisal of the plaques, concluding that they predated Portuguese contact and were of African origin. By 1899, Ormond Dalton and Hercules Read of the British Museum were questioning the degree of Egyptian influence on the brass-castings. This may have reflected a desire to raise the status of the Ethnography Department's collections, overshadowed in the British Museum by Egypt, particularly after disappointment at the Foreign Office selling off a third of the plaques to raise money for the colonial administration.

KUBA, THE CONGO

In the first decade of the twentieth century, the Hungarian Emil Torday, an employee of the Congo Free State, began collecting and documenting local culture with rather more sympathy and respect than was usual among Europeans of the time. When he struck up a relationship with the British Museum and began sending shipments of artefacts, those from the Kuba kingdom were so admired that in 1909 they were displayed in a case of their own.

Compared to the west and central African sculpture with which scholars and curio collectors were already familiar, Kuba artefacts were much easier for most Europeans to understand. The carving was generally geometric surface decoration, and the few figurative sculptures looked like attempts at naturalism. Torday's accounts of the courtly gentility of the Kuba kingdom and its apparent isolation from foreign contacts encouraged writers of the time to consider its works as art, in almost European terms. Torday's British Museum collaborator T. A. Joyce and his colleague Dalton gave them a special mention in the 1910 *Handbook to the Ethnographical Collections*:

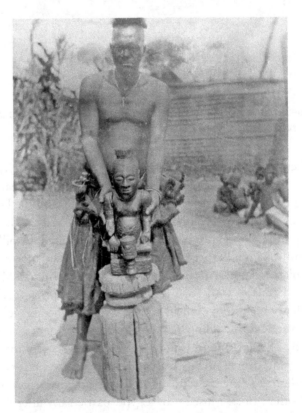

Figure 54 Torday's photograph of a Kuba official with an image of a former king, which he obtained for the British Museum. (The Trustees of the British Museum)

The art of the Bushongo [the Kuba ruling clan] is remarkable: not only are their wood-carvings exceedingly graceful in outline and covered with patterns of singular beauty, similar to the embroidered designs on their cloth (which often recall our "Late Keltic" period, Pl.X), but the art of portraiture is practised amongst them, and the wooden statues of their early kings are the most striking products of indigenous African art. (British Museum 1910:222)

This was a great compliment in a book devoted mainly to arid lists of cultural traits and their distribution among various so-called tribes of Negros of higher or lower types, with little said of Benin sculpture except "the Bini acquired the art of bronze casting by the cire perdue process from the Portuguese of the sixteenth century" (1910:241). Academic praise may not have done much to change popular European attitudes to Africa, which their authors broadly shared, but it did prepare museums to participate in an emerging enthusiasm for primitive art.

ADOPTING PRIMITIVE ART

Primitive art actually gained popularity from the work of European painters and sculptors who discovered the idea in the 1900s. Artists, dissatisfied with the tradition of idealized naturalism inherited from the Renaissance, began to see alternative formal principles in the sculpture of Africa and the Pacific Islands, which appeared to express new moral values. They made a virtue of prevailing European primitivist ideas to convince themselves that the small colonized societies that produced such artefacts represented humanity unconstrained by the stale and repressive conventions of civilization—natural, instinctual, and primal. In providing inspiration for rebellious, discontented artists to shock the art market, primitive art began also to inspire the connoisseurs, collectors, and curators of art, who were so much more influential than the anthropologists and museum curators who had studied it until then. By the 1910s, they were using African sculpture to support a formalist theory of art that discounted the history and symbolic content of artefacts on the basis that remarkable aesthetic qualities could be produced by peoples without a culture of art appreciation. The assumption that Africans worked more by instinct than intellect, as primitives who barely understood what they had achieved, was all the art world needed to know.

Appreciating the form of a painting or sculpture without considering its content is rather like listening to a song while ignoring the words. This is particularly appealing if the song is in a foreign language, for its tune can be interpreted in the imagination with less fear of contradiction. So formalist theory gave Western artists and art critics a way of interpreting exotic artefacts by imputing significances to the form without the need to understand the content intended by their society of origin. These were the terms under which European artists and connoisseurs came to adopt certain non-Western artefacts as art, particularly the African and Pacific Islands sculpture that appealed to the Primitivist

art movement. William Rubin of the Museum of Modern Art in New York summarized these developments for his exhibition *"Primitivism" in 20th Century Art* in 1984:

> The "discovery" of tribal art by vanguard artists between 1906 and 1908 was a case of new insights illuminating objects that had been known for years. Tribal art had not been a buried treasure. Paris' Musée d'Ethnographie du Trocadéro (now the Musée de l'Homme) opened to the public in 1882 with a considerable collection. International exhibitions, such as those in Paris in 1889 and 1900, showed tribal art. Curio shops also offered a number of objects—including Kota reliquary figures—for decades before modern artists began collecting them.
>
> The "discovery" depended primarily on a change in Western artistic attitudes. Tribal art had no relevance to the fundamentally realist aesthetic concerns of the Impressionist generation. Among post-Impressionists, only Gaugin was seriously intrigued by the lessons tribal objects could offer. It was only after the shift towards less realistic, more conceptual ways of depicting . . . that modern artists were prepared to see tribal art as a significant source of inspiration.
>
> More was at stake than just formal issues. Picasso responded with intense emotion to a magical force he sensed in the objects he encountered at the Trocadéro museum. He regretted that the Western tradition had lost touch with the primordial sense of image-making as a magic operation. Tribal art led him back to such origins. (1984:17)

By Rubin's time, primitivist attitudes were changing, with "primitive peoples," euphemistically described as "tribal," governing their own independent states since the decolonization process of the 1960s and 1970s. The Metropolitan Museum of Art in New York demonstrated a growing respect for primitive art in 1969 when it absorbed the Museum of Primitive Art, founded in 1954 by the collector Nelson Rockefeller. In the British Museum's Museum of Mankind, this trend was represented by William Fagg, who applied Western art-historical methods to his research into African art. In *The Tribal Image: Wooden Figure Sculpture of the World* in 1970, he took advice from the sculptor Leon Underwood for "an exhibition chosen by sculptural standards alone" (Fagg 1970; junior colleagues nicknamed it Paddington Station for all the figures standing as if waiting for trains). Rubin wrote of *"Primitivism" in 20th Century Art*:

> Modern Western culture owes a spiritual debt to the tribal societies of Africa, Oceania, and the Americas. Their arts have broadly and profoundly enriched the vocabulary of twentieth century painting and sculpture. This exhibition examines the influence of tribal art on modern art, the affinities they share, and the nature of modernist primitivism as a force in Western art over the past century. (1984:1)

However, Rubin's exhibition was criticized for presenting exotic artefacts as contributions to the Western art on display, rather than as works of art in their own right,

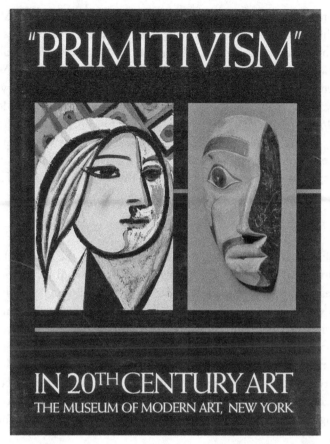

"PRIMITIVISM"

IN 20TH CENTURY ART
THE MUSEUM OF MODERN ART, NEW YORK

Figure 55 The cover of Rubin's exhibition catalog, comparing part of a painting by Picasso with a Northwest Coast Native American carving. (Museum of Modern Art, New York, 1984. © SCALA, Florence)

and this raised issues of how primitive art should represented. In 1988 the exhibition *Art and Artefact*, curated by Susan Vogel of the Museum of African Arts in New York, sought to demonstrate how attitudes to African artefacts as art reflected Western rather than African categories. Similar artefacts were displayed in the contrasting modes of the art gallery, the ethnographic or natural history museum, including contextual dioramas, and the private curio collection. The purpose was to make audiences aware of how their responses to the artefacts were conditioned by the usually unacknowledged exhibition policies of museum curators. The fact that the art-gallery setting elevated a bundle of hunting net to a work of art in the eyes of many commentators demonstrated above all the capacity of the art world to appropriate whatever it fancied (Vogel 1996).

In 1989, Jean Herbert Martin presented an exhibition at the Pompidou Centre in Paris entitled *Magiciens de la Terre*. This was intended to counter Eurocentric colonial attitudes and remedy the approach of the Paris biennale international art exhibitions, which only

included non-Western artists who worked in the Western tradition. Martin presented work from fifty Western modern artists and fifty non-Western cultures, all selected according to the same artistic criteria, which were his own Western art values. This represented a growing fashion in the late twentieth century for treating non-Western artefacts as if they were Western works of art, the products of individual creativity to be exhibited in art gallery rather than ethnographic museum contexts. In 1995, the Royal Academy's exhibition *Africa: The Art of a Continent* in London for the Africa95 festival presented, in an art-gallery setting, a conventional selection of what to many was still primitive art. But this and other such art exhibitions now included artefacts such as pots, baskets, textiles, and weapons; all co-opted, with sculpture, into the Western category of art.

THE PRIMITIVE ART MARKET

These exhibitions contributed to a debate through which the art world eventually convinced itself that primitive art, as tribal or primal art, should be accepted on the same terms as Western art, rather than as understood by anthropologists and ethnography curators. As such, it became subject to similar criteria of aesthetic appreciation and authenticity, with certain qualifications. Being primitive, the makers were usually anonymous, so instead of being credited to named artists, artefacts had to be authenticated as deriving from an identifiable primitive art tradition and made by a traditional person in traditional style for a traditional purpose. This ensured its scarcity and collectability, for, as Shelly Errington observed, "Dealers would unhesitatingly explain to customers who were resisting the high price of a tribal artefact, 'But they're not making it anymore'" (1998:3–4).

AUTHENTICATING PRIMITIVE ART

The criteria for authenticity applied to primitive art were described for African art by Sidney Kasfir in 1999 as based on the notion of precolonial traditional cultures—pristine, isolated, and timeless—in which art was made for local purposes. This approach ignored the contradiction that the artefacts had been collected by outsiders and denied the colonial relationship between them and the producers. It noticed the effect of colonial change upon the art only when it offended the collector's taste and paid little attention to comparable cultural developments of earlier eras. It often denied the possibility of precolonial history and created an "ethnographic present" at the eve of colonization, as if the society had henceforth ceased to have validity as a source of artistic production, emphasizing the destruction of culture rather than its transformation and continued existence. Creativity was attributed to cultures rather than individuals, who were left anonymous and bound by tradition, thus giving artefacts the mystical character of "otherness" that allowed the collectors to imagine primitive culture as homogenous, standardized, unconscious, segregated by ethnic group, and producing exotica such as fetishes and fertility symbols.

Kasfir pointed to the irony that, with conformity as a criterion for authenticity, replicas of fine old carvings would be dismissed by collectors as fakes, although the carvers might well be acknowledging the artistic value of the original while producing whatever was required by the purchasers, whether collectors or local users. Her point was that notions of authenticity imposed colonial criteria for what African art should be, denying African perspectives and prejudicing evaluations of what they actually made.

As authentic primitive art, exotic artefacts became commodities to be bought and sold on the lucrative international art market through which wealthy countries stocked their public and private collections. The irony was that the people who produced authentic primitive art, almost by definition, did not regard it as art at all, although they might value it just as highly as religious symbols, relics, heirlooms, and the other things that made it authentic to collectors. Since these people also tended to be poor and powerless relative to the collectors, they could easily be dispossessed by sale, fraud, or theft. Colonial looting may have ceased, but unethical and illegal dealing in primitive art continues unabated. The international art market is inevitably implicated in innumerable local tragedies, which include the loss of religious relics and ancestral heritage (see overleaf), the looting of ancient archaeological sites (as in Peru, see Chapter 9, and Ecuador, page 231), and theft from the museums of poor or war-torn countries.

JOINING THE WORLD ART MARKET

The primitive art sector of the art market received a boost in the 1970s from the sale of some old private collections, and it has been expanding ever since. It is promoted by auctioneers like Sotheby's and Christie's through increasingly lavish illustrated sales catalogs with collection provenances and ethnographic commentaries to affirm authenticity in art-historical terms. At the top end of this market, wealthy collectors, dealers, and auctioneers form a select international network, which also involves museum curators. Even if curators seldom have the funds to purchase on the open market, they provide essential services of identification and authentication, personally and through exhibitions and published catalogs. In return, public museums continue to benefit from the donation of private collections and sponsorship by wealthy collectors. The close relationship is revealed in museum galleries, academic posts, and collaborative publications bearing the names of wealthy collectors and dealers. At the British Museum, one obvious conflict of interest has long been recognized in a strict rule forbidding staff from giving valuations.

According to Shelly Errington (2005):

> The state of so-called primitive art during the twentieth century can be summarized briefly. Pronounced "art" by Picasso and Vlaminck in the early years of the century, allied with modernism and displayed in the homes of prominent collectors in the twenties, inspiration to the Surrealists and scourge of the Nazis in the thirties, promoted and displayed by collector Nelson Rockefeller and Museum of Modern

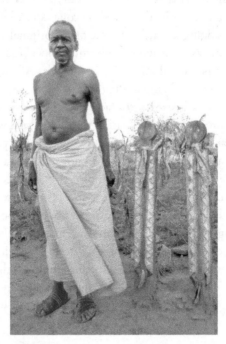

Figure 56 In 1985, anthropologist Monica Udvardy photographed Kalume Mwakiru, a Mijikenda man of Kenya, with the memorial posts for two of his deceased brothers. Shortly afterwards, in a calamitous loss to his community, the posts were stolen and sold on the international African art market.

The Mijikenda carve such posts as incarnations of dead members of their fraternal society, to appease their spirits and garner spiritual support and protection, as plain posts do for ordinary ancestors. The posts should remain in place even when the living have moved their homesteads away and if they are disturbed the spirits would bring misfortune to their descendants as well as to the offender, who might go mad. However, in the 1980s and 1990s, these dangers were not enough to deter certain local men, who seem to have used their own protective magic to steal many of the carved posts and sell them to Kenyan and Western art dealers. The elders felt these sacrileges should be punished by the same fine as for murder and blamed them for various local natural and community disasters.

Many of the stolen posts were purchased and exported by a particular American art dealer who was well aware of their local significance, having done his own research among the Mijikenda. There were several hundred in American museums, which must all have been stolen, as their new owners would have concluded if they took an interest in their cultural significance. With no protection under Kenyan law against the illicit trade in such artefacts, the Mijikenda could only guard those that remained and hope that publicity for their case would do something to counteract the power of the art market.

In 2000, Udvardy found these particular posts in American museums and, with her colleagues, arranged their return to the Mwakiru family in 2007. (Udvardy, Giles, and Mitsanze 2003; Monica Udvardy photo)

Art director René d'Harnoncourt in the thirties and forties, institutionalized in the Museum of Primitive Art in the fifties, celebrated by art historians and anthropologists in the sixties, embraced by a broad spectrum of the collectors and public in the seventies, primitive art reached its institutional peak in 1982 with the opening of the Michael C. Rockefeller Wing at the Metropolitan Museum of Art. It reached its marketing peak the same year, evidenced by its appearance in the home furnishings department of Macy's of San Francisco. Finally, the Museum of Modern Art's 1984 exhibition "Primitivism" in twentieth Century Art laid it to rest and canonized it as a dead master, providing its first retrospective, which showed its influence on early twentieth-century (dead) masters of modernism. Like the work of all masters who have major posthumous exhibits, the price of primitive art rose after its 1984 MoMA retrospective. That show certified it as a safe investment of excellent taste: the opposite, in short, of avant-garde, edgy, and adventurous, which it had been for collectors back in the 1930s.

EXHIBITING EXOTIC ARTEFACTS

The adoption of primitive art by the Western art world has important implications for the way the cultural traditions concerned have been represented in museums, galleries, and publications. The connoisseurial approach of art appreciation has been influential but has been challenged, not least by the British Museum.

THE MUSEUM OF MANKIND

In 1970, the British Museum began a twenty-five-year experiment with alternative approaches when it opened the Museum of Mankind to house its Ethnography Department on temporary exile from the main site (see page 18). Until then, the British Museum had exhibited a representative sample of its enormous ethnography collections in a kind of visible storage arranged by culture areas, but the new policy of the Museum of Mankind was for a program of temporary exhibitions illustrating particular cultures or cultural themes in depth. Many Museum of Mankind exhibitions deliberately challenged colonial stereotypes and raised issues of cultural representation.

The first Keeper of the Museum of Mankind was William Fagg, whose *The Tribal Image* was not at all typical of its early exhibitions. In 1970, Fagg curated *Divine Kingship in Africa*, which featured a modest stylized courtyard from Benin in Nigeria, its pillars covered with brass plaques, and an altar with brass effigies and carved elephant tusks. This was the first of many attempts by several curators to present artefacts in reconstructions of their original context. In 1974, *Yoruba Religious Cults* displayed a large collection of ceremonial artefacts as they would have been stored, in alcoves around a realistic mud-walled, iron-roofed cloister supported by carved posts. In 1976, for the World of Islam Festival, the exhibition *Nomad and City* presented positive images of Arab culture by taking visitors past a fully furnished Bedouin tent, then through a market street, a kitchen, and a

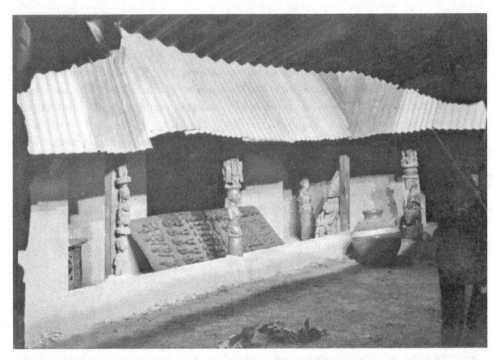

Figure 57 The courtyard of the Museum of Mankind's *Yoruba Religious Cults* exhibition, with carved posts and a pot to catch the rain. (The Trustees of the British Museum)

men's sitting room in urban Yemen. In 1981, the spaces became *Asante: Kingdom of Gold*, with a village and royal palace in Ghana. In 1982, there was also *Vasna: Inside an Indian Village*, with a contemporary house as if its occupants had just left, a real cart drawn by fiberglass bullocks, and a small shrine where Hindu visitors sometimes left offerings. In 1985, there was the interior of a Tukano communal house from Amazonia, with model inhabitants, and in 1986 there were houses, village scenes, and a tomb from Madagascar. In 1987, *Living Arctic* challenged stereotypes of Native American life with reconstructions of contemporary homes; a Cree tipi, a Dene log cabin, an Inuit snow house, and an Inuit bungalow, inhabited by model people. Later exhibitions had less elaborate reconstructions, but continued to raise cultural issues. In 1988, *Rickshaw Paintings from Bangladesh* combined an art gallery with tableaux and photographs illustrating the hard life of rickshaw pullers, and in 1989 *Palestinian Costume* affirmed the cultural identities being denied by Israeli colonialism. In 1991, the Mexican Day of the Dead festival was illustrated in *The Skeleton at the Feast*, with market stalls, altars, and elaborate papier-mâché tableaux. The last such exhibition was *Paradise* in 1993, illustrating the changing contemporary culture of the Papua New Guinea Highlands, with coffee production and a trade store setting the scene for pig feasts and costumed dancing (as described on pages 116–18).

The Museum of Mankind did stage more conventional exhibitions, and most of the reconstructions were complemented by conventional glass cases of more vulnerable artefacts.

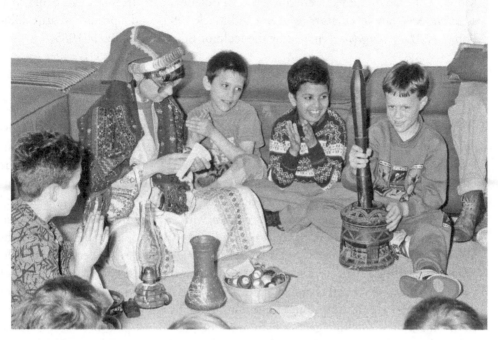

Figure 58 Palestinian historian Sonia Nimr using role-play to introduce the culture and history behind the Museum of Mankind's *Palestinian Costume* exhibition in 1990. (The Trustees of the British Museum)

But there were also activity programs for schools and other visitors, focusing on the cultural and historical issues raised by the exhibitions, many run by people from those cultures. With its programs of artistic performances, artefact demonstrations, and workshops, the Museum of Mankind became a popular venue for experiencing exotic artefacts in a broader culture context. Some critics complained that it was too "educational," that they could not see the art for the context, or that the context was more like tourism, but for many visitors the Museum of Mankind gave enjoyable new insights into non-Western cultures.

In its time, the Museum of Mankind was part of a reaction against Eurocentric primitivism by curators, educators, anthropologists, and representatives of colonized societies who had gained a voice through Western education and experience. It reflected a more general shift in Western attitudes towards its own civilization, from the triumphant modernization of the colonial period—denigrating non-Western culture as savage or primitive—toward a self-doubting critique of industrial capitalism. While some idealized the natural wisdom of original peoples living in harmony with their threatened environment, others ran practical campaigns on behalf of Third World peoples and educational initiatives in development studies, multiculturalism, and antiracism. However, the connoisseurial approach to exotic artefacts never went away, shifting from "primitive" to "tribal" and "ethnic" art with the fashions of the time. Under Fagg's successors at the

Museum of Mankind, there were conventional galleries of art "treasures," art books such as *Ethnic Sculpture* by curators (McLeod and Mack 1985), and a primitivist art exhibition, *Lost Magic Kingdoms,* curated by the sculptor Eduardo Paolozzi in 1985.

THE RETURN TO THE BRITISH MUSEUM

As the Museum of Mankind was reincorporated into the British Museum during the 1990s and 2000s, the ethnography collections went back behind glass and under spotlights, and contentious historical issues disappeared from sight. The new American galleries illustrate the trend. The rich and varied collections from Central America include Hispanic artefacts from the early colonial period and recent material from both rural Indian and urban communities. When a new gallery opened in 1992, it was sponsored by the Mexican government and was strictly *Mexico*, with artefacts from before the Spanish conquest only, displayed in a sparse, stone-clad room with sloping ceiling and plinths imitating ancient Mexican architecture. The inevitable effect was a gallery of lost civilizations whose living heirs were totally excluded. Then the Chase-Manhattan Gallery of North America, covering the United States and Canada, opened in 1999 purporting to illustrate Native culture at the outset of colonization, by culture areas (see pages 63–4). Both galleries relegated indigenous culture to the precolonial past, obscuring cultural politics by avoiding historical issues. They recalled Shelly Errington's critique of museums in Mexico presenting the Aztecs and their predecessors as antecedents of the national elite rather than of their cultural heirs among the Indian peasantry, and of those in the United States treating Native culture as "before the white man." "Simultaneously attacking the way of life of the living peoples while celebrating that way of life as an emblem of national heritage and a commodifiable tourist attraction, has become a standard move on the part of governments throughout the world" (Errington 1998:187).

Treating artefacts as art avoids such uncomfortable debates. The British Museum's Sainsbury African Galleries opened in 2000 with an introductory panel celebrating the inspiration gained from African art by its sponsors, a wealthy family of primitive art collectors, and the artist Henry Moore. It grouped artefacts of the "authentic primitive art" kind from diverse cultures across the continent according to technological and artistic categories, with minimal cultural or historical context, even for the contested collection of Benin "bronzes." Examples of African "contemporary art" were included (such as sculpture by Sokari Douglas Camp; see page 186), but not the flourishing tradition of export carvings (see pages 192–3). (An alternative approach, using the British Museum collections to illustrate the history of Africa in relation to the rest of the world, was suggested by an educational booklet; Burt 2005.) Nor was the British Museum alone; in Paris the new Musée du quai Branly opened in 2006 to present national artefact collections from Africa, Asia, Oceania, and the Americas (formerly in the Musée de l'Homme) in an exhibition style that reflected the city's prominent role in the tribal art market, also ignoring historical and cultural issues.

The art-world argument for such presentations is that the artefact traditions of other cultures deserve the same dignity and respect accorded to Western art. The argument against is that this appropriates those traditions by imputing Western art values that they do not share, while their own values are obscured by abstracting the artefacts from their cultural and historical context. Curators inevitably provide their own context for the artefacts they display, and the challenge is to take responsibility for what this communicates about the artefacts and their source communities. Depending on how it is exhibited, an African carving may remind a Western audience of its own cultural tradition of colonial primitivism and Primitivist art; reflect the artistic values of its present owners; introduce its society of origin; or comment on the colonial relationships that brought it to exhibition, among other possibilities. While connoisseurs sometimes say that "artefacts speak for themselves," when they do inevitably comment on such issues they too often simply repeat what a Western audience expects to hear.

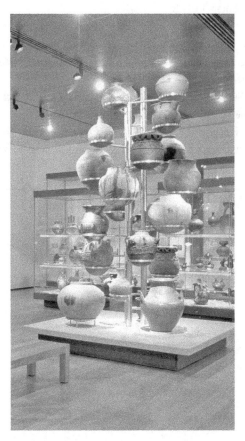

Figure 59 An artistic display of pottery utensils in the British Museum's Sainsbury Africa Galleries. (The Trustees of the British Museum)

QUESTIONS FOR DISCUSSION

- Do the attitudes of nineteenth-century primitivism still have a significant legacy in the twenty-first century?
- Is there really a problem in appreciating other people's artefacts in terms of Western art values?
- What responsibility do museums have to the people and cultures who produced the artefacts in their collections, and why?

FURTHER READING

- Coombes's book *Reinventing Africa* (1994) recounts the conquest of Benin in Chapter 1 of a study of colonial attitudes to African artefacts.
- Price's book *Primitive Art in Civilized Places* (1989) deconstructs Eurocentric prejudices, and a portion is reprinted as Chapter 10 of Morphy and Perkins's *Anthropology of Art* (2006).
- Court's case study "Africa on Display" (1999) is a critical review of issues raised by the influential primitivist art exhibitions of the late twentieth century.
- Udvardy, Giles, and Mitsanze's article "The Transatlantic Trade in African Ancestors" (2003) uses the Mijikenda case to examine ethical issues around the primitive art trade.
- The Introduction to Errington's book *The Death of Authentic Primitive Art* (1998) is a history of the concept's development. Chapter 6 examines museum representations of Native peoples in Mexico and the United States.

13 MARKETING EXOTIC ART

The Western market for exotic artefacts led to a fluorescence of local art styles adapted for sale to collectors. How have the producers of the artefacts negotiated the hierarchical art values of Western consumers, and how has this affected their own art values?

Outline of the Chapter

- Exporting Local Artefacts
 Native American and West Africans adaptations to the exotic art market.

- Reconsidering Authenticity
 Academic acceptance of the expanding trade in export art.

- Market Contributions to Local Culture
 How the export market has sustained and reconstituted local art traditions and identities.

- The Homogenization of Exotic Art
 The response of local art traditions to global fashions for "ethnic arts."

While colonizing Europeans collected artefacts to represent exotic places and primitive peoples, colonized peoples recognized opportunities to participate in commercial exchange on terms over which they had some control. Artefacts whose value had depended on relationships within and between their own communities could be made as commodities to be exported for whatever money could buy in the world beyond. But as they tried to meet the consumers' demand for collectible artefacts that were at once exotic and familiar, or at least predictable, the producers often became ensnared in the complex and contradictory system of Western art values. The way metropolitan elites constantly redefined the most prestigious categories of collectibles, in the face of overproduction and lower-class collecting aspirations, challenged them to meet ever-changing standards of value in a

market dominated by traditions of collection and display that they had very little understanding of and even less control over. The best prices depend on the scarcity value of what Errington has described as "authentic primitive art," but artefacts deliberately produced for this market risk being devalued as "inauthentic," "fake," or "kitsch" by collectors of the more prestigious categories. But there has always been a market for these things too and, with too much money chasing too little primitive art, standards of authenticity have changed to accommodate new categories of exotica such as "ethnic" or "world art."

EXPORTING LOCAL ARTEFACTS

The contradictory values of the export market have been especially challenging for indigenous minorities like Native North Americans, who became marginalized in their own lands under settler colonization. The final stages of colonizing North America in the late nineteenth century, with the dispossession of the Native peoples of the west, coincided with the rise of consumerism among their industrialized colonizers. At the same time that Native American culture was being suppressed as a matter of colonial policy, colonial tourists and artefact collectors were eager to purchase it. Making things for this market provided a source of income for needy Native communities, and one that sustained their own artistic traditions, but when they developed and adapted these traditions for the market, they risked accusations of inauthenticity.

NORTHWEST COAST NATIVE AMERICA

The development of export art on the Northwest Coast of North America for the Haida of Queen Charlotte Islands has been traced by Carol Kaufman (1976). Like others in the region (see Chapter 5 and pages 105–6), these people once decorated artefacts of all kinds with creatures of the forests and seas, often with human and other special characteristics. These were emblematic of their clan histories and sources of spiritual power invoked by shamans and by ritual performances, in which they appeared as masked figures.

The Haida traded with neighboring peoples and visiting Europeans. From the 1820s, fur companies began to establish permanent posts in their region, and increased access to imported wealth led to growing competition for status through the accumulation and ostentatious distribution of goods in giveaways or "potlatches." By this time, the most prized fur—sea otter—had been depleted, but the Haida developed a new export market in "curios" and began to carve argillite, a fine local shale, into the kind of objects that appealed to Europeans. First they specialized in tobacco pipes—more and more ornamented and impossible to smoke—then, from the 1840s, also human figures, often of Europeans, and models of European objects, from ships and houses to dishes and cutlery, with European decorative motifs.

During the nineteenth century, Haida society became increasingly destabilized by the intrusion of European settlers, Canadian government opposition to local culture, and

new diseases. After a devastating epidemic of smallpox in 1862 reduced their numbers from about 9,000 to 1,200, local commissions for ceremonial and architectural carving declined, and surviving carvers had to rely upon the export market, particularly argillite carvings. But now they decorated European-style objects with local motifs and made models of ceremonial woodcarvings, such as house-posts, chests, and, of most enduring demand, totem poles. In response to the market, they often carved clan emblems as narratives, showing creatures as part of their histories rather than standing alone. Charles Edenshaw was one of the best known of these carvers, who kept the artistic tradition alive, particularly through his argillite carvings.

By the 1870s, people were turning to Christianity and rejecting both the religious and status values of clan iconography. From 1885, the Canadian government did its best to suppress potlatching by law. When steamships began regular services along the coast from California to the goldfields of Alaska in the 1880s, they carried tourists to view the totem poles for which the Haida in particular were famous. But by the 1890s, following another smallpox epidemic, the totem poles had been abandoned to the forest and the Haida were making only models for sale to the tourists.

The history of the Northwest Coast artefact market from the turn of the twentieth century was taken up by Molly Lee (1999), focusing on Alaska and looking at the "taste culture" of the collectors. She identified three kinds of collectors.

"Tourists" would purchase a limited quantity of curios, as souvenirs of a single journey that for them was an expensive and prestigious adventure. Their curios were a way of retaining something concrete from the experience, not of great value to anyone else, but required to be authentic as genuine products of exotic people who represented the places they visited. However, they were not very rigorous in judging this authenticity, being prepared to imagine that the artefacts they acquired had some role in Native life other than simply to be sold, which for most of their purchases was obviously not the case. Most curio collectors were women, who chose objects that could be displayed as bric-a-brac in their homes, among other kinds of objects, both indigenous and exotic.

"Basket collectors" were following a craze that developed from the Art and Crafts movement of Britain and then America as a reaction against industrialization, especially among middle-class women. Native American baskets came to represent pre-industrial societies in which art was part of everyday life, and the decorative motifs were attributed symbolic religious meanings. Baskets appealed especially to women, as they were light, robust, and relatively cheap. Some collected from many Native groups; others specialized in particular areas. These collectors had a strong concern for authenticity in terms of traditional style, preferably made for local use, and eschewed the bright commercial dyes accepted by most tourists. They often went beyond the main tourist routes but also purchased from dealers in the western towns. Natives responded by reviving old-style forms and vegetable dyes to satisfy this market. The baskets were exhibited as collections to represent lost Native culture, rather than being integrated into domestic décor.

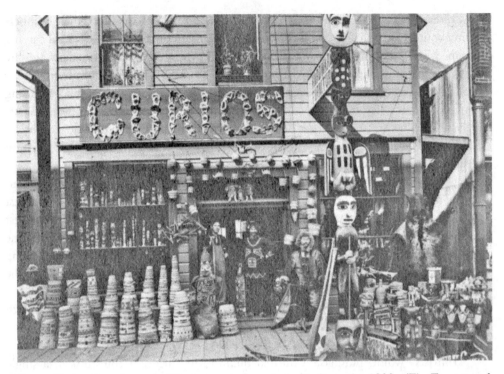

Figure 60 Artefacts from the Tlingit people for sale in Alaska in the 1900s. (The Trustees of the British Museum; Am-B59-14)

"Special access collectors" were middle-class men who worked among the Native Americans in professions such as missionaries, teachers, or government officials. They often built up large collections over the years, including a wide range of artefacts representative of Native life and ritual objects from the Native male domain. They tended to represent their collections as ethnological specimens, of scientific interest in terms of current academic theories about the primitive origins of Native culture, and sought authenticity in these terms even though most of what they acquired had been made for sale. As men, these collectors tended to display their artefacts to represent the place of origin as a natural wild environment, with animal trophies and remains, in the men's areas of their houses, such as smoking rooms and studies. Some special access collectors donated collections to museums or became artefact dealers.

WEST AFRICA

It was not only marginalized people like Native Americans who adapted their artefacts to this market; any artistic tradition able to capture the Western imagination as authentically exotic could take part, providing it conformed to a marketable category. West African woodcarvers have proved especially adept in meeting the criteria for "authentic primitive

art," at least when not too strictly applied, as shown in the documentary film *In and Out of Africa* by Ilisa Barbash and Lucien Taylor (1993). This focused on a Hausa dealer in Ivory Coast of the early 1990s who bought "wood" from the rural areas of several countries and many ethnic groups, shipped it by the crateful to the United States, and sold it to dealers in major cities coast to coast. Much of the wood was made in large workshops, some with skill, care, and pride, some more repetitively and crudely, but all styled and aged according to the demands of this market. While the Hausa dealer treated the wood strictly as a commodity, otherwise undesirable in terms of his Muslim faith, he responded to his buyers by providing what they appreciated most, while presenting it jumbled in the back of a van as if ignorant of its artistic value. An American purchaser sold it on from an elegant gallery display that emphasized these art values, labeled with provenances suggesting the kind of authentic exoticism desired by the collectors who bought there.

Such collectors, the final arbiters of the art values on which the commercial value depended, spoke of their emotional response to aesthetic values conveyed only by the authentic work of carvers working in the style and for the purpose of their own traditional cultures. In the film, this connoisseurship appeared self-deceiving and pretentious, especially in the light of the African scenes of making and selling the carvings, but ultimately it underpinned the whole system of relationships that provided an income for the woodcarvers.

RECONSIDERING AUTHENTICITY

Until the 1970s, the distinction between authentically exotic artefacts and those produced for export was supported by academics, as art historians, anthropologists, and connoisseurs, who proclaimed export artefacts to be artistically inferior and aesthetically debased by Western influence; that is, by the tastes of less educated and discriminating purchasers. Eventually, developments in the collectors' market and growing contradictions in its criteria for authenticity led to a reappraisal, led in particular by the American anthropologist Nelson Graburn.

Graburn began research into what he called the "arts of acculturation" in the late 1950s and 1960s, among Inuit producers of soapstone carvings. At the time, such artefacts from colonized peoples were commonly known as "airport art," "tourist art," or "commercial art;" all terms implying "nontraditional" and hence "inauthentic" to their culture of origin, provoking initial resistance to Graburn's research in academic circles. For Graburn, such new artistic developments were of interest as sources of income for the colonized that reaffirmed pride in their cultural identities under conditions of cultural transition. Other American anthropologists were also beginning to document novel art styles among colonized peoples in many parts of the world, contributing to Graburn's book *Ethnic and Tourist Arts: Cultural Expressions from the Fourth World*, published in 1976. This was the first concerted attempt to treat seriously as art the production of distinctive local artefacts by colonized peoples for sale to their colonizers.

By "arts of the Fourth World," Graburn meant the artefacts of colonized minority peoples within countries that might be called First, Second, or Third World. "Ethnic" was a way of avoiding the pejorative "primitive." He classified their changing products as:

- "Traditional or functional fine arts," which, despite colonial influence, retained their cultural significance to the producers
- "Commercial fine arts," which retained the traditional formal style but were made for export
- "Souvenirs," also known as tourist or airport art, in styles developed to please the export market
- "Reintegrated arts," in new colonially influenced styles but made for local use as well as for export
- "Assimilated art," in styles adopted from the colonizers
- "Popular arts," which adapted such styles to local purposes

In 1999, Graburn distinguished all these from "traditional" or "purebred" arts, as "hybrid" between indigenous and colonial cultures. He also made the important point that "the artists dependent on the cross-cultural market are rarely socialized into the symbolic and aesthetic system of the consumers who support them" (1999:347). This put them at a disadvantage in negotiating the artistic categories that affected the commercial value of their products by continuing to distinguish "tourist" or "souvenir" goods and "craft" from the prestigious and profitable "fine arts."

Graburn's categories of Fourth World art were of course those of the consumers, based on exactly those Western art values that the producers had trouble understanding. By enabling export artefacts to be treated as objects of academic study, these categories helped to legitimate them to the art brokers—always seeking new material to collect, trade, exhibit, and curate. But while this may have benefited the producers in raising the status and price of their work, it has been less useful in advancing understandings of it. The problem with Graburn's analysis was that it maintained an invidious distinction between what he called "arts of acculturation" and (in Errington's sense) "authentic primitive art." The very term "acculturation" implied a loss of culture, hence of authenticity, rather than the recognition that colonized people still have culture even if some of it has been recently adopted from their colonizers. "Hybridity" acknowledged the primitivist stereotype of pure, pristine art uncompromised by colonial influence, rather than recognizing the constant cross-fertilization and change that occurs in all artefact traditions.

With the growth in international tourism and artefact trading, the Western market came to recognize such a shift in categories in its own less-academic terms. By the late twentieth century, "tourist art" had become a way for middle-class collectors to dismiss artefacts made for sale to the increasing number of tourists who were less discerning than themselves. "Primitive art" appeared a rather pretentious description for artefacts evidently made for sale, especially as the purchasers came into increasing contact with

the makers and recognized the implicit insult. Instead, "ethnic" came into fashion, as an easy and ostensibly nonjudgmental way of saying "exotic and unsophisticated." Ruth Phillips and Christopher Steiner explained in their book *Unpacking Culture* (1999), the successor to Graburn's *Ethnic and Tourist Arts*, the significance of "ethnic art" as adopted by interior designers in the 1990s:

> In particular, three major themes may be discerned: (1) that "ethnic" art is closer to nature and therefore less artificial than its modern counterpart; (2) that the "ethnic" arts of all regions share a common denominator, making them largely interchangeable and somehow comparable on a formal level; and (3) that "ethnic" art represents the final, fleeting testimony to the tenuous existence of rapidly vanishing worlds. (1999:17)

However, as interior décor rather than art collectors' trophies, ethnic art does allow the enjoyment of the exotic to prevail over the elitist standards of artistic authenticity. The commodity value of the artefacts is more transparent, and the commercial relationships between producers, dealers, and consumers are less obscured by the Western ideology of art. This should allow more honest and informative appraisals of the artistic values expressed in the production of the artefacts themselves. It also allows many poor people to gain a cash income from their own local products, as a preferable alternative to work in unskilled and often demeaning employment.

MARKET CONTRIBUTIONS TO LOCAL CULTURE

The contribution of Graburn's and Phillips and Steiner's books was to show that exotic export art could be more than a simple commodity to its producers and might be significant to their culture and identity in ways its consumers did not realize. Throughout the world, those who depend on selling their local culture as an exotic attraction to tourists wealthier than themselves face the challenge of retaining their self-respect through a degree of cultural autonomy.

SEPIK, PAPUA NEW GUINEA

The meaning of export artefacts to the Iatmul people of the Sepik River (neighbors to the Abelam, see pages 107–10) has been described by Eric Silverman (1999). Europeans have been collecting Sepik artefacts since the late nineteenth century, and Sepik people have been making them for European buyers since the early twentieth century. The market increased when the Australian colonial administration took over from the Germans after the First World War, and artefacts had become an important source of income by the 1960s, shifting in emphasis with national independence and foreign tourism from the 1970s. Sepik carvings play a similar role in Western culture to African artefacts as primitive art, with all the implications for lost worlds of authentic primal culture.

The carvings that the Iatmul produced and displayed in great quantities for visiting tourist ships were designed according to their experience of Western tastes and expectations, not only as Western-style artefacts such as naturalistic creatures, but also as their own local ritual carvings, interpreted to give the carvers individual competitive advantage in the market. Such carvings also reproduced and reinterpreted the ritual iconography of the traditional religion and cosmology to suit the circumstances of Iatmul integration into national and global society. Iatmul carvings represented the grotesque bodily functions of birth and death, eating and excreting, which belied the Iatmul ideals of bodily control and cleanliness. There was an identity between carvings as embodiments of clan ancestor spirits and individuals named for them, and they had to be carved by the clan's nephews, born to other clans. Hence spirit carvings represented the range of relationships that constituted a man's personal and clan identity. The materials used for carvings, including the wood, paints, shells, tusks, and feathers, also represented the neighboring communities and districts that supplied these things to each other.

To Silverman, the dynamic tensions between the natural and the social body, individual and community identity, community independence and inter-community interdependence, seemed expressed in the swirling patterns adorning the carvings, evoking the snaking Sepik River and the lively movement of its waters and fish. Many export carvings imitated the form and style of ritual carvings, but they were not named for spirits and did not embody them, and might be modified to appeal to European purchasers.

Tourism and especially artefact sales to visitors and, in large quantities, to dealers, provided an important cash income for the Iatmul and gave their artefact traditions renewed value within contemporary society. This contributed to confident new identities—local, regional, and national—through the production of distinctive styles of artefacts, while continuing to give meaningful expression to local cosmological values through carvings that met the market's criteria of "traditional" art. At the same time, the market favored artistic individuality and innovation, which allowed carvers to express the new contradictions and ambiguities of contemporary life in terms of the old. Hence, masks with bold, staring eyes had a small face on the back as if in contradiction, and others had a crocodile, emblem of the Sepik, emerging from the mouth as if to represent the grotesque functions of the social transformation experienced by the Sepik peoples. Silverman offered the Iatmul as a case study of people adapting their local artefact tradition to meet expectations of the market while maintaining its relevance to themselves by reflecting their changing social and cultural concerns.

Authenticity is in the eye of the beholder. While Sepik carvers sought to express local culture through individual creations, other sellers of export artefacts display objects of similar form in massed ranks. For the purchasers, this establishes what the local artefact style is, making them appropriate souvenirs of the place and saving tourists from having to select what to buy. This experience becomes reassuringly familiar, which makes it authentic in tourist terms.

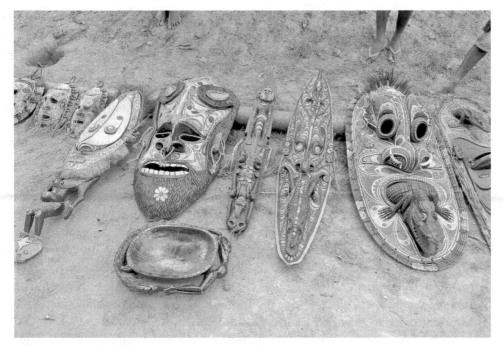

Figure 61 Carvings for sale in the Iatmul village of Tambunum in 2010. (Nina L. Chang photo)

THE HOMOGENIZATION OF EXOTIC ART

As the makers of export artefacts have become better acquainted with the tastes of metropolitan purchasers of exotica, so they have adopted styles from distant parts of the world that share the common values of this market. These are things that will hang on a wall or stand on a shelf in a Western-style home, appearing at once exotic and familiar. A resemblance to African sculpture helps, especially when mediated by European Primitivist painting and sculpture, providing there is a distinctive local interpretation. Likewise, Western naturalism works well as long as the content of the painting or sculpture is local and exotic. An indigenous origin is an important symbolic property, lending artefacts obviously made for sale some of the authenticity so important in primitive art, and affecting artistic and commercial evaluation in the same way.

SHONA, ZIMBABWE

The Shona sculpture of Zimbabwe is an interesting case of a new artistic tradition, which originated in the 1960s in response to a Western export market in what was then Rhodesia, and Carole Pearce (1993) has provided an art-historical critique.

In 1957, Frank McEwen became the first director of the Rhodesia National Gallery in Salisbury (now Harare). As an art historian inspired by expressionist Primitivist artists in 1930s Paris, McEwen expected to find an unconscious natural creativity in African culture, contradicting the crude racist primitivism of White Rhodesian settler society. He was familiar with West African sculpture but found himself in a country with no sculptural tradition and sought to promote its development from the local culture, predominantly Shona. McEwen set up art workshops at the National Gallery for African men of limited Western education, encouraging them to develop their own sculptural style in stone without any formal training or exposure to images from other traditions. He intended and claimed the result to be spontaneously and authentically African, but besides the sculpture from other parts of Africa on display in the gallery, the sculptors were also guided by McEwen to produce artefacts that appealed to him and to White purchasers of similar tastes. Other White art teachers in Rhodesia who gave more direct instruction in European modernist art also contributed to the development of Shona sculpture, but it was McEwen who sought to establish its authenticity as an expression of solely African culture. As he wrote in 1989: "Zimbabwe artists at no time borrowed from abroad. They relate exclusively to their own mystical folk traditions and to early African styles and they are instinctively aware of the millennial foundations of their ancient culture" (quoted in Pearce 1993:89).

This has been the dominant theme in both academic and commercial commentaries on Shona sculpture from the start. Pearce dismissed such claims in the title of her paper, "The Myth of 'Shona Sculpture,'" treating cultural authenticity as an ethnographic question rather than a valid criterion in art appreciation. She also questioned the sculpture's quality in terms of the modernist art values claimed for it, regarding its style as generally formulaic and its content as fantasy:

> The world of the sculptor is a purified and largely invented world. Zimbabwean stone sculpture depicts, for a market of jet-setting, bourgeois, foreign city-dwellers, a stable and harmonious rural life which has structured hierarchies of authority and innocent, respectful and humble women. . . . so far removed from the harsh realities of life in the communal lands, characterized by poverty, dispersal, destablilization, crime, the destruction of family life, urbanization, modernization and the collapse of authority. (Pearce 1993:100)

All this is explained by the fact that, from the first, the sculptors worked and developed styles and genres for a market that gave them a rare opportunity for a rewarding occupation. This market never included their own communities, who could not afford to purchase the sculpture even if they had wanted to. The sculptors' lack of formal training and art education precluded participation in the Western art values of self-critical experimentation and innovation, relegating them, as Pearce put it, to "work as craftsmen rather than autonomous agents . . . restricted to reproducing the artistic taste of someone else." Hence, she considered, "the spiral into commercialization and homogeneity has been

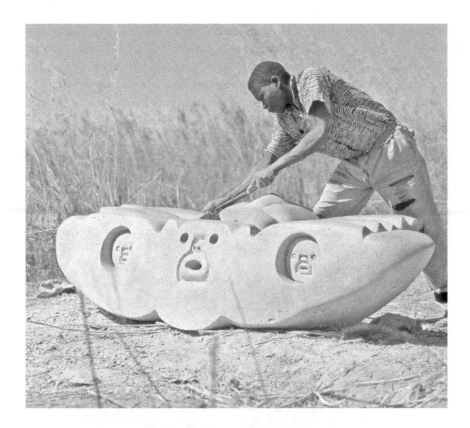

Figure 62 Henry Munyaradzi, one of the first generation of Shona sculptors, at work in the early 1970s. (Frank McEwen bequest, The Trustees of the British Museum)

inescapable" (1993:94). So, for Pearce, Shona sculpture failed in terms of ethnographic authenticity, fine art, and relevance to the community of its producers, despite the fact that its commercial success was built upon claims to the contrary. Fortunately for the sculptors themselves and for the international dealers and purchasers, those who enjoy these exotic artistic fantasies have been less concerned with such academic art appreciation.

SOLOMON ISLANDS

African styles, publicized by the primitivism of the Western art world, have had a far-ranging influence on the ethnic art market. On the far side of the world, in Solomon Islands, a colonial market for local woodcarvings developed from the end of the nineteenth century, encouraged by Christian missions and substituting for local use under the declining ancestral religion. Sales expanded during the Second World War with the massive demand for souvenirs from American servicemen, and by the 1960s export carvings were widely sold in shops in the capital, Honiara. Motifs were based on precolonial themes such as canoe figureheads from the western Solomons and bowls and figures from Makira

in the southeast, but new styles developed in polished hardwood, often inlaid with pearl-shell, with images such as sea-creatures, eagles, warrior figures and busts, and masks.

The masks, now accepted by foreign visitors as characteristic of the Pacific Islands, derived from East African prototypes, themselves developed to supply what Europeans expected from Africa in a region without a masking tradition. They were introduced by well-traveled colonial residents, interpreted and elaborated by Solomon Islanders who also had no masking tradition, and influenced also by export carvings of masks from Papua New Guinea. Solomon Islands now has a thriving carving industry with origins in local artefact traditions that are hardly visible to those who do not know its history.

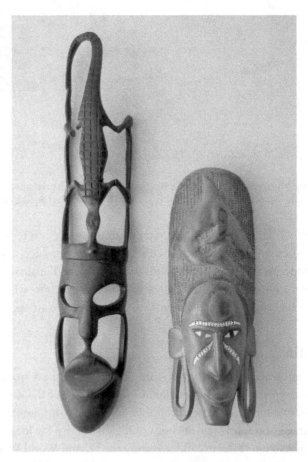

Figure 63 Distant relatives: carvings from East Africa and Solomon Islands, both inspired by the Western market for exotic "masks" to hang on the wall. (Ben Burt photo)

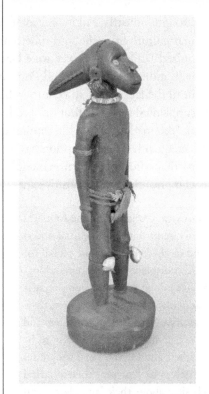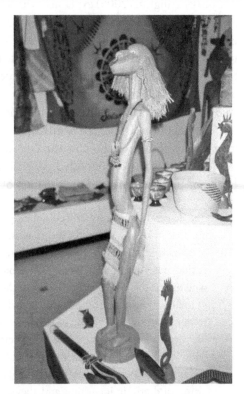

Figure 64 The history of a particular type of Solomon Islands export image has been traced by Rhys Richards (2003). In the eastern islands of Santa Cruz, small wooden *dukna* figures representing men's personal spiritual guardians were disposed of with conversion to Christianity, and by the 1950s they survived only in museums around the world. In about 1980, Frank Haiku, a commercial woodcarver from the Polynesian island of Bellona, adapted the form of the only *dukna* in the Solomon Islands Museum (similar to one in the British Museum, 33 cm. tall; Oc1944,02.1172). He wanted to make taller, slimmer figures that were, as he said, "more abstract and more African."

Then a Santa Cruz man, David Kio, began carving *dukna* figures, following a museum photograph and Haiku's adaptation, and researched the spiritual background to the original *dukna* carvings. As a result, he began producing carvings representing a legendary trickster spirit, Menepo, who was not a *dukna* spirit at all. By the time of his death in 2003, Kio had produced almost a hundred Menepo figures, some of which were displayed in public buildings around Honiara, exhibited in the Art Gallery, and purchased by the New Zealand National Museum, Te Papa, as well as proving popular with foreign collectors. Other carvers also adopted the motif, including Polynesians and carvers from Marovo in the western Solomons, who adapted the head to their own canoe figurehead style. So it was that a new icon entered the Solomon Islands carvers' repertoire, appearing in shops in Honiara, like this example in 1999 (Ben Burt photos).

Shelly Errington (2005) explained what has happened to exotic export art in the twenty-first century. The historical paradigm of "progress" through industrialization and colonialism, which dominated Western academic and popular culture from the mid-nineteenth to the mid-twentieth centuries, supposed that colonized lands and peoples were being brought out of a more or less primitive state into civilization. Primitive art and Primitivism in Western art reflected this view of the world until the late twentieth century, when colonial ideas of progress in a single direction were supplanted by "globalization" producing "development" in regions of the world linked by "the market." Notwithstanding the long history of globalization, its variable reach, and inequalities, the perception has been that everyone is newly connected, accessible, and participating in a global marketplace. Errington aptly summarized the situation of those who once produced primitive art:

> The descendants of formerly colonized peoples of Africa, Oceania, and the Americas are now in a wide variety of locations and material circumstances. Like their ancestors, many continue to live on the periphery and at the bottom of the global (or nation-state) economic system. They may have been displaced by mining and logging operations or by national armies; they may have joined the urban poor in cities of their nation-states; or they may have become agricultural or factory laborers close to home or migrant workers elsewhere. They may have kept their native dress and identity or they may have lost it deliberately or accidentally. They are likely to be conscious of being in contact with world labor markets and international congresses on indigenous rights; they make videos of themselves to represent their political claims and ethnic identities; and they post Web sites about their land claims and their bitter objections to multinational mining and logging corporations encroaching on their ancestral territories. And they may be making art for the market, and enjoying great success by selling it on the internet. (2005:226)

Insofar as the purchasers of these artefacts recognize the new circumstances of the makers, they now evaluate the artefacts as "ethnic" art, or the art of a particular local identity. The exoticism still requires authentication, but this is now certified by its culture of origin, maybe enhanced by the maker's name as artist, and artefacts are acceptable as commodities rather than for their supposed role in local life. Accordingly, the makers themselves are now able to market their artefacts as artists or craftworkers in Western terms, rather than as unconscious producers of primitive art.

QUESTIONS FOR DISCUSSION

- How does making local artefacts for export affect people's control of their own artistic heritage and identity?
- In what sense, if at all, can artefacts made for export be judged as authentic, and does it matter?
- What are Westerners seeking when they purchase exotic artefacts?

FURTHER READING

- Graburn's book *Ethnic and Tourist Arts* (1976) contains relevant case studies, including Kaufman on the Haida.
- Phillips and Steiner's Introduction to *Unpacking Culture* (1999) reviews the incorporation of exotic artefacts into Western art categories and markets, and chapters in the book include Lee on Northwest Coast art, Silverman on the Sepik, and Graburn's "Ethnic and Tourist Arts Revisited."
- Steiner's paper "The Art of the Trade" (1995), reprinted as Chapter 25 of Morphy and Perkins's *The Anthropology of Art* (2006), describes the West African art market, as illustrated by Barbash and Taylor's film *In and Out of Africa* (1993).
- Venbrux, Rosi, and Welsch include studies of local export art traditions in their edited book *Exploring World Art* (2006).

14 ARTISTIC COLONIALISM

As colonizers, Europeans produced artistic images that affirmed their claims over other places and peoples while promoting their own fine art tradition around the world. Western ideas of art have become global, shared by colonized minorities in rich countries and cosmopolitan elites in poor ones, but still under the hegemony of the Western art world.

Outline of the Chapter

Images of Appropriation
The artistic representation of indigenous people and places by settler colonists of North America and Australasia, in the process of constructing identities for themselves and for those they displaced.

- Finding a Place in the Art World
 How colonized minorities in Australia and North America have adapted the art values of their colonizers.

- Art Goes Global
 Exporting Western gallery art to India, Ghana, and Papua New Guinea, and importing it to Japan.

- Global but Exclusive
 Can gallery art be freed from control by metropolitan elites?

The arts of conquest—of taking, holding, and legitimating power over lands and peoples—include refashioning artistic products to deal with new political realities. Europeans have become experts in the artistic domination of other regions of the world during the last few centuries, but it has been a mutual process between the colonizers and the colonized, albeit on unequal terms. In their homelands and in the countries they settled, Europeans created artefacts to persuade themselves of the merits and success of the colonial enterprise. In seeking new identities for new lands, they had to deal with their uncomfortable relationships with the people they had dispossessed, which they expressed through their preferred media of painting and sculpture. They also pressed this art tradition upon those they colonized, who used it both to accommodate the colonial order and to resist it.

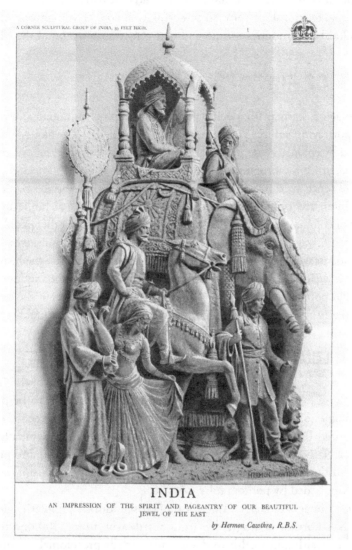

INDIA

AN IMPRESSION OF THE SPIRIT AND PAGEANTRY OF OUR BEAUTIFUL JEWEL OF THE EAST

by Hermon Cawthra, R.B.S.

Figure 65 In 1937, when the coronation of King George VI was held in London, Selfridges department store commissioned a set of sculptures to decorate its façade on the parade route in Oxford Street. They celebrated four major regions of the British empire, then at the height of its power just before it was fatally undermined by the Second World War. These showed "the unlimited resources of our far distant commonwealth," for Australia; "the wealth and activities of our brothers and sisters in this great union of peoples," for South Africa; and "this virile member of our great empire family," for Canada. India, shown here, was portrayed in an Orientalist vision of "the spirit and pageantry of our beautiful jewel of the East" (Selfridges 1937).

But the end of colonial rule has not been the end of artistic hegemony, which continues in the unequal relationships between powerful, well-connected metropolitan centers and peripheral local communities, within and between countries around the world.

IMAGES OF APPROPRIATION

Western imaging, particularly painting and photography, has a long and continuing tradition of portraying subject peoples—whether governed and exploited from Europe or dispossessed by colonial settlement—as if they were survivals from an earlier age who have been overtaken by the progress of civilization. In the colonial homelands, the glories of empire were proclaimed through stereotyped images personifying the exotic wealth of far-flung dominions, while in the colonies settlers represented the new homelands they sought to create. For colonial settlers fighting to establish themselves on other people's lands, it was expedient to portray their indigenous opponents as savages and primitives. Their more secure descendants were often more inclined to reflect nostalgically on the history of the land that was now theirs and to claim its former inhabitants in the same way. Some of the most enduring and popular colonial images are those that convey regret at the passing of exotic primal humanity and reproach the mundane materialism of the culture that has replaced it.

NORTH AMERICA

In colonial images, Native North Americans became the epitome of the "noble savage," especially those in the west who avoided conquest long enough to be portrayed with the technologies of the nineteenth and twentieth centuries. Nineteenth-century painters who toured the American frontier regions made generally sympathetic romantic paintings of Natives and their lifestyles that were widely exhibited and published. This painting tradition continued well into the twentieth century, but from the 1860s it was gradually superseded by photography.

Among the images of Native Americans of most enduring popularity are those by Edward Curtis, a portrait photographer from Seattle who from 1900 devoted his life and sacrificed his health and wealth to documenting their precolonial culture and appearance. He published his research in twenty lavishly illustrated volumes with additional photographic portfolios.

While the nineteenth-century painters anticipated the impending American invasion of the west, Curtis several generations later looked back upon ways of life that had been destroyed by that invasion and found himself having to reconstruct much of what he wanted to portray. His photographs have been both admired and criticized for their romanticism, as Anne Makepeace commented for her film on his work:

> Curtis' photographs capture only a part of American Indian life. They do not show the desperation of Indian people starving after the buffalo were gone, or when

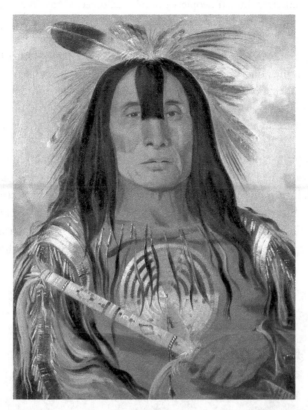

Figure 66 George Catlin painted the Blackfoot chief Bull's-backfat at Fort Union in North Dakota in 1832. Catlin was a self-taught portrait painter who left Philadelphia to travel the western Plains in the 1830s, for "a life devoted to the production of a literal and graphic delineation of the living manners, customs, and character of an interesting race of people, who are rapidly passing from the face of the earth . . . snatching from a hasty oblivion what could be saved . . . as a fair and just monument, to the memory of a truly lofty and noble race" (1844:1, 3). He exhibited hundreds of paintings in the eastern United States and Europe, toured with Native American performers, published illustrated memoirs, and undertook further painting tours to the Northwest Coast and South America, in a project lasting until his death in 1872. Catlin was best at portraits like this, capturing impressive-looking men in full dress. (Smithsonian Institution)

rations promised to them in treaties were not delivered. We do not see missionaries preaching in the plazas or on the Plains in his pictures, or medicine men being arrested for performing outlawed ceremonies, or Indian children being hauled off to boarding schools, or the abuse they suffered there. Curtis wrote about these things and he lobbied for Indian Rights, but in his photographs he portrays only the traditional aspects of Indian life. . . .

Some American Indian people I interviewed objected that the pictures are fake because they don't show their ancestors in their everyday lives. They argue that Curtis' many images of Indians riding off into darkness reinforced white people's belief that indigenous American cultures were doomed to disappear. Other Indian people argued that their ancestors in the pictures remembered the old ways and were able to recreate them accurately for Curtis' camera. They point out that the traditional and the modern coexist in Indian life now as they did in Curtis' time, and that his images capture an aspect of their history, which they treasure. (Makepeace 2002)

When Europeans and Euro-Americans developed a serious interest in Native American culture from the 1960s and 1970s, Curtis's photographs were among the images republished in innumerable popular books, which celebrated the Native life of the nineteenth century but made little if any mention of the twentieth. Only in the late twentieth century did the grievances of the reservations come to popular attention with the protests and repression of the American Indian Movement and other Native political

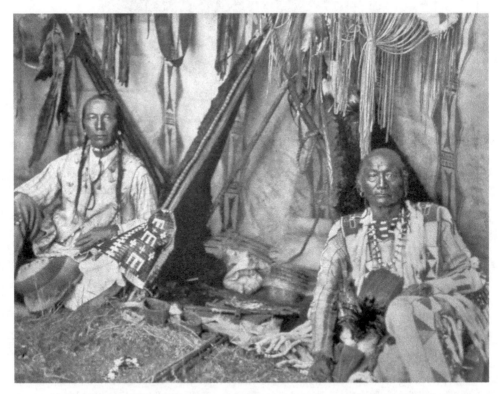

Figure 67 A photograph by Edward Curtis taken during a Piegan (Blackfoot) festival gathering in Montana in 1910, of Little Plume and his son Yellow Kidney. Curtis painted out a clock between them, but the costumes still reveal the period in which it was taken, thirty years after the buffalo disappeared. (Curtis 1911: Vol.6 portfolio)

organizations. As Native North Americans have gained a voice in mainstream culture and politics, using the educational and professional skills learned from their conquerors, some other Americans have become more sensitive to Native histories and identities, but many still prefer to remember their ancestors, less troublesome and more romantic for having been dead a century and more.

AUSTRALIA AND NEW ZEALAND

In the process of replacing indigenous peoples, colonial settlers also asserted claims to their land and culture symbolically through new styles of artefacts. Nicholas Thomas (1999) has explained how the settlers of Australia and New Zealand portrayed the landscape as their own in paintings of pristine wilderness and domesticated rural settlements, in which the indigenous people usually appeared—if at all—as part of the natural scene or as incidental bystanders left over from the past. By the end of the nineteenth century, as Australian Aboriginals were indeed disappearing from the settled areas, paintings were portraying their European successors as native to a distinctive landscape of their own. The Maoris of New Zealand were politically stronger and harder to ignore, and there were painters who specialized in sympathetic portrayals of them, but still as a disappearing culture.

As Australians and New Zealanders built their own cultural identities by means such as these, so they incorporated the indigenous peoples as features of their own past, inevitably and perhaps regrettably overtaken by their own civilization. They seldom acknowledged the indigenous traumas of dispossession or their new role on the margins of colonial society. But images from the indigenous past did help to counter the fear that local European culture was merely a second-rate derivative from the home country. Besides portraying the landscape, flora, and fauna, they eventually began to adopt indigenous artefacts and designs.

In New Zealand, by the second half of the nineteenth century, Maoris were producing curios in their own styles for settler markets, and settlers began adapting Maori designs for their own artefacts. From the end of the century, illustrated publications on Maori art and romantic popular images and texts on Maori oral traditions were used to give a local identity to all kinds of settler activities and artefacts. Particularly successful were adaptations of the kind of designs painted on the rafters of meeting-houses, which appeared on settler artefacts from book covers and postage stamps to crockery.

Aboriginal Australians had less romantic appeal than the warrior Maoris, and their artefacts were less compatible with the precise and regular formalism of nineteenth- and early-twentieth-century European decorative art (and of little interest to the Primitivist artists either). But from the 1930s, Australian artists began to adapt Aboriginal styles and motifs to their own artefacts, from decorative designs to paintings, more from a desire to develop an Australian national artistic identity than an interest in Aboriginal culture.

The settler artists' interest in indigenous art contributed to a wider public appreciation, and Aboriginal and Maori artefacts began to move from ethnography museums to art galleries from the 1940s. This undermined settler use of their own paintings to create a White national identity and their primitivist attitude to indigenous artefacts. It also enabled the indigenous people to have artefacts developing from settler as well as indigenous traditions judged as art rather than as acculturated derivatives of primitive stereotypes. From the 1960s and 1970s, Aborigines, Maoris, and Pacific Islands migrants to New Zealand became recognized as artists, with their work exhibited in galleries, albeit usually within a separate genre rather than in the mainstream of Western art.

FINDING A PLACE IN THE ART WORLD

Colonized minorities have ventured into the art world of their colonizers only with the support of brokers who could facilitate access to galleries and markets for exotic variations on Western fine art. From the 1960s, Aboriginals of central and northern Australia developed new graphic styles from local traditions to produce paintings that appealed to Western connoisseurs as abstract designs which were enhanced by the symbolic connotations of the exotic dreamtime narratives that they represented. This work has been collected, exhibited, and published internationally, giving Aboriginal communities an important income from the artistic traditions that they also practice for their own purposes.

NATIVE NORTH AMERICANS

Others have adapted colonial art styles to represent changing indigenous identities, with the benefit of Western institutional training. This was the experience of some Native North American painters. A southern Plains tradition of gallery painting developed from the late nineteenth century in Oklahoma, whence a number of different Native peoples had been deported to "Indian Territory." Plains men began drawing on paper in a style adapted from their pictorial records of war exploits and chronologies on hide. In the 1870s, Native prisoners of war at Fort Marion in Florida were encouraged by their U.S. Army captors to draw scenes from their former lives, which they could sell to tourists, and these were also acquired by museums such as the Smithsonian Institution and the British Museum, for their ethnographic interest. In Oklahoma during the 1890s and 1900s, Native Americans were commissioned by American researchers to document their former way of life in this way.

Among the Kiowa in particular, some of these men encouraged the generation born in the 1900s to continue this drawing tradition, and in the 1910s a number of them took advantage of art classes at a mission school, then at the government Kiowa Agency. Their potential was recognized by the head of the art department of the University of Oklahoma, who sponsored six of them to train there. He had their work exhibited at

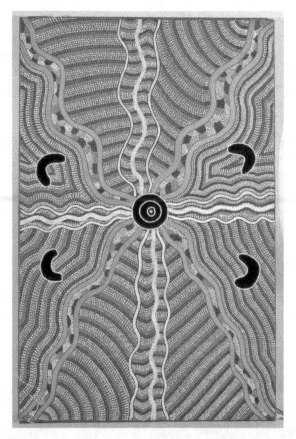

Figure 68 *Bush Potato Dreaming*, painted in the 1980s by Victor Jupurrula Ross of Yuendumu, the Northern Territory community researched by Nancy Munn in the 1950s (see pages 153–55). At the center is the potato and hole where an old man was digging for it, the radiating lines are its roots and the wind released from the hole, and the crescents are the man and people who were also released from underground. (The Trustees of the British Museum; Oc1987,04.7)

the Denver Art Museum, then at the 1928 International Art Congress in Prague, at an exhibition of southwest U.S. art in New York, and at the 1932 Venice biennale art festival. By this means, the "Kiowa Five" (one, the only woman, having dropped out) gained recognition and a market for their work among American and European art collectors. They founded what came to be known as the Oklahoma style of Native American painting, developed at Bacone College, which was founded in 1935. The Oklahoma style also influenced Pueblo and Navaho painters in New Mexico, where drawings of ceremonial themes had been commissioned by American ethnologists from the 1920s for documentary interest. A market developed in Santa Fe, and from 1932 painting was taught at the Santa Fe Indian School.

A 1955 *National Geographic Magazine* article by Dorothy Dunn, founder of the "Studio" of the Santa Fe Indian School, made an important contribution to publicizing Native American gallery art. It was titled "America's First Painters: Indians, Who Once Painted Rocks and Buffalo Hides, Now Use Paper and Canvas to Preserve Ancient Art Forms," and it conveyed a romantic colonial attitude to Native American culture:

> The Indian painter poses no models, follows no color theory, gauges no true perspective. He seldom rounds an object by using light and shade. Often he leaves the background to the imagination.
>
> By omitting nonessentials, he produces abstract symbols for plants, animals, earth, and sky. Yet he acutely senses life and movement and can convey mood or intense action with a few lines.
>
> The typical Indian painting is, therefore, imaginative, symbolic, two-dimensional. Its style may vary from seminatural to abstract. Subjects range from archaic religious symbols to portrayals of everyday life, from stylized landscapes to spirited hunting scenes. Painters are continually inventing new ways to combine symbols of sky, harvest, or life forms, or to depict a certain dance, occupation, or event. (Dunn 1955:349)

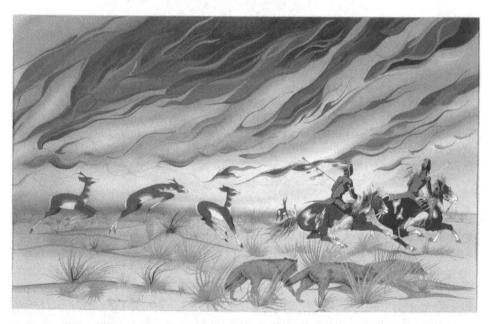

Figure 69 *Prairie Fire*, painted about 1953 by Francis Blackbear Bosin, one of the generation of Native American painters following the Kiowa Five. Publication of the painting in Dorothy Dunn's *National Geographic* article established Bosin's reputation. (© 2013 The Philbrook Museum of Art, Inc., Tulsa, Oklahoma)

Although these Native American painters were producing images similar to the book illustrations, cartoons, and other works by American and European artists that were never exhibited in art galleries or reproduced for display, colonial racism would have made it difficult for them to compete for such employment. Instead, they found a prestigious market niche in the art world for Native American themes and styles, supporting their own ambitions to develop nostalgic images of their culture. This required their work to be authenticated by the tribal affiliations always noted after their names, distinguishing them from their many imitators. These included Walt Disney's *Bambi*, said to have been inspired by the animal paintings of Pop Chalee of Taos Pueblo, who trained at the Santa Fe Indian School.

ART GOES GLOBAL

In commercial colonies, where indigenous majorities retained more cultural autonomy, the artistic influence of the colonizers was greatest among the emerging Western-educated elites, who have since drawn their countries into the now global art world. Here, too, Western art training was a feature of paternalistic cultural colonialism, but with rather different consequences.

INDIA

The history of British art education in colonial India has been traced by Partha Mitter (1994). European academic art was introduced to India in the 1850s in accordance with British imperial policy, with the paternalistic aim of improving Indian culture. After some earlier short-lived attempts, the British founded schools in Madras in 1850, Calcutta in 1854, and Bombay in 1856, to introduce their fine arts and improve local craft production. Their purpose was to improve the artistic taste of the Indian higher class and the quality of exportable manufactures among the artisans, raising their social and moral condition by introducing the technical and intellectual values of the superior European civilization.

The distinction between fine and applied art (or craft), hotly debated in Britain at the time, was exported with the art schools. From the Great Exhibition of 1851, Indian artefacts, threatened by competition from the industrial manufactures of Europe, came to represent the virtues of Europe's own lost artisan traditions. Rather than introducing the fine art of imaginative painting and sculpture, teaching aimed at training artisans to develop the lower-status applied art suitable for manufacturing, reflecting British cultural prejudices as well as their colonial economic policy. In practice, the teaching of drawing and painting contradicted the emphasis on applied art technique by encouraging the study of Western fine art, and the educational qualifications required for admission discriminated against artisan students. Their British teachers regarded the Indians as technically adept but inheriting inferior standards of taste, which they sought

to remedy through drawing from nature and from Western fine art artefacts, according to the teaching methods of the Central School of Industrial Art in London. The official government policy of improving Indian decorative design was thus compromised by teaching the representation of two-dimensional objects by Western fine art techniques.

By the 1880s, the teaching of artisan craft was giving way to fine art sculpture and painting. The art schools were publicizing their achievements through art galleries, founded from the 1850s onwards in Madras, Bombay, and Calcutta. The Calcutta school in particular made a specialty of fine art and design teaching for portraiture and book illustration. But the purpose and value of the art schools, as publicly funded institutions, was questioned by the arts establishment in Britain. An underlying question was whether Indian art deserved to be improved or superseded, with a prejudice that the decorative art was worthwhile but that fine art values were absent from Hindu painting and sculpture and only poorly represented by the work of Indians trained in the art schools. At the same time, there was a concern that the Indian decorative tradition, regarded as inherently conservative and static like other Oriental art, would not survive Western progress. The general conclusion was that Indians, like the European lower classes, should concentrate on applied arts or crafts, which required only the technical skills of the artisan, and leave the true fine art in the Classical tradition, pinnacle of Western cultural achievement, to the European elite.

In Calcutta, this European school of art became associated with the development of Indian cultural nationalism during the period of greatest colonial repression, in the early twentieth century. In the 1900s, in reaction against European painting, the artists introduced Japanese wash techniques to enliven Mughal-style painting and developed the

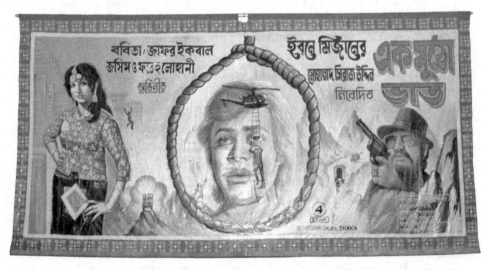

Figure 70 A film advertising banner from Bangladesh from the 1980s, painted in a style derived from European realism. (The Trustees of the British Museum; As 1987, 16.2)

distinctly Indian but modern Bengal School, which was nevertheless heavily influenced by the European tradition. The paintings often portrayed scenes from Indian history, but in emphasizing Hindu themes it tended to constitute the new Indian identity as Hindu, hence offending Muslims and others, and as elitist, since the subject matter was known only to the educated classes and did not address issues of colonial power relations. In reaction, an art movement in the 1930s drew on peasant and artisan crafts and valorized village India, but largely as an appropriation of folk art by middle-class artists who had no real engagement with village people. Alternative lineages from the same artistic ancestry are represented by rickshaw paintings and film-poster paintings, which draw in different ways on both Indian artisan and European fine art traditions.

GHANA

The Western tradition of gallery art, with its rewarding markets, transnational connections, prestigious galleries, and wealthy sponsors, has permeated every urban center of the world as part of the culture of global capitalism. It offers the prospects of prestigious job satisfaction to creative individuals, but if they come from non-Western backgrounds they are likely to be disappointed. Many ordinary people, even in the West, do not understand or appreciate such art. While this may only irritate artists in metropolitan countries, it can be deeply discouraging to those in former colonies who have adopted Western art values only to find themselves marginalized in an international art world dominated by metropolitan elites, including their former colonizers.

This is the case with gallery art in Ghana, examined by Marusk Svasek (1997) as "international African art." When the British colonial government introduced Western education in what was then the Gold Coast at the end of the nineteenth century, it included drawing in the style of Western realism. Local artefact traditions were devalued as primitive and as craft, until they became recognized as primitive art under the influence of European painters and sculptors. Then, with the introduction of secondary school art teaching in 1936, local styles became the standard models, to promote the development of an African style from a primitive tradition. With the demand for local political and religious artefacts declining under colonial rule and Western images gaining in appeal to the young, this policy represented a repression of local aspirations for cultural development, which was continued in the Academy of Arts in Kumasi in the 1950s. However, the experience of the Second World War challenged colonial racist values, and would-be artists claimed the Western art tradition as a fulfillment of their own aspirations for cultural and political independence. Some painted local African scenes, both ceremonial and everyday, to create idealized images of traditional life. Others reinterpreted local artefact styles as expressions of pan-African identity, rejecting European realism for styles that inevitably resembled European modernism. In either case, anticolonial sentiments were expressed by means of colonial artistic values, as they continued to be after Ghana's independence in 1957.

However, the main market for these artefacts was non-African foreigners, for whom they represented the very primitivist and colonialist values that their makers were trying to challenge. The mediating role of art dealers insulated the makers and buyers from each other, communicating only the values required to make their relationship commercially rewarding. In reaction against the romanticization of the African past shared by both painters and buyers in the 1960s, some painters began to portray scenes of contemporary city life, although these too were idealized, to exclude sights that proved unpalatable to the buyers.

In late 1950s, the Kumasi School of Fine Arts promoted an ideal of art for art's sake, encouraging students to think of themselves as "free individual creators of non-commercial but genuine art." They regarded themselves as superior to the commercial painters, sculptors, and designers from poorer backgrounds who gained economic security by training and working under local masters, producing artefacts for commission or sale in shops. The academic artists had a much smaller market among Ghanaians and Western residents and tourists, supported by a few galleries and foreign institutional sponsors. They eschewed commercial values, as their buyers expected them to, in mutual support of the ideal of art as disinterested creativity.

In the late 1960s and 1970s, as coups and wars undermined the ideals of African nationalism and identity, many such artists began to question whether art should support those political values. Some claimed an identity as artists rather than as Africans—as creative individuals belonging to an international art world, drawing on African motifs and styles only for their universal artistic value. However, they found it hard to sell their work on these terms and often retreated into more marketable styles of African exoticism, proclaiming this as a move between alternative identities. As Western museums admitted more African artefacts as "contemporary art" with exhibitions like *Magiciens de la Terre* in 1989, Ghanaian fine artists found themselves passed over in favor of commercial work like novelty coffins, revealing the power that Western curators retain in the international art world.

PAPUA NEW GUINEA

This African experience was repeated in other commercial colonies, and Pamela Rosi (2006, 2011b) has described the predicament of artists in Papua New Guinea. Western-style realistic drawing was taught in primary schools from the 1950s, and from the late 1960s it was used to promote a national identity in anticipation of eventual independence, with expatriate art teachers in the capital, Port Moresby, encouraging urban migrants to develop distinctive new styles based on local artefact traditions. A National Art School promoted gallery art with much success, until cuts in government funding led to a decline from the mid-1980s, amid dispute over the priority of academic or popular arts.

The career of one prominent painter illustrates the precarious position of Papua New Guinea artists since. Larry Santana grew up in the town of Madang, studied graphics and painting at Goroka technical college, and by the 1980s was working as a graphic

designer in Port Moresby, where he exhibited paintings at the Waigani Arts Centre. His work was chosen for art shows in Brussels and Boston, and by the 1990s he had his own graphic design company, receiving public commissions through family contacts. This all ended with the national economic decline and public spending cuts of the next decade, obliging him to return to Madang, destitute until his reputation gained him an art-teaching job in his old high school.

Santana regards his paintings as recording the past for the future of his rapidly changing country, creating images from local oral and artistic traditions that contribute to developing a national culture from diverse sources. His paintings represent issues arising from capitalist development in small societies: traditional stories as metaphors for contemporary moral dilemmas, colonialism, indigenous Christianity, women's rights, urban corruption, his personal experience of destitution, and the threatened environment and rural life of the forest.

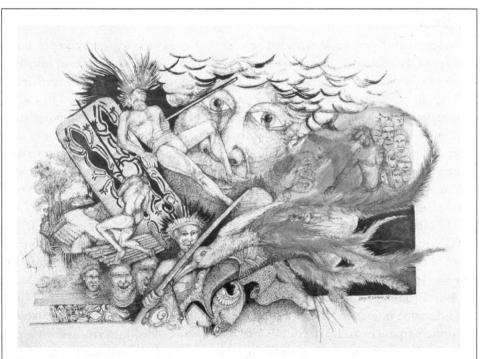

Figure 71 Larry Santana's 1986 wash drawing *Kombong'abe: The River Spirit* shows the ancient resolution of a feud in which the victors compensated the losers for killing two of them, with valuables and wives. As he explained: "in our traditional warfare, damage was limited and enemies ended up marrying one another. We created new life from death and compensated losers. Tears spill from Kombon'abe's eyes because the old beliefs and customs he once sustained are breaking down. I use red to denote fire and pain, mixing it with yellow, a color that signifies tradition. Our old ways are being consumed by ideas of progress." (Rosi 2011a:74, Pamela Rosi photo)

The main problem faced by Papua New Guinea artists like Santana is that an income from painting is not sufficiently regular and sustained to provide for their families and obligations to relatives. Artists complain of lack of public interest and rely heavily on state commissions for public works, which have proved an unreliable source of support. Metropolitan markets are rewarding but limiting for those who, like Santana, do not confirm primitivist stereotypes about their little-known country. They are compared unfavorably with the Western realism that influences their work, and images of difficult social issues are rejected in favor of romantic tropical scenes. Papua New Guineans have little interest in gallery art and cannot afford prices inflated by the metropolitan market. But, as would-be artists are obliged to commercialize their work in media such as T-shirt designs and graphics for local publications, they may yet create a new market relying less on art-world collecting than on local consumption of artistic products.

JAPAN

The appeal of the art world extended beyond the European colonies, with the economic power of the West. The Japanese adopted Western art values on their own initiative as part of their opening to foreign trade in the mid-nineteenth century. To participate in European expositions, they adapted their category of *shoga*, characterized by the most prestigious techniques of calligraphy and painting but also including techniques such as ceramics, textiles, and metalwork. This took account of the Western interest in figurative and expressive images but not the crucial Western distinction between prestigious fine art and more mundane decorative or applied art. The aesthetic values of *kasari* or "ornamentation" that governed the style and display of *shoga* artefacts in the broadest sense had more in common with decorative art.

In order to adapt appropriate kinds of *shoga* to the increasingly popular styles of Western art, the new category of *bijutsu* or "beautiful technique" was developed. As part of this effort to engage with Western power and culture, new concepts were devised in the 1890s to distinguish fine arts (*bijutsu*), decorative arts (*kōjei*), and decoration (*sōshoku*), on lines currently being debated by Western art critics. In 1907, the Ministry of Education introduced annual *bunten* art exhibitions modeled on the European salon. For the purpose of such art exhibitions, *bijutsu* was divided into Japanese-style painting (as distinct from painting-and-calligraphy, or *shoga*), Western-style painting, and sculpture. Sculpture attracted far fewer exhibits than painting, apparently because it had less in common with particular kinds of *shoga*, and monumental secular sculpture was a new fashion. Contributions included polychrome Japanese-style figures in temple style as well as Western Classical-style unpainted nudes. All such work was displayed in exhibitions modeled on Western galleries, in contrast to the decorative *bazari* style of *shoga*. It was only late in the twentieth century that other categories of *shoga* artefact such as ceramics were accepted as *bijutsu* in response to the much expanding Western category of fine art.

GLOBAL BUT EXCLUSIVE

Although the art brokers of the West's metropolitan centers enjoy the increasingly global reach of their art world, they equally enjoy controlling admission to it on their own terms. Would-be artists from non-Western backgrounds have long complained of discrimination, particularly of being accepted as representatives of particular ethnic identities rather than simply as artists on the same terms as Westerners. Artists struggling for recognition in non-Western countries, where art itself is barely recognized, may welcome opportunities to participate in the art world in distant countries they might otherwise never reach, but for the ethnic minorities of Western countries, being treated as an "ethnic" artist can be frustrating.

In Europe, this issue emerged with mass immigration from the colonies from the 1950s. British artists from South Asia, the Caribbean, and Africa, working in Western styles, sometimes but not always on themes reflecting their ethnic origins, had some initial success in the galleries, but in the 1970s and 1980s found themselves increasingly marginalized as "Black." In the 1980s, a new generation of artists began to identify themselves as black and focus more on Black cultural themes, as part of a developing political and cultural assertiveness by second-generation immigrants. They struggled hard for recognition, but employment and prestigious exhibition venues continued to be denied by the art-world establishment. By the end of the twentieth century, the third generation of Black artists did feature in major exhibitions, some drawing on African and Asian forms and symbols, and some preferring not to be identified as Black at all. As Nelson Graburn summarized the problem:

> ethnic artists everywhere in the world continue to be subjected to immense pressures to create only those arts (and crafts) that cater to the image desired by the mainstream art market. Even the breakthrough exhibition Magiciens de la Terre in Paris (Centre Georges Pompidou 1989), which exhibited the works of First, Third, and Fourth World artists side by side, revealed by this very juxtaposition that the "ethnic" artists were expected to create something stereotypically traditional, yet the metropolitan (white) artists were allowed to draw their images from anywhere and to appropriate motifs or materials from nature or from cultural alterity without limitation. (1999:348–49)

Rasheed Araeen challenged the exclusiveness of the art world from his own position as a British artist of non-European background. He argued against an artistic internationalism in which "Afro-Asian" artists continued to be treated as the "other" against which the West defined itself within a metropolitan society that was pluralistic but still subject to Eurocentric cultural hegemony.

> The prevailing western notion of multiculturalism is the main hurdle we now face in our attempt to change the system and create an international paradigm in which

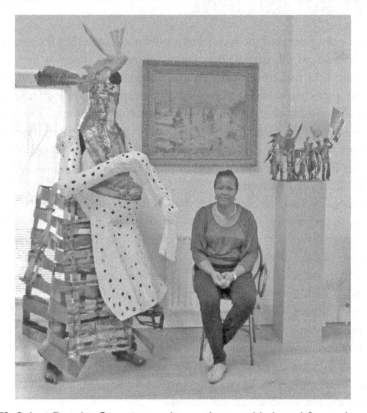

Figure 72 Sokari Douglas Camp is a sculptor whose welded steel figures have been exhibited in African contexts, including at the British Museum. Her work, like the Okolokrukru masquerade figure at her home in London, is inspired by her Kalabari origins in the Niger Delta in Nigeria (see pages 121–23), but she dislikes being classed as an "African artist." As she points out, her background is actually cosmopolitan: She has family in Nigeria, was educated at school and art college in England, and is married to an Englishman whom she met while studying in California. She believes that her work should be allowed to speak for itself, free of invidious classifications such as "black and minority ethnic art." (Ben Burt photo)

> what takes precedence is art work, with its own set of rules for production and legitimation in terms of aesthetics, historical formation, location and significance, rules not necessarily derived from any one or originary [*sic*] culture. (Araeen 1994:10)

Such calls for the art world to be freed from the hegemony of the Western vested interests that created it may seem idealistic, but then so did the independence movements that claimed nationhood for the colonial states created by European empires. But as long as the objective is to participate in institutional systems so firmly controlled

by metropolitan elites, the prospects for art to realize its own professed ideals seem no better than that of ex-colonial states to participate on equal terms in international capitalism. What the art-world critics of ethnic stereotyping and multiculturalism have not challenged is the Western ideology of art itself, developed to serve exclusive elite interests where value is measured by criteria that legitimate the commercial market. The fame and wealth attending success in this art world encourages some "ethnic" artists to fight their way in and contest its persistent Eurocentrism, while others do well enough within the ethnic niche markets through which metropolitan consumers continue to enjoy cultural exotica as otherness. A more radical and less futile critique of the self-interested exclusiveness of the mainstream art world might question its fundamental values and promote alternative audiences, on the basis of "if you can't join them, beat them."

QUESTIONS FOR DISCUSSION

- How have artistic images served the conflicting interests of colonizers and the colonized?
- Why is ethnic stereotyping in the art market such an issue for artists from non-Western backgrounds?
- When non-Western artists participate in the Western art world, are they contesting Western cultural hegemony, or are they succumbing to it?

FURTHER READING

- Gidley's edited book *Representing Others* (1992) reviews the issues in his Introduction and includes his own chapter on Curtis, among other studies of colonial images.
- Thomas's book *Possessions* (1999) is a study of artistic colonization in Australasia.
- Mitter's chapter "Art Education and Raj Patronage" (1994) examines the development of Western art in India.
- Rosi's papers "Painting My Country" (2011a) and "Travelling Ahead with the Ancestors" (2011b) complement Svasek's paper on "Identity and Style in Ghanaian Artistic Discourse" (1997).
- Venbrux, Rosi, and Welsch include studies of adaptations to Western gallery art in their edited book *Exploring World Art* (2006).

15 THE GLOBAL AND THE LOCAL

This final chapter considers the cultural implications of globalization and the role of public institutions and popular movements in artistic developments for the future. Can a clearer understanding of world art contribute to a more democratic artistic culture?

Outline of the Chapter

- The Commodification of Art
 How mass consumption creates global styles and buys up local ones.

- Universal and National Museums
 The limitations of the Western model of museums, in metropolitan countries and in Africa.

- Alternative Museums
 Community ownership of art institutions, in Melanesia and the Americas.

- New Art Communities
 Artistic creativity in support of cultural diversity, in North America and Britain.

The history of the last five hundred years has been one of increasing integration among the peoples and cultures of the world. The global economic and political system was driven by Europeans and the West for long enough to give their culture enormous influence throughout the world, despite the emergence of new centers of power in the late twentieth century. This influence has been exercised in the interests of wealthy elites whose power and privilege enables them to set the agenda for others, especially from the metropolitan centers of Western countries. But cultural hegemony is not always passively accepted by those on the periphery of global society. Artefact traditions, both old and new, can be a powerful means for people to assert more democratic control of their culture.

THE COMMODIFICATION OF ART

The world has changed even more rapidly in the last one hundred years. By the early twentieth century, European settlers had taken control of the whole of North America, Australia, and New Zealand, much of South America, and parts of south and east Africa. Almost everywhere else in Africa, Asia, and the Pacific, European empires had colonial agents governing or influencing government in pursuit of their commercial interests. In the middle of the century, encouraged by the disruption of the Second World War, most of the colonies claimed political independence, but their erstwhile rulers continued to exploit the economic systems they had imposed. In the meantime, the United States took over from Europe to become the dominant global power, then other regional economies rose and fell in ever-expanding cycles of industrialization, consumption, and resource exploitation. The recent industrialization of India and China promises further shifts in political and cultural power in times to come, as the global economy staggers from one crisis to the next.

Every community in the world is touched by these developments, however hard some try to evade them, and the consequences include changes in their artistic culture, for better or worse. There can be no doubt that globalization is reducing the artistic diversity of the world, even as it offers new creative opportunities. The standardized products of the industrial centers are traded everywhere in exchange for whatever there is to sell. Those whose independent livelihoods fail to compete for resources, markets, and material rewards with capitalist business migrate for work to wealthier regions and cities from which they may never return. Those whose culture is exotic enough to attract tourists from wealthier backgrounds may be able to earn something from artistic products and performances. Many cultural minorities around the world are under pressure to adopt global culture while selling their own culture as commodity and spectacle.

The predicament of those who seek to live by inherited local artefact traditions in the poor countries of the world at the beginning of the twenty-first century has been summarized by Timothy Scrase:

> There is no doubt that artisans live a precarious, fractured and marginalised existence. It has been estimated by the United Nations that, in India for example, over the past 30 years the numbers of artisans have declined by at least 30%, with many artisans joining the ranks of casual wage labourers and the informal economy. Mass produced, standardised and cheap factory items have replaced many of the various goods once produced by the artisans. Moreover, essential raw materials like skins and hides, certain types of wood, metals, shells and other craft materials have either become too expensive for the artisans to purchase, or else have been diverted to mass production. Those artisans that do survive invariably produce for a world market, and so daily confront the vagaries of that market. Significantly, the issues and

problems . . . apply to many artisan communities drawn from the developing world, but especially those marginal artisan groups and craft workers in Central and Latin America, Africa, and throughout Asia. (2003:449)

As local consumption of local products has declined with the availability of cheaper and often more useful industrial imports, many artisans rely increasingly on exporting their products to wealthier industrial countries, particularly in Europe and North America. The consumers may purchase craft products to connect themselves with more traditional exotic ways of life, which the producers may be seeking to maintain for local economic and cultural autonomy. However, the relationship between them is often mediated by commercial businesses that have an interest in increasing output and driving down prices to the producers, who tend to be poor, uneducated, and politically weak. Women, working at home with the least opportunities to organize, are particularly vulnerable to such exploitation. These commercial pressures also lead to a decline in the quality of the work and a consequent loss of skills, and some artefacts face competition from even cheaper, industrially produced imitations. The foreign markets, in which artisans products are generally luxuries, are inherently unstable and subject to fluctuations in disposable income and changes in fashion, leading producers to compete by chasing new opportunities and undercutting each other. While governing elites may seek to support artisans' production, they usually have little concern for or understanding of the poor and marginalized communities of the producers. They may feel that it is in the national interest to sponsor art in the Western sense, but local artistic traditions are not valued in the same way, nor are less artistic products which are also less prestigious than industrially produced substitutes. Nongovernmental development agencies may offer support, linking to the fair-trade export market with varying success, often compromised by a tendency to impose their own solutions rather than to support local initiatives. Nonetheless, many local artefact traditions survive through the consumer market for alternatives to industrialized mass production.

Of course, these processes of artistic homogenization are long established in industrial countries, where concerns for lost artisan traditions were being voiced in the mid-nineteenth century (as referred to on pages 43, 45, and 213). Most people have long accepted their artificial surroundings, public and private, as professionally designed and industrially produced. "Creating" has come to be an advertising slogan synonymous with shopping, and few people actually participate in creating artefacts rather than consuming them.

UNIVERSAL AND NATIONAL MUSEUMS

With so many of the world's local artistic traditions under threat, museums as invented in Europe and exported worldwide are often held to be bastions for their protection. In 2002, a group of North American and European museum directors stated in a *Declaration on the Importance and Value of Universal Museums*:

> The responsibility for the presentation, study, protection, and care of much of the artistic achievement of mankind rests with the world's art museums. Whether public or private, museums undertake this work in furtherance of the public good. The experience of art fosters the appreciation of beauty and human ingenuity, and promotes understanding among the diverse peoples and cultures of the world. (Association of Art Museum Directors 2002:250)

There is a certain irony in institutions of the Western countries which have played such a large part in homogenizing the world's cultures, assuming the role of preserving diversity, but there is no denying that they possess the artistic resources to make a significant contribution. In the process of conquest and colonization, Europeans collected artefacts that are now among the world's most treasured museum possessions. However, as the heirs or representatives of former owners have gained political influence, some have contested the morality or legality of such acquisitions and made claims on them as their patrimony or heritage. Museums like the British Museum, with global collections, have received demands for the return of artefacts such as the Parthenon and Benin sculptures, and there are innumerable less famous artefacts from around the world that could be claimed on similar grounds. The art museum directors addressed this issue as follows:

> The objects and monumental works that were installed decades and even centuries ago in museums throughout Europe and America were acquired under conditions that are not comparable with current ones.
> Over time, objects so acquired—whether by purchase, gift, or partage—have become part of the museums that have cared for them, and by extension, part of the heritage of the nations which house them. (Association of Art Museum Directors 2002:247–8)

There is no doubt that objects do change their identities and meanings as they change hands. Western museums are full of objects that became the patrimony of European imperial powers after they took them from people who had appropriated them from others, in processes as old as humanity. Archaeologists regularly acquire the trophies and spoils of conquest of ancient empires, and more recent empires have allowed the export of ancient remains from subject lands that have later been claimed by new, independent states. However, historical changes of artefact identity are not necessarily a guide to ethical judgments, which are fraught with complications. Should a trophy belong to the heirs of the victor or of the vanquished? What if no one knows who the previous owners were, whether because a colonial collector was not interested or because they have been dead for thousands of years? If no one can trace legal, genealogical, or cultural inheritance from such owners, what claims can be made by the local inhabitants who replaced them, or by a state that did not exist when the artefacts were made, appropriated, or exported to the museum? Such questions are usually disputed in terms of local, national, or global identities, in which ethics are hard to separate from politics.

The argument of the "universal museum," holding artefacts "in trust for the world," seeks to transcend such disputes. According to the director of the British Museum, Neil MacGregor (2004): "World museums of this kind offer us a chance to forge the arguments that can hope to defeat the simplifying brutalities which disfigure politics all round the world. . . . Where else can the world see that it is one?" The problem with this argument is that the "world as one" is imagined from the viewpoint of the Western owners of the universal museums, who have a vested interest in maintaining the cultural ascendancy claimed in the colonial period. Although adapted to the changing times, this universalism stands accused of legitimating the possession of colonial collections in the face of a growing chorus of claims for repatriation. According to the anthropologist Magnus Fiskesjö:

> the current global debate . . . is ultimately a contest of values over what idea of "universal" culture the people of the world would like to guide them and their identity as humans. Will it be a hollow universalism that perpetuates the power relations of the past, organized in terms of "property" held presumptuously on the world's behalf—or is an alternative universalism possible . . . that can recognize local custody and appreciation as part of a shared responsibility for human creativity inherited from the past? (2010:12)

While seeking to defend possessions that are the very reason for their existence as part of their own national patrimony, museums like the British Museum have been persuaded to reflect on their colonial legacy and to seek new relationships with the source countries of their collections. However, they have been less reflective on the role of museums in non-Western societies.

Museums were introduced by European colonial expansion into new areas of the Americas, Africa, and the Pacific in the late nineteenth and early twentieth century. As colonizers became increasingly conscious of the transformations they were bringing about, some treated artefact collecting as a way to preserve evidence of disappearing cultures and peoples, and, besides sending collections to their homelands, colonial residents founded local museums in the process of identifying themselves with their new countries. Their collections represented Western values of traditional culture embodied in authentic artefacts and, insofar as the source communities were considered, these were assumed to be values they would share. But in the late twentieth century, as colonized peoples took power in independent states and gained civil rights in settler colonies, indigenous attitudes toward old artefacts proved to be rather different.

AFRICA

National museums in Black Africa illustrate the limitations of the Western model. With the independence of many African countries in the 1960s, an early assumption of

governing elites, old and new, was that museums had great potential for supporting local culture in the creation of new national identities. Independent governments provided state sponsorship, encouraged by international organizations such as UNESCO, which set up training centers for museum professionals at Jos in Nigeria and Niamey in Niger. The new African curators, trained in Western museum practice, developed their national museums, founded new local ones, and proclaimed their history and culture to their own people and the world.

But the interest of the African governing elites was not sustained, and few museums developed alternative local constituencies. From the 1980s, as both state and international funding declined, so did professional training, standards, and motivation. Curators ceased to collect; storage, conservation, and security were neglected; and collections were plundered for the art market. With inadequate state funding, museums became relics of the colonial era with little to show but unchanging, dusty exhibitions, increasingly irrelevant to the changing times. The curators found it hard to grasp the Western curatorial values of collecting, cultural relevance, authenticity, and artistic quality. Local people tended to regard museums as repositories for redundant artefacts of little interest, and some became actively hostile to them, especially evangelical Christians who regarded the artefacts of other religions as spiritually dangerous.

African museum professionals soon recognized that the colonial museum model was failing its proclaimed objective of preserving cultural heritage. At a West African museums conference in 1985, Alpha Oumar Konare argued, "Our national museums . . . are no longer part of the everyday culture of the people." He considered that, while they could usefully conserve objects that had lost their functions, "European-style," they should also engage in programs to support local museums, where objects were conserved as useful parts of local traditions in the ongoing creation of culture by local communities. The agendas of these museums should be set by their communities, and not confined to artefacts: "The whole of the heritage must be our concern: the physical and natural heritage . . . as well as the artistic heritage" (Konare 1995).

Museums of this kind have indeed been founded by West African communities to preserve and proclaim local cultural identities and perhaps to make political claims. Local rulers have also turned their collections of ceremonial and religious regalia into museums, accessible to the public. But such initiatives have not received much support from national or international museum institutions, which continue attempts to improve the Western museum model rather than to transform it. The British Museum, which contributed to setting up the Jos museum program in the 1960s, has since 2005 run a sponsored program to train African museum specialists and advise on improvements in museum infrastructure. Despite their success in restoring curatorial standards in several countries, some of those involved echo the doubts of the 1980s of the relevance of the Western museum model to Africa.

ALTERNATIVE MUSEUMS

Reconciliation between metropolitan museums and former colonies now seems to require something more imaginative than returning artefacts as museum collections to people who might not appreciate museums. In Australia, museums of Aboriginal culture founded by colonial settlers have learned to respect Aboriginal values of secrecy and control access to sacred objects, to the extent of returning such things to appropriate heirs or at least employing Aboriginal staff and consultants. But although some Aboriginals have founded their own local museums, they have generally been more interested in the role of artefacts in their communities than as relics to be preserved for their own sake. They often expect museums to represent contemporary issues through history rather than a disappearing past as ethnography, and there are other colonized peoples who share this approach.

MELANESIA

In the Melanesian countries of Papua New Guinea, Solomon Islands, and Vanuatu, local people have proved less interested in museums as artefact repositories than as institutions to support their own ideas of traditional culture or *kastom*. They focus on knowledge and practice, including performance but especially issues such as land tenure and law, in which artefacts are incidental rather than central. Artefacts are of more interest as features of ancestral sites or as family heirlooms than as museum collections, and preferred exhibitions feature contemporary artistic culture. But Melanesians also recognize the tourist interest in their culture, and in order to display as well as sustain it they have embraced the idea of cultural centers, as both local and national institutions.

The Vanuatu Cultural Centre in the capital, Port Vila, has been particularly successful. It grew out of a colonial museum founded in the 1960s and supported after independence in 1980 by an indigenous governing elite concerned to promote local culture in the construction of a national identity. But, under the direction of an enthusiastic expatriate curator, it responded to popular interest to develop country-wide cultural programs. Rather than focusing solely upon the museum's artefact collection in the capital, the Cultural Centre coordinated a network of unpaid local "fieldworkers"—men and women throughout the country who were supported with training and equipment to document the local traditions of most interest to them. The cultural knowledge they recorded was archived according to local requirements of confidentiality and copyright and published where appropriate, especially through radio broadcasts and film.

By facilitating as well as regulating cultural research, the Vanuatu Cultural Centre and its fieldworkers also benefited from the professional expertise of foreign researchers, and avoided academic and commercial exploitation. By dealing with culture as a whole, according to local notions of tradition or *kastom*, it avoided the Western focus on artefact collection that has failed to interest local constituencies in Melanesia, as in Africa.

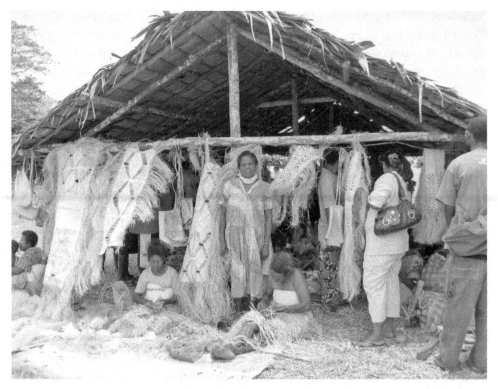

Figure 73 Irene Lini from the island of Maewo at Vanuatu's Third National Arts Festival in 2009, displaying textiles revived through her work as a Cultural Centre fieldworker. (Lissant Bolton photo)

With the support of local communities, the national elite, and metropolitan academics, including British Museum curator Lissant Bolton, the Cultural Centre supported programs on artefacts, ecological knowledge and resource management, music and dance, school education and digital cultural resources. As a result, it has played a significant part in reviving and sustaining the diverse cultures of a small, cash-poor country.

NORTHWEST COAST NATIVE AMERICA

The cultural center model can also provide a solution to issues of repatriation of colonial collections, restoring them to the local communities whence they came rather than to state institutions that they cannot identify with. So it was that the Nuyumbalees and U'mista Cultural Centres on the Northwest Coast in British Columbia were founded in 1979 and 1980, to house a large collection of artefacts belonging to two Kwakwaka'wakw (Kwakiutl) communities (Mauzé 2003). In 1922, about 450 ceremonial items had been confiscated following a raid by Canadian authorities on a potlatch

giveaway festival, under an 1884 law to suppress Native American ceremonies (of the kind described on pages 92–3). Twenty people were imprisoned, and the potlatch equipment—the community's most treasured possessions—was given to public museums or sold. In the 1950s, after the law was abolished, their owners campaigned to have them back, and in the 1970s the National Museum of Man in Ottawa was persuaded to return the large proportion it held, on the condition that it be housed in a museum. In response, two Kwakwaka'wakw communities formed cultural societies responsible for separate museums, supported by state funding, to house their own artefacts. In 1988, the Royal Ontario Museum returned another large quantity of objects, and other institutions did likewise in later years.

The Nuyumbalees community of Cape Mudge began with a fairly conventional Kwagiulth Museum, but with their artefacts displayed to emphasize the inherited ceremonial rights of the chiefly families who owned them. However, the project foundered due to insufficient funding and support from the community, which had ceased to benefit from the business success of its wealthy chiefs.

The U'mista ("Restoration") Cultural Society of Alert Bay had broader objectives than simply their own museum. The suppression of ceremonial life was only part of a Canadian program to destroy Native American culture during the first half of the twentieth century, including also compulsory remedial education that confined children in English-speaking boarding schools. Natives had made covert efforts to keep their artistic traditions alive, with some support from tourism and museum funding, and old museum collections provided inspiration for its reconstruction. The Alert Bay people saw a role for museums in recovering their cultural heritage, but on their own terms. At the U'mista Cultural Centre, the potlatch artefacts were displayed in a communal big-house setting according to the order in which they appeared in the ceremonies. Captions assumed audience knowledge of the significance of the artefacts (as museums of European artefacts do) rather than explaining them either as exotic culture or as art, and texts focused on the colonial repression of Native American culture and Kwakwaka'wakw resistance.

U'mista treated the potlatch collection as a community resource: part of public and school programs to preserve, develop, and promote all aspects of Kwakwaka'wakw culture. At the Cultural Centre, elders passed on their skills to younger generations, including language, craft, and performance, and their cultural knowledge was researched and archived. On the principle of sharing their culture, the Cultural Centre also raised funds from performances and artefact sales to tourists, gaining sympathetic understanding and support from the wider population of Canada and beyond. But the key to its success has been the active voluntary participation in cultural revival by the Alert Bay community as a whole, including the hereditary custodians of ceremonial prerogatives and community leaders—a model that Nuyumbalees has since tried to follow.

SOUTH AND CENTRAL AMERICA

Cultural centers have benefited not only communities seeking to recover their own remembered traditions, but also those seeking to construct new relationships with the places in which they live. Archaeologists Colin McEwan of the British Museum, María-Isabel Silva, and Chris Hudson (2006) have described the experience of Agua Blanca, a village near the coast of Ecuador, where a peasant community lives on the site of an ancient town abandoned not long after the Spanish conquest of the Inca empire. The present inhabitants only arrived there in the 1930s, but by the 1970s, drought, along with logging, charcoal burning, and the encroachment of cattle farmers, was impoverishing them and degrading the forest. To supplement their declining incomes, people were looting archaeological remains for the collectors' market. By the time a British archaeological project arrived in 1979, the government had instituted a national park to conserve the unusual ecosystem, further threatening the peasants' livelihood.

The archaeologists employed and trained a team of local assistants and responded to curiosity about their work. On their periodic visits during the 1980s, local people learned about the site and began to identify with it, contributing their own finds to an exhibition of artefacts in the village hall and organizing annual festivals to show off the site. The archaeologists became advocates for local participation in the management of

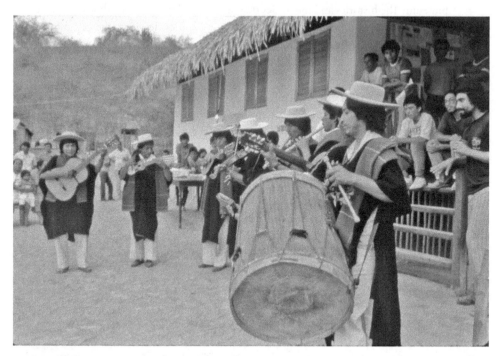

Figure 74 Opening celebrations for the community site museum of Agua Blanca in 1990. (Colin McEwan photo)

the national park and the site, as it became a tourist attraction, and they raised funds for an irrigation project to improve agricultural productivity and take pressure off other sources of income. Eventually they were able to fund a small museum as a cultural center to house, display, and explain the archaeological finds from the site, which was built with voluntary labor and opened in 1990. The project proved a great success in enabling local people to benefit from tourist income, while encouraging them to appreciate and conserve the site as their own. The main problem was persuading the bureaucratic authorities to invest in its long-term future.

Whether they are called cultural centers or museums, such community-based institutions have demonstrated what artefact collections can achieve when deployed in cultural development programs, rather than simply viewed as works of art. Cuauhtemoc Camarena and Teresa Morales (2006) have outlined an alternative museum model appropriate to cultural minorities resisting globalization, based on their experience of the Union of Community Museums of Oaxaca in Mexico:

> The community museum is a strategy for communities to control their future by controlling their past. To control the past, communities take action regarding their cultural heritage. They struggle to possess their material heritage, which has often been expropriated by private or public agents. They struggle to preserve their own symbols and their own meanings, and to legitimize these meanings through the museum. The histories and memories that are not told in official textbooks come to life. As the process of collecting and representing stories develops, the community museum also becomes a vehicle for a collective process of interpretation, through which new elements of debate and consensus are created. . . .
>
> The community museum is a platform for a wide variety of actions that respond to community needs. The museum can develop effective ways to engage and educate children and young people, strengthening their bonds to community culture, and offering new skills for creative expression. The museum can contribute to the revitalization of a great variety of cultural traditions, including dance, music, and native languages. The museum can make diverse forms of training available and provide skills that allow community members to develop projects that respond to their own needs and aspirations. The museum can become a window through which the community relates to other communities, carrying out cultural exchange and building networks to impact diverse projects and policies. Through the museum a community can organize services for visitors, designed by community members, in a respectful and orderly exchange, instead of remaining an object of consumption by commercial tourism agencies. (2006:327–28)

NEW ART COMMUNITIES

Throughout the world, local communities are also developing new artistic programs as indigenous, migrant, or diaspora groups who create identities for themselves in

multiethnic societies. Although they may draw upon museums and cultural centers, the artistic activities that seem of most interest to most people are not so much artefacts for their own sake as social activities in which artefacts can play a crucial role.

NATIVE NORTH AMERICANS

Dance festivals, or "powwows," have helped Native Americans of the United States and Canada to create a shared identity as an ethnic minority possessed of distinctive artistic traditions. The common dance styles adopted by peoples of many Native cultures originated in Oklahoma in the 1870s with a social dance complex that was passed on to Native communities throughout the Great Plains to Canada during the 1880s, at a time when they were being confined to reservations under colonial rule. This was a period of hardship and oppression, and the social dances were sometimes associated with the Ghost Dance movement of spiritual resistance to the American conquest. As public events of distinctively Native character, performed with great enthusiasm by desperate people, the social dances were recognized as challenges to the colonial order and to government policies of assimilation. Both U.S. and Canadian authorities tried to suppress them, although Wild West Shows and Indian Fairs provided support for dance displays. After the Second World War, Native American veterans revived some of the warrior values of the Plains, and there was a renewed confidence in Native identity. By the 1950s, the social dances were becoming part of powwow gatherings, which were spreading among Native peoples from the Great Lakes region, contributing to the Pan-Indian movement for Native identity and civil rights that developed during the 1960s and 1970s. Since then, powwows have come to involve Native communities throughout the West.

Powwows are organized by local Native American communities through their councils or voluntary organizations. Large sums of money have to be raised to fund them, including generous cash prizes for the dance competitions, hospitality, and gifts for visitors from other communities. They are usually held for one to three days over a weekend or up to a week for major events, and scheduled to follow one after another in circuits over the spring and summer season. The success of the powwow in terms of the performances, attendance, and public appreciation brings credit to the host community.

Participants usually camp around the circular dance arena and its stalls selling food and Native artefacts, and events are carefully programmed with appropriate ceremony. There is a Grand Entry procession to introduce the participants and local notables and officials, with war veterans and elders playing prominent roles, and proceedings are blessed with prayers to deities. Giveaways of goods and distributions of free food by the organizers and others are staged to honor people's achievements or the recently dead.

Music is provided by groups of singers around a drum, which provides a spiritual focus for the dancing. This includes open dances for everyone to join in and often dance competitions organized by gender, age, and styles of dance, each with its own style of "outfit." These derive from nineteenth-century Plains ceremonial and dance dress,

including warrior society regalia, but elaborated to be exuberant and eye-catching. There is an emphasis on feathers, fringes, and beadwork embroidery, incorporating both Native and mainstream American materials and motifs, often with features identified with the dancer's own ethnic group, as documented in old photos and museum collections. While designed for dancing, the outfits are also displayed in parades and follow changing fashions to compete for attention and admiration, as artistic symbols of Native American identity and values.

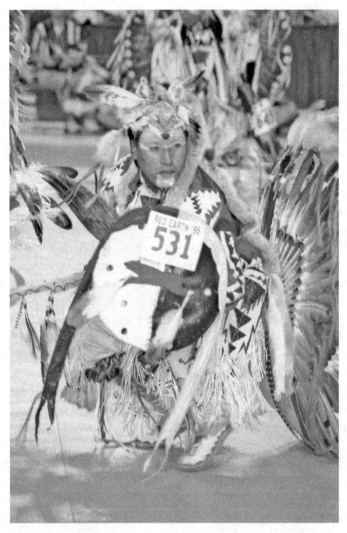

Figure 75 Kevin Haywahe performing in a traditional-style dance competition at a powwow in Oklahoma in the 1990s. (Milton Paddlety photo, The Trustees of the British Museum; F.N.1607)

BRITISH PACIFIC ISLANDERS

As Native Americans have done with the powwow, so people migrating from rural areas to towns and from poor countries to rich ones form new cultural communities around artistic activities. Britain has innumerable national and ethnic organizations formed by immigrants from its former colonies and beyond that unite around artistic programs celebrating their minority identities, particularly through costumed performance. Most spectacular is London's Notting Hill Carnival, developed by Caribbean communities since the 1960s and now attended by people of all backgrounds as one of the world's great popular festivals. But there are many smaller groups devoted to maintaining cultural identity and solidarity through artistic performance.

The Kiribati Tungaru Association, or KTA, is a membership organization that has used the dance traditions of its home islands in Micronesia to support a diaspora community scattered throughout Britain. It was founded in 1994 by a small group of women from Kiribati (pronounced Kiribas) who had married British expatriate workers and kept in touch with each other when they moved to Britain. To recall their home culture and pass it on to their children, they would bring their families together for occasional

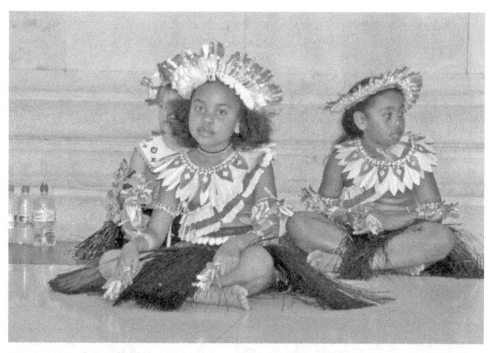

Figure 76 British Pacific Islanders Christine and Angela Betero Ewurum, of Kiribati and Nigerian ancestry, resting between KTA performances at the British Museum in 2006. (Ben Burt photo)

weekends, camp somewhere like a village hall, and practice their life from home, including dancing. Being colonially educated, they realized the limits of their own knowledge and eventually obtained funding to bring a dance teacher from Kiribati. After that, their dancing improved enough to stage performances for which they could charge fees to meet the costs of their costumes, travel, and other expenses. The dancing, displaying artistic costumes brought from Kiribati or made by the women themselves, has become a focus for their regular meetings, which include an annual festival to celebrate Kiribati independence from British rule each July. The younger generation, of mixed Kiribati and British descent, provide most of the dancers, with their mothers doing the singing and their husbands and fathers providing logistical support. As representatives of a former colony, which is threatened by rising sea-levels, the KTA also act as advocates on behalf of their country of origin and recognize their artistic traditions as a crucial part of the identity that enables them to do so.

Such artistic creativity, deriving from local traditions that people can identify with as their own distinctive heritage, however diverse their backgrounds, is a democratic alternative to the cultural hegemony of global capitalism and its elitist art world. Most of us will only ever be admitted to this art world as casual visitors to the museums and galleries whose goal of enlightening humanity is too often measured in the attendance figures

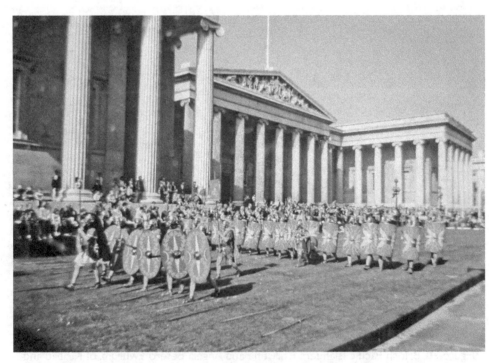

Figure 77 The Ermine Street Guard reenactment group performing Roman Britain at the British Museum in 1989. (The Trustees of the British Museum)

that justify their public funding. Some of us may participate in the Western art tradition through classes and societies, but only as amateurs in an art-world hierarchy controlled by professionals, public institutions, and wealthy sponsors. Organizations formed out of popular interest in shared cultural identities, old or new, inherited or constructed, can actively engage people in artistic creativity to enrich their lives and communities. Nor is it only ethnic minorities who seek such alternatives to the dominant culture. The indigenous British who research, make, and perform the costumes of the English Civil War, the ancient Roman army, or Native Americans reveal a pervasive dissatisfaction with Western culture and its artistic traditions as presented to them by their own elites and a desire to be creative within their own cultural communities. As societies around the world become at once more culturally homogenous and socially diverse, people continue to assert their own cultural autonomy through new artistic production.

QUESTIONS FOR DISCUSSION

- Is it a problem if local artistic traditions are replaced by more widely shared global ones?
- What role should museums play in the world's artistic heritage?
- Are the values of Western art and the art world compatible with those of local artistic traditions and popular artistic movements?

FURTHER READING

- Thomas's Introduction to the book *Melanesia* (2012) provides an academic perspective on a British Museum project to engage source communities with colonial museum collections.
- Kaplan's book *Museums and the Making of Ourselves* (1994) is a collection of papers on the role of museums in early postcolonial nation-building.
- Silverman's book *Archaeological Site Museums in Latin America* (2006) includes a chapter on Agua Blanca and one on Moche sites in Peru (see Chapter 9).
- Roberts's highly illustrated book (1992) gives a history and description of *Powwow Country*.
- Stanley's book *Being Ourselves for You* (1998) examines the development of cultural centers in Melanesia in Chapter 3.

AFTERWORD

This book has advocated an approach to the world's diverse artefact traditions based on understanding the cultures they participate in, to counter the Western tendency to assimilate some artefacts into its own hegemonic categories of art while relegating others to non-art. The discipline of anthropology brings a certain cultural relativism to the task, allowing critical reflection on its own Western culture, in which art has been a particularly obdurate category. Underlying this approach is a conviction that the Western concepts and institutions of art that have so effectively colonized the artefacts of other cultures, have been exploitative and deficient in certain important social values. The Western, and increasingly global, art world conflates artistic with commercial values to promote a culture of consumption that deprives many ordinary people of their own cultural heritage and homogenizes their diverse artefact traditions. Global markets introduce Western hierarchical categories and criteria for collectibility that distort the appreciation of artefacts in terms of local values. Within their own metropolitan centers, the elitist institutions of the art world, with their emphasis on collecting and display to passive audiences, discourage the popular creativity that should enrich everyone's lives.

Yet this creativity is continually revived in the cause of local identities, whether in support of cultural regeneration or in response to economic opportunities, and it often draws upon the institutions and markets of the art world. Museums and galleries have a vital contribution to make to popular artistic movements, which should not be constrained by the tendency to fetishize artefacts as works of art to be traded, collected, and exhibited according to the agenda of the art-world elite. Such may be the intended role of certain kinds of Western artefacts, but other traditions show the work of art to be diverse and pervasive, as indeed it is in Western societies under other names. Of course, most artefacts in museum collections have been made redundant from their original jobs, but they can still work as repositories of cultural knowledge and artistic values about, and often for, the people who made, used, and possessed them. Such people might not declare an interest in art or regard themselves as artists, but they may yet participate in artistic traditions, old and new.

Considering art as an aspect of cultural production, rather than as a thing in itself, should help us to appreciate better its work in the ongoing reproduction of world culture. Ultimately, culture resides not in artefacts and collections, but in living persons

participating in the communities and networks of society. Artefacts are like books: they contribute to culture only insofar as they are read, comprehended, discussed, and shared, and this book recommends that we try to comprehend the languages in which they are written, rather than just look at the pictures. The work of art in society is to contribute meaningful pattern to people's lives, and artefacts are but moments in this ongoing process.

REFERENCES

Titles in **bold** are suggested as further reading in the lists at the end of each chapter.

Alva, W., & Donnan, C. (1988) Discovering the New World's Richest Unlooted Tomb / Unravelling the Mystery of the Warrior-Priest. *National Geographic Magazine* 510–55.

Amin, S. (1988) *Eurocentrism*. Zed Books, London.

Araeen, R. (1994) New Internationalism or the Multiculturalism of Global Bantustans. In J. Fisher (ed.) *Global Visions: Towards a new internationalism in the visual arts*. Kala Press, London.

Association of Art Museum Directors (2002) Declaration on the Importance and Value of Universal Museums and Art Museums and the International Exchange of Cultural Artefacts (Reprinted in I. Karp, C. A. Kratz, L. Szwaja, & T. Ybarra-Frausto [eds.] [2006] *Museum Frictions: Public cultures / global transformations*. Duke University Press, Durham, NC).

Baker, M., & Richardson, B. (eds.) (1997) *A Grand Design: The art of the Victoria and Albert Museum*. V&A Publications, London.

Barbash, I., & Taylor, L. (1993) *In and Out of Africa*. Film, 59 min. Berkeley Media LLC.

Barley, N. (1994) *Smashing Pots: Feats of clay from Africa*. British Museum Press, London.

Barthes, R. (1977) The Rhetoric of the Image. In R. Barthes *Image, Music, Text* (ed. & trans. S. Heath). Hill & Wang, New York.

Beard, M. (2003) *The Parthenon*. Harvard University Press, Cambridge, MA.

Beazley, J. D., Robertson, D. S., & Ashmole, B. (1929) *Suggestions for the New Exhibition of the Sculptures of the Parthenon*. British Museum.

Belk, R. W. (1995) *Collecting in a Consumer Society*. Routledge, London.

Bell, C. (1913) *Art*. Chatto & Windus, London.

Ben-Amos, P. (1971) Humans and Animals in Benin Art. *Man* 11:243–52. (Reprinted in J. C. Beloe & L. A. Wilson [eds.] [1993] *Arts of Africa, Oceania, and the Americas*. Prentice-Hall, Englewood Cliffs, NJ)

Ben-Amos, P. (1995) *The Art of Benin*. British Museum Press, London.

***Berg Encyclopedia of World Dress and Fashion*. (2010)** 10 volumes. Berg, Oxford.

Bernal, M. (1987) The Fabrication of Ancient Greece 1785–1985. Vol. 1 of *Black Athena: The Afroasiatic roots of classical civilization*. Rutgers University Press, New Brunswick, NJ.

Birdwood, G.C.M. (1880) *The Industrial Arts of India*. Chapman & Hall, London.

Birdwood, G.C.M. (1903) Conventionalism in Primitive Art. *Journal of the Society of Arts* 52:81.

Black, J. (2008) *World History Atlas*. Dorling Kindersley, London (first published 1999).

Blair, S. S., & Bloom, J. M. (2003) The Mirage of Islamic Art: Reflections on the study of an unwieldy field. *The Art Bulletin* 85:152–84.

Boas, F. (1927) *Primitive Art.* Aschehoug, Oslo.

Bock, E. K. de (2003) Organisation in Nazca iconography. A.D. 1–700. In *Colecciones Latinoamericanos, Latin American collections: Essays in honour of Ted J. J. Leyenaar.* Ed. Tetl., Leiden.

Bohrer, F. (1994) The Times and Spaces of History: Representation, Assyria, and the British Museum. In D. J. Sherman & I. Rogoff (eds.) *Museum Culture: Histories, discourses, spectacles.* Routledge, London.

Bohrer, F. (1998) Inventing Assyria: Exoticism and reception in nineteenth-century England and France. *Arts Bulletin* 80:336–56.

Bourget, S. (2005) But is it Art? The complex roles of images in Moche culture, an ancient Andean society of the Peruvian North coast. In M. Westermann (ed.) *Anthropologies of Art.* Sterling & Francine Clark Art Institute, Williamstown, MA.

Brade-Birks, S. G. (1954) *Teach Yourself Archaeology.* English Universities Press, London.

British Museum (1910) *Handbook to the Ethnographical Collections.* British Museum, London.

Buck, L. (2004) *Market Matters: The dynamics of the contemporary art market.* Arts Council England, London.

Bullock, W. (1824) *A Descriptive Catalogue of the Exhibition, Entitled Ancient and Modern Mexico . . . at the Egyptian Hall, Piccadilly.* Bullock, London.

Burrows, G. (1898) *The Land of the Pygmies.* Pearson, London.

Burt, B. (2005) *Africa in the World: A museum history.* British Museum Press, London.

Burt, B. (2009) *Body Ornaments of Malaita, Solomon Islands.* British Museum Press, London & University of Hawai'i Press, Honolulu.

Burt, B., Mindel, C., & Woff, R. (2002) *Art: The J. P. Morgan Chase Gallery of North America: A Guide for Primary and Secondary Teachers.* British Museum Education Dept.

Camarena, C., & Morales, T. (2006) Community Museums and Global Connections: The Union of Community Museums of Oaxaca. In I. Karp, C. A. Kratz, L. Szwaja, & T. Ybarra-Frausto (eds.) *Museum Frictions: Public cultures / global transformations.* Duke University Press, Durham, NC.

Campbell, S. (2001) The Captivating Agency of Art: Many ways of seeing. In N. Thomas & C. Pinney (eds.) *Beyond Aesthetics: Art and the technologies of enchantment.* Berg, Oxford.

Campbell, S. (2002) *The Art of Kula.* Berg, Oxford.

Catlin, G. (1844) *Letters and Notes on the Manners, Customs, and Conditions of the North American Indians.* (Reprinted 1973, Dover, New York)

Caygill, M. (1981) *The Story of the British Museum.* British Museum Press, London.

Clark, K. (1977) *Animals and Men: Their relationship as reflected in Western art from prehistory to the present day.* Thames & Hudson, London.

Cole, H. (1874) *Catalogue of the Objects of Indian Art Exhibited in the South Kensington Museum Eyre & Spottiswoode, London.*

Cook, J. (2003) The Discovery of British Antiquity. In K. Sloan (ed.) *Enlightenment: Discovering the world in the eighteenth century.* British Museum Press, London.

Coombes, A. (1994) *Reinventing Africa: Museums, material culture and popular imagination in late Victorian and Edwardian England.* Yale University Press, New Haven, CT.

Coote, J. (1992) "Marvels of Everyday Vision": The anthropology of aesthetics and the cattle-keeping Nilotes. In J. Coote & A. Shelton (eds) *Anthropology, Art and Aesthetics*. Clarendon Press, Oxford. (Reprinted in H. Morphy & M. Perkins [eds.] [2006] *The Anthropology of Art: A reader*. Blackwell, Oxford)

Court, E. (1999) **Africa on Display: Exhibiting art by Africans.** In E. Barker (ed.) *Contemporary Cultures of Display*. Yale University Press, New Haven, CT.

Craig, B. (1998) Relic and Trophy Arrays as Art among the Mountain-Ok, Central New Guinea. In A. Hanson & L. Hanson (eds.) *Art and Identity in Oceania*. Crawford House, Bathurst.

Craig, B. (2005) **What Can Material Culture Studies Tell Us about the Past in New Guinea?** In A. Pawley, J. Golson, R. Attenborough, & R. Hide (eds.) *Papuan Pasts: Cultural, linguistic and biological histories of Papuan-speaking peoples*. Australian National University, Canberra.

d'Azevedo, W. L. (1973) **Mask Makers and Myth in Western Liberia.** In A. Forge (ed.) *Primitive Art and Society*. Oxford University Press, London. (Reprinted in J. C. Berlo & L. A. Wilson [eds.] [1993] *Arts of Africa, Oceania and the Americas*. Prentice-Hall, Englewood Cliffs, NJ)

Deloria, V. (1995) *Red Earth, White Lies: Native Americans and the myth of scientific fact.* Scribner, New York.

Donnan, C. B. (1992) *Ceramics of Ancient Peru.* University of California, Los Angeles.

Donnan, C. B. (1997) Deer Hunting and Combat: Parallel activities in the Moche world. In K. Berrin (ed.) *The Spirit of Ancient Peru: Treasures from the Museo Arqueológico Rafael Larco Herrera*. Thames & Hudson, New York.

Dunn, D. (1955) America's First Painters: Indians, who once painted rocks and buffalo hides, now use paper and canvas to preserve ancient art forms. *National Geographic Magazine* 107:349–77.

Economist (2011, July 21) Chinese Checkers: Contemporary art in China. 79–80.

Errington, S. (1998) *The Death of Authentic Primitive Art and Other Tales of Progress.* University of California Press, Berkeley.

Errington, S. (2005) History Now: Post-tribal art. In M. Westermann (ed.) *Anthropologies of Art*. Sterling & Francine Clark Art Institute, Williamstown, MA.

Fagg, W. (1965) *Tribes and Forms in African Art.* Tudor, New York. (Introduction reprinted in H. Morphy & M. Perkins [eds.] [2006] *The Anthropology of Art: A reader*. Blackwell, Oxford)

Fagg, W. (1970) *The Tribal Image: Wooden figure sculpture of the world*. British Museum, London.

Fagg, W. (1973) **In Search of Meaning in African Art.** In A. Forge (ed.) *Primitive Art and Society*. Oxford University Press, London.

Félibien, A. (1669) Preface to *Conférences de L'Académie Royale de Peinture et de Sculpturee pendant l'année* 1667. Paris.

Fergusson, J. (1876) History of Indian and Eastern Architecture. (Extract reprinted in S. Edwards [ed.] [1999] *Art and Its Histories: A reader*. Yale University Press, New Haven, CT, with the Open University)

Firth, R. (1992) **Art and Anthropology.** In J. Coote & A. Shelton (eds.) *Anthropology, Art and Aesthetics*. Clarendon Press, Oxford.

Fiskesjö, M. (2010) Global Repatriation and "Universal Museums." *Anthropology News* 51:10–12.

Forge, A. (ed.) (1973) *Primitive Art and Society.* Oxford University Press, London.

Forge, A. (1973) Style and Meaning in Sepik Art. In A. Forge (ed.) *Primitive Art and Society*. Oxford University Press, London.

Fraser, D. (1966a) The Heraldic Woman: A study in diffusion. In D. Fraser (ed.) *The Many Faces of Primitive Art; A critical anthology*. Prentice-Hall, Englewood Cliffs, NJ.

Fraser, D. (1966b) *Primitive Art*. Thames & Hudson, London.

Frazer, J. F. (1890) *The Golden Bough: A study in comparative religion*. Macmillan, London.

Garlake, P. (2002) *Early Art and Architecture of Africa*. Oxford History of Art, Oxford University Press.

Gell, A. (1992) The Technology of Enchantment and the Enchantment of Technology. In J. Coote & A. Shelton (eds.) *Anthropology, Art and Aesthetics*. Clarendon Press, Oxford.

Gell, A. (1998) *Art and Agency: An anthropological theory*. Clarendon Press, Oxford.

Gidley, M. (1992) *Representing Others: White views of indigenous peoples*. University of Exeter Press.

Giles, L., Udvardy, M., & Mitsanze, J. (2004) Cultural Property as Global Commodities: The case of Mijikenda memorial statues. *Cultural Survival Quarterly* 27:78–82.

Gombrich, E. (1950) *The Story of Art*. Phaidon, London.

Gow, P. (1999) Piro Design: Painting as meaningful action in an Amazonian lived world. *Journal of the Royal Anthropological Institute* 5:229–47.

Graburn, N. H. (ed.) (1976) *Ethnic and Tourist Arts: Cultural expressions from the Fourth World*. University of California Press, Berkeley.

Graburn, N. H. (1999) Ethnic and Tourist Arts Revisited. Epilogue to R. B. Phillips & C. B. Steiner (eds.) *Unpacking Culture: Art and commodity in colonial and postcolonial worlds*. University of California Press, Berkeley.

Greene, K. (2002) *Archaeology: An introduction*. 4th edition. Routledge, London.

Greenfield, J. (1989) *The Return of Cultural Treasures*. Cambridge University Press.

Gretton, T. (1986) New Lamps for Old. In A. L. Rees & F. Borzello (eds.) *The New Art History*. Camden Press, London.

Gwynne-Jones, P. (1998) *The Art of Heraldry: Origins, Symbols and Designs*. Parkgate Books, London.

Haplin, M. (1994) A Critique of the Boasian Paradigm for Northwest Coast Art. *Culture* 14:5–6.

Hatley, B. (1971) Wayang and Ludruk: Polarities in Java. *The Drama Review* 15:88–101.

Havell, E. B. (1911) *The Ideals of Indian Art*. John Murray, London.

Holm, B. (1965) *Northwest Coast Indian Art: An analysis of form*. University of Washington Press, Seattle.

Horton, R. (1963) The Kalabari *Ekine* Society: A borderland of religion and art. *Africa: Journal of the International African Institute* 33:94–114.

House of Commons (1816) *Report from the House of Commons Select Committee on the Earl of Elgin's Collection of Sculptured Marbles*. (Reprinted [1851] *Museum of Classical Antiquities* 1; cited at length in Greenfield 1989 Ch.2)

Illustrated London News (1897, Jan. 23).

Jenkins, I. (1992) *Archaeologists and Aesthetes in the Sculpture Galleries of the British Museum 1800–1939*. British Museum Press, London.

Jenkins, I. (2007a) *The Parthenon Sculptures in the British Museum*. British Museum Press, London.

Jenkins, I. (2007b) Timeless Beauty. *British Museum Magazine* 58.

Jones, O. (1856) *The Grammar of Ornament*. Day, London.

Kabbani, R. (1986) *Europe's Myths of Orient: Devise and rule*. Pandora Press, London.

Kaplan, F.E.S. (ed.) (1994) *Museums and the Making of Ourselves: The role of objects in national identity*. Leicester University Press, London.

Kasfir, S. (1992) African Art and Authenticity: A Text with a Shadow. *African Arts* 25:40–53, 96–97.

Kaufman, C. (1976) Functional Aspects of Haida Argillite Carving. In N.H. Graburn (ed.) *Ethnic and Tourist Arts: Cultural expressions from the Fourth World*. University of California Press, Berkeley.

Konare, A. O. (1995) The Creation and Survival of Local Museums. In C.D. Ardouin & E. Arisze (eds.) *Museums and the Community in West Africa*. Smithsonian Institution, Washington, DC, & James Curry, London.

Langness, L. L. (2005) *The Study of Culture*. 3rd edition. Chandler & Sharp, Novato, CA.

Layard, A. H. (1849) *Niniveh and its Remains*. John Murray, London.

Lee, M. (1999) Tourism and Taste Cultures: Collecting Native art in Alaska at the turn of the twentieth century. In R. B. Phillips & C. B. Steiner (eds.) *Unpacking Culture: Art and commodity in colonial and postcolonial worlds*. University of California Press, Berkeley.

Lévi-Strauss, C. (1963) Split Representation in the Art of Asia and America. In *Structural Anthropology*. Basic Books, New York. (Reprinted in H. Morphy & M. Perkins [eds.] [2006] *The Anthropology of Art: A reader*. Blackwell, Oxford)

Lubbock, J. (1913) *Prehistoric Times as Illustrated by Ancient Remains and the Manners and Customs of Modern Savages*. 7th edition. Williams & Norgate, London.

MacGregor, N. (2004) The Whole World in Our Hands. *The Guardian*, July 24.

Makepeace, A. (2001) Commentary for *Coming to Light: Edward S. Curtis and the North American Indians*. American Masters series, Bullfrog Films, Reading, PA.

Mamiya, C., & Sumnick, E. (1982) Hevehe: Art, Economics and Status in the Papuan Gulf. Museum of Cultural History, UCLA, Monograph series 18.

Mauzé, M. (2003) Two Kwakwaka'wakw Museums: Heritage and politics. *Ethnohistory* 50:503–22.

McEwan, C., Silva, M. I., & Hudson, C. (2006) Using the Past to Forge the Future: The genesis of the community site museum at Agua Blanca, Ecuador. In H. Silverman (ed.) *Archaeological Site Museums in Latin America*. Florida University Press, Gainesville.

McLeod, M., & Mack, J. (1985) *Ethnic Sculpture*. British Museum Publications, London.

Mercouri, M. (1986) *The Parthenon Marbles*. (Speech to the Oxford Union) The British Committee for the Restitution of the Parthenon Marbles.

Mitra, R. (1875) *The Antiquities of Orissa*. Wyman & Co, Calcutta.

Mitter, P. (1977) *Much Maligned Monsters: History of European reactions to Indian art*. Clarendon Press, Oxford.

Mitter, P. (1994) Art Education and Raj Patronage. In *Art and Nationalism in Colonial India 1850–1922: Occidental orientations*. Cambridge University Press.

Mitter, P. (1999) "Decadent" Art of South Indian Temples. In C. King (ed.) *Views of Difference: Different views of art*. Yale University Press, New Haven, CT, with the Open University.

Mitter, P., & Clunas, C. (1997) The Empire of Things: Engagement with the Orient. In M. Baker & B. Richardson (eds.) *A Grand Design: The art of the Victoria and Albert Museum*. V&A Publications, London.

Morel, E. (1904) *King Leopold's Rule in Africa.* Heinemann, London.

Morphy, H. (2007) ***Becoming Art: Exploring cross-cultural categories.*** Berg, Oxford.

Morphy, H., & Perkins, M. (eds.) (2006) ***The Anthropology of Art: A reader.*** Blackwell, Oxford.

Munn, N. (1962) Walbiri Graphic Designs: An analysis. *American Anthropologist* 64: 972–84.

Munn, N. (1973) *Walbiri Graphic Art: Graphic representation and cultural symbolism in a Central Australian society.* University of Chicago Press.

Munn, N. (1976) The Spatial Presentation of Cosmic Order in Walbiri Iconography. In A. Forge (ed.) *Primitive Art and Society.* Oxford University Press, London.

O'Hanlon, M. (1989) *Reading the Skin: Adornment, display and society among the Wahgi.* Crawford House Press, Bathurst.

Overy, P. (1986) The New Art History and Art Criticism. In A. L. Rees & F. Borzello (eds.) *The New Art History.* Camden Press, London.

Pagini, C. (1988) Chinese material culture and British perceptions of China in the mid-19th century. In T. Barringer & T. Flynn (eds.) *Colonialism and the Object: Empire, material culture and the museum.* Routledge, London.

Parker, R., & Pollock, G. (1981) *Old Mistresses: Women, art and ideology.* Harper Collins, London.

Pearce, C. (1993) The Myth of Shona Sculpture. *Zambezia* 20:85–107.

Phillips, R., & Steiner, C. B. (1999) Art, Authenticity, and the Baggage of Cultural Encounter. In R. B. Phillips & C. B. Steiner (eds.) *Unpacking Culture: Art and commodity in colonial and postcolonial worlds.* University of California Press, Berkeley.

Pillsbury, J. (2001) Introduction in J. Pillsbury (ed.) *Moche Art and Archaeology in Ancient Peru.* National Gallery of Art, Washington, DC.

Pitt-Rivers, L. F. (1906) *The Evolution of Culture and Other Essays.* Clarendon Press, Oxford.

Pooke, G., & Newall, D. (2008) ***Art History: The basics.*** Routledge, London.

Portal, J. (1992) Decorative Arts for Display. In J. Rawson (ed.) *The British Museum Book of Chinese Art.* British Museum Press, London.

Powell, A. (1925) *The Map that is Half Unrolled.* The Century Co., New York.

Price, S. (1989) ***Primitive Art in Civilized Places.*** University of Chicago Press.

Quilter, J. (1990) The Moche Revolt of the Objects. *Latin American Antiquity* 1:42–65.

Quilter, J. (1997) The Narrative Approach to Moche Iconography. *Latin American Antiquity* 8:113–33.

Rees, A. L., & Borzello, F. (eds.) (1986) ***The New Art History.*** Camden Press, London.

Richards, R. (2003) Menepo: The recent evolution of a traditional wood sculpture from Santa Cruz in the Solomon Islands. *Tuhinga* 14:35–40.

Richardson, J. (1719) *An ESSAY On the whole Art of Criticism as it relates to PAINTING and An ARGUMENT in behalf of the SCIENCE of a CONNOISSEUR.* London.

Roberts, C. (1992) ***Powwow Country.*** American & World Geographic Publishing, Helena, MT.

Rosi, P. (2006) The Disputed Value of Contemporary Papua New Guinea Artists and their Work. In E. Venbrux, P. S. Rosi, & R. L. Welsh (eds.) *Exploring World Art.* Waveland Press, Long Grove, IL.

Rosi, P. (2011a) *Painting My Country Papua New Guinea: The creative (contested) vision of Larry Santana.* In K. Stevenson (ed.) *Pacific Island Artists: Navigating the global art world.* Masalai Press, Oakland, CA.

Rosi, P. (2011b) Travelling Ahead with the Ancestors: Re-directing tertiary education in Papua New Guinea (PNG) and the promotion of contemporary PNG art (1972–2009). *Pacific Arts* 11:19–32.

Rosman, A., & Rubel, P.G. (1990) Structural Patterning in Kwakiutl Art and Ritual. *Man* 25:620–39. (Reprinted in H. Morphy & M. Perkins [eds.] [2006] *The Anthropology of Art: A reader*. Blackwell, Oxford)

Rubin, W. (1984) *"Primitivism" in 20th-Century Art: Affinity of the tribal and the modern.* Museum of Modern Art, New York. (exhibition brochure)

Ruskin, J. (1873) A Joy Forever. In E. T. Cook & A. Wedderburn (eds.) (1903–1912) *The Works of John Ruskin*. London.

Said, E. (1978) *Orientalism.* Pantheon Books, New York.

Scrase, T. (2003) Precarious Production: Gobalisation and artisan labour in the Third World. *Third World Quarterly* 24:449–61.

Sears, L. J. (1989) Aesthetic Displacement in Javanese Shadow Theatre: Three contemporary performance styles. *The Drama Review* 33:122–40.

Selfridges (1937) *A Portfolio of Selfridges Decorations for the Coronation.* Selfridge, London.

Sillitoe, P. (1988) From Head-dresses to Head-messages: The art of self-decoration in the Highlands of Papua New Guinea. *Man* 23:298–318.

Silverman, E. K. (1999) Tourist Art as the Crafting of Identity in the Sepik River (Papua New Guinea). In R. B. Phillips & C. B. Steiner (eds.) *Unpacking Culture: Art and commodity in colonial and postcolonial worlds*. University of California Press, Berkeley.

Silverman, H. (ed.) (2006) *Archaeological Site Museums in Latin America.* Florida University Press, Gainesville.

Sims, L. (2006) The "Solarization" of the Moon: Manipulated knowledge at Stonehenge. *Cambridge Archaeological Journal* 16:191–207.

Sims, L. (2008) Stonehenge and the Neolithic Counter-revolution. *Weekly Worker* 740, 9 October.

Sloan, K. (ed.) (2003) *Enlightenment: Discovering the world in the eighteenth century.* British Museum Press, London.

Smith, V. (1889) Graeco-Roman Influence on the Civilization of Ancient India. *Journal of the Asiatic Society of Bengal* 58:107–98.

Speiser, F. (1941) Art Styles in the Pacific. (Reprinted in D. Fraser [ed.] [1966] *The Many Faces of Primitive Art*. Prentice-Hall, Englewood Cliffs, NJ)

Stanley, N. (1998) *Being Ourselves for You: The global display of cultures.* Middlesex University Press, London.

Steiner, C. B. (1995) The Art of the Trade: On the creation of value and authenticity in the African art market. In G. E. Marcus & F. R. Myers (eds.) *The Traffic in Culture: Refiguring art and anthropology*. University of California Press, Berkeley.

Strathern, A., & Strathern, M. (1971) *Self Decoration in Mount Hagen.* Duckworth, London.

Svasek, M. (1997) Identity and Style in Ghanaian Artistic Discourse. In J. MacClancy (ed.) *Contesting Art: Art, politics and identity in the modern world*. Berg, Oxford.

Thomas, D. H. (2000) *The Skull Wars: Kennewick Man, archaeology, and the battle for Native American identity.* Basic Books, New York.

Thomas, N. (1999) *Possessions: Indigenous art / colonial culture.* Thames & Hudson, London.

Thomas, N. (2012) Introduction. In L. Bolton et al. (eds.) *Melanesia: Art and encounter.* British Museum Press, London.

Thomas, N., & Pinney, C. (eds.) (2001) *Beyond Aesthetics: Art and the technologies of enchantment.* Berg, Oxford.

Townsend, R. (1985) Deciphering the Nazca World: Ceramic images from ancient Peru. *The Art Institute of Chicago Museum Studies* 11:116–39.

Udvardy, M., Giles, L. L., & Mitsanze, J. B. (2003) The Transatlantic Trade in African Ancestors: Mijikenda memorial statues (Vigango) and the ethics of collecting and curating non-Western cultural property. *American Anthropologist* 105:566–80.

Vastokas, J. M. (1978) Cognitive Aspects of Northwest Coast Art. In M. Greenhalgh & V. Megaw (eds.) *Art in Society: Studies in style, culture and aesthetics.* Duckworth, London.

Venbrux, E., Rosi, P., & Welsch, R. L. (2006) *Exploring World Art.* Waveland Press, Long Grove, IL.

Vogel, S. (1996) Always True to the Object, in Our Fashion. In I. Karp & S. D. Lavine (eds.) *The Poetics and Politics of Museum Display.* Routledge, London.

Wall Street Journal (2002, Dec. 12) *Declaration on the Importance and Value of Universal Museums.* (Reprinted in I. Karp, C. A. Kratz, L. Szwaja, & T. Ybarra-Frausto [eds.] [2006] *Museum Frictions: Public cultures / global transformations.* Duke University Press, Durham, NC)

Werner, A. (2003) Egypt in London: Public and private displays in the nineteenth century metropolis. In J. Humbert & C. Price (eds.) *Imhotep Today: Egyptianizing architecture.* UCL Press, Institute of Archaeology, London.

Williams, F. E. (1940) *Drama of Orokolo: The social and ceremonial life of the Elema.* Clarendon Press, Oxford.

INDEX

CPSIA information can be obtained
at www.ICGtesting.com
Printed in the USA
LVHW060335140120
643463LV00009B/152/P